# Fashion

## Oxford History of Art

Christopher Breward is currently Professor in Historical and Cultural Studies at London College of Fashion, The London Institute, where he directs postgraduate research in the field of fashion studies. He has taught art and design history at Manchester Metropolitan University and the Royal College of Art, London, and has lectured widely in Great Britain, the United States, and Europe. He has also served on the executive committee of the Design History Society and the Costume Society. He sits on the editorial board of the international research journal *Fashion Theory* and has contributed to the *Journal of Design History*, *Parallax*, *Gender and History*, and *New Formations*. His publications include *The Culture of Fashion* (Manchester University Press 1995), *The Hidden Consumer* (Manchester University Press 1999), and co-edited collections *Material Memories* (Berg 1999) and *The Englishness of English Dress* (Berg 2002).

# Oxford History of Art

Titles in the Oxford History of Art series are up-to-date, fully illustrated introductions to a wide variety of subjects written by leading experts in their field. They will appear regularly, building into an interlocking and comprehensive series. In the list below, published titles appear in bold.

# Fashion

Christopher Breward

# OXFORD

UNIVERSITY PRESS

Great Clarendon Street, Oxford OX2 6DP

Oxford New York

Auckland Bangkok Buenos Aires Cape Town
Chennai Dar es Salaam Delhi Hong Kong Istanbul Karachi
Kolkata Kuala Lumpur Madrid Melbourne Mexico City Mumbai
Nairobi São Paulo Shanghai Taipei Tokyo Toronto
and associated companies in Berlin Ibadan

Oxford is a registered trade mark of Oxford University Press
in the UK and in certain other countries

0–19–284030–4

10 9 8 7 6 5 4 3 2 1

British Library Cataloguing in Publication Data
Data available

Library of Congress Cataloguing in Publication Data
Data available

ISBN 0–19–284030–4

Picture research by Charlotte Morris and Elisabeth Agate
Copy-editing, typesetting, and production management by
The Running Head Limited, Cambridge, www.therunninghead.com
Printed in Hong Kong on acid-free paper by C&C Offset Printing Co. Ltd

# Contents

# Acknowledgements

With thanks to the friends who have read and commented on drafts of this book, especially Caroline Evans, Pamela Church Gibson, and Adam Briggs at The London Institute, and Katharine Reeve, Charlotte Morris, David Williams, and their colleagues at OUP and The Running Head. I would also like to thank the students who have inspired its content, especially Paola De Giovanni Pastore for her assistance in the early stages of picture research.

# Introduction

Fashion now occupies the centre ground in popular understandings of modern culture. It enjoys unprecedented coverage in the western media and defines the tenor of urban life like no other visual medium. Such is its relevance that in the normally conservative world of academia it has recently attracted the attentions of a specialist refereed journal.[1] This growing sense of respectability has run in tandem with the publication of a variety of ground-breaking texts that have aimed, over the past fifteen years or more, to place the study of fashion alongside other popular phenomena including theatre, journalism, advertising, and film, recognizing its potential as a significant cultural force. Fashion has been positioned in this literature as an important conduit for the expression of social identity, political ideas, and aesthetic taste, and this model of interpretation has arguably influenced a reevaluation of all creative practices, including art.[2] Such analysis is not new. Indeed, from the late nineteenth to the mid-twentieth century the system of fashion was regularly cited by radicals and revolutionaries as a cultural model worthy of closer examination—as a paradigm, in fact, of modernity itself.[3] What is fresh is the way in which fashion has at last begun to generate a critical literature that it can properly call its own.

Informed by the concerns of anthropology, psychology, linguistics, sociology, and cultural studies, this new body of work complements those specialized studies of aspects of fashion culture that have been completed within the fields of social, cultural, and economic history.[4] These works have tended to concentrate on the creation of fashionable western dress between the fourteenth and nineteenth centuries, seeing in the study of clothing a useful framework for analysing trends in the manufacture, distribution, and use of commodities in historical communities. Though, for the lay reader, the published output of such research may appear to be parochial in its scope and tentative in its findings, its very existence points to a profound shift in attitude amongst historians whose profession has not always been so open to suggestion and change. It seems that the rising prominence of fashion in both popular and academic arenas must bear some responsibility for, and take succour from, the effects of the much touted 'cultural turn'

**1**

Dressmaker's dummy, 1955
A dressmaker pins a jacket in
progress, a fundamental
action in the creation of
fashionable clothing.

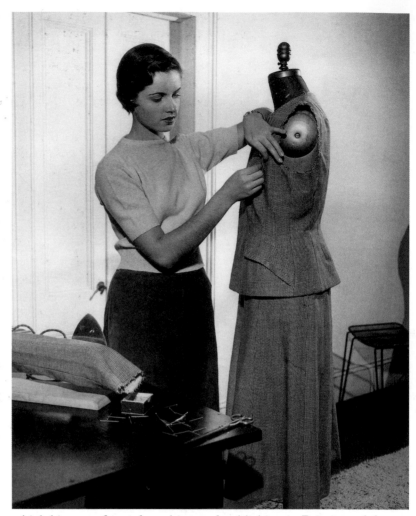

which has transformed teaching and publishing in Britain and America over the course of the late twentieth century. Where formerly empiricist principles had dictated histories of scientific authority but precious little empathy or nuance, a questioning of accepted truths has opened up the field of historical enquiry to projects which share fashion's concern with the ephemeral, with the seemingly irrational world of style and surfaces, and with issues of consumption and identity.

Before this broader renaissance in fashion awareness took place, interest in the subject was not by any means dormant. But it thrived within a much narrower context, its existence known only to the dedicated few. The long-standing activities of costume societies in Britain and America attest to an accumulated wealth of knowledge related to the study of historical dress which has been in circulation amongst museum curators, archivists, private collectors, and theatrical designers since the late nineteenth century at least. Fundamentally interested

in questions of construction, style, and patterns of usage, 'costume history' has endured a great deal of unfair criticism in academic circles, which usually neglects to credit the significant contribution made to our understanding of the development of fashionable form by many pioneering authors.[5] This specialized mode of scholarship found further scope for development through the establishment of academic courses relating to the history of fashion which have been in existence in British universities since the mid-1960s.

It is fair to claim, however, that an expansion of the critical and historical study of fashion has so far occurred outside the centre of its production as a creative and commercial practice. Though courses in fashion design have been offered by the British and American education systems for over a century, these have not tended to support the intellectual foundations from which studies of the industry's history and cultural meanings have since been developed. Indeed this divorce of theory and practice has if anything been thrown into sharper relief by the general expansion of debates on fashion in the wider community. It is then significant that the creative and intellectual needs of the fashion student have largely been met by an expanding category of publications whose appeal is visual and descriptive rather than discursive. These run the gamut from coffee-table picture books, to racy biographies, to glossy exhibition catalogues, and place the products of the fashion system firmly in the role of desirable commodity or art object. Authored by fashion journalists or ghost-written for fashion designers themselves, their purpose is avowedly promotional. But tellingly, such books are sometimes truer to the rapaciously commercial

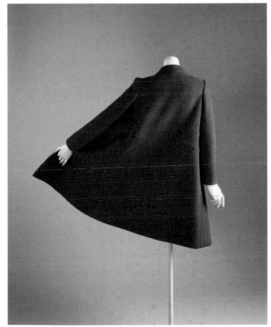

**2 Pierre Cardin**

Day coat in plum wool, autumn 1966

In the museum setting clothing assumes a status akin to art. It is carefully draped over a stand and lit to accentuate colour and texture. Consideration of conservation issues and the rarity or expense of the item further distance the object from its original economic or social context. Nevertheless fashion in the museum forms the key source and focus for many historians of dress.

A clothing store interior, London *c.*1990
In the retail sphere clothing functions primarily as a commodity. It is often presented in a manner that will enhance its attractiveness, but the main incentive is to encourage a sale. Throughout the modern period the style of fashion shops has often resembled that of the museum, blurring distinctions between commercial and contemplative spaces. Here the shop interior echoes the 'white cube' characteristics of the contemporary art gallery. It is the status of clothing as a carrier of economic and social value that most interests the cultural historian.

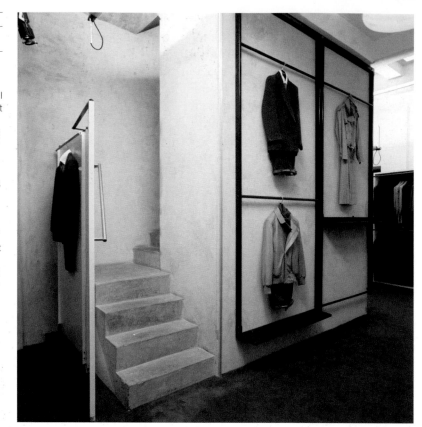

**4 Gustav Klimt**
*Portrait of Johanna Staude,* 1918
Though painters and photographers sometimes manipulate dress for compositional reasons or to suggest mood and personality, portraits and representational images have formed an important resource for the fashion historian. Klimt's work was closely connected with the world of avant-garde dressing, conforming to the spirit of the Wiener Werkstätte. His wife was a fashion designer and the fabric in this portrait was designed by fellow artist Martha Alber. Above all else the spirited depiction of clothing in this image is informed by the philosophical and aesthetic registers of the time.

spirit of the culture in which directional fashion is produced than any number of more abstract 'academic' treatises.

This marked similarity between the content of the glossy fashion publication and the carefully constructed self-image of the fashion industry also has its parallel in the extraordinary rise of the public fashion exhibition as a primary conduit for debates about the nature of modern fashion in the late twentieth century. Moving away from the second-hand investigations of fashion as image or text which mark most book-bound examinations of the medium, the exhibition allows for considerations of form and surface which, though restricted by the fixed environment and conservation constraints of display, offer a vital platform from which the status and meaning of fashion have been challenged and reconfigured. The most notable curatorial interventions have aimed to establish common ground between the registers of fashion and art, possibly reflecting an attempt by the institutions concerned to reach valuable new constituencies of visitors, supposedly put off by the élitist connotations of painting and sculpture more usually associated with the publicly funded museums sector in Britain and America.[6] That such alliances have also been utilized by the fashion industry is evidenced in the controversial curation of retrospective exhibitions of living designers such as the Armani show which

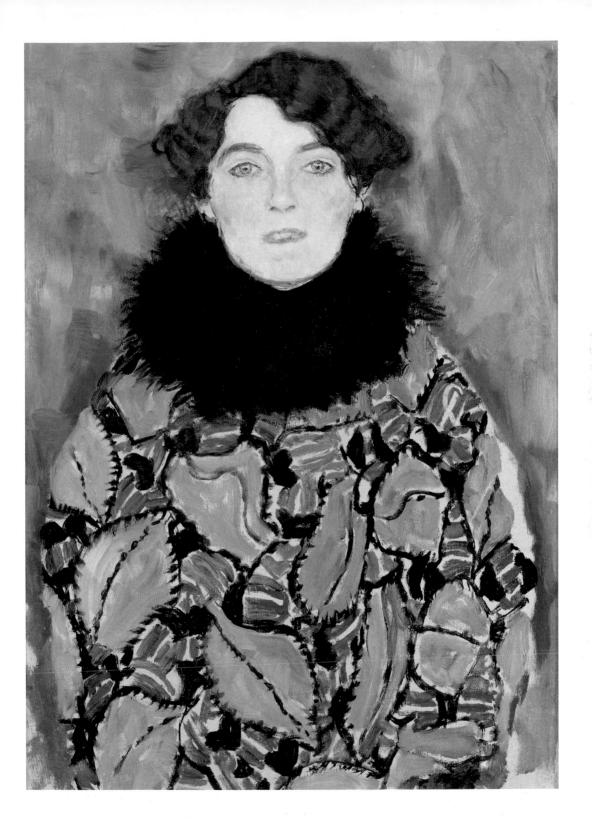

received such a hostile reception from critics when it was held at the Guggenheim Museum, New York in 2000, or the more recent 'Radical Fashion', showcasing the extraordinary work of contemporary cutting-edge designers, which was held at the Victoria and Albert Museum, London in 2001. In related cases, several designers including Issey Miyake and Martin Margiela have presented their work as self-curated installations, whose poetic reflections have done much to further the cause of fashion as a meaningful philosophical and creative endeavour, existing independently of its commercial imperatives.

This desire to divorce the subject from its crude economic context is also revealed in exhibitions which have deliberately echoed the concerns of academic investigations of fashion. The 'Streetstyle' show which took place at the Victoria and Albert Museum, London in 1994 clearly utilized anthropological studies of youth subcultures to present its content, and its staging initiated a concerted oral history project designed to meet the research and acquisition needs of the curators. In its realization the exhibition managed to pioneer innovative methods of display and analysis whilst drawing in the desired new student audience. Its critical reception, however, was still mixed, and many internal and external commentators seemed unsure that a national museum of the decorative arts was the appropriate location for an exploration so focused on demotic concerns.

Tensions between different approaches to the study of fashion are thus legion in all their variations, and the medium of dress seems to bring out the prejudices of academics, journalists, curators, and designers in a particularly concentrated form. For the potential student of the subject such a state of affairs must be confusing and alienating. In acknowledgement of this impasse it is not the intention of this book to adopt a discriminatory tone with any of its sources (there are in any case, other texts which provide useful accounts of the historiography of dress studies and the methods of its various practitioners).[7] Whilst stopping short of an account which seeks to erase differences, I value instead an informed synthesis of approaches which disregards perceived hierarchies to seek a coherent and comprehensive overview. Paramount to the effectiveness of this pooling of resources is a shared recognition of the power of the modern fashion medium to inform cultural formations, social movements, and the material and aesthetic environment of life in the developed world. Perhaps one of the weaknesses of the newly emerging discipline of fashion studies is a tendency to address fashion in a singular manner, as cultural sign, as designed consumable, or as evidence of broader historical and social processes. These facets are rarely considered simultaneously which is a shame, because harnessing the benefits of seemingly divergent works promises fresh insights and productive arguments.

The primary challenge of this book, then, will be to present modern

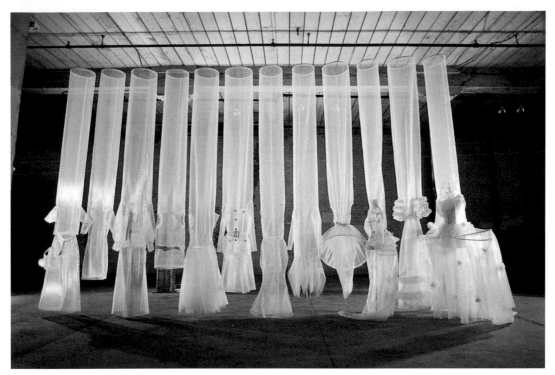

**5 Lun*na Menoh**

'Spring and Summer
Collection 1770–1998',
1998

Many sculptors and installation
artists have found inspiration in
the fabric and meaning of
clothing. Los Angeles-based
Menoh utilizes the forms of
historical dress to suggest a
ghostly genealogy of changing
taste, identity and experience.
Some recent fashion designers
have also endeavoured to
imbue their products with the
philosophical and aesthetic
qualities of installation art,
critiquing the context of their
practice and obscuring the
commercial and functional
underpinnings of their trade.

fashion as the outcome of a precarious marriage between the processes of creative authorship, technological production, and cultural dissemination, and to reconcile the notions of fashion as idea, object, and image. One of the most promising ways of doing this will be to reinsert the nature and process of design into a discussion which has perhaps come to downplay the practices of the designer in favour of a concentration on issues of consumption, with potentially unbalancing effects. A refocusing on named designers is not necessarily a retrograde step. It offers a means of unpacking those questions of intention and style, craft and materiality, that sit at the heart of any definition of fashion. It is also very necessary, in the face of a new fashion literature which tends to be thematic and anti-linear in its organization, to revisit the unfashionable concept of a 'canon'. Students of fashion still require a working knowledge of key personalities and protagonists, together with an understanding of the values and judgements through which their work has been promoted over that of others. Such considerations should not of course be taken in isolation, and a focus on the individual needs to be placed within a definition of the history of fashion as a history of industrial manufacture and distribution, allied to the growth of a metropolitan sensibility, the energies of a consumer culture, and the expanded sphere of visual reproduction. Furthermore, it should be recognized that these are developments embedded in the stuff of clothing itself, and it is in the product of the fashion designer and its wider representation that the most pressing evidence

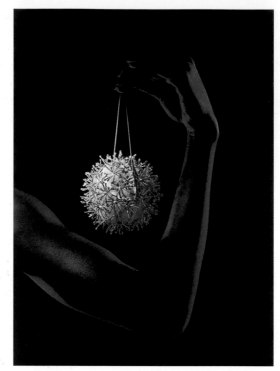

of cultural and social change—those lubricants of modernity—is suspended.

The following chapters take as their starting point the emergence of fashion in the late eighteenth century as a self-consciously élite but newly commercialized medium reproduced through the nascent couture houses of Paris, sparking a triumphant progress that would see fashion celebrated as one of the defining features of metropolitan life in modern Europe and America. This is not to discount the existence of comparable circumstances in earlier periods or other non-western cultures. Nor is it to underplay the importance of other functional, psychological, or ceremonial influences on dress. It is simply a consequence of the fact that the parameters of the book are defined in relation to the ways in which the modern fashion industry in the west has defined itself over time. That is to say that for our purposes modern fashionable clothing is a manufactured commodity that has been designed according to predominantly western social, economic, and aesthetic values, and which in its formal and conceptual qualities has aided the shaping of a sense of the present for its various consumers. From charting its beginnings in eighteenth-century Paris, the book ends with an assessment of the pluralistic nature of the mass-market fashion system at the start of the twenty-first century. It acknowledges its continuing global importance for world economies and for pan-cultural definitions of status, race, and sexuality. Within this chronological tracing, individual sections and chapters aim to communicate

the internal logic of the fashion system which hinges on considerations of its production, its promotion, and its practice. Fashion is presented here as a process which moves through several modes of action and experience, passing from the designer, through the manufacturer, the advertiser, and the retailer and on to the consumer, and sometimes linking back from consumer to designer, or even running in reverse. It is this cyclical momentum that drives the order of the book, echoing the patterns of a medium which is in constant and seemingly chaotic flux.

Finally, it should be stated clearly that what follows is not by any means the last word on fashion and its copious meanings. Like all such books, its coverage can only be partial, and this is also entirely contingent on the circumstances of its production. It is reliant for its content and perspectives on the work of countless other scholars, though I am entirely responsible for the ways in which their arguments have been framed and reinterpreted here. Furthermore, the field of study is still relatively young and much work remains to be done—this book simply maps the terrain for those who are starting out on that task. By way of encouragement I should stress that in writing such a guide I have become more aware than ever of fashion's extraordinary capacity as a vehicle for social action and for the promotion of a profound beauty. I sincerely hope that these positive characteristics survive any subsequent reading and inspire further thoughts.

# Part 1
# The Production of Fashion

# The Rise of
# the Designer

1

How are fashions made and by whom? In a sense this question has always been a fundamental one for the historian of dress, though attempts to answer it have often been partial. The standard literature tells us that a succession of great makers have made the most significant contributions to the progression of fashionable style, but it does not really offer many explanations as to how or why this might be the case. In moving beyond such uncritical accounts it has become necessary for the historian to consider a whole range of influences and contexts which encompass not just the artistic and emotional motivations of fashion *auteurs*, but also the effects of manufacturing and its technologies; distribution, retailing, marketing, and consumer demand; and the impact of cultural and societal changes on the cycle of innovation and obsolescence which characterizes the creation of modes and trends in clothing.

Only when all of the above stages have been taken into account is it possible to arrive at a comprehensive understanding of the fashion system. Even then the emergence of a new fashionable style is revealed as a phenomenon which slips tantalizingly between categories and moments in a never-ceasing play between the processes of production and consumption. It is not surprising, then, given these difficulties, that the role of the fashion designer has been so consistently highlighted in fashion's own mythology. In the mystique that has grown up around the designer's working practices and professional identity commentators have found a convenient way of avoiding the much more complex and sometimes unsettling network of economic, aesthetic, and moral factors which constitute the idea or problem of fashionable modernity.

Yet the opposing tendency to underplay the input of individual creatives has perhaps wilfully ignored the powerful legends which have contributed to the enduring impact of fashion as 'the' modern cultural form *par excellence*. The precious and autocratic designer, dictating global skirt-lengths at a whim, may be an overblown caricature most at home in the spectacular context of the Hollywood film or the glossy magazine; but the symbolic importance of such stereotypes in defining fashion as product and process over the past two centuries has without

Detail of 19

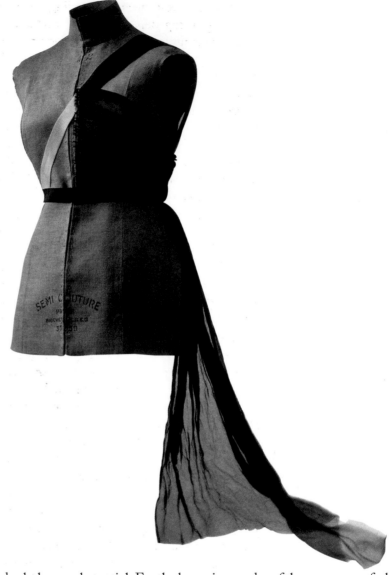

**7 Maison Martin Margiela**
Stockman-shaped jacket and a study of drapery, c.2000
Belgian-born Margiela, who always communicates through the collective voice of his studio, has claimed that 'fashion is an inspiration, a craft, a technical know-how and not, in our opinion, an art form'. His uncompromising design statements similarly challenge contemporary definitions of fashion, deconstructing the process of design and questioning the status of the designer.

doubt been substantial. For the browsing reader of the newspaper fashion column, or the purchaser of a new fashion item on the high street, the named fashion designer *is* fashion. It is in recognition of this more popular understanding that I aim to address here the particular ways in which the actions and characterization of such individuals have played a part in the progressive development of fashionable form over the course of the modern period. For to write the designer out of fashion history completely would be on a par with attempting to construct a history of art without considering the contribution of painters—an interesting project, but one with an undeniable absence at its heart.

The conditions for the rise of the celebrity designer were the same as those which paved the way for the emergence of a modern consumer

society in the west. Factors including the expansion of urban civilizations, a growing dependence on mechanization, and the reorganization of labour in industrial manufacturing provided a context within which innovation and productivity could thrive. Improvements in transport and communication systems, an increased level of visual and textual literacy, and a concurrent democratization of supply further ensured that by the mid-nineteenth century consumers across a range of social classes in all of the major European and American cities (together with those in more provincial settings) had access to a high turnover of fashionable products whose proliferation was undreamed of by their ancestors. This was a process that had been gathering speed since the fifteenth century at least, but it was in the specific locations of London and especially Paris from the 1840s onwards that a revolution in fashion production of unprecedented scope really took hold.

The fashion designer was a product of this development rather than its initiator. The designer's practical skills in communicating novel ideas eased the smooth relationship between the production and consumption of goods necessary in a capitalist system of provision, and ensured that new products carried the requisite cachet to stand out in an overcrowded marketplace. This was the case across all facets of material culture and explains the emergence of the commercial designer in a wide range of trades from silversmithing to textile weaving at about the same historical moment. Where the genius of men like Charles Worth and Paul Poiret or women like Coco Chanel and Madeleine Vionnet lay was in their ability to read the implications of cultural and stylistic change and incorporate it into a characteristic and very well-promoted personal vision. It is really only in the field of architecture that the names and personalities of individuals have carried a similar resonance for the consumer. Graphic and product designers may feature as personalities in trade literature and in the many inward-looking histories of their professions, but as figures in the popular imagination they are shadows of their fashion counterparts. Before accounting for the success of the latter in so influencing our understanding of the development of modern clothing it will be useful to sketch briefly the context which preceded and aided their rise.

## The roots of modern fashion

Paris in the mid-nineteenth century had been the pre-eminent fashion city for at least 100 years, though this status was not easily won. The Italian city-states of the Renaissance witnessed the first stirrings of sartorial competition which initiated a consequent speeding-up of style change. The potential of modern dress as a signifier of local status then rapidly spread through Europe, implicating the ruling houses of first Burgundy and then Spain as important centres for the promotion of

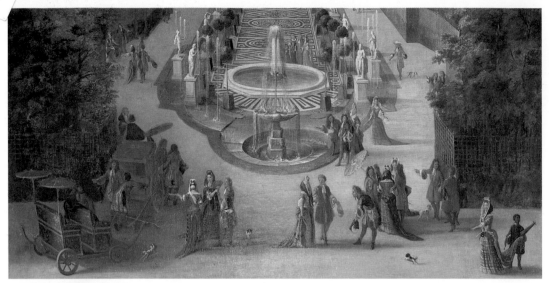

**8 Jean Baptiste Martin**

*A Promenade in the Gardens at Versailles, c.*1690

The spectacular court of Louis XIV at Versailles ran on strict rules which carefully orchestrated the clothing of the French aristocracy according to rank. In the luxurious grounds of the new palace, courtiers paraded their status and symbolized the wealth and sophistication of the nation to visitors.

fashionable magnificence and innovation in the fifteenth, sixteenth, and seventeenth centuries. The dominance of Burgundian and Spanish sartorial styles reflected those periods during which their respective courts enjoyed an unparalleled level of political and military influence. Paris, though a significant centre for the production of luxury goods, held no early monopoly on the dictating of trends—its association with any particular ruling dynasty was too tenuous. It enjoyed only a fleeting moment of international renown during the reign of François I, whose elegant regime dominated northern European taste in the middle of the sixteenth century.

In the late seventeenth century however, the French court of the Sun King Louis XIV played host to the most concerted effort yet to harness the power of fashion propaganda for dynastic and nationalistic ends. As Louis's most powerful minister and architect of his rise to power, Jean-Baptiste Colbert commented, 'fashion is to France what the gold mines of Peru are to Spain'. State sponsorship of the textile and decorative arts industries, and the consolidation of the court at Versailles as a carefully managed symbol of absolutism, utilized the idea of French fashion as a means of control and self-promotion. Ambitious courtiers and subjects were kept in check by a complex system of sartorial rules, and foreign competitors were awed into submission by the centralization and spectacular staging of ostentatious examples of fashionable activity.

The labour which lay behind this emphasis on the creation of fashion was centred on nearby Paris, and unsurprisingly the multitude of weavers, embroiderers, tailors, dressmakers, and milliners employed in the service of the court swiftly established themselves as an alternative source of fashionable knowledge and materials to the more heavily policed locus of style situated at Versailles. The *demi-monde* of wealthy

courtesans and actresses at home in the city could call on the same skills and expertise in the fashion industries as the courtier. In this manner they benefited indirectly from the royal patronage which had energized Parisian clothing manufacture, whilst their own dressing practices subtly subverted the stranglehold of court etiquette. By the beginning of the eighteenth century Parisians found that their tastes and preferences, freed from the restrictions of court practice, were attracting the attention of a younger generation of the nobility. After 1715 Louis XV's court chose to embrace the chic urbanity of city modes over the fossilized ceremonial of official life and it was in this context that the Parisian purveyor of fashionable wares and know-how gained a new currency.

This development can be read through changes in fashionable form itself. Seventeenth-century court dress or *grand habit* was characterized by its formal construction, rigid internal composition and hierarchical orders of decoration. Though its supremacy as a fashionable garment was challenged in the new century by the Parisian's *robe volante* or informal sack dress, and its successor the *robe à la française* (a more fitted version of the *volante*, worn over panniers or skirt-supports and opened at the front to reveal a decorated petticoat and stomacher), the importance of surface ornamentation survived. The details of embroidery, lace, ribbons, and ruffles were more likely to signify shifting taste and style than the cut of a dress which changed more slowly. In this scenario the *marchandes de modes* who supplied trimmings had greater influence over the direction of fashion than the *maitresses couturières* whose responsibility lay in the cutting-out and construction of the basic garment.

The *couturière*'s role had in any case been annexed in 1675 under trade guild policies which dictated that her role should be restricted to the production of various elements of the female wardrobe only, protecting the trade of the (male) tailor whose practice had traditionally extended over both men's and women's clothing. The *marchandes de modes* fell under the jurisdiction of another guild and subsequently found it easy to muscle in on the *couturière*'s already compromised status, promoting their expertise on a par with that claimed by tailors in the sphere of masculine dress. The most famous *marchande de modes*, Rose Bertin, thus took control of *Ancien Régime* fashion direction from her business in the rue Saint-Honoré and used her premier client Marie-Antoinette as a valuable promotional tool. Bertin's reputation as a domineering icon of fashionability arguably formed the prototype from which later popular constructions of the fashion designer developed, though like several self-styled designers in succeeding decades her expertise lay in a masterful juxtaposing of existing elements and an ability to flatter and anticipate the tastes of her élite clients rather than in the initiation of completely new lines.

## The first fashion designers

Such is the stuff from which fashion legends are made. How much weight one places on the individual role of characters like Bertin in initiating a modern fashion system is debatable. The argument relates to a much broader discussion concerning the contradictory nature of consumer culture itself and the relationship between supply and demand. It could be argued that the desire for innovation and differentiation which the *marchande de mode* capitalized on arose from intellectual and social currents amongst the professional citizens of Paris, whose articulation of progressive taste marked them out as the rising political body, in opposition to traditional aristocratic prerogative. Alternatively, Bertin and her like might be seen as reactionary yet entrepreneurial figures, trading on social snobbery and a reputation for the refinement of their judgement amongst the élite, whilst ruthlessly stamping their signatures over the new products and increased style changes which

**9 Elisabeth Vigée-Le Brun**

*Queen Marie Antoinette and Her Children*, 1786

The Queen of France is here dressed in an ensemble characteristic of the work of Rose Bertin. Her velvet robe *à l'anglaise* is trimmed with sable and *point d'Alençon* lace, the red, black, and white palette suggesting the traditional royal colours of France. On her head a matching 'pouf' decorated with white silk, ostrich feathers and an egret conjures up the romantic associations of the East. This combination of allegorical allusion, modishness and luxury was typical of Parisian fashion in the period.

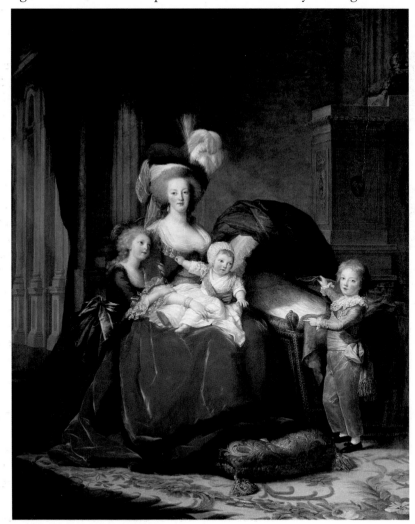

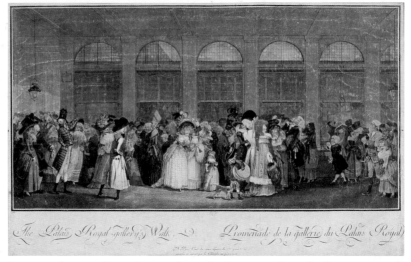

The Palais Royal gallery's Walk.    Promenade de la gallerie du Palais Royal

improved manufacturing and marketing practices had encouraged. Whatever the reasons for their success however, and it is likely that individual *marchandes* were as varied in their sympathies as the broad social spectrum of their patrons, there is no question that by the start of the nineteenth century the control of fashionable taste in clothing had been wrested from the court (aided in no small part by the upheaval of political revolution) and was now identified with the practices and products of a select group of innovators secure in their hegemony in the commercial sphere of Paris.

The Revolution failed to eradicate the deeply hierarchical and antiquated organization of the Paris clothing trades, and the reputation of its most elevated practitioners ensured that the city's fame as a centre for the luxurious and the chic endured. Dressmakers and tailors to the new nobilities of the Directory and the Empire prospered from the careful manipulation of their reputations as highly sought-after purveyors of typically Parisian elegance and distinction to an international clientele marked out by their money, or their royal blood. Louis Hyppolite Leroy—renowned for his skill at structuring the subtle and deceptively simple 'Empire' line of dress—enjoyed the patronage of Josephine de Beauharnais, Queen Hortense, the Duchess of Wellington, and the Queens of Spain and Sweden, and at the reinstatement of the Bourbons as crowned heads of France, he designed the robes for the coronation of Charles X. The confections of Mesdames Palmyre, Victorine, and Vignon were similarly prized by the ruling classes of the July Monarchy (1830–48), and their continued importance in fashioning the flounced and exquisitely trimmed wardrobes of iconic women like the Empress Eugénie during the middle years of the century forged a link back to the enduring influence of Rose Bertin.

Bertin's world had been located amongst the discreet sartorial establishments of the rue Saint-Honoré. By the mid-nineteenth century

this rarefied domain of small gilded showrooms and prestigious work-shops had expanded and diversified to incorporate the rue de Richelieu and latterly the rue de la Paix. The neighbouring Palais Royal bene-fited from the reflected glow of these grand locations for the acquisi-tion of 'made-to-measure' magnificence, but housed a less refined, though no less opulent collection of ready-made fashion goods for visiting tourists and provincials eager for the latest 'look'. In contrast the rue Saint-Denis was associated with the respectable purchases of the lower-middle classes and its pavements were equally thronged. Despite their different atmospheres, what all these areas held in common was the blind belief of their inhabitants in the global suprem-acy of Parisian fashion, and a scattering of tenants whose trading-names had become synonymous with that very same phenomenon. This was the local business context that fostered the emergence of *grande couture* in the 1850s and 1860s and in these streets, so some fashion historians have argued, modern fashion was born.[1]

## Charles Frederick Worth

If the epoch-making reputation accorded to Charles Frederick Worth carries any weight then the inspiration for *grande couture* lay not in the rue Saint-Honoré or the Palais Royal, but in the remodelled shopping

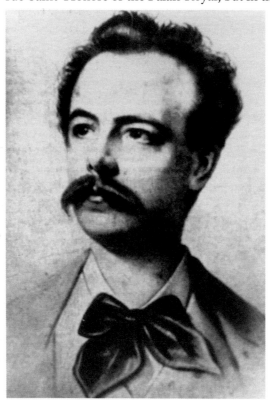

**11**

Charles Frederick Worth
The 'father of couture' carefully controlled the promotion of his image, elevating his status above that of dressmaker and accentuating his role as an artist.

streets of early nineteenth-century London. Though frequently credited as the grandfather of French couture, Worth's eye for the self-promotional possibilities inherent in the clothing trade was trained in Britain. Born in 1825 to a family of Lincolnshire solicitors, Worth was apprenticed to work at the London draper's Swan & Edgar of Piccadilly Circus in 1838. A domestic crisis had necessitated that the young man relinquish the prospect of a legal career in the provinces for the much more hectic world of metropolitan retail.

Swan & Edgar was one of many drapery shops to enjoy a period of growth in the mid-nineteenth century. Its business lay in the provision of lengths of fabric and trimmings to customers who would then take such materials for making up into a gown at a dressmaker's. Like their competitors, the directors of Swan & Edgar capitalized on the emerging importance of shopping as a social pursuit for middle-class and aristocratic women. The store also fed the contemporary craze for shawls and mantles, which did not require the complex construction skills of a dressmaker. This provided the capital and the custom which enabled further expansion. In the process traditional drapers' shops were transformed into exotic bazaars of leviathan proportions where the range of goods for sale, and the impact of store displays and promotions, offered the consumer an entirely novel shopping experience. Previously customers had negotiated their fashionable look in consultation with a small trader and his narrower stock, balancing the ideals portrayed in fashion magazine plates with a more constrained reality. Now the scale of operations meant that large city-centre stores played a crucial role in introducing new styles and trends on a much wider and more spectacular scale.

Worth was involved in this retailing revolution from the beginning, gaining a valuable knowledge of a broad range of textiles and experiencing new selling techniques which essentially styled customers according to the dreams currently being promoted by the store's buyers, set-dressers and advertisers. Beyond the sphere of commerce he was also able to benefit from the cultural repositioning of London as a world city during the 1830s and 1840s. As a focus for international trade and tourism the capital was unchallenged, and its galleries, exhibitions, theatres, and bookshops offered Worth a wealth of inspirational material.[2] His later expertise was identified as an ability to choose and manipulate fabrics to suit the character and complexion of the client, with an almost operatic control of historical sources which injected drama into new styles. These skills were clearly honed in the environment of London's retail and entertainment sectors.

Following the completion of his apprenticeship Worth took up a selling position at Lewis and Allenby, silk mercers to Queen Victoria, in Regent Street, before gambling on throwing everything in for the possibilities that beckoned from across the English Channel. In 1845,

inspired perhaps by his reading of romantic heroes and dandyish pursuits in the fashionable novels of Bulwer-Lytton, and by the tantalizingly profitable connections with continental silk producers on which his employer's success depended, Worth made the one-way passage from London to Paris. After a difficult few months learning French whilst working as an assistant in a dry goods store, Worth secured a post at Gagelin-Opigez, a premier drapery store in the rue de Richelieu. Gagelin were widely recognized for the qualities of their ready-made shawls and mantles whose fine cut, trimmings, and patterns were shown to customers 'as worn' by the female shop assistants. One of these women, Marie Vernet, who was later to marry Worth, worked closely with the new employee to redesign the very plain white muslin dress which served as the uniform against which the shop's products could be most effectively displayed. The strikingly simple, well-tailored quality of these dresses rapidly drew the attention of clients and led to the establishment of a dressmaking department of which Worth was made chief cutter.

Following the award of several gold medals at the international design exhibitions which dominated American and European culture in the latter half of the century, Worth's reputation spread. At Gagelin he capitalized on the firm's relationship with French fabric manufacturers to present regular collections of new designs in a rich variety of textiles and colours. These were marketed not just to local customers, but to

**12 Franz Xavier Winterhalter**

*The Empress Eugénie Surrounded by Her Ladies-in-Waiting*, 1855

The patronage of women in the Second Empire court eased Worth's passage from a post at the drapery store Gagelin to the establishment of his own business. The sociability and romantic leanings of Empress Eugénie's circle were well-suited to Worth's talents.

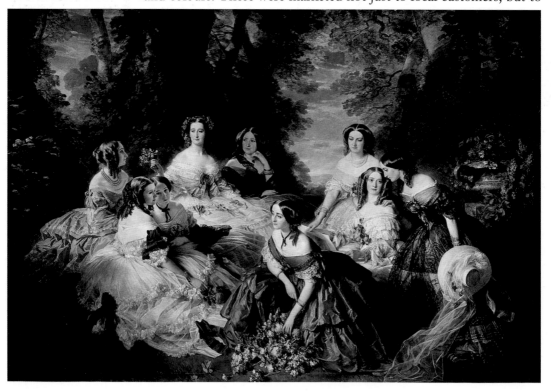

**13 Franz Xavier Winterhalter**
*Empress Elizabeth of Austria,*
1865

By the eve of the Franco-
Prussian War, Worth's name
had secured an international
reputation. In her spangled
tulle crinoline the Empress of
Austria displays the
quintessential Worth line. A
vaguely eighteenth-century
historicism, novelty of effect
and technical daring were all
qualities associated with the
house of Worth.

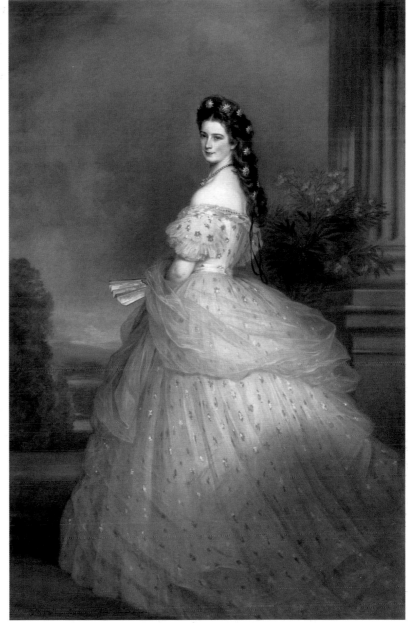

foreign buyers who could be assured of high and consistent standards.
By 1858 he was confident enough to establish his own dressmaking
business in the rue de la Paix, in partnership with the Swede Otto
Bobergh. The patronage of the Princess Metternich, wife of the Aus-
trian ambassador to Paris, ensured an entrée into the lucrative world of
the court of Napoleon III and the Empress Eugénie, with its round of
state balls, government receptions, military parades, and gala perfor-
mances. Once the Empress had realized the political benefits of
promoting the Lyonnaise textile trades through her choice of attire, she

turned consistently to Worth, who by 1864 was responsible for supplying all of her state and evening wear.

With the seal of royal approval firmly set, Worth was able to raise his prices and refine his public image. Whilst his commercial success was very firmly rooted in good retail practice and an acknowledgement of the importance of dependable supply chains, sound marketing, and impeccable social contacts, Worth was concerned to ensure that his products were not reduced to the level of mere commodities. Part of their value lay in the fact that their design was associated with the aesthetic ideas and taste of one man alone, and with this in mind Worth spent much effort during his remaining years in promoting his own identity as an arbiter of style. Published portraits of the mature master depicted him in the velvet bonnet, fur-lined cape and loose cravat of the artist. His huge country villa overlooking the Seine at Suresnes became the focus for ostentatious displays of interior design and hospitality. And in the conduct of his professional affairs, Worth dictated the direction of fashionable taste from his salon in the rue de la Paix. Regardless of their status, all personal clients had to keep to an appointment system and travel to, rather than receive, the couturier. Once in his presence the customer submitted to Worth's vision and selected her garment from his current range. The item itself would then be made up to her precise measurements. With Bobergh concentrating on the financial management of the business, Worth was left free to work on the veneer of exclusivity and creativity which lent his name its resonance and ensured that his dresses received maximum coverage in the élite women's magazines whose circulation was central to his success.

The salon closed temporarily on the collapse of the Second Empire in 1870. But from its reopening in 1871 to Worth's death in 1895, the company enjoyed a turnover and international influence that was unprecedented in the history of clothing manufacture. Employing a staff of 1,200 in 1871, which included draughtsmen, cutters, seamstresses, hand- and machine-embroiderers, clerks, *vendeuses*, models, and salesmen, Worth's practice incorporated a range of activities from the bespoke fitting of an individual client to the syndication of a model for reproduction by dressmakers across the globe (beyond the nobility and *haute bourgeoisie* of Europe, the new wealthy of North America were an important market for Worth). It was only in the former case that Worth would attend personally to the completed look of the garment. For the rest, his signature lay in the characteristic play of textures and patterns, and attention to cut and finely tailored finish that singled out a Worth creation.

The sketchbooks which recorded his design ideas across the thirty-five years of his mature career show in abbreviated form Worth's preference for fabrics that emphasized sculptural effects and surfaces

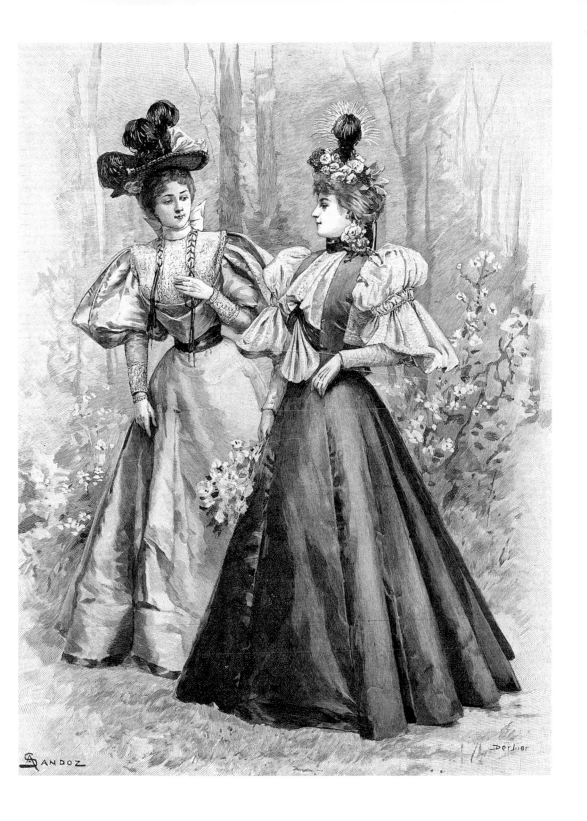

SANDOZ

Derbier

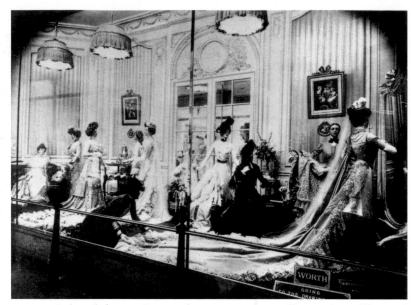

over peripheral decoration or deeper textures: tulles, satins, silks, and brocades rather than moires and velvets. The sketchbooks draw attention to the refining of the body's proportions and a process of skilful pattern-cutting, repositioning dress design as a form of engineering, rather than a mere synthesis of existing elements. The house depended on a stock of interchangeable standard patterns as a way of renewing its designs on a cyclical basis, but new effects were always deliberately astonishing. From decade to decade Worth clearly championed a progressive attitude to fashionable changes, experimenting with the flat fronted crinoline and gored skirts in the mid-1860s, the mermaid-like 'princess line' devoid of waist-seam in the 1870s and the revival of gigot sleeves in the 1890s. Whether or not his promotion of them constituted a form of invention, as some of the magazines liked to claim, is not entirely relevant. What was significant was that their being bracketed with his name ensured that Worth's fame as an author of novel styles overshadowed his probable direct involvement in their genesis.[3] For the modern fashion designer, the maintenance of a reputation and skill in business was as important as any evidence of design flair, and whilst Worth's massive output undoubtedly benefited from his distinctive artistic vision, his ability to promote himself and encourage the consumer to believe in the singularity of an essentially industrial, serial product whilst remaining unaware of the business infrastructure which supported it, set a distinctive template for the myth of modern fashion.

## Paul Poiret

After his death in 1895, Worth's sons Jean-Philippe and Gaston continued the business in a similar vein. Jean-Philippe adopted the same

socially conservative attitude as his father in courting the patronage of select clients, associating fashionability with aristocratic taste and élite lifestyles. Gaston, however, whose responsibility as business manager was commercial rather than creative, saw the need to reach out to a broader audience and in 1901 engaged a young designer with the express remit to supply a range of outfits suited to the practicalities of modern living and tighter budgets. As Paul Poiret, the new employee, remembered, Gaston had noticed that 'sometimes Princesses take the omnibus, and go on foot in the street'. The imperious Jean-Philippe refused to make the simple garments that such activities called out for, but recognized their importance. The house of Worth, so the brothers claimed, was 'like a great restaurant, which would refuse to serve aught but truffles. It is therefore necessary for us to create a department for fried potatoes.'[4] The older Poiret revelled in his provocative earlier role as 'potato fryer' at Worth, and though the association only lasted two years, ending abruptly due to the inevitable clash of temperaments, its colourful legends helped to establish Poiret's reputation as the harbinger of modernity in Parisian fashion design. His career was the logical, though rather brash result of Charles Worth's more measured insistence on the centrality of marketing and public image to the production of fashion.

Like Worth, Poiret's origins lay in the drapery trade, though the latter's attitude to the business possibilities of retailing was less positive. Apprenticed by his father to a Parisian umbrella manufacturer in 1896, Poiret only enjoyed his duties there as a delivery boy. These brought him into contact with major department stores such as Le Bon Marché and the Grands Magasins du Louvre, with their extravagant displays of contemporary fashions and textiles. The lavish exoticism must have appealed to the boy's imagination. In his spare time he indulged his professional and creative frustrations by producing sketchbooks of dress designs which he supplied on a freelance basis to couturiers including Mesdames Cheruit, Rouff, and Paquin, and Messieurs Doucet and Worth. At Doucet his persistence paid off with the offer of a permanent position as an assistant in the tailoring workrooms.

Jacques Doucet's patrons were drawn from the world of the Parisian *demi-monde*, famous actresses and hostesses attracted perhaps to the firm's origins as a supplier of luxury lingerie on the rue de la Paix. The style of his garments was seductive, making great use of lace and fluid, semi-transparent textiles that flattered under the limelight of the theatre. Doucet constructed for himself an elegant persona, described by Poiret as 'exceedingly soigné and looking as if he had just come out of a bandbox'. If Worth commandeered the identity of a dictatorial artist, Doucet, with his toy dog and renowned collection of eighteenth-century furniture and paintings, posed as the exquisite connoisseur.

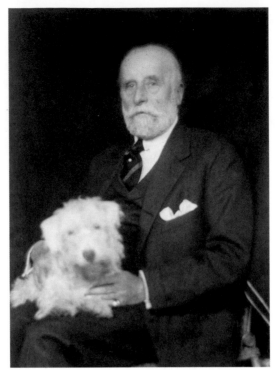

**16 Man Ray**

Jacques Doucet, *c.*1925

The couturier Doucet, famed for his sensuous *fin-de-siècle* designs, developed Worth's cult of the personality to a greater level of sophistication. In his perfect tailoring, accompanied by a lap dog, he has eschewed all pretensions to craft. Here the fashion designer embodies that sense of distanced control that has characterized the upper levels of the trade in the modern period.

Poiret modelled his own emerging character on that of his first serious employer, spending much time being seen in his new English suit at significant sites of Parisian entertainment. In this sense the young designer embraced the world of the *boulevardier*, drawing clear connections between the mass-consumed pleasures of the city and a more vibrant conception of what constituted fashionable dress.[5]

At work Doucet encouraged Poiret's talent for draping and decorating textiles in dramatic style by assigning him to the actresses Réjane and Sarah Bernhardt. It was Poiret's too intimate relationship with another theatrical client, an operetta star from New York, which brought an end to this stage in his career. Rather than the affair itself, whose minor scandal was good for a business in which gossip oiled commercial transactions, it was Poiret's flouting of a convention whereby all of his designs belonged to Doucet that precipitated the termination of his contract. He had taken the liberty of designing his lover's wardrobe in secret and allowing her to have it made up by another dressmaker. Such issues of copyright regularly undermined Poiret's professional advancement. But the increasing importance placed on assigning artistic authorship to a collection of clothing revealed how central the idea of the designer had become to the development of the fashion industry.

Following military service and the period working for Worth, Poiret opened his own couture house on the rue Auber in 1903, which soon gained a reputation for its striking window displays. His marriage

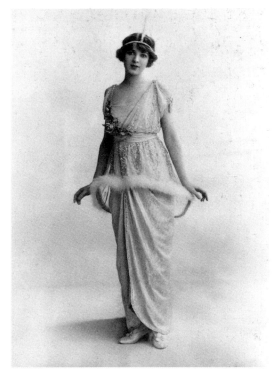

to Denise Boulet, the daughter of a provincial textile manufacturer, in 1905 provided him with a suitable muse and it was largely in response to her youthful figure and adventurous temperament, together with the need to publicize his work, that Poiret produced a reinterpretation of the tubular Directoire line. His 'Josephine' model of 1907 featured a simple high-waisted evening dress of ivory satin, covered with a black gauze tunic bordered by a neo-classical pattern of gold braid and fastened with a pink fabric rose at the breast. It illustrates the departure Poiret was making from the established standard of beauty which had emphasized matronly curves achieved through lacing and padding. The new look appeared to offer more freedom of movement than that previously favoured. It was also a great deal less expensive. In reality though, its simplicity was a little deceptive. The slim straight line still required a support garment and a servant was needed to fasten the dress at the back. Poiret was also mischievous in his claim to have released women from the tyranny of the corset single-handedly. Madeleine Vionnet and the Callot sœurs, Mariano Fortuny in Venice and the Viennese Fluge sisters, were simultaneously presenting collections of simpler dresses based on the popular tea-gown, and English dress reformers had been advocating the Empire style, minus corset, for at least three decades.

Poiret did however make an unprecedented contribution to the modernization of the industry through his novel attitude towards the process and promotion of design. The inspiration for his clothing was

**18 Georges Lepape**

*Les Choses de Paul Poiret,*
1911

The simplified lines and flat colour of Lepape's illustrations matched the avant-garde aesthetic of Poiret's work with an equally innovative graphic style. In combining modernist principles of representation with a romanticising neo-Napoleonic content, limited-edition books such as these succeeded in imbuing Poiret's product with an atmospheric and aspirational modishness.

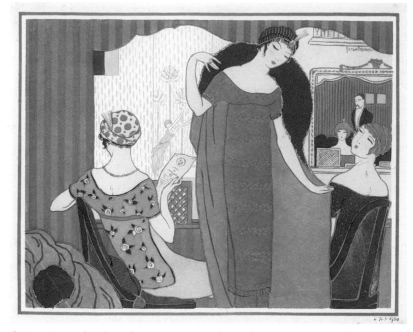

far more radical and provocative than the picturesque historicism favoured by the generation of Worth. Poiret drew attention to the originality of his sources, whose exoticism or violent pattern and colour challenged contemporary aesthetic and sexual preconceptions. He was adept at reconfiguring visual elements from the Far and Middle East, India, central and eastern Europe, avant-garde contemporary painting, theatre, and the history of western dress. The designer worked in the manner of an illustrator or set-dresser—manipulating surfaces to suggest mood.[6] This process of stylization was extended by Poiret to incorporate new methods for the circulation and marketing of his designs. In 1908 he commissioned the graphic artist Paul Iribe to make the images for a bound album of designs, *Les Robes de Paul Poiret*, which was circulated in the manner of a catalogue to potential clients. This success was repeated in 1911 with a similar publication illustrated by Georges Lepape. Both illustrators presented Poiret's work in a flattened and highly decorative modern idiom that conveyed the escapist spirit of the clothing in a manner that was far more convincing than the traditional fashion plate with its fetishization of detail, or even the atmospheric but essentially realist photography of Edward Steichen, with whom Poiret also collaborated.

The recognition that the work of the couturier was in part to sell a fantasy also lay behind Poiret's offering up of his own extravagant tastes and lifestyle for public consumption. In 1911 he renovated an eighteenth-century mansion on the avenue d'Antin as the romantic setting for fabulous fancy-dress events which showcased his creations. These included the spectacular 'Thousand and Second Night' party

Like many designers of his generation, Poiret placed great importance on the presentation of his clothing through fashion shows, international tours and commercial tie-ins. In some respects his business resembled the mythical harem which had so inspired the development of his style.

whose provocative orientalism shared in the glamour of the Ballets Russes, who were performing *Scheherazade* in Paris at that time, and suggested common links with those progressive attitudes towards the expression of sexual desire pioneered in contemporary experiments with psychoanalysis.[7] In the same year Poiret diversified his activities beyond the design of clothing, echoing the situation in avant-garde Vienna where the progression of design and culture was perceived as an organic and interdisciplinary system, rather than a rigid hierarchy.[8] He promoted education in interior design at the Atelier Martine, the production and merchandizing of perfume and make-up at the House of Rosine, paper goods at the Colin workshop, fabric printing with the painter Raoul Dufy at the Petite Usine, and contemporary painting at a gallery in the Faubourg Saint-Honoré.

During 1912 and 1913 Poiret capitalized on his growing influence by touring first Europe and then the United States with a travelling fashion show, a lecture and a promotional film. In New York he found that his fame had preceded him, manifesting itself in a rash of unlicensed department-store copies of his dresses. On his return to Paris, the designer attempted to raise awareness of the problem and combat piracy with the foundation of Le Syndicat de Défense de la Grande Couture Française, though there was some irony in the fact

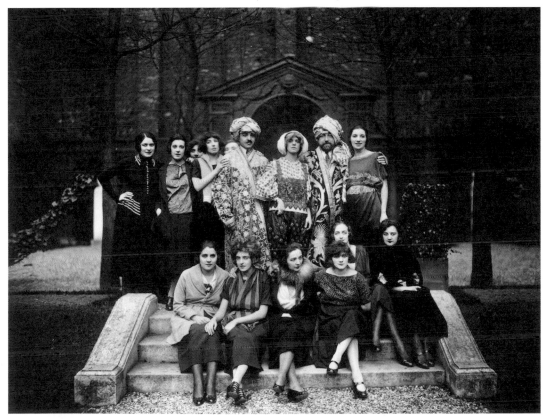

**20 Paul Poiret**

Folk-inspired dress, 1922
After the First World War,
Poiret lost his position at the
cutting edge of Parisian
culture. However, he
continued to find interest in
experimentation with looser
shapes, dramatic mood and
applied decoration, seeking
novelty and prototypes in the
cut and embroideries of
eastern European peasant
dress.

that it was Poiret's embracing of modern communications and market-
ing panache which rendered his personal vision vulnerable to the boot-
leggers. This was his moment of supremacy as far as press-coverage
and sales were concerned. After the First World War, though Poiret
continued to produce flamboyant collections using the folk motifs and
rich decoration which had always attracted him, the collapse of the
élite society which had sponsored his rise, a shift in popular taste, and
his own irresponsible attitude towards business matters ensured
eventual bankruptcy.

  By the time of his death in 1944 Poiret had degenerated into a cari-
cature of himself. Yet his legacy was a significant one. More at home in
the role of creative agent and theatrical impresario, Poiret's practical
skill as a dressmaker was not extraordinary. Most of his clothes
followed a fairly basic construction heavily influenced by non-western
dress forms, especially in the set of the sleeves. It was his ability to
weave a legend around simple foundations and draw associations with
the radical directions taken in other spheres of culture that marked out
his work. Through careful collaboration across media, a playing with

Coco Chanel, 1954
Doisneau's famous photograph shows the 71-year-old designer descending the mirrored staircase in her newly re-opened fashion house on the rue Cambon. With her mask-like face and rigorously ordered dress Chanel has become a cipher for creative control, promoting herself as woman and brand.

surfaces to suggest splendour, and a perceptive understanding of the idea of desire as propounded by contemporary pioneers of psycho-analysis, Poiret anticipated Hollywood and offered a showman's definition of fashion as dream. This interpretation of couture is one that still persists in the industry in the twenty-first century, albeit in a more commercially viable version.[9]

## Coco Chanel

In 1954, on the occasion of the reopening of her fashion house at 31 rue Cambon, the photographer Robert Doisneau produced an image of perhaps the most iconic couturière of the twentieth century. In it the 71-year-old Coco Chanel stands replicated nine times in the mirrored panels that flank the spiral staircase running through the salon where her haute couture collections had been presented since 1928. This is a representation of creative control that constitutes a kind of apotheosis for the profession of couture. It illustrates how far the concept of the role had been developed since Worth's earlier attempts to stamp his authority on the production of fashionable style.

Chanel looks pensively down from a lofty position, the very public drama of her career etched into a mask-like face. On her body and through its contrivedly relaxed posture she wears the hallmarks of her personal vision: the simple jersey skirt skimming below the knee,

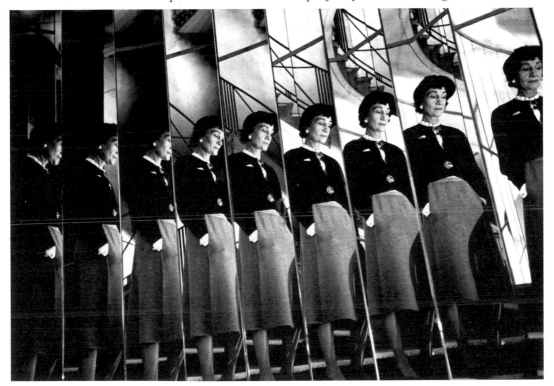

stark white blouse and boyish black jacket, matched with a boater-like bonnet and sling-back high heels. This sophisticated display of under-stated casualness, which is anything but casual in its preparation, is offset by costume jewellery of contrasting opulence. But beyond cap-turing the carefully engineered oppositions of her wardrobe, Doisneau has adroitly drawn attention to the fractured nature of Chanel's own persona and the multi-faceted surfaces now demanded of the cou-turier. For while she embodied the notion of authorial power and self-containment, the photograph suggests the existence of several competing versions of the same woman. Chanel is designer, business-woman, hostess, leader of taste, and model all at once. And in her engagement with the mirror her pose suggests the presence of the female consumer whose rapport with the desires and aspirations of the designer was central to the success of the trade in the twentieth century.[10]

It is almost impossible to disentangle the various strands which contributed towards making Chanel the formidable influence she undoubtedly became. Her turbulent life story and creative output have attracted more attention than any other designer, yet we are no nearer to pinning down the essence of her success. That perhaps is the key to the longevity of her reputation. Behind the rigid mask, in her adapt-ability and willingness to meet the challenges thrown up by a cultural and commercial form marked out by its contingency and shifting defi-nitions, Chanel allowed her own image to reflect the very irreducibility of fashion culture. Building on the precedent of Worth and Poiret, the history and myth of Chanel epitomize the limits and potential of modern couture as monstrous publicity machine.

Several biographies aim to attribute Chanel's distinctive signature style to the extraordinary circumstances of her life.[11] Thus her espousal of apparent simplicity in dress and her adoption of fabrics and items more usually associated with the demotic clothing choices of the working class have been linked to her early experiences as the descen-dant of rural peasant stock. She was born in Saumur in 1883 and raised, after the death of her mother, first in an orphanage and then in a convent. Her tendency to work against convention and prioritize the comfort and self-worth of the wearer through the articulation of a pared-down glamour has been interpreted as a reflection of her years, around the turn of the century, as a café performer and professional beauty, entertaining the officers in the garrison town of Moulins. Her skill both in constructing wearable, basic, yet elegant costumes and in merchandizing them as elements of a definable lifestyle is often traced back to her training as a seamstress and her formative entrepreneurial experiences in millinery. She designed and retailed an exclusive range of items from her first hat shop, opened in 1910 in the rue Cambon, Paris.

**22 Coco Chanel**

Costumes for Diaghilev's *Le Train bleu*, 1924
Though designed for a ballet, these variations on the bathing-suit, the tennis dress, and the golfing outfit relate closely to Chanel's general philosophy that functional leisure clothes should form the basis for modern fashionable dressing.

The fairy-tale narrative continues after the First World War, revolving around horse-racing, sun-bathing, and beach-culture at Longchamp, Deauville, and Biarritz, and financed by Chanel's wealthy English lover, Boy Capel. The modish leisure interests of this social milieu have been cited as the inspiration for her experiments with textiles and construction techniques more usually associated with sporting and holiday garments. Chanel used such serviceable materials and relaxed patterns in the design of fashionable daywear for sophisticated urban women, safe in her knowledge of their aspirational and practical qualities. Later romantic liaisons with the impoverished Russian emigré, the Grand Duke Dimitri Pavlovich, the Duke of Westminster, and Poiret's illustrator Paul Iribe, have similarly been used to account for Chanel's successive discovery and co-optation of *faux* jewellery, classic English men's tailoring, the flourishes of the Parisian avant-garde, and Hollywood sophistication into her repertoire of design

Magazine illustration of
Chanel daywear, 1928
The use of soft jersey fabric cut
in an easy fluid line typified
Chanel's work during the
1920s. This unassuming style
provided the ideal wardrobe
for the modern emancipated
woman, here depicted
alighting from an automobile,
that alternative icon of forward-
looking democratization with
which Chanel's work was often
compared.

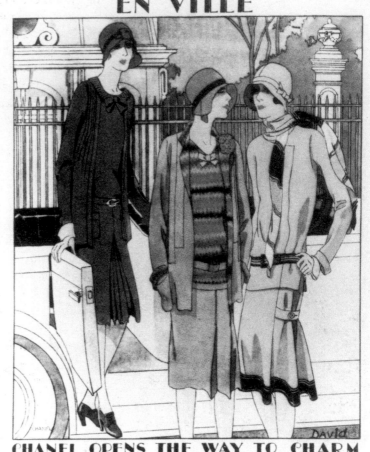

## EN VILLE

## CHANEL OPENS THE WAY TO CHARM

Chanel has the rare gift of giving to the clothes she designs a pleasant feeling of friendliness. Take the sympathetic simplicity of this two-piece of violet jersey, with its tucked sleeveless cardigan, and round pleated collar. There is the Chanel colour appeal in this suit where a jumper of beige, rust, brown and black sparkles amidst the beige of the coat and skirt. And what surer touch of genius than to put the band of black and beige to hem the beige-grey walking suit, catching up the same colour not only by the scarf of black, yellow, beige, and white, but in the striped belt of the same tones?

tricks through the 1920s and 1930s. This evidence of directed ambition and a distinctive pattern of patronage have helped situate Chanel simultaneously in the roles of feminist pioneer, kept mistress, and empowered *femme fatale*. Certainly her gender and her explicit acknowledgement of her sexuality as a personal creative force have positioned her as an ideal subject for the incident-hungry biographer.

Whichever way one reads the significance of her private life, there is no question that by 1930 she appears to have utilized her patrons and honed her design and marketing expertise to such an extent that the name of Chanel had become associated (rightly or wrongly) with a wholesale modernization of women's clothing styles redolent of Henry Ford's impact on the automobile industry. Her little black dress, the so-called 'Model T' of the wardrobe, had been launched to a rather more

discreet market than Ford's in 1926. American *Vogue* illustrated chic versions where dramatic geometric chevrons, rhinestone-studded belts, and a play with dull and shiny textures emphasized the flattering and expensive simplicity of the cut. The real beauty of simplification in construction and decoration was that such designs could—theoretically—be more usefully translated for the mass market. Though Chanel never endorsed illegal copying of her collections, she was aware of the positive democratic connotations some of her styles carried and happily designed lines and licensed her name to middle-market retail companies. The standard literature rather confuses the issue, keen on one hand to protect the idea of Chanel the imperious dictator of chic, whilst on the other suggesting her revolutionary zeal to break down the élitist distinctions of fashionable taste. Tellingly, in 1935, her most productive year before a period of industrial strife and the outbreak of war, the house of Chanel employed 4,000 workers and sold 28,000 designs across the globe. A contradictory and fanciful public image was no bar to commercial success.

Even Chanel's surprise return to couture in 1954, after several years of obscurity caused by rumours of her associations with the Nazis during the occupation of Paris and the rise to prominence of Dior's antithetical New Look in 1947, is presented as part of a climactic last act to a popular melodrama. In this version the heroine triumphs over

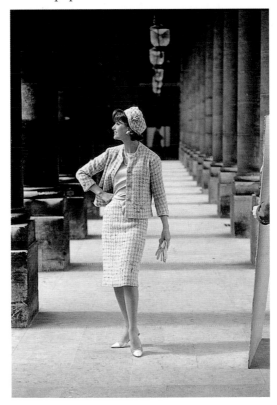

**24 Coco Chanel**

Bouclé wool suit, early 1960s In the post-war period Chanel's name became synonymous with the brightly checked, sharply tailored wool suit, accessorized with heavy gold and pearl costume jewellery. Rather than signify a democratizing zeal, this outfit was redolent of ostentatious wealth.

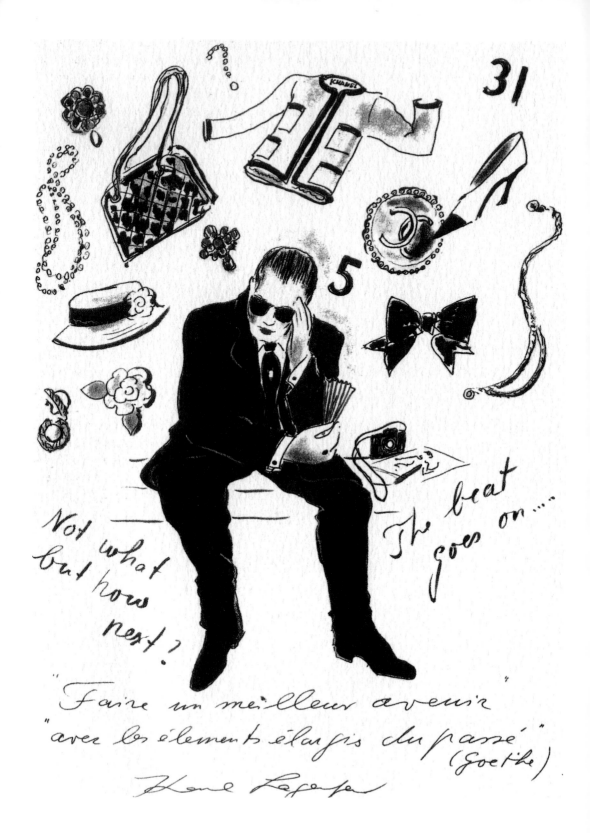

31

5

Not what
but how
next?

The beat
goes on....

"Faire un meilleur avenir
avec les éléments élargis du passé"
(Goethe)

Karl Lagerfeld

**25**

'Not what but how next?',
c.1985

Karl Lagerfeld became artistic
director of the House of Chanel
in 1983. Whilst retaining many
of the trademark Chanel
elements, his approach
rejuvenated the brand through
the introduction of new
textiles, colour and variations
in construction. Most
importantly, Lagerfeld's
personality and profile were
equal to the formidable
reputation of Chanel herself.

personal disaster to capture the lucrative American market with her snappy bouclé suits and trademark handbag before her final exit from the stage in 1971. Her successors in the company inherited a global high-fashion business with a profitable sideline in perfumes, jewellery, and accessories, and the potential for expansion into ready-to-wear, all thanks to Coco Chanel's personal drive, creative vision, and determination to triumph over adversity.

This tendency towards myth-making is not entirely confined to the realm of the best-selling biography. Chanel was very much in control of her own story and its undoubted legendary qualities have inevitably influenced the manner of its telling. It is precisely the tale of individual endeavour and Coco Chanel's distinctive tastes and prejudices, moulded by extraordinary experiences, which endow her products with their precise meaning for the consumer. Chanel was adept at performing the identity which the market had come to expect of an élite fashion designer and this accounts for the proliferation of rumours which attached to her life and its work. Many of these do not benefit from close scrutiny. For example, Chanel was just one of a generation of women who came to dominate Parisian couture during the inter-war years. Designers like Elsa Schiaparelli, Jeanne Paquin,[12] and Madeleine Vionnet presented collections which were as sympathetic to the lifestyles and tastes of modern metropolitan women as Chanel's and at least as innovative in terms of their aesthetic references, use of fabrics, and ingenious construction.[13] Where Chanel was arguably more succesful than her competitors was in her fundamental understanding of the value attached to celebrity in contemporary society, and the potential for applying the creative mystique of the couture designer to a much broader swathe of the fashion market. In this sense, her long career links the refined individualism first espoused as a marketable tool by Worth to the supposedly democratic individualism that characterized mass consumer culture in the second half of the twentieth century.

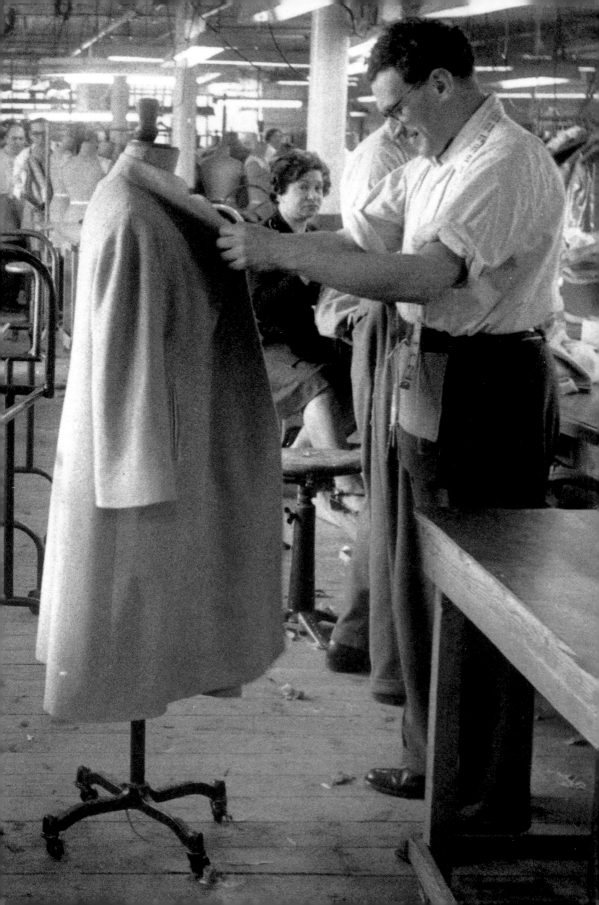

# Making Clothes

2

Charles Frederick Worth, Paul Poiret, and Coco Chanel may loom large as important personalities in the history of modern fashion, but as active designers or makers their contribution towards fashion as material product was not as significant as their more nebulous role as strategists and creative promoters. Their influence relied on the practical efforts of millions of anonymous workers whose labour translated the idea of a remote couturier, or its syndicated or illegally copied approximation, into three-dimensional reality. Now, as then, modern fashion is an industry. Whether confined to the exclusive and state-supported realm of haute couture or extended out to the wider networks of the ready-to-wear sector, its object is dependent on the mechanical processes of construction in order for idea to become commodity. Much of the work involved in that transition is repetitive, uncomfortable, dirty, undervalued, and poorly paid (especially in the sphere of mass-production), though in some circumstances it has also been a source of great pride and creative fulfilment.

This is the reality that lies behind, and partly explains, the rise of the named designer, whose role might well be interpreted as that of glamorous adjunct, employed to impart the sheen of fashionability to a trade that is sometimes anything but 'fashionable' in the sophisticated sense of the word. It also inflects discussion concerning the relative status of fashion as a cultural form—giving rise to an inevitable questioning in books such as this as to whether the focus should be on fashion as art, social process, or commercial product. Is fashion the sketch of a designer, informed by reference to historical precedent or contemporary cultural influences and translated into surfaces and seams of a refined sculptural beauty?[1] Is it the ritualistic adorning of the body by a subject whose sartorial actions relate to predominant aesthetic and sociological contexts?[2] Or is it the limp textile construction, replicated according to body size and spending power, which hangs on the rail of a boutique, given meaning and relevance for the potential consumer by its reproduction in the promotional images of a magazine?[3]

The most productive way forward must be to consider all three interpretations as a valid and interdependent set of interpretative models. Fashion as a system of meaning and a historical phenomenon

Detail of 28

incorporates all of these categories—their importance waxing and waning at different moments of the fashion cycle and according to the specific interests of the interpreter. What links them together as a common referent is the defining concept of modish clothing, material items whose usefulness, in fashion terms, relies on the prioritization of temporal notions of style over functional considerations of wear and tear. The haptic properties and physical manufacture of garments have often escaped interrogation in the critical literature of fashion history, overshadowed by the need to identify this elusive quality of fashion-ability.[4] Yet without the basic coordination of needle and thread there would be no raw material for the formation of such processes. This chapter breaks down the shifting circumstances of clothing production in order to understand more clearly the structures through which the state of 'fashion' has been achieved.

## Couture

The élite sector of the fashion market associated with the careers of the designers reviewed in the previous chapter produced the most expensive goods and, as we have seen, achieved the exclusivity necessary for the persistence of such high prices through a deliberate glorification of the role and identity of the couturier. This was coupled with the promotion of Paris as the superior inheritor of a luxury tradition which entailed the persistence of working practices and social relationships dating back to the seventeenth century. The couture customer from the 1870s to the 1950s was encouraged to believe that she was the direct descendant of those *Ancien Régime* exquisites who first patronized the tradition. She was in direct and privileged communication with a 'genius' who could produce for her an inimitable artefact, unsullied by the reproduced glamour of cheaper fashions, yet innovative enough in its effects that mass-produced or 'inferior' copies—in essence a homage to the heightened taste of couturier and client—would surely follow. The maintenance of such a masquerade required significant organizational and creative skills from a range of employees, the test of which resided in the apparent perfect finish of the product and the effectiveness of the publicity surrounding it.[5]

Fine hand-sewing, bureaucratic control, and creative vision, then, underpinned the success of a couture house. When a client of the *belle époque* arrived to acquire a new garment her needs would be placed in the hands of a *vendeuse*. The *vendeuse* played the role of personal hostess and administrator who ensured that the client's needs were fully met and that all stages in the production process ran smoothly. Her presentational and management skills eased a conduit between the directional impulses of the couturier, the desires of the customer, and the finishing skills of the seamstress. After an initial consultation

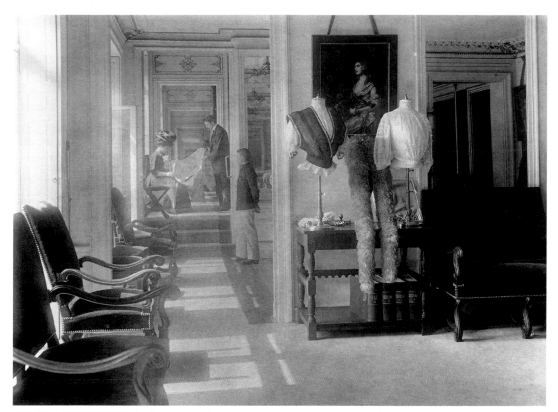

**26 Lipnitzki-Viollet**

The Worth salon, rue de la Paix, Paris, 1907

Worth's premises formed a prototype for later couture houses. The country house ambience, eighteenth-century portraits, rococo furniture and artfully displayed mannequins form a backdrop to the discreet activities of front of house staff. This luxurious image has sustained an idealized notion of couture for over a century, hiding the more mundane processes of production behind the polished surfaces.

between client, *vendeuse*, and fitter, possibly in the presence of the couturier, three ranks of seamstress—from apprentice to senior—would assist in the painstaking construction of a perfect dress which hugged the body like a glove. Its contours would be defined and redefined at a succession of fittings. A buyer would ensure that the house had the requisite materials and trimmings, negotiating with a network of small local businesses whose exotic wares were sourced exclusively to achieve the sense of individuality central to the identity of couture.

The rhythm of work at a couture house was seasonal. The types of orders completed were dependent on annual weather patterns but were also dictated, in the nineteenth and early twentieth centuries, by the related social behaviour of the aristocratic woman. Thus different wardrobes were required for town events in spring and early summer, country and foreign pursuits in July, and hunting in autumn and winter. The couturier followed this logic with a regular presentation of seasonal collections, a practice which has continued in the fashion industry to the present. Throughout the year clients might expect the couture house to provide a repair and alteration service, but employees could not expect permanent employment on this basis. Considering the high level of skill required in the sector, remuneration was also low. An average seamstress in 1867 was paid 2 francs 25 centimes a day or by the piece, whilst the price of a Worth dress started at 1,600 francs. In

1938, after some improvement in conditions, a senior seamstress at Paquin earned 45 shillings a week, though a Paquin dress would have cost more than a year's wages. Front of house staff such as the *vendeuse* fared rather better, receiving a stable salary and commission on sales.

This concentration of labour and expertise undoubtedly resulted in a product of exemplary qualities, at least on the glittering and highly decorated surface. Early examples of couture garments from the 1860s reveal a much rougher standard of finish on linings and inside seams, but owing to increasing competition and the complexity of items that entailed hidden boning, padding, and ties from the 1870s onwards, attention to detail intensified. The fragility of fine silks, lawns, and laces dictated minute and multiple fastenings. Tiny tucks and darts supported the exquisite engineering of clothing which was designed to flatter and mould the figure. Even in the inter-war years, when the layered structuring of the fashionable form had given way to a seeming simplicity, bias cutting and draping demanded a high level of ingenuity. Hems had to be rolled and weighted, supporting petticoats and integral under-bodices had to be anchored under apparently fluid shoulders and necklines. The final garment, in terms of its intrinsic value and sheer display of technique, well-merited the associations with art and sculpture that have often been highlighted in critiques of couture.

Clearly the couture house was and is an anachronistic organization. Its running costs, in terms of intensive labour and exotic materials, were very high in comparison to the level of output achieved (at least as far as bespoke dresses were concerned). In some ways the coordination and concentration of work were not so different from that experienced in other sectors of the clothing industry such as high-class men's tailoring and, like them, the practice of couture was a constantly evolving rather than a fossilized business (despite appearances). However, the machinery and mass-production methods which by the 1920s had rendered factory-made items such as underwear and hosiery superior to equivalent hand-made items and had introduced the profitable idea of the 'made-to-measure' suit to the menswear industry, were absent from its precincts. The language and technology of the production line were taboo in the philosophy of couture. Both kinds of enterprises (the bespoke and the ready-made) did share in the sophistication of their marketing techniques, and it was in this sphere that the couture house could claim a remarkable modernity. Despite its antiquated working practices and strict craft ethos, high fashion maintained a monopoly on the concept of desirability which was supported through the promotion of the couturier as a quixotic dictator of trends. Extraordinary one-off garments paid their way, in tandem with the selling of directional toiles to mass-producers, in-house diffusion lines, and a diversification into other aspirational products such as perfume and

accessories, as symbols of the economic sense in encouraging a fantasy of narcissistic individualism.

## Made-to-measure and the ready-made

Paradoxically the myth of sartorial individualism which encouraged the symbolic predominance of couture also pervaded and influenced the increasing provision of mass-produced, ready-made and wholesale clothing to a fashion-literate market from the mid-nineteenth century onwards. So much so that sometimes the boundaries between bespoke garments—tailored on the premises to the measurements of the individual customer—and those that were ready-made—constructed to a range of sizes in bulk or to order, either in a factory or by a network of outworkers, and sourced directly or through a wholesaler—appear very blurred. Rather than attempt to categorize types of garment into two exclusive camps through a simple identification of the method and place of their manufacture, it may be more useful to view the production of fashionable dress in the modern period as a more complex and interlinked chain, its sections informed to a greater or lesser degree by broader and cross-cutting considerations of labour, skill, technology, distribution, and marketing know-how.

Beyond couture, other methods of production in the nineteenth and early twentieth century provided bespoke garments to a middle-class market who could not afford Paris, Bond Street, or Fifth Avenue models, but may well have been inspired to acquire similar versions by the dissemination of fashion plates and paper patterns which followed metropolitan lines. The skilled professional dressmaker was well able to coordinate the cutting-out of intricate shapes, the manipulation of seams and darts, the insertion of bones and pads, and the addition of trimmings and fastenings that went towards the completion of a fashionable dress between 1850 and 1920.[6] Much of this work was completed by a team of work-room employees, as it was in the couture system, but in the middling sector of the trade certain elements might be sent out to piece-workers or 'sweaters' who worked from home for very low wages, paid according to the volume of items finished rather than the time spent in employ.[7]

When the services of a professional were not available, the genteel middle-class woman could rely on her own creative resources and perhaps the assistance of a maid, to create a proportion of her wardrobe herself. The acquisition of sewing skills was viewed as a prerequisite in the education of respectable young women until well into the middle of the twentieth century. Restricted in the middle years of the nineteenth century to the production of simple underwear, children's clothes, and men's shirts, by the 1860s, with a range of helpful new household magazines to guide her, the ambitious amateur sewer could

attempt more complicated patterns including mantles, washable day-dresses and some formal wear.

The sewing machine, which was patented in 1846 by the American Elias Howe, promoted in Britain by William Thomas, and improved by Isaac Merritt Singer, made a gradual and significant impact on the production of garments in both the commercial and domestic spheres. Undoubtedly, the complexity of mid- to late nineteenth-century women's dress and a residual suspicion of the social worth of cheap ready-made goods hindered the outright triumph of mechanization in the manufacture of womenswear until the simpler lines and more democratic attitudes of the 1920s. However, the introduction of half a million sewing machines world-wide in 1871 (from just over 2,000 in 1853) contributed towards a rapid fall in the price of clothing and a huge increase in the scale of operations in the garment trades.[8]

Initially only simple outerwear such as mantles, hosiery, and under-wear were completely constructed using the machine. Straightforward seaming, which had averaged at about 35 stitches a minute by hand, was speeded up thirty-fold through automation, and the production of such garments increased by 500 per cent. Specialized machines were introduced for processes such as button-holing, lace-making and embroidery, which extended the technology to a broader range of fash-ionable goods. And advances in the speed of construction encouraged similar innovation in the field of cutting. But significantly such mecha-nization had very little impact on the spatial organization of labour. The power-driven band-saws which cut the cloth were so bulky and expensive that their operation was restricted to those with some space and capital who also often acted as middlemen, supplying ready-cut items for making-up by piece-workers. Sewing-machine manufac-turers were adept at marketing their hardware direct to the individual through attractive (but often exploitative) hire-purchase arrange-ments. They backed up their provision to piece-workers and amateurs alike with technical support and lessons. The site of much clothing production thus remained in the home or in small workshops until well into the twentieth century.

In other ways a quickening of production gave rise to an increasing control of the sector by those immigrant entrepreneurs who gravitated towards the low-investment, rapid-yield areas of manufacturing and retail in cities like London and New York from the 1870s onwards. For reasons of efficiency and profit such men introduced a greater degree of sub-contracting and sub-division of labour to the industry. These had been features of ready-made garment production since the eighteenth century at least, but their intensification in fields such as tailoring, which had a strong tradition of trade unionism and industrial pride in the skilled, craft base of the profession, led to a widely held conception (not necessarily always based in fact, but usually reflecting the anti-

The Grover and Baker sewing machine, *c.*1870

Following the patenting of the first sewing machine by Elias Howe in 1846, several companies profited from the manufacture, distribution, and hire of machines in Europe and the United States. This image from an American advertising brochure clearly targets the respectable middle-class consumer for whom sewing skills constituted a desideratum of refined womanhood. However working-class home-workers made up a higher proportion of users for this new technology—their labour hidden in a domestic context.

Semitism endemic in nineteenth-century culture) of declining standards and conditions.[9] It is historical circumstances like these that have so influenced the specific character of particular sectors of the fashion industry since, giving rise to common perceptions that the couture house is home to a rather grandiose and precious culture, that tailoring remains something of an exclusive and conservative gentleman's club, while the provision of clothing to the mass market is identified with the rough and tumble of the rag trade with its language of deals and robust attitude to officialdom.[10]

Often the introduction of new practices could be innovative and energizing. Elias Moses established a vigorous enterprise in the City of London in the middle years of the nineteenth century providing clothing for a growing market of office-workers. Not restricting himself to any particular sector, he offered a vast range of bespoke goods, shirts, and accessories and ready-made suits, both produced in his own workrooms and sourced from outworkers. Much of his success can be attributed to a careful control of the relationship between manufacturing, consumer tastes, retail, and a masterful series of advertising campaigns which convinced potential customers of the value and fashionability of his products. Such strategies also served later generations of menswear producers through to the second half of the twentieth century. These were large-scale, multiple-outlet organizations, including those owned by Joseph Hepworth and Montague Burton which could provide their national markets with an assurance of perfection in fit and contemporary styling, whilst relying on classic mass-production techniques to maintain a standardized range of garments which were just flexible enough to respond to gradual fluctuations in taste and trade.[11]

Mass-producers of womenswear found it more difficult to capitalize on the potential of technology, faced with a diversified and fragmented market where taste could fluctuate in a terrifying manner and consumers had become adept at reading the mass-circulation of fashion codes and selecting or discarding discrete styles for themselves.

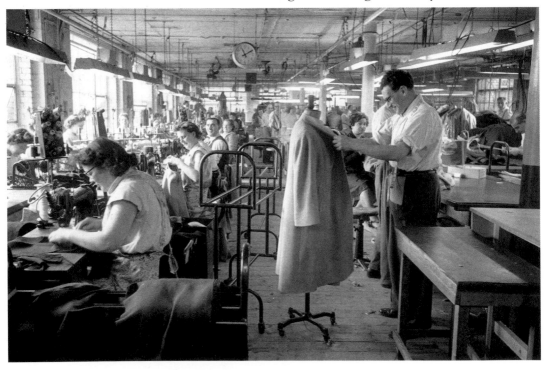

The unregulated nature of the relationship between clothing manufacture and provision, and an unshakeable faith in the primacy of the designer and style-leader which had been well established in female garment construction since the 1860s, presented the mid-twentieth-century clothing entrepreneur with a formidable precedent. The achievement of full-scale mass-production, in which a limited set of standardized products were marketed as widely as possible was not appropriate for a specialized field that had come to prize individuality and change, and whose manufacturing infrastructure encouraged a corresponding flexibility. During the 1920s and 1930s smaller firms, like Windsmoor, Tootal, and Berkertex, in Britain, established a following of discerning consumers through their careful self-promotion as exclusive brands and offered a range of 'designed' products from coats and separates, through to cocktail and evening dresses.[12]

Ironically it was just as mass-producers in other industries were coming to accept the logic of 'fashion' and 'dynamic obsolescence' as a valuable tool that womenswear manufacturers were edging closer towards standardization. In Britain, the war-time utility scheme offered the captive market and cultural and economic stability which allowed the industry to expand. Regulated by government restrictions on fabric use, members of the scheme—led by the Incorporated Society of London Fashion Designers—produced a limited range of ingenious garments which combined design-led fashionable accents derived from the economic necessity of textile rationing, with efficient production values.[13] After the war, a middle-class market accustomed to such standardization was far more receptive to the value and quality represented in mass-produced clothes. In the post-war period re-equipped factories utilizing the latest technology supplied newly expanded high-street multiples such as Woolworth, British Home Stores, C&A, and Marks & Spencer with branded goods to meet a growing demand. On the world stage, and especially in France and the United States, similar circumstances supported the burgeoning success of ready-to-wear or *prêt-à-porter* lines emerging from diversification within the couture houses from the late 1950s onwards. Here the cachet of the designer name and a more directional aesthetic brought an expensive version of mass-production to a more youthful but evidently wealthy market alienated by the perceived conservatism of traditional couture.[14]

In other ways the industry resisted modernization, and the legacy of nineteenth-century practices still dictates the way that much fashionable clothing is manufactured today. A battle for market dominance in the high street is fought by global brands who look to the cheap labour markets of the developing world for the 'sweating' that is necessary to maintain profits.[15] Other companies, most famously the Italian knitwear retailer Benetton, have co-opted the policy of 'flexible

specialization' as a way of maintaining their market share, benefiting from digitized technology, improved distribution networks, and a direct link with sales trends in a manner that can almost predict localized turns in consumer taste before they happen, ensuring that their factories are always producing the appropriate stock.[16] Elsewhere, in the inner-city districts of London, Paris, and New York, thousands of small workshops continue to exist on the margins of visibility, employing unregistered immigrant workers to work long hours on a handful of relatively low-tech machines. Often such outfits are best placed to respond to the short runs dictated by an edgy contemporary fashion system, subject to the most violent fluctuations of taste and economics. From the couture salon to the market-stall, it is this volatility which has given dynamic character to the idea of modern fashion whilst defining its very form and direction.

## Educating the designer

One common definition of fashion arising from this discussion of its commercial production might point to the provision of clothing according to the needs and aspirations (genuine or encouraged) of evolving markets. Though both ends of the production spectrum, from the couturier to the rag-trade sweatshop worker, appear fundamentally to engage in the same practice, agreement as to what constitutes the most appropriate form of training for such a trade has never followed a straightforward route. Indeed the conflicting philosophies which have informed fashion education over the past century have both influenced the way in which fashion is conceptualized generally (the art or industry debate) and arguably contributed towards the various crises which have rocked the fashion business during those years. Given the cultural and economic importance placed on fashion in modern society, the education of its practitioners has been of prime importance in steering processes of production and consumption. A brief study of its trajectory thus forms the final part of this section.[17]

In Britain, the official recognition of fashion design as a subject worthy of serious academic study came relatively late. Though state-sanctioned training in fine art had been established since the founding of academies in the eighteenth century, and public provision for the education of designers of industrial products (including textiles) was put in place from the 1830s onwards in mechanics' institutes and the National Schools of Design, those working in the garment industries continued to follow the traditional route of trade apprenticeships (if they were lucky) until the early twentieth century. Some sectors organized their own training schemes in an attempt to raise standards and conditions and accrue professional status from within. The institution of tailoring academies in the 1870s offered one solution to the perceived

In order to rectify some of the
poor working and living
conditions associated with the
garment trades in the early
twentieth century, vocational
colleges were set up for the
education of potential workers.
In a bid to raise skills and
standards, students were
taught the fundamental skills
of clothing construction and
embroidery before
employment in dressmaking
establishments and
department stores.

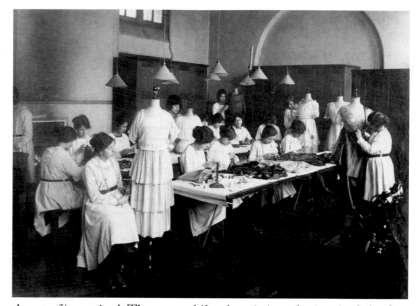

threat of 'sweating'. The same philanthropic impulse inspired the first local-authority funded trade schools, opened at the turn of the century in London for those working-class girls destined to enter the high-class garment industries of the West End. These provided training in the practical skills of fine needlework that would produce skilled seam-stresses for court dressmaking establishments and department stores and discourage the bad employment practices and social problems that government regulators detected in the field.

Private needlecraft and drawing schools from the same period fur-nished middle-class young women with a more genteel amateur education, and the creative bias of their courses formed a closer bridge to the established concerns of public art and design schools. From the 1930s onwards, teachers of fashion illustration and dressmaking in the private schools, such as Muriel Pemberton, Madge Garland, and Janey Ironside, managed against much internal resistance to pioneer diploma courses in established institutions such as Saint Martin's School of Art and the Royal College of Art. Their educational philosophy stressed the affinity between fashion design and painting and attempted to locate the practice of fashion within a high cultural context. In many ways this encouraged a divergent approach towards the subsequent delivery of fashion courses, split between those who advocated links with industry and skills in manufacturing, and those who favoured a liberal understanding of the designer as artist. As more courses were introduced in polytechnics and art schools across Britain in the post-war period, this two-tiered and rather divisive system persisted, though its current manifestation is far more diluted and most fashion courses now contain elements of vocational, theoretical, and practical design teaching.

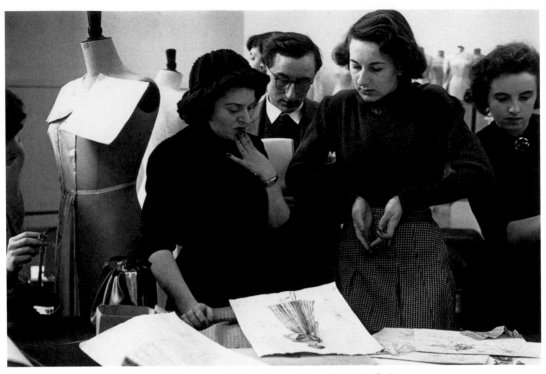

**30**

Fashion teaching at the Royal College of Art, 1949

In this image from *Picture Post* celebrating the appointment of the first British professor of fashion, students at the Royal College of Art receive a tutorial from a designer at Berkertex. In the 1950s and 1960s, fashion courses began to be incorporated into British art schools. These replaced the vocational emphasis of the trade schools with an art and design based curriculum.

Whatever their orientation, British fashion courses were not accorded equal degree status with other art school disciplines until the late 1960s. Ironically this came about at a moment when young London fashion designers were achieving unprecedented media coverage as standard-bearers for a new modernity informed by the energies of popular culture, and art students generally were protesting against precisely the sort of élitist and reactionary thinking which strove to draw value distinctions between different forms of learning and experience.

These discussions around the status and teaching of fashion disciplines may seem arcane, but they have continued to influence the health and direction of British fashion practices in a profound sense. Whilst a very few British fashion graduates have been lauded as international icons of extravagant creativity in the 1980s and 1990s, Britain's garment manufacturing base has shrunk to dangerous proportions over the same period. London and other British cities formerly identified with industrial prowess such as Glasgow, Manchester, Leeds, Newcastle, Sheffield, and Liverpool have instead come to be identified as powerhouses for fragile service economies which owe much of their energies to a vibrant fashion and music culture fed by an egalitarian art-school ethos which prizes a fusion of entrepreneurial and management know-how with an avant-garde creative vision. Other fashion centres including Paris, Milan, and New York have fostered far more monolithic education systems based on the traditional idea of the atelier, or on directed professional training, without experiencing quite

the same sense of cultural shift. It may be fair enough to suggest that the art–industry tensions which have marked the British experience, with all their connotations of class and gender conflict, give rise to an innovative but rather contradictory impulse that defines the problem of fashion itself.

# Innovating Change

3

The previous chapters of this book have considered the development of modern fashion as a profession and an industry, addressing the various contexts in which clothing designs have been created, promoted, and manufactured. Contexts, however, are just that. They provide an explanation of the broad external influences that went towards the production of a particular look. But it is the 'look' itself, the subject of those influences made tactile as object, in which the essence of fashion momentarily resides. Fashion as material artefact and idea is clearly the directed result of a creative and industrial process, a system of 'innovation' engineered to meet and encourage seasonal consumer demands and fulfilling a cultural requirement to define ever-shifting social identities and relationships. But at its core lies that rather mundane amalgamation of woven pieces, hollow voids, and seams which constitute clothing. One might argue that this physical nature of the clothing product has largely escaped analysis in recent appraisals of the fashion system. Such garments are the fundamental products of the design process, yet their incorporation into the chain of production and consumption has rendered their actual surfaces as coincidental and temporary receptacles of floating meanings which historians and critics are far more likely to seek in the circumstances of their inception, manufacture, representation, or use than in the original object.

By contrast, in studies of societies other than those which evolved in the industrialized west, the haptic material of clothing has often featured as a seemingly static indicator of social customs and hierarchies (though there is certainly much ethnographical research which seeks to demonstrate the contingent and multi-layered meanings of textile products from the developing world). The symbolism of its surfaces is usually assumed to be less prone to the frenetic rhythms of the capitalist marketplace (to changes in fashion) and thus richer in its diagnostic potential as a stable carrier of sociological and cultural truths. Anthropologists have therefore invested far more energy in an examination of the significance of structure, form, and pattern in non-western dress than most social and cultural historians of European and American clothing, who tend to overlook those remnants of occidental fashions which survive in museum costume collections.[1] Scholars of western

**31 Issey Miyake**
Dunes, spring 1998
Miyake's constant engagement with innovative textile treatments and forms of presentation have positioned him as the 'designer's designer'. The layered effects of fabrics which have been treated to mould or distort the proportions of the body operate outside the usual parameters of seasonal trends, challenging conceptions of fashionable clothing.

**The Artificial Silk Exhibition, London, 1926**
Here visitors examine the tactile qualities of the synthetic fibre, rayon. Models show off its application in evening-wear, pyjamas, and a bathing suit. Though exhibitions such as this strove hard to prove the versatility and economy of new fabrics, their main application remained in the realm of underwear and hosiery until the 1930s when prejudices were broken down by the necessities imposed by the Depression.

dress have perhaps too often assumed that the clothes which constitute the material subject of their study are merely curious and frustratingly empty vessels, denuded of their original signification and bereft of an embodied vitality whose fugitive meaning can only be reclaimed through the study of contextual evidence or the application of abstract interpretative codes.[2]

Unsurprisingly museum curators take another view. The fashion-ability of an item may be an ephemeral quality whose absence leaves a costume as lifeless as a corpse, but curatorial skills replicate the practice of pathology with great effect. Through a careful analysis of the textiles and construction techniques used, the degree of wear and tear endured, and its similarity or difference to comparative examples, something of an object's original spirit and significance can be retrieved. More than this, the imprint of the body on which it was once hung and some inti-mation of the spaces and occasions through which it was worn cling to the folds and seams of a garment, leaving faint traces of a context in which the idea of fashion was very present. Attempting to relegate the textile object as a simple illustration of cultural trends, rather than rec-ognizing its role as an active participant in their evolution, is thus revealed as a limiting exercise in which much useful information can be missed.[3]

One might extend this method of investigation to consider the ways in which advances in taste and technique shift our understanding of fashionable form and find their effects reflected in the very stuff of clothing. If this process of innovation can be viewed as an integral part of the fashion cycle then it is perhaps to the products and practices of

those designers and manufacturers who led the market that we should look first for physical evidence of fashionable change and development. Beyond the promotion and manufacture of a fashionable garment lie a whole range of innovative characteristics which imbue dress with a sense of modernity and progress and mark out certain examples of nineteenth- and twentieth-century clothing as cultural phenomena on a par with other avant-garde systems including fine art, theatre, and film. These characteristics can be understood as productive and radical strategies that—at the point of design—fabricate challenging philosophies into the form and structure of fashion itself. In this way, as this chapter will illustrate, forward-looking ideas about hygiene, the psyche, sexuality, comfort, decoration, and technology—in themselves central to the formation of modern culture—have become embedded in both the history and the material of modern dress, producing fashionable meaning in a very tangible sense.

## Gustave Jaeger—hygiene, taste, and the rational body

Paradoxically one of the most radical departures in the history of modern fashion was the promotion of a design philosophy and aesthetic trend which set itself up in opposition to the idea of fashion per se. The Victorian champions of this cause shifted the design of fashionable dress away from a concern with surface elaboration and the demonstration of a leisured and luxurious lifestyle towards a more rational understanding of the demands and impulses of contemporary life, with far-reaching effects. The late nineteenth-century Parisian

### Synthetic fabrics

During the modern period innovation in fabrics has been most marked in the invention of synthetic products. The beginnings of this interest date from the 1880s when French fibres with a nitrocellulose base were exhibited at international exhibitions in an unstable imitation of silk. By the 1900s the British firm Courtaulds owned the rights to an improved viscose yarn derived from plant cellulose. Known as celanese, this product was used in lingerie and hosiery. From the 1920s the American company DuPont dominated the market, producing rayon, the generic term for celanese. In 1938 DuPont introduced coal-tar derived nylon—a stronger, more supple alternative to rayon. The success of nylon spawned many new petrochemical synthetics during the 1950s. The most important was polyester, developed in Britain but sold to DuPont and ICI in 1946. Related fabrics such as dacron and crimplene promised easy maintenance and a convincing replication of the qualities of natural fibres. The 1960s witnessed a celebration of synthetics as synthetics. Established thermoplastic materials like PVC were promoted for their shiny 'pop' connotations. Though synthetics fell from favour in the 1970s, they enjoyed a revival in the 1980s. The experiments of Japanese designers and the body-enhancing effects of Lycra had a significant effect on the direction of fashion. Now research in the field is focused on the possibilities for clothes to communicate with, protect and nourish their wearers.

interpretation of fashionable form, promoted through the publicity and exquisite productions of competing couture houses, stressed a materiality based on notions of wealth and sensual excess. Worth, Paquin, Doucet, and Poiret effectively monopolized a system whereby fashionability was marked through the prodigious use of extravagant materials and body-enhancing cut. In this context, design innovation was a simple case of pushing the accepted boundaries of spectacle, subtly realigning bodily proportions, structural emphases, decorative patterns, colours, and textures in a cyclical repertoire of historical referencing, sexual theatrics, and bravura examples of craft skill. Successive generations of society women whose clothing practices endorsed the primacy of couture and set fashionable standards from the mid-nineteenth century to the early twentieth thus found themselves featuring centre-stage in a dramatic tableau of sweeping layers, intricate sartorial engineering, and jewel-like tones, where distinction was the primary motor for fashionable experimentation and changing form.[4]

Other voices attached to the fashion trades saw no beauty and little moral merit in this ostentatious parade. More than this, such brazen displays of extremism were viewed as corrupting and unhealthy for body and spirit. In Britain critics of the new industrial society and its wares such as William Morris and E. W. Godwin were implacably opposed to all the fripperies and injustices that established notions of fashion represented. They aimed to remedy the visual and spiritual ugliness of contemporary fashion through a revival of supposedly worker-friendly medieval production processes and a utopian encouragement of a more 'tasteful' consumption of dress, informed by a bohemian appreciation of natural colours and fluid classical draping.[5] Commentators in the medical professions similarly attacked the physical constrictions of fashionable garments, from corsets to heavy skirts, pointing to the damage they wrought on the physiology of the human body.[6]

But it seems fair to state that the ideas of such reformers carried much more impact in terms of the various channels through which they were circulated than in the appearance of the population at large. Representations of the 'aesthetic' body, uncorseted and quaint, became a staple of advertising and caricature in the 1870s and 1880s. The many lectures, pamphlets, and exhibitions which promoted rational clothing were clearly very effective in tapping a popular consciousness. But despite the ubiquity of the image, the physical experience of 'artistic dressing' proper remained largely the home-spun preserve of an avant-garde creative minority, or the expensive hobby of a self-proclaimed progressive urban élite whose fashion outlet of choice was the Arts and Crafts department store Liberty—itself a bastion of capitalist and imperialist endeavour. When it was adopted at all, a great deal of what

**33 William Powell Frith**

*The Private View at the Royal Academy*, 1881

One of Frith's aims in this painting was to document the extremes of dress associated with what was known as the 'aesthetic craze'. To the right of the picture, the apostle of beauty, Oscar Wilde, is surrounded by a group of admirers in rational clothing, whilst on the left, two more female followers are engrossed in the exhibition and its catalogue. Though the green and yellow palette, lack of corsetry, and affected posturing of the rational wardrobe attracted much negative comment, its progressive content laid the foundations for twentieth-century clothing norms.

passed for rational dress was rapidly commodified, becoming a fashion like any other, constructed from similar rich and exotic components as those which went to make up a Worth gown—a case of sartorial progression led by style rather than function or philosophy.

Only one designer/manufacturer really succeeded in marrying the theoretical imperatives of dress reform with his own practice as a successful producer and retailer of clothing, offering something that was truly distinctive from the Paris-dominated *status quo*. Dr Gustave Jaeger prioritized health over beauty in his influential writings and in the practice of his system of dressing, though it was understood that the pursuit of a hygienic ideal in fashion would automatically give rise to a more pleasing visual effect. Building on an academic training in zoology and anthropology honed during a lectureship at Stuttgart Royal Polytechnic, Jaeger pioneered a sartorial philosophy for men and women based on the central 'scientific' premise that the wearing of undyed and knitted woollen fibres next to the skin would aid the dispersion of bodily poisons and allow the skin to breathe freely. Vegetable products such as cotton or linen and 'the insect excretion known as silk' were viewed as essentially contaminated, constricting, and synthetic. In publications such as *Essays on Health Culture*, published in English in 1887, Jaeger advocated the adoption of fitted woollen undergarments to protect the entire body and the careful choosing of clothing which avoided chemical and many natural dyes which were felt to be too unstable. In a period during which manufactured chemical tints such as aniline mauve transformed and brightened the wardrobe of mainstream consumers, the ancient shades of indigo and cochineal were the only colours allowed to complement the cool creams and whites which constituted the basic shades of the Jaeger system.[7]

As far as structure (rather than material) was concerned, Jaeger's

Jaeger catalogue, 1885
Following the company's success at the 1884 Health Exhibition in London, Jaeger issued this catalogue to promote their sanitary-wear to a wider public. Combinations in wool stockinette were a staple product of the firm, promising to protect the body and conserve 'sanitary emanations'. These were accompanied by wool shirts, vests, corsets and dresses.

42 & 43, Fore Street, London, E.C.   17

## JAEGER'S SANITARY STOCKINGNETTE COMBINATIONS
### PATENTED.
## BENGER'S MAKE.

The great Sanitary advantages and comfort derived from this soft and durable under-clothing are fully described on page 5, to which reference is requested to be made.

*Guaranteed pure Animal Wool,*
FOR
## MEN, WOMEN, AND CHILDREN.

SANITARY COMBINATION.

The Combination Under-Garments will be found particularly convenient by Ladies, and have been widely recognised as agreeable and practical to wear.

Recommended in the *Medical Record*, 15th Aug., 1881.

Recommended in the *Medical Times*, 30th July, 1881.

Recommended in the *Medical Times*, 15th Sept., 1881.

Recommended in the *Draper*, 1st July, 1881.

*For prices and sizes see page* 59.

---

## JAEGER'S
## Sanitary Stockingnette Combinations for Bathing
### REGISTERED.
With short sleeves and legs, fitting close, with girdle.

Surgeon General BEATSON, M.D., F.R.C.S., writes:— "The JAEGER Bathing Dress is quite perfect, and should be used by all swimmers. It does away with all sense of being cold and naked when the other clothing is taken off. The shock caused by entering cold water is greatly reduced and quickly recovered from, and the normal temperature of the body is conserved while swimming, so that immersion can be maintained with comfort for a long time. On leaving the water again no shock from the colder atmosphere is felt if the dress be not taken off for the purpose of drying the body. It is conducive to comfort to absorb as much moisture as possible from the dress with a towel; but it is a mistake to suppose that any harm can arise from putting on woollen outergarments over the damp bathing-dress. The more general use of the JAEGER swimming-dress at our sea-side resorts, would no doubt tend to diminish greatly the number of bathing fatalities which fill the columns of newspapers during the bathing season, and are so frequently the result of sudden cramp and impaired action of the heart, caused by the diminution of animal heat, against which the unclothed swimmer, however skilful, has no defence.

*For prices and sizes see page* 59.

**For Great Britain and the British Possessions.**

ideas were more forcibly directed towards the reform of the design of men's rather than women's dress. Stockings and breeches were felt to be far less constricting than trousers and more likely to encourage physical exercise. To avoid harmful draughts 'Jaeger system' shirts fastened at the shoulder and his jackets were always double-breasted and tightly sleeved. Separate and capacious pockets were suspended like hunting pouches from the belt. The rational and comfortable appeal of

Dr Gustave Jaeger, *c*.1880
Jaeger is here shown in the
woollen suit which made his
name. Its form suggests both
practicality of maintenance,
ease of movement, and
warmth, whilst its military style
hints at the seriousness with
which followers of the rational
dress movement took their
regime of healthy living.

such a wardrobe encouraged its use by such social and political progressives as George Bernard Shaw whose costume was described by G. K. Chesterton in 1910 as having

become a part of his personality; one can come to think of the reddish-brown Jaeger suit as if it were a sort of reddish-brown fur, and was, like the hair and eyebrows, a part of the animal . . . In any case his brown woollen clothes, at once artistic and hygienic, completed the appeal for which he stood; which might be defined as an eccentric healthy-mindedness.[8]

Eccentricity was certainly one characteristic levelled at innovations such as those pursued by Jaeger, but his broader significance to the material development of modern fashion should be taken seriously.

A party in rational dress,
*c.*1895

Progressive attitudes towards sexual politics, health, and aesthetics cohered in the clothing of rational dressers. Discarding the elegant but impractical tea gowns of the period, this group of upper-middle-class women have adopted elements of dress derived from school uniform, the blouse and skirt of the New Woman, and some woollen items.

His flagship shop, close to Liberty in London's Regent Street, purveyed a kind of anti-fashion which claimed inspiration not from the seasonal demands of Paris but from the more active and democratic circumstances of contemporary life and the effects that these wrought on consumers' bodies. Jaeger's fluid and practical items, in subdued autumnal colours, found a niche with the British middle classes that survived well into the second half of the twentieth century. At the start of his success in the 1880s Jaeger shared a platform with several innovators whose products and philosophies also challenged prevailing assumptions about the links between fashion, function, taste, class, and clothing. The artists Walter Crane and G. F. Watts, journalists like Mrs Haweis, and society figures including Oscar Wilde and Viscountess Harberton, all saw contemporary dress and its reform as a vehicle for furthering debate on sexual and social emancipation, though their practical contributions were less emphatic than Jaeger's. Popular events such as the London International Health Exhibition of 1884, which promoted rational and aesthetic clothing and provided a precedent for the later publication of specialist journals such as *The Rational Dress Society Gazette* and *Aglaia*, further helped to transform a minority issue into a familiar one. Such was the pace of progress that by 1900 the formerly rather exotic idea that one might dress to express political, aesthetic, or philosophical affiliations, with bodily comfort and freedom of movement as primary desiderata, was taken for granted by many fashion consumers. It might reasonably be claimed that this was a legacy largely put in place (in Britain at least) by pioneers such as Dr Jaeger and his reformist contemporaries.

## Schiaparelli and Vionnet—performing the modern psyche

Once or twice I had thought that instead of painting or sculpture, both of which I did fairly well, I could invent dresses or costumes. Dress designing, incidentally, is to me not a profession but an art. I found that it was a most difficult and unsatisfying art, because as soon as a dress is born it has already become a thing of the past. As often as not too many elements are required to allow one to realize the actual vision one had in mind. The interpretation of a dress, the means of making it, and the surprising way in which some materials react—all these factors, no matter how good an interpreter you have, invariably reserve a slight if not bitter disappointment for you. In a way it is even worse if you are satisfied, because once you have created it the dress no longer belongs to you. A dress cannot just hang like a painting on a wall, or like a book remain intact and live a long and sheltered life.[9]

In her autobiography *Shocking Life* the couturier Elsa Schiaparelli revealed the frustrating paradox that lay at the heart of the practice of fashion. Excited by the notion of creative innovation and faced with the tactile challenge of transforming inert materials into living sculpture, she realized that the designer is nevertheless forced to acknowledge the transitory demands of the marketplace that lend the product its ultimate meaning and rob it of the profoundly affective qualities which accrue to other 'higher' forms of aesthetic endeavour. Schiaparelli reconciled these tensions in her own work by looking towards the anti-rational impulses of surrealist fine art practice which were dominant in Paris during the inter-war years as a source of inspiration, and embracing the idea of paradox as a productive tool. In this sense her work stands at the opposite end of the fashion spectrum to that of Jaeger. The 'rational' German seer sought to eradicate the inconsistencies of fashionable dress through a system driven by considerations of physical practicality, whilst the iconoclastic Italian 'artist-couturier' celebrated inconsistency and offered an uncanny model of fashion which revealed unsettling glimpses of the contradictory neuroses and desires on which its beauty was founded.[10]

Established, at the age of thirty-two, as a knitwear and sportswear designer in an atelier in the rue de Seine in 1922, Schiaparelli could already boast of a full and varied life played out in avant-garde social circles. Born in Rome to a cultured and intellectual family, her interests and career took her to London, Nice, and the United States before she settled in Paris, and was introduced to Marcel Duchamp, Picabia, Alfred Stieglitz, Paul Poiret, and Man Ray. By 1928 she had attracted lucrative press interest and gained a dedicated following of élite customers through her production of a startling range of sweaters, some utilizing the new elastic woolen fabric kasha which clung provocatively to the body, others appropriating the three-needle stretch-resistant technique of immigrant Armenian knitters and emblazoned with *trompe-l'œil* bows at the neck and wrists. Encouraged by her success to

Elsa Schiaparelli in London, 1931

Schiaparelli's innovative take on fashion and identity is illustrated in this juxtaposition of the designer herself dressed in trademark knitwear, culottes, beret, and surreally over-sized gloves with a companion wearing more conventional female attire.

open a boutique in the rue de la Paix, Schiaparelli moved on to launch her first collection in 1929. This built upon previous radical experiments with the structure, material, and function of familiar garments: riding jodhpurs adapted for skiing, waistcoats cut from horseblanket, masculine cellular cotton utilized in women's dresses and blouses. For day- and evening-wear she pioneered severely tailored tweeds and interchangeable combinations of garments, removable and sculptural collars, cuffs, capes, and scarves. Her understanding of the architectural qualities of knit contributed to the international success of the pixie-like 'mad cap' of 1930, a tiny hat that could be manipulated by the wearer into a variety of bizarre shapes.

This witty refashioning and juxtaposing of the elements of the body and the wardrobe shadowed recent Dadaist interventions in the established genres of art: Duchamp's subversive reframing of the utilitarian urinal and bottle rack as a focus for aesthetic reverence, and his flirtations with cross-dressing as a form of creative self-performance, are

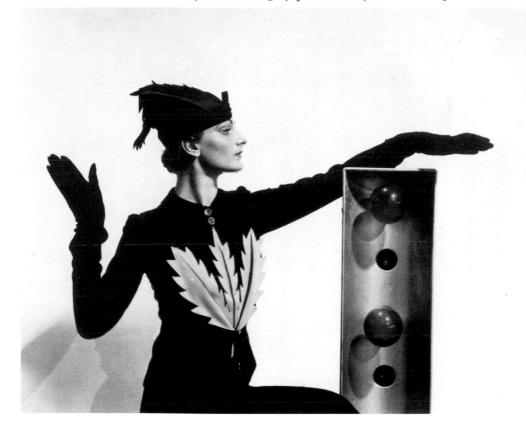

**38 Cecil Beaton**

Schiaparelli leaf suit, *c.*1937
A Schiaparelli ensemble
featuring a model posed in a
typically theatrical and
confrontational pose in a
starkly surreal setting. Her
tunic is emblazoned with a
bold decontextualized leaf
design. Schiaparelli was
known for overlaying the sharp
tailoring associated with
couture with strange and
emblematic motifs.

clearly referenced, if only subliminally, in the designer's play with
expected sartorial hierarchies and gendered modes of dressing. In a
more deliberate annexation of the techniques of the contemporary
painter and sculptor, Schiaparelli's most radical attacks on the conven-
tions of couture focused on surface forms and their potential as a canvas
for surreal commentaries on vanity and repressed corporeal desire.
Here the skills of embroiderers, jewellers, and accessories-makers
combined with tailoring and fabric design to challenge preconceptions
regarding correct taste and sexual attraction. From the late 1930s until
the outbreak of war Schiaparelli collaborated with Salvador Dali, Jean
Cocteau, Christian Bérard, and Van Dongen to produce a succession
of unsettling thematic collections which traded on the shock of
unlikely connections and a fetishistic attention to de-contextualized
details. Zips, lips, newsprint, hair, hands, mirrors, and astrological
symbols stretched across vividly coloured torsos, whilst costume jewel-
lery and millinery in the guise of shoes, sweets, toys, and bric-a-brac
framed the face.

   Schiaparelli maintained a fruitful relationship with Hollywood and
the American market with far greater ease than Chanel experienced.
Her cosmopolitanism and sense of theatre lent themselves more
directly to the imagery promoted by the Los Angeles dream factory

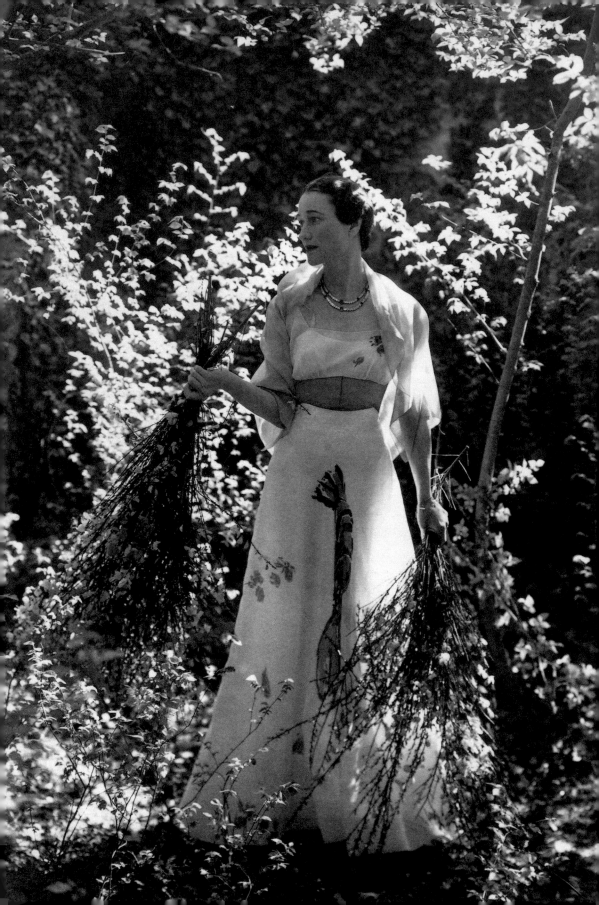

and the link was immortalized through the launch of her perfume 'Shocking' in 1938, its bottle based on the famous bust of one of her clients, Mae West. The following year Schiaparelli left Paris to reside in New York throughout the duration of the war, an evacuation which earned accusations of disloyalty from the Chambre Syndicale de la Couture on the outbreak of peace in 1944. In the post-war period she found it difficult to compete with the retrogressive and conservative trends introduced by Christian Dior, even though much of the dramatic power of the New Look owed a clear debt to Schiaparelli's challenging pre-war innovations. By 1954 financial collapse was inevitable and she was forced to close her business.

Her significance as a designer, however, lay not in her ability to accommodate or predict commercial trends, which by the end was clearly failing, but in her determination to follow through an idiosyncratic and eclectic personal vision which resided in the field of avant-garde creativity and an understanding of the fragility of the fashion psyche. The epilogue of her autobiography pictures her in her Moroccan house, happily, if claustrophobically, surrounded by the exotic objects which marked the progression of her professional life. Their profusion is paradigmatic of Schiaparelli's innovative adoption of a method of design which treated the world and the unconscious as a working archive.[11] They suggest a form of intense and obsessive cultural production which has continued to mark dominant conceptions of high fashion practice and the spectacle of the modern couture garment to the close of the twentieth century:

She is lying on an orange sofa made in Paris by Jean Franck of Moroccan leather, wrapped in a vivid Scotch rug of yellow-and-black tartan, framed by narrow and low Arab cement seats with pillows made in the local bazaar, and a Hammamet straw mat on the floor. Surrounded by quantities of multicolour Italian hats bought at the Galleries Lafayette, a dispatch-case bought in New York, a cigarette-case of silver and enamelled pink rose bought in Leningrad . . . a red rug from the Bedouins marketing in El Djeb under the Coliseum, a woollen donkey bag brilliantly coloured in her preferred shades, woven in Peru and given to her by a Russian woman friend . . . with shorts made in Paris of American cotton, with an English silver ring, with Chinese slippers, Swedish matches, Turkish cigarettes, and an ash-tray of broken pottery brought in by the sea from the never-never land.[12]

Whilst Schiaparelli looked to external aesthetic stimuli and her own psychic preoccupations as fuel for the refining of her collections, the career of her contemporary Madeleine Vionnet presents a very different model for considering the ways in which designers have worked towards the synthesis of a novel signature style through the concrete characteristics of their products. If Schiaparelli's output represented a form of anti-rational surrealist gesture then Vionnet's work bears closest comparison with the austere and considered rationalism of

Vionnet appears as the
consummate manager,
technician, and artist in the
photograph. Sitting behind a
director's desk, she examines
a bolt of fabric, a series of
Japanese prints lining the wall
behind her.

inter-war architectural modernism.[13] For her the reactive capabilities
of materials, in conjunction with the demands of function and style
produced an oeuvre of astonishing and complex purity. Her formative
experiences at the end of the nineteenth century differed from those of
Chanel and Schiaparelli, who had both astutely navigated their profes-
sional rise through an engagement with the social hierarchies of
London and Paris. Vionnet's interest lay more in learning the craft and
trade of clothing construction. She honed her considerable skills as a
seamstress in the establishment of a London court dressmaker, return-
ing to Paris to work for the Callot *sœurs* and Jacques Doucet before
setting up her own fashion house in 1912.

The contradictory influences of English tailoring and *belle époque*
escapism engendered a distinctive signature style for Vionnet which

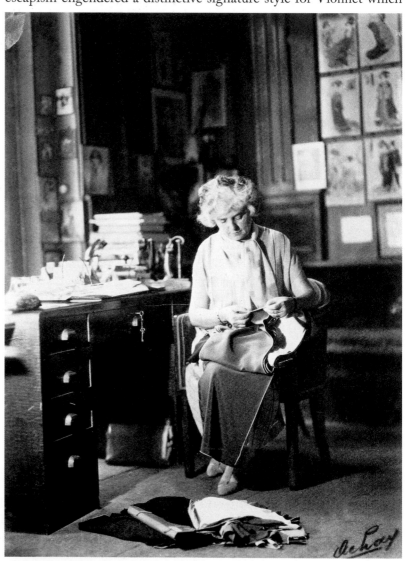

**41 Madeleine Vionnet**

Dress, August 1924
During the 1920s Vionnet's clothes combined a fluid line with complex construction. Their angular forms fitted well with general trends in the decorative arts—later to be termed art deco. The recording of her output in copyright books served both to protect her originality and offer an indication of the manner in which the garment should be arranged.

was entirely focused on the tension between dress as an abstract geometrical proposition and its transformed role as a sensuous veil for a living, moving body. Her earliest collections, produced after the reopening of her house in 1918, combined applied encrustations of fabric roses, which adhered to the theatrical expectations of couture, with ingenious experiments with cut and fabric engineered to emphasize the curves and gestures of the wearer. Though Vionnet was not solely responsible for introducing bias cutting (the practice of sewing against the grain of the fabric to ensure a clinging elasticity has a much longer history), her adeptness at anticipating and influencing the behaviour of cloth produced revolutionary interpretations of sartorial form. In its sympathetic and graceful framing of the figure her clothing approximated to a modernity which was concurrently being pursued by avant-garde dancers such as Isadora Duncan and Loie Fuller. It also found appropriate illustration in the dynamic futurist fashion drawings of Thayaht.

By the mid-1920s fluidity and complexity had become trademarks of the Vionnet style. Approached as a problem of structure and engineering, the hang of a garment was worked out on a scaled-down wooden mannequin. In April 1927 *Vogue* gave some intimation of her working practices:

A wide shaft of light shone from one wall and the large glass ceiling. Everything was on a large scale—the office, the carpet—and there was an intense silence. About twenty wooden manikins [*sic*] frozen in majestic poses stood in solemn assembly round the empty room. Mademoiselle works on these figures; with a length of material, scissors, a few pins and unwavering determination, she seeks to solve the problem of Form.

The lambent studio space, the simple tools of the trade, and the striving after platonic enlightenment all pulled Vionnet towards the

practices and aspirations of modernist architects such as Adolf Loos and Le Corbusier, with their purist interest in geometrical truths. The reality of dealing in the fashion marketplace, however, necessitated an attention to commercial issues, and the attractive novelty of Vionnet's designs meant that she was forced to fight a constant battle against illegal imitations. One of the outcomes of her legal challenges was the production of a bi-annual photographic record of her completed collections and the incorporation of a code number and fingerprint on every authorized product. In this sense individual creativity became subsumed in a mirage of standardization and control that was perfectly in harmony with the deification of mechanization that so influenced other spheres of cultural production at the time. This extended to Vionnet's revolutionary concern with the welfare of her workers, who benefited from access to the latest technologies in construction and organization and unprecedented health and social provision. In many ways Vionnet's persona was closer to that of the philanthropic industrialist than the autocratic couturier.

The garments themselves, though apparently a reduction of dress to the most simple combination of draping and minimal seams, were in effect very difficult to copy successfully. Once removed from the supporting armature of the body, they were transformed into a confusing knot of twisted fabric and interior ties that only made sense in three dimensions. Further complications were added by Vionnet's interest in the interaction between the depth and hollowness of clothing and its function as a canvas for surface decoration. Lightly applied shimmering embroidery in art deco chevrons or following the archaic lines of Greek and Egyptian designs punctuated the gliding folds of chiffon that marked collections in the late 1920s. By the 1930s such embellishment was given over to a severe classicism which offered Vionnet the greatest opportunity for a virtuoso display of her designing talents. The skilful draping of scarves and an attention to the precision of folds and pleats, together with an acknowledgement of the various effects of surface reflection on fabric achieved a series of collections which took their inspiration from ancient columns and bas-reliefs. Their intricate manufacture required a particular expertise on behalf of the dresser and every time an item was worn the process of design was re-enacted.

Re-enactment and reproduction were themes which characterized Vionnet's final collections before her retirement on the outbreak of war in 1939. Less conceptually challenging than her earlier output, but equally innovative in technical terms, they embraced a romantic historicism that was current in nostalgic Hollywood interpretations of the great nineteenth-century novels. Taffeta and tulle, fur, velvet, and lace were utilized to re-create the billowing forms of crinolines and the luxury of the Second Empire without recourse to the impractical supports upon which the original fashions had relied. Putting aside the

**42 Madeleine Vionnet**

Ivory crêpe evening dress,
1935–6

By the mid 1930s Vionnet had
developed a more sinuous line
inspired by the drapery in
classical friezes. The seeming
simplicity and 'barely sewn'
appearance of these items
belied their complicated
pattern. The copyright books
now show the model in front of
a mirror, the dress seen from
all angles.

retrogressive associations of neo-Victorian styling, Vionnet's late garments still revealed a fascination with the potential of space and surface, and the role of fabric as an active intermediary between the two. In attempting to reproduce a solution to the problem of form and function her work continued to achieve a remarkable modernity that formed the basis for succeeding innovations by younger designers in the post-war years.

## Cristóbal Balenciaga—style and tradition

There is one brief, pithy Spanish word, *cursi*, that Balenciaga uses to describe what he hates most in fashion: vulgarity and bad taste. Of these he has never, ever, been guilty. Almost since the first day he launched his salon . . . he has been acclaimed as the great leader in fashion; what Balenciaga does today, other designers will do tomorrow, or next year, by which time he will have moved on again, out in the forefront of true elegance and chic. But because of his obsessive shyness, his dislike of Press publicity . . . a kind of mystique has been built up around him, which makes some people wonder if there really is a Balenciaga at all.[14]

In the autumn of 1962 British *Vogue* offered a prescient account of the Spanish designer Balenciaga's paradoxical identity as both the embodiment of a finely honed and progressive couture aesthetic and the antithesis of a modern concern with celebrity. By the close of the

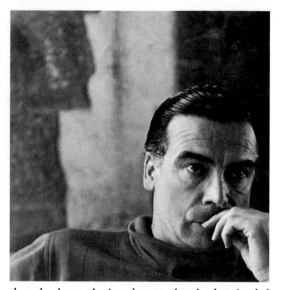

decade the reclusive dressmaker had retired, having completed a professional life in which his clothing became synonymous with a detached and analytical intellectualism, a sharp appreciation of the functional and abstract potential of clothing as a form of modernist body sculpture, and a deep appreciation of the cultural and historical affinities between dress and other modes of high and decorative art. All the while the maker himself retreated behind a series of complex barriers constructed to protect his privacy whilst contributing towards a mystique that was eminently bankable. He was simultaneously the reticent Spanish-speaker in an industry dominated by spoken French, the intense craftsman stranded in an atmosphere of frivolous make-believe, and the timid introvert who forced attendant journalists to observe rigid social rituals more fitting in a royal court than a business concern. The dramatic declamation of the name 'Balenciaga' still connotes a polished sheen and sense of hauteur that is quintessentially wrapped up with definitions of couture itself, though the man behind it remained almost unknowable in his lifetime.

In this, and more especially in the nature of his output, Balenciaga was a natural heir to Vionnet, who had herself dismissed his early debt to her innovations by praising his original vision. Both designers allied themselves to a style of creativity rooted in a radical experimentation with cut and structure, and saw success only as an affirmation of the effectiveness of their product according to their own high standards and the satisfaction of their clients, not as a self-promotional end in itself. Like Vionnet, Balenciaga's contribution to the development of modern fashion largely circumvented temporal considerations of trends and directions or an anti-rational concern with subconscious desire and image-building, for a more abstract fusing of archival investigation, manual and visual dexterity, and a clear understanding of

clothing as a kinetic and volumetric phenomenon. An architect by inclination rather than a stylist, his oeuvre bridged the aesthetic modernism of the inter-war years and the more brutal formalism of the 1950s and 1960s.

Even though his signature style has often been characterized as 'timeless', Balenciaga's methods and outlook were deeply conditioned by his Spanish heritage and formative experiences. Born in a Basque fishing village in 1895 and brought up by a widowed mother who taught dressmaking, Balenciaga showed an early interest in the design of clothing and was apprenticed to a tailor in San Sebastian. This was a fashionable resort much frequented by the Spanish aristocracy and its streets and promenades formed a focus for the retailing of high-quality clothing and luxury goods. It was in this milieu that Balenciaga opened his first couture house in 1919, expanding to a second outlet in 1931 with further branches established in Madrid and Barcelona. The outbreak

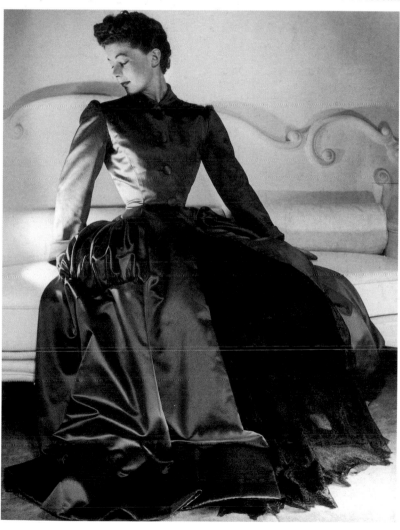

**45 Cristóbal Balenciaga**

Day dress, 1946

Balenciaga remained in Paris during the Second World War and this item reflects both the exigencies of fabric shortages in its shorter length and ingenious cut, and a prevailing militarism in its double-breasted tunic.

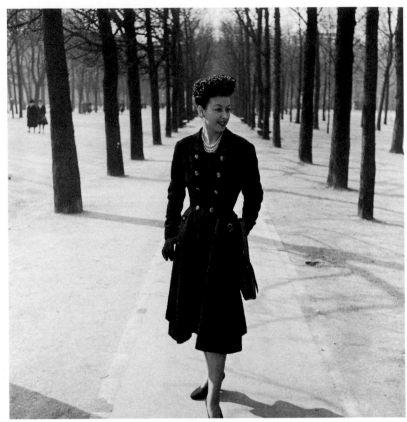

of civil war in 1937 encouraged him to move via London to Paris where he founded his house on the avenue George V during the same year. The patronage of the influential Duchess of Westminster and orders from major American department stores cemented his reputation as a gifted manipulator of colour and structure. Balenciaga's pre-war collections bore some relation to general trends in European fashion in their emphasis on precise tailoring for daywear and a nostalgic romanticism in evening dress, but the accent of his work was clearly Iberian in its striking combination of shades, textures, and historical references.

After a war spent in Paris, Balenciaga's mature collections were more forcefully stamped with his own innovatory ideas, and were still shot through with inspirations derived from the landscape, culture, and history of his homeland. A devout Catholic who left his studio twice a day to attend church, Balenciaga's work was infused with the sombre intensity of the Spanish Counter-Reformation. The abundant draperies and severe vestments which clothed the saints and clerics of the seventeenth-century painter Francisco de Zurbarán were constantly referenced by him, alongside debts to the portraits of Velázquez and Goya and clear homages to folk dress. The resultant designs carried a dramatic impact magnified by Balenciaga's ability to develop

Dress and coat, 1955

Balenciaga's later collections accentuated architectural form, delighting in the juxtaposition of shapes and the effects of movement. Though his clothes were nominally directed towards the changing lifestyle of the modern woman, their theatrical impact and expensive craftsmanship limited their take-up and rendered them part of an older world of luxury.

a historical quotation into something uncompromisingly contemporary. As early as September 1938 *Harper's Bazaar* professed to be startled by the unrelenting blackness of Balenciaga's perennial version of the 'little black dress':

fitting the figure like a wet glove, unrelieved by any soothing touches, immaculately plain from neck to hem . . . the black is so black that it hits you like a blow. Thick Spanish black almost velvety, a night without stars, which makes the ordinary black seem almost grey.

This combination of asceticism and drama became a hallmark for Balenciaga during his most successful years in the 1950s and early 1960s, though tempered with an accommodating understanding of the functional imperatives incumbent upon clothing and the primary

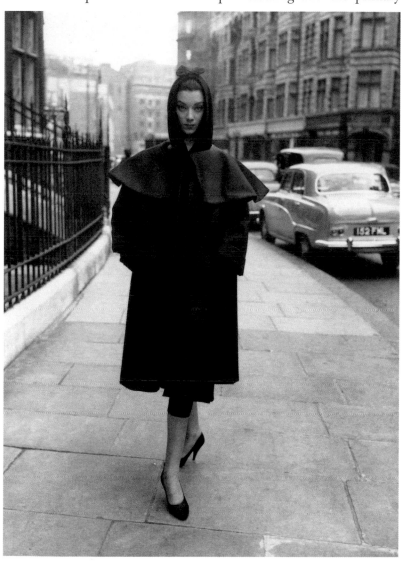

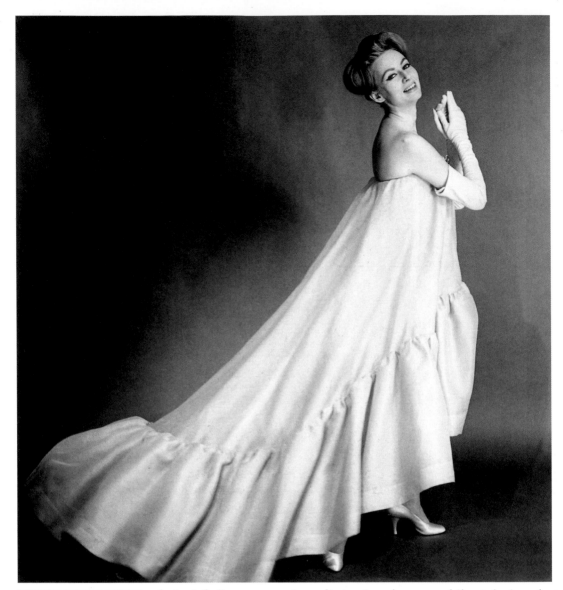

**47 Cristóbal Balenciaga**

Flared cape, 1958

The drama of Balenciaga's designs is well represented in this image for French *Vogue* by photographer Henry Clarke. In his daring manipulation of line and abstract form, the designer set a precedent for a younger generation of couturiers whose interest lay in producing stunning fashion imagery for the press rather than bespoke clothing for rich clients.

desire of clients to attain a distinctive elegance whilst enjoying the maximum level of comfort. Stand-away collars, three-quarter-length sleeves and a cut which smoothly skimmed rather than moulded the contours of the body were utilized in simple daywear collections fashioned for an idealized conception of the active modern woman. In September 1952 *Vogue* perceptively labelled the style as one of 'magnificent ease'. Evening wear offered the opportunities for a more radical experimentation with shapes and textures. This was a forum in which Balenciaga's training in tailoring and his understanding of sculptural form fed an audacious play with proportion and surface. Heavy fabrics, encrusted with beading and embroidery, layered with lace, or dense with tactile qualities achieved through new production technologies,

were made to flow with apparently minimal intervention in terms of structural seams or hidden support, suggesting an exceptional purity of line and an appreciation of the beauty of mass.

Such craftsmanship was however expensive and symbolized a style of life that was rapidly passing. Balenciaga was perhaps the last of the 'artist-couturiers' and his premature retirement in 1968 was in part a tacit acknowledgement of the rise of a younger generation and the inevitability of the primacy of ready-to-wear over older, less cost-effective designing practices. Ironically Courrèges and Ungaro, two of the pioneers of the new couture, gained their training under Balenciaga's tutelage, finding in his rigorous dedication to the building of a look the source of their own anti-establishment energies.[15] When Balenciaga died in 1972 *Women's Wear Daily* lamented that 'the father of contemporary fashion is dead, but his influence remains. Balenciaga was . . . the father of tough chic . . . the father of great tailoring . . . the father of sure clothes.'

## Yves Saint Laurent—outrage and modernity

I have often said that I wish I had invented blue jeans: the most spectacular, the most practical, the most relaxed and nonchalant. They have expression, modesty, sex appeal, simplicity—all I hope for in my clothes.[16]

Yves Saint Laurent is perhaps the most contradictory and yet symptomatic of a generation of post-war designers whose work in the 1960s and 1970s helped to redefine the idea and material nature of fashionable clothing for a marketplace no longer enamoured with the rarefied precepts of traditional haute couture as personified in the work of Balenciaga. In a controversial one-man exhibition staged by Diana Vreeland at the Metropolitan Museum of Art, New York in 1984 (the first devoted to a living designer), the trajectory of a career which further pioneered the notion of the creative genius in tandem with a model of sleekly elegant yet purportedly democratic fashionability, was laid out in a tableau of iconic and familiar ensembles. Explaining his influences and method of working in an introductory chapter to the attendant catalogue, Saint Laurent revealed a diffuse and confused philosophy which was entirely in step with the fragmented nature of fashion culture in a new era of mass media, the globalization of culture, the supremacy of the brand, a post-Fordist collapsing of the distinctions between production and consumption, and an attendant epidemic of post-modern neuroses which hinged on the figure of the celebrity. Unsurprisingly this self-characterization accommodates an all-encompassing interpretation of his profession as being that of the stylist in pursuit of the timeless look that would supersede ephemeral considerations of fashion, the inheritor of the craft-based secrets of the

couture house, the translator of street-level energies, the poet of form and colour, and the intellectual in thrall to Proust and Nietszche.

In reality, by this stage Saint Laurent was essentially a figurehead for a hugely profitable international company, and the striving after 'tortured artist' status that pervaded the exhibition, and most of the many publications which trace his career, is evidence of the added value which accrues to the initials YSL, the eponymous logo of his business. Yves himself had long since ceased playing an active daily role in the physical process of design across all aspects of his empire. When he did work it was in concentrated bursts that preceded the seasonal Paris shows which showcased the house. The sustained success of his reputation owed much more to the commercial expertise of his partner Pierre Berge. It is, then, difficult to approach the clothing produced under his name in the same way as one would interpret a Balenciaga or a Vionnet. Questions of authorship are still key, but issues of innovation lie more in the field of business, promotion, and marketing than they do in the realm of the studio and the workbench. The several images which circulate of Saint Laurent in the guise of creator, dressed in his workmanlike white coat or posed with sketchbook and pencil, act as an insistent reminder of a creative endeavour which in truth encompassed much more than the productivity and vision of a single individual.

This is not to suggest that the myth of Saint Laurent is a hollow one. Its potency is based on a life story and output that also challenged contemporary understandings of fashion, design, and taste in a significant manner. Born in 1936 to a bourgeois colonial family in Algeria, his entry into the profession of fashion was swift and privileged. Trained at the school of the Chambre Syndicale de la Haute Couture, he graduated to the role of assistant to Christian Dior, whose house he took over as chief designer on the death of Dior in 1957. His first collection under the Dior name in 1958 paid due respect to the traditions of couture, using the fine fabrics and skilful cutting associated with the genre but stripping away the stiff linings and padding to reveal a freshness and seemingly unstructured sense of relaxation. The resultant 'Trapeze Line' garnered enormous publicity and was credited by the press with rejuvenating the Paris fashion industry overnight. Yet following this triumph Saint Laurent was drafted into the army with disastrous effects for his mental and physical health. On his discharge in 1960 he was forced to initiate legal action against Dior who had replaced him with Marc Bohan, a move which edged him towards opening his own house. Though unsettling, this period of transition helped to redefine the young designer as a delicate and mysterious aesthete whose public persona was more suited to the creative and introverted world of Left-Bank bohemianism than the gilded salons of an ageing couture culture, and this perhaps is the key to his influential impact on the development of late twentieth-century fashion.

**48 Yves Saint Laurent**

Mondrian Collection, 1965

Saint Laurent's iconic collections of the mid-1960s referenced the parallel worlds of art, popular culture, and social revolution. Here the designer has imposed Piet Mondrian's chromatic grids on to a simply cut shift dress. A quotation from the history of modern painting is thus transformed into a statement about pop sensibilities and new models of feminine beauty.

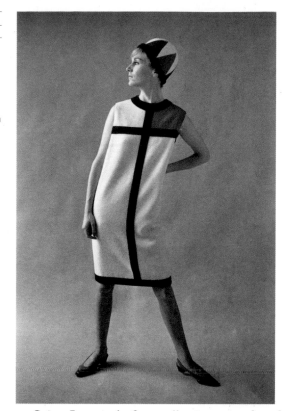

Saint Laurent's first collections, produced under his own name from 1962, maintained the standards of finish and well-mannered restraint that had been expected of him at Dior, but were infused with the chic glamour, the beading, and rich surface effects that were put to more directed use in his concurrent commissions for the ballet and theatre. It was not until 1965 that his work took on a radical edge, challenging the polished 'tough chic' aesthetic that had dominated high fashion design since the launch of the New Look in 1947. In this departure he was joined by his near contemporaries Pierre Cardin and André Courrèges (both were older by just over a decade).[17]

Like Saint Laurent, Cardin's pedigree was deeply traditional and included periods of employment with Paquin, Schiaparelli, Cocteau, and Dior. As a risk-taker his affronts to the propriety of the Chambre Syndicale de la Couture pre-dated Saint Laurent's more personalized wrangles. In 1959 he was expelled from their ranks for launching a ready-to-wear collection and in the same year he took the unprecedented step of designing directional fashions for men. But it was his promotion, from 1964 onwards, of cleanly sculpted and hard-edged futuristic designs in plain or geometrically patterned but brightly coloured and densely woven fabrics that placed him amongst an avant-garde who looked to the influences of space-age technology, American abstract, and pop art, and the rise of teenage street culture rather than

Betty Calroux, Yves Saint
Laurent and Loulou de la
Falaise at Rive Gauche, 1969
Fashion model, designer, and
artistic muse pose in safari-
themed outfits, outside of
Saint Laurent's recent foray
into boutique-style selling.
While maintaining the chic
allure of élite dressing, Saint
Laurent opened up the idea of
Paris fashion to a much wider
audience.

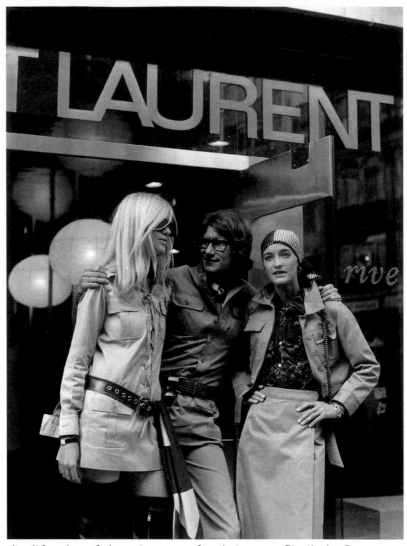

the lifestyles of the aristocracy for their cues. Similarly Courrèges,
though benefiting from a training with Balenciaga, offered shockingly
white and child-like clothes which utilized high-tech synthetic sports
fabrics and embraced a manifesto of exuberant and innocent energy
quite at odds with the soigné elegance of old-style couture.

Saint Laurent's own contribution to the new style resulted in a suc-
cession of themed collections which married a remoulding of the ideal
female body along supposedly natural lines and a sympathy for the
concerns of a youthful popular culture, with a more highbrow borrow-
ing from the histories of art, architecture, and theatre. The 'Mondrian'
collection of 1965, with its appropriation of De Stijl linearity on simple
jersey tunic dresses, was followed by 'Pop Art' in 1966, a vibrant collage
of cartoonish motifs inspired by the canvases of Warhol, Lichtenstein,
and Wesselman. In 1967 the flat planes of the previous years were

**50 Yves Saint Laurent**

See-through dress, winter 1968

Saint Laurent's appreciation of the erotic attractions of bohemian culture was part of a highly marketable house style in tune with the progressive aesthetics and revolutionary sexual politics of the late 1960s. This dress in black chiffon with ostrich trim, worn over a golden snake belt, reflects a concurrent interest in decadence.

replaced by a more sculptural knit of raffia, flax, glass, and wooden beads in a celebration of African art that complemented a rising interest amongst the western bourgeoisie in alternative philosophies and ethnic cultures. By 1968, somewhat ironically, tribal art was succeeded by a collection which borrowed from the colonial past, but subverted the uniform of the imperial adventurer by remoulding the masculine safari jacket as a sensual laced item for the female wardrobe. Sexual provocation and the tawdry glamour of the flea market were also accented in the transparent black chiffon dress of the same year, trimmed with ostrich feathers and fastened with a gold snake belt. The theme was reprised in 1971 in the lace-backed cocktail dress that

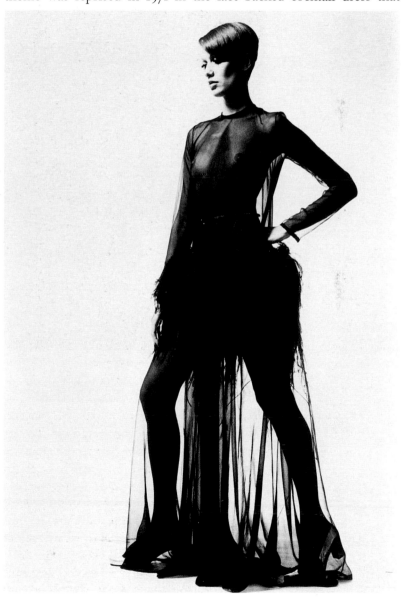

**51 Yves Saint Laurent**

Autumn/winter ready-to-wear collection, 1995

Saint Laurent first introduced elements of the masculine suit into womenswear in 1966. This provocative play with gendered styles has since become a perennial feature of the house, while sharp tailoring and fine textiles also satisfy the core market for Saint Laurent's clothing.

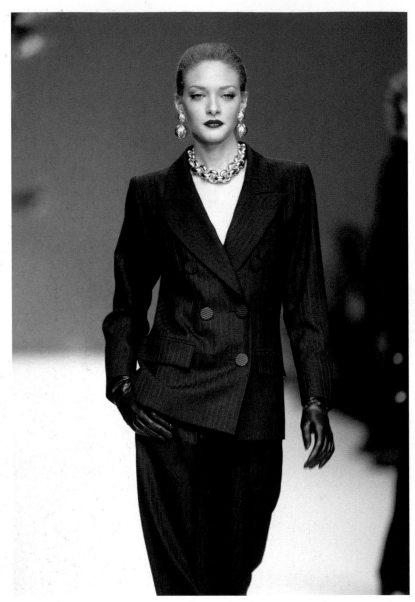

**52 Jeanloup Sieff**

Yves Saint Laurent, 1971

Sieff's celebrated nude portrait of the designer was produced for the launch of a men's fragrance. It captures the air of sensitive vulnerability that has constantly characterized the public persona of Saint Laurent, skilfully obscuring the aggressive economic realities underlying the running of a highly successful corporation for whom the modern designer acts as a symbolic figurehead.

formed the highlight of the 'Forties' collection, and in 1975 when Helmut Newton's photography captured the frisson of transvestism that accompanied Saint Laurent's most celebrated contribution to twentieth-century fashion history—the tailored trouser suit for women.

First pioneered in his winter collection of 1966–7 'Le Smoking' as it became known formed a perennial feature of Saint Laurent's collections and an examination of its recurrence through the 1970s and 1980s aids a closer understanding of the designer's working methods. Sure of his market and their tastes, his output by this stage tended to reiterate the formal virtues of cut, colour, and proportion, paying only

passing attention to ephemeral trends and looking to a sense of the spectacular only in a few ostentatious platform pieces which sat more comfortably within the category of theatre design. Collections such as 'The Ballets Russes—Opera' of 1976, 'The Tribute to Diaghilev and Picasso' of 1979, or the 'Cubist' of 1988, with their literal lifting of historical graphic motifs interpreted in impossibly expensive embroidery by Lesage, acted as signifiers of the designer's creativity and vocation—aiding the promotion of a mood and assisting the sales of YSL perfume, accessories, and diffusion lines. But the staple items for daily wear represent a much quieter influence, attractive to a loyal following and subtly responsive to social mores.

Beyond the clothing, it is the design of Yves Saint Laurent the man that reveals the most innovative strategies in gaining a share of the market. At the height of his popularity during the 1960s and 1970s Saint Laurent could use his celebrity as a means of penetrating consumer consciousness. His body, name, tastes, and opinions were utilized in campaigns of deliberate outrage to promote the brand. The launch in 1966 of a chain of boutiques to sell a relatively cheap line of YSL clothing and accessories used the label Rive Gauche to suggest radical, bohemian intent. Similarly in 1968 Saint Laurent dedicated his autumn range of duffle coats and fringed jackets to the student protestors whose activities were aimed at undermining precisely the sort of capitalist and élitist activities which high fashion embraced. Most famously in 1971 Saint Laurent posed naked in a photograph by Jeanloup Sieff for the advertising campaign which accompanied the launch of the first YSL fragrance for men. For the first time the sexuality of a fashion designer was a cause for celebration rather than scandal. In less positive terms, Saint Laurent appears to have encouraged the association of his name with a jet-set lifestyle of glamorous decadence and fragile sensitivity that led in the 1980s to constant press rumours of illness and addiction, so that the private and public aspects of the man became perhaps dangerously confused. It was this deliberate confusion that arguably contributed most to dominant late twentieth-century conceptions of what constituted and drove the iconic figure of the fashion designer.

## Issey Miyake—fabrics and futures

In seeming opposition to the cult of personality which accompanied Yves Saint Laurent's rise to global dominance, the work of the Japanese designer Issey Miyake has generated an alternative reading of fashion in which the essence of innovation has been seen to lie in the manipulation of fabric itself, leading to a partial erasure of the designer as 'star' for an apparently more subtle construction of creativity.[18] These new myths trade on essentializing orientalist assumptions concerning the different and supposedly purer practices of Japanese artistic production, in tandem with an emphasis on the possibilities of new technologies and a familiar borrowing from the rhetorics of avant-garde fine art production and curation.[19] More than any other contemporary fashion designer, Miyake's work has become familiar through the process of reproduction, outside the traditional fashion system. Whether photographed as de-contextualized objects, as part of the series of collaborative publishing projects undertaken with Irving Penn, or frozen as contemplative sculpture in one of many successive museum installations, Miyake's clothing designs have sought to transcend the stylistic, physical, and temporal parameters of fashion per se. In their literal cleaving to the broad idea of innovation

as an end in itself, and their surface repudiation of fashionability as shallow affectation, such products have been adopted almost as a mode of uniform by a self-identified cultural élite as evidence of their aesthetic superiority. It is then possible to trace here a direct genealogy from Jaeger and the nineteenth-century reformists' coupling of spirituality and function as sole motors for the proper design of clothing to Miyake's invention of a material shorthand for sartorial progressiveness. Ironically, both positions have also found themselves forcibly incorporated into the very commercial system which they set out to oppose.

Miyake's invention of a practical design language which could circumvent the taint of fashion whilst emphasizing a radical creativity was in evidence from his earliest experimentation in clothing production whilst a student of graphic design at the Tama Art University in Tokyo during the early 1960s. Working in a context where the study of dress design was associated both with a lowly commercial training and subordinate feminine skills, he felt the need to investigate adjacent disciplines for appropriate methods and systems. His student show, titled 'A poem of cloth and stone' of 1963, used metaphors from sculpture and literature as a means of justifying his interest in textiles. The prospectus of the show

aimed at suggesting clothing as visual creation rather than being utilitarian. We want to stimulate the imagination through clothing. It is not a fashion show, though the works do breathe in contemporary style. Accordingly, I think the next step will be clothing that looks to the future.[20]

A continuing education in the traditions of couture under the tutelage of Guy Laroche and Givenchy at the Ecole de la Chambre Syndicale de la Couture Parisienne, though valuable, did not offer Miyake the space for invention that he was seeking. He claims that his outlook was politicized and enriched by the student protests of 1968, the burgeoning youth culture of London, and the energy of the New York art scene at the close of the decade. Moving through these changing metropolitan scenarios at some speed provided Miyake with a global perspective that goes some way towards explaining the universalizing aesthetic—predicated on cross-cultural connections—which has become associated with his name. Underpinning these formations was a concurrent reorientation of Miyake's home culture, whereby, on the back of American aid, an economically vibrant Japan was developing a programme for the mass-production and exportation of cutting-edge technological and consumer goods, retaining its allegiance to traditional virtues whilst embracing a spectacular modernity. This new outlook was exemplified in the Osaka International Exposition of 1970 for which Miyake was commissioned to design futuristic staff uniforms.

**53 Issey Miyake Printworks**
Tattoo in memory of Jimi
Hendrix and Janis Joplin,
spring/summer 1970
Miyake's early work benefited
from his experience of the
cultures of Tokyo, Paris,
London and New York. Here
the ancient art of Japanese
tattooing is used in a print of
contemporary rock icons,
celebrating the hybrid nature
of traditional and progressive,
eastern and western idioms.

The early 1970s saw Miyake establishing his reputation and testing his signature style in Japan. He opened his own Tokyo-based design studio as a collaborative venture with textile designer Makiko Minagawa and graphic/print designer Tadanori Yokoo in 1970 and worked on projects which utilized aspects of Japanese folk culture as part of a new paradigm for designing around the body. The tattoos of yakuza gangsters were adopted for fabric prints, but manipulated to include the likenesses of American rock heroes Janis Joplin and Jimi Hendrix. This both challenged the sacred idea of tradition and questioned the relationship between body, skin, and garment. Similarly the hard-wearing qualities of cotton *sashiko* quilting which had been used for generations to make functional protective clothing for the martial arts was requisitioned by Miyake in a softened form as the basis for contemporary outerwear. New fabrics such as polyester jersey and the acrylic knit Pewlon were adopted for their supple, flowing qualities, together with the cotton crêpe of rural Japan, the exotic checks of Bali, and Irish wool. His eclectic sourcing of materials and incorporation of mass-production techniques and craft skill were echoed in his resistance to cultural stereotyping. Frustrated by the epithet 'Japanese design', Miyake maintained a crucial presence in Paris and New York and continued to draw his inspiration from diverse international sources, including the Nubian culture celebrated in Leni Riefenstahl's controversial photographs of 1976 and the tradition of nineteenth-century book illustration, especially the work of Gustave Doré, whose images for Milton's *Paradise Lost* were used in a collection of the same name in 1977.

Through the 1970s and 1980s Miyake's most characteristic productions were, however, more closely concerned with the abstract geometrical properties of cloth and its relationship to the body than with questions of national identity. Aiming to refine the construction of dress to its simplest coordinates, Miyake famously arrived at a fundamental square to which sleeves could be attached. Conforming to the precepts of architectural modernism in its functional adherence to the modularized, standard body, the minimal imposition of cloth on flesh also drew on the tradition of the kimono and worked against the western idea of garment construction and fashionable change. Inhabiting the space between cultures, products like 'A Piece of Cloth' of 1976, in knitted cotton and linen stripes, returned to fundamental definitions regarding the purpose and appearance of modern dress. By 1982 such experimentation had evolved almost as a complementary sideline to the continuing production of wearable everyday items like the 'Plantation' line or 'Clothes for real life' which was launched in 1981 and promoted a straight, simple cut in practical fabrics. The flowing freedom of kimono-like forms was superseded in the mid-1980s by the staging of rigid sculptural installations, whose content was closer to

body jewellery than clothing. Theatrical rattan and bamboo cages reminiscent of samurai armour were followed by moulded silicon breast plates with cyborgian science-fiction connotations.[21]

These assaults on conservative preconceptions regarding the aesthetic and functional status of dress found a natural home in the context of the gallery exhibit or the photographic monograph, rather

During the 1970s and 1980s, Miyake developed the geometrical formation of Japanese garments such as the kimono or traditional working dress, to arrive at an abbreviated style system with non-specific global applications.

than in the commercial sphere of fashion retail. Though the promotion of such events acted as a useful publicity tool, their practical implications were not fully realized until the establishment of the 'Pleats Please' project in 1988. Here was a medium through which Miyake could combine an interest in the surface effects of textile treatments, or sculptural investigation, with a concern for functionality and comfort. Recalling Mariano Fortuny's early twentieth-century innovations with pleated silk, which themselves re-created the effects of ancient Greek and Egyptian costume, Miyake's products aimed to test the boundaries of textile manipulation, pleating, twisting, shrinking, printing, and dyeing natural and synthetic fibres in a manner that fused traditional and avant-garde technique whilst recognizing the elemental concerns of the moving body.[22]

The apparently rational progression of ideas and prototypes which have marked Miyake's career, together with the constant (and rather disingenuous) elevation of product over personality that characterizes the copious Miyake literature, have ensured his status as 'the designer's designer', a creative who seems to have balanced the prerogatives of commercial success with an uncompromised aesthetic vision. His productive position on the boundaries of sartorial culture, between an idea of east and west, art and fashion, singular endeavour and collaboration, craft and mass-production, has encouraged a richly coloured interpretation of innovation, of fashion design as an elevated mode of cultural and technical research. But this is perhaps misleading, crediting individuals like Miyake with an influence that is hugely overstated in real terms. As the following chapter will suggest, it is the promotion

**55 Issey Miyake**

Bustier, 1983

Miyake's experimentation with rigid materials such as rattan, bamboo and silicon offered an alternative design language closer to product design than fashion. Here the armour-like form of a bustier suggests the fluid bodywork of a car, the protective clothing of martial arts, and the sculptural drape of fabric on flesh.

**56 Dominik Mentzos**
Miyake design in pleats for
the Frankfurt Ballet, 1991
Miyake has constantly
experimented with formats
and venues for the display of
clothing, collaborating with
photographers, curators, and
choreographers to present
fashion in innovative ways. His
work on the pleating of fabric
has benefited from its
association with the mobile
medium of dance, illustrating
the manner in which his textiles
are dynamic, shifting forms.

rather than the production of sartorial ideals and aspirations that has
provided the central rationale for the modern fashion system, forming
a bridge between the élite context of high design and a popular under-
standing of developing style, between singular object and democra-
tized idea.

# Part 2
# The Promotion of
# Fashion

# Disseminating Desire

4

In his useful book on the relationship between fashion, culture, and identity, sociologist Fred Davis quotes an evocative passage from the journal of an American traveller returning home from a visit to the Far East in 1947. This was the year in which Christian Dior launched his influential New Look, a collection which offered a provocative departure from the fabric restrictions and low expectations of post-war austerity, seemingly rerouting the direction of fashionable style in the space of a season. For the traveller in question, Dior's supposed revolution effected an extraordinarily swift, yet orderly impact both on the dress of fellow-tourists and on her judgement of her own standing as a woman of taste:

At every airport where we stopped on the way back from China I started watching the women coming the other way. At Calcutta the first long skirt and unpadded shoulders looked like something out of a masquerade party. At the American installations in Frankfurt (also in Vienna) a lot of the newer arrivals were converted and were catching everyone's attention. At the airport in Shannon I had a long wait; I got into conversation with a lady en route to Europe. She was from San Francisco, and told me that they hadn't been completely won over; just as many were wearing the long skirts as not. But as she flew East, she found that just about everybody in New York had gone in for the new styles and she was happy she wasn't staying or her wardrobe would have been dated. By the time I took the train from New York for home, my short skirts felt conspicuous and my shoulders seemed awfully wide! Two weeks now and I am letting down hems, trying to figure out which of all my China-made clothes can be salvaged, and going on a buying spree![1]

The diarist has here become witness to the mysterious process of change in fashion—a process that in the static and familiar environment of home remains hidden and ineffable. Suffering from a version of sartorial jet-lag in which the clock rushes on before her eyes, she faces an oncoming tide of novelties, fresh versions of the couturier's diktat, whilst her own wardrobe and that of her compatriots lingers in another, less contemporary, time zone. She knows that she must soon adapt or be overtaken. It would be difficult to re-enact such a scenario today. The speed and complexity of modern communications, the globalization of the media and fashion industries, and the demise of a

**57**

A fashion demonstration, Paris, 1950

Here the designer Jacques Fath instructs pupils of a Parisian finishing school on the rules of correct dressing. His lesson seems to suggest that fashion is a mode of communication whose grammar needs to be learnt.

singular vision which might once have led fashionable culture before the onslaught of a new multiplicity of possible models, have helped to compress the sensation of a linear sartorial development. The twenty-first-century consumer experiences fashion as a more fragmented, competitive, simultaneous, and potentially confusing cultural phenomenon that some commentators have likened, rather apocalyptically, to the spreading of a virus.

It is this idea of infection (or cycle, or wave, to use the less emotive terminology of other fashion theorists) and its direction over the past century that forms the central focus of this chapter. Moving further away from a study of the design and production of fashionable clothing as a discrete category, it will now be necessary to look at its wider mediation beyond the boundaries of the studio, the factory, and the warehouse, or the seams and surfaces of the manufactured object. This

necessitates an understanding of fashion as a culture industry which incorporates the whole gamut of economic, sociological, psychological, and aesthetic experiences. Here, under the creative rubric of marketing and publicity, production and consumption are knitted together in such a profound relationship that the mundane and often inequitable circumstances of manufacture become subsumed in a mirage of desires where all human values are commodified.[2] It is little wonder that some critics have been driven to equate the nature of fashionable promotion not just with the selling of clothing, but as a powerful (and often negative) metaphor for the mercenary and materialistic state of modern society and culture in general.[3]

## Celebrity and publicity before Hollywood

The cult of celebrity in which the late nineteenth- and early twentieth-century fashion designer played such an integral part was one of the earliest means by which fashionable commodities could be marketed and publicized to a consumer constituency much wider than the narrow urban élites of Paris, London, and New York who formed the core customer base of the great couturiers. In tandem with the establishment of couture houses and the self-transformation of their figureheads from mere dressmakers to 'artists of the cloth', the idea of fashion took on a new seriousness in *fin de siècle* literary salons and metropolitan coteries as a phenomenon to be freely discussed and exhibited, exalting what had previously been dismissed as feminized trivia or the esoteric pursuit of the dandified aristocrat to the status of high philosophy. This popular glorification of the luxurious lifestyles and habits of the rich relied on the repeated description and reproduction of its details in gossip columns, magazines, novels, paintings, theatre, and latterly film. In Paris its effects can be read in the work of Balzac, Baudelaire, the Goncourt brothers and Proust.[4] In London it finds its apotheosis in the satirical voice of Wilde, whose professional interest in the worlds of fashion and leisure saw him both lampooning its pretensions in his dramatic works whilst fuelling its activities (albeit in a progressive manner) in his role as editor of the journal *The Woman's World*. In Boston and New York, Henry James and Edith Wharton chronicled an 'over investment in the world of appearances' which was simultaneously captured on canvas in the Golden Age portraits of John Singer Sargent.[5] Following the First World War the European artistic avant-garde recognized a valuable commentary on modernism in the promotion and circulation of fashion, and its slippery characteristics were utilized in the theoretical writings of architects including Adolf Loos and Le Corbusier, the novels of writers such as Franz Kafka and Virginia Woolf, and the imagery of various Futurists, Expressionists, Dadaists, and Surrealists.[6]

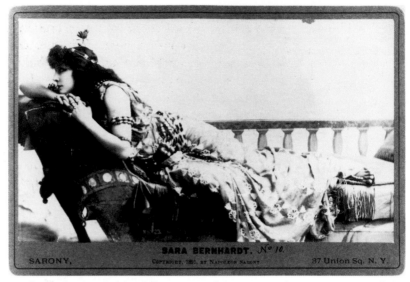

Outside the field of fine art and literature the promotion of the elegant life fell under the jurisdiction of real women (and some men) who utilized their position on the borders of polite society as a means of projecting their talents and tastes to the widest possible audience (often in close coordination with significant players in the clothing industry itself). Social and sexual scandal frequently went hand-in-hand with the promotion of fashion, usefully bracketing a desire for luxury and novelty with a new moral code in which self-love and rapid gratification were no longer identified as being especially sinful, but instead rather modish. The emerging consumer society which had been developing since the late eighteenth century and before was one which, by the early twentieth, had fully embraced the uncompromising modernity of fashion culture. In its vanguard were personalities such as the dancers Loie Fuller, Isadora Duncan, and Josephine Baker, the actresses Lily Langtry and Sarah Bernhardt, and various 'men about town' including Wilde himself, Robert de Montesquiou, and Stephen Tennant, men and women who traded on their notoriety, their 'uniqueness' and their unchallenged mastery of the sartorial and cosmetic arts.[7] Everything from the social opinions through to the decorating choices and clothing preferences of such proto-celebrities were used to advertise the desirability of the fashionable life to a broader market for whom the mass-produced trappings of metropolitan civilization were increasingly within reach.

## The model and the runway

Closely allied to the emergence of a fashion-orientated celebrity culture with its associated style-leaders was the increasing use and promotion of living models within the salons of the couture and dress-

Daisy Irving, 1910
Popular theatre offered a lively
forum for the dissemination of
new fashion ideas during the
Belle Époque and the role of
the actress frequently
overlapped with that of the
mannequin. Here Daisy Irving
poses in an orientalist
ensemble influenced by the
work of Paul Poiret.

making industries. As we have seen, the famous story of the rise of
Worth includes accounts of the manner in which his wife (herself a
former mannequin) encouraged the greater prominence given to the
organized display of new lines on the bodies of women on the staff
(*demoiselles du magasin*) from the earliest days of his career in the 1850s.
By the first decades of the twentieth century Poiret had engineered the
spectacular, thematic party or event as a backdrop for the promotion of
seasonal collections, and in London the high-society court dressmaker

Lucile (Lady Duff Gordon) trained her statuesque models to adopt individualized and potently erotic stage personas in order to attract publicity and the valued custom of plutocratic male patrons.[8] In the adjacent, but more democratic worlds of the department store and the popular theatre similar scenarios were played out through the 1920s and 1930s. Professional beauties modelled the latest designs in store as a part of the many attractions which retail pioneers promoted for the benefit of a predominantly middle-class and female audience. Musical comedies turned to the subject of fashionable life via familiar, breezily accessible characters such as the shop-girl, who shared the bill with more aspirational figures drawn from an imaginary and compensatory leisured society centred on boudoir intrigue, romantic dalliance, and conspicuous consumption.[9]

Arguably it is from out of this commercialization of glamour, via female bodies whose primary, indeed only, significant role lay in displaying and enhancing the spectacular products of fashion designers, that the seasonal promotion of the collection in the fashion centres of the world emerged, to be further honed in the post-war era. The pragmatic consideration of appropriate display inaugurated by Worth, and the concern with sensual impact and news-worthiness which marked the promotional activities of Poiret and Lucile, gradually combined with the narrative thrust and tendency to mass-dissemination of *fin de siècle* retailing and dramatic culture to inform the later development of the fashion runway show and the isolation of the fashion model as an iconic figure of late modernity. The celebrated Théâtre de la Mode in which the Parisian couture industry attempted to entice back an international market after the isolation of the Second World War, condensed the theatricality of the fashion show in a scaled-down and surreal puppet presentation of wire figures and doll-like gowns, stage-managed as static set-pieces by artists like Jean Cocteau.[10] By the late 1950s, though the generic parading of novelties through the restrained rococo interior of the couturier's salon remained much as it had done in the Edwardian and inter-war periods, the women chosen as models were beginning to attain a renewed cultural prominence. In the images of photographers such as Richard Avedon, models achieved a sense of individuality that was shocking in its modernity. Yet whilst the presentation evolved away from the frosty hauteur of the mature and elegant Fifties catwalk model towards a graphic celebration of the pubescent and demotic gawkiness of accessible young photographic models such as Jean Shrimpton and Twiggy during the Sixties (edging its subjects to the centre of a new pop-cultural discourse located in London), the context of the display as a shop window for élite fashion products and a launch pad for the reputations of edgy young cameramen still reduced its female protaganists to the equivalent of Cocteau's inanimate mannequins in terms of their autonomy within the trade.[11]

Models Robin Tattersall and
Suzy Parker, place de la
Concorde, Paris, 1956
Avedon's work for fashion
magazines during the 1950s
marks a transitional moment in
the representation of the
fashion model and her clothes.
The supreme elegance and
hauteur associated with the
best models since the early
twentieth century was now
giving way to more
experimental modes of
presentation where unlikely
settings or expressive poses
challenged the traditions of the
couture salons.

Between Twiggy's pre-eminence as a symbol of the gradual opening
up of fashion representation and the furore surrounding the rise of the
super-model in the late 1980s, the industry which supported the
production of such imagery also experienced a profound period of re-
organization. Though the idea of the celebrity style-leader still main-
tained its currency as an important player in the origination and
circulation of trends, the association of faces and bodies like Twiggy's
with a more egalitarian fashion scene put paid to the notion of a singu-
lar high-fashion vision emanating from Paris at strategic moments
during the year. The working-class energies of the street and of a more
visible youthfulness embodied in the figure of the teenager reordered
established understandings of the formation of fashionable taste, so
that innovation became more dispersed in terms of its centres and
pluralistic in terms of its icons. Running parallel to this shift was a

**61**

**Twiggy, 1967**

By the mid 1960s the image of the model herself had begun to supersede the importance of the clothing she was ostensibly paid to promote. Here London model Twiggy assumes the status of pop star, surrounded by reproductions of her iconic face.

**62**

**Twiggy promotes her brand, London, 1970**

Much of Twiggy's success lay in her rapport with the more egalitarian fashion scene associated with 'Swinging London'. Her appeal extended to those teenagers who had little interest in high Paris fashion but were prepared to invest their rising incomes in the mass-produced, disposable products which the model here endorses.

**63 Karl Lagerfeld**

**63 Karl Lagerfeld**

Fashion show for Chanel,
spring 1998

During the 1980s and 1990s
media attention returned to
the fashion runway and the
figure of the so-called 'super
model'. Far from presenting
the empathetic face
associated with the era of
Twiggy, models now embodied
contemporary concerns with
aspirational celebrity lifestyles
and the cult of the perfect
body. Incidental to their
appearance in fashion shows,
the publicity generated by
their notoriety turned such
models into perfect marketing
tools.

growing need for the established industry to recognize global markets, increased competition, and mass-dissemination as the keys to economic survival. The consuming preferences of urban élites alone offered no guarantee that adequate sales could be achieved, and the craft-based production of exclusive lines could not sustain future growth.

However, whilst the material output of the couture houses was affected by the shrinkage of their traditional markets and a decline in their functional relevance from the 1960s onwards, the small body of designers, retail buyers, publicists, stylists, and journalists who remained ensconced within the field of so-called high fashion retained the remarkable ability to coordinate a less tangible and more amorphous symbolic power. This trend has seen the established luxury fashion business (financially shored up by successive mergers and corporate takeovers to the point that a majority of the famous houses established as independent concerns from the 1920s onwards are at the time of writing under the ownership of just two virtual monopolies) shift its attention from the narrow provision of bespoke clothing to the mass-selling of fragrance, luggage, accessories, and licensed or branded items. The aspirational associations of these products partake of the mythology of distinction which has always characterized this segment of the industry (such commodities had regularly played a prominent role in the displays of successive international exhibitions from 1851 onwards, attracting particular attention at the Exposition des Arts Décoratifs of 1925 in Paris). In this shift the figure of the fashion model and the phenomenon of the fashion show have been retained as vital

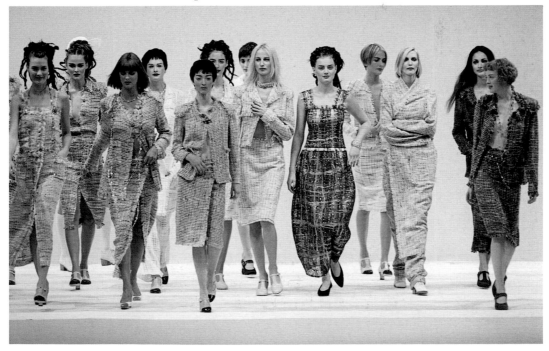

conduits for suggesting those properties of prestige and glamour which a deodorizing bottle of synthesized chemicals, a suitcase or an item of workwear would otherwise lack. Thus the amazonian proportions and dramatic lifestyles of models like Cindy Crawford or Naomi Cambell, and the extravagantly staged runway installations of designers such as John Galliano and Alexander McQueen which captured global press attention in the 1990s, served (alongside advertising) to generate the publicity and debate which endowed mass-produced perfumes, hand-bags, and jeans with a spectacular added value.[12]

## Product diversification and the brand

The jean itself originated from more humble stock, though its complex aura might suggest otherwise. Associated over its two-century history with the freedom of the American landscape and the American way, the jean's soft blue nap has offered a fresh canvas to successive genera-tions of snake-oil merchants and peddlers of fantasy keen to raise their profits ('cultural intermediaries' would be the preferred terminology of contemporary sociology). In its earliest sixteenth- and seventeenth-century incarnation the indigo-dyed hard-wearing cotton claimed connections with both the textile centre Nîmes in France (thus denim) and the port of Genoa in Italy (jean). There certainly seems to be an antecedent in the sea-going breeches of eighteenth-century sailors, though it was the needs of land-workers, gold-diggers and cattle-drivers in the American West of the 1850s which inspired local clothing manufacturers and wholesalers such as Levi Strauss to produce durable

**64 Levi Strauss & Co.**

Advertising card, *c.*1900
The modern jean originated from the durable workwear provided for frontier pioneers by such American clothing companies as Levi Strauss. The practicality of riveted denim appealed to workers in agriculture, mining, and heavy industry whose brawny bodies and optimistic outlook set the model for the rugged American image later associated with such clothing. Even at this early stage in their evolution, jeans manufacturers skilfully used the imagery of the landscape and pioneer life in their promotions.

**65**

James Dean in *Giant*, 1956
The wholesome associations
of denim jeans were revised
during the 1950s to reflect
their take-up by Hollywood
stars and a new generation of
teenagers. The garment now
symbolized rebellion and
sexual desire rather than
practicality or conformity.

overalls and trousers for an active and itinerant workforce who were
without ready recourse to tailoring or outfitting shops or domestic
support in the way of laundries and home-sewers. These were seamed
with the strong stitches of the new sewing technology and reinforced
with the rivets more usually used in the construction of horse-blankets
and saddlery. They were cheap, demanded little maintenance in the
way of washing and pressing and travelled well, but their social and
aesthetic connotations were lowly—a uniform of labour.[13]

A century later and such connotations had been transformed in line
with America's mythologizing of its own recent history as a land of
noble pioneers, newly immortalized in Hollywood. The realities of
corporate culture and urbanization, together with agricultural depres-
sion in the mid- and far West in the inter-war years lent the jean a
sentimental and nostalgic patina that had little to do with its original
functionalism, but made it the patriotic garment of choice for the
increasing leisure hours enjoyed by ordinary Americans. By the 1950s
further suburbanization and a virtual worship of mass-consumerism
meant that the escapist legend of denim came to offer a more
oppositional stance. Its unchanging anti-fashion characteristics and
essentializing ties to action and adventure set the jean up as the badge
of a more subversive intent, chosen by rebels and outcasts as a marker
of difference and refusal. That its neutral coordinates could encompass
adherents as varied as broodingly contemptuous film stars James Dean
and Marlon Brando, bohemian intellectuals, left-leaning political
radicals, feminists, gay men, students, and teenage misfits was a tribute
to its malleability and supremely suggestive symbolic qualities.

DISSEMINATING DESIRE III

Advertisement for Chanel
lipstick, *c.*1990

Increasingly it is the sale of cosmetics and accessories to a global market that generates profits for leading fashion houses rather than the core activities of couture and clothing design. Such heavily advertised products carry with them all the associations of glamour, their packaging and marketing representing the identity of the company. Here, in a promotion for American department stores, lipstick cases assume the phallic skyline of New York, the black and gold containers and prominent logos endorsing Chanel's reputation as a luxury brand.

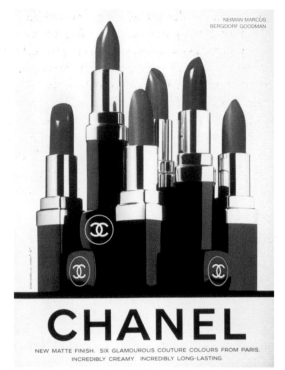

NEIMAN MARCUS
BERGDORF GOODMAN

# CHANEL

NEW MATTE FINISH. SIX GLAMOUROUS COUTURE COLOURS FROM PARIS.
INCREDIBLY CREAMY. INCREDIBLY LONG-LASTING.

By the late 1970s such properties had not gone unnoticed by the garment industry. But whereas earlier versions of the garment were largely standardized and undifferentiated in terms of their manufacture and styling, the new variants capitalized on the romantic sense of heritage that companies like Levi or Wrangler could lay claim to, whilst inventing a multiplicity of reinvented traditions and associations through intensive advertising. Subtle styling differences and the development of fashionable change together with the competitive promotion of particular designer brands to niche markets transformed the jean from a fairly functional throw-away garment to a 'lifestyle' concept rich in iconic potential and profit. A virtual saturation of the global market for denim goods by the turn of the twenty-first century has resulted in some extraordinary renegotiations of this staple garment. Now shorn of its innocence the once American jean has been consecutively manipulated as a rare collector's item, hived off to increasingly obscure Japanese and European labels and re-engineered to meet the aesthetic desires of a generation enamoured of new technologies and futurism.

It could be argued that the history of the jean provides a metaphor for understanding the increasing importance placed on the role of the fashion process in the operation of the late capitalist system generally. This reflects a development which many writers on consumer culture have identified as a broad cultural shift from a society in which a focus on the utility of objects and products was prioritized to one in which

much greater value is placed on their symbolic and associative worth.[14] The early twenty-first century offers a scenario in which the carefully manipulated associations of the fashionable brand and a keen attention to the vagaries of style have transformed the humble equipment of contemporary living into the ephemeral props of ever-changing life-style concepts. The air traveller of the present does not confine her worries to the modish state of her wardrobe; virtually every facet of her existence from the choice of airline through mobile phones to food and financial packages must now accord with the complex directions of global trends. The remit of fashion today has expanded well beyond the design, manufacture, and wearing of a new dress.

# Fashion on the Page

5

The efficient circulation of products and personalities, designed to encourage sartorial desires on an ever-increasing scale, marks out the late nineteenth and early twentieth centuries as a period of rapid modernization for the clothing trades. However, the swift and far-reaching changes associated with the rise of the celebrity style-leader, the spectacular new theatricals of the fashion industry and the ever-expanding proliferation of luxury consumables would have counted for little without the publicity engendered by the mass-produced images and texts that accompanied and preceded them. Alongside its trans-formation from a simple manufacturing to a culture industry, the field of fashion depended on the well-established power of graphic com-munication and the potential of visual reproduction as mediums for translating its raw materials into garments and products seen, sold, discussed, and perhaps even worn.[1]

Such an expansion of fashion-related texts and images was also a response to the demands of a growing reading public with rising levels of literacy and a clear appetite for the ephemeral products of fashion culture. The pictorial and social forms of address chosen by designers, manufacturers, publishers, and advertisers in their bids to encourage such a demand follow a clear historical progression. This can be sum-marized as a shift from a concentration throughout the nineteenth century on the material qualities of the product, its intended function and context in use, towards a growing interest in the symbolism of its surfaces and its psychological potential as a communicator of particular moral and aesthetic values in the inter-war years. For example, on the billboard or in the newspaper advertising column it is possible to trace the transformation of cosmetic goods from items promising physical cleanliness in the 1890s to magical bearers of vitality and inner purity in the 1930s. During the 1950s and 1960s this progression was extended by designers and advertisers who presented their products as active agents in social interactions. Thus household goods, foodstuffs, and items of clothing were endowed with human characteristics, leading to an acknowledgement of the product's role in signifying the consumer's individuality and lifestyle in the segmented marketplace of the late twentieth century. In this scenario furniture and fashion were now

**67 A. E. Marty**
*Vogue*, September 1932
Building on the contribution to the development of fashion illustration made by Paul Iribe and George Lepape, commercial artists in the 1920s and 1930s continued to produce stylized, atmospheric imagery which suggested the essence of contemporary style in a manner complementary to photography.

In the nineteenth and early twentieth centuries, the mode of address adopted by most fashion magazines tended to be dictatorial, advising readers through clear illustration and emphatic editorial advice on the modes of the day.
Shopping columns were a popular medium for this sort of approach.

### YOUR AUTUMN OUTFIT COMPLETE

*In which Mrs. Delahaye excels herself in her powers of selection. She chooses from a London store one coat and two dresses to be worn under it, with accessories which have the very best accent!*

The coat is of plain brown cloth with an important roll collar and cuffs of Caracul. It has a bolero back which reflects the bolero on the afternoon dress of crêpe silk.

In the show case is the "runabout" frock in Meyer lace tweed. With the first dress you can wear the small felt of dark brown with the little feather posies over the forehead, court shoes of glacé kid stitched in beige, " La Joie " silk stockings, beige washable suède gloves, and a triangular pearl clip.

For the morning frock she selects a "cap" in brown and beige "astrakhan wool," a shoe of dark brown crocodile, and an "umbrella bag" of crocodile. The gloves are washable "Welcraft," and the stockings of artificial silk and cotton in brown and beige. All from Peter Jones (London).

*Further particulars will be supplied if you write to Elsa Shelley, c'o Woman's Journal, The Fleetway House, London, E.C.4*

frequently marketed as being youthful, stylish, sexy or fun. The development of the fashion magazine and its imagery plays an important role in this turn towards an understanding of economic, emotional, and social life as a mobilization of style.[2]

## The fashion plate

Since its emergence in the early eighteenth century the aristocratic society magazine had functioned as a key repository for new fashionable information. Its fashion plates provided a detailed record of desirable fashions, indicating changes of style and taste and showing the wide possibilities of function and season-specific garments which were available to a wealthy metropolitan readership. The manner in which clothing was described and shown in the plates also gave some indication of appropriate models of female beauty and posture and

aided an understanding of the rules of polite behaviour in their
portrayal of various activities and settings. They provided a visual com-
mentary on the gossip columns and didactic social commentary that
generally filled the written columns of the magazines. Graphic and
printing techniques developed through the following two centuries to
suit the demands of growing circulation figures and as a response to the
drawing styles of particular fashion artists, or the application of new
pigments and increasing mechanization in the publishing industries.

In early French publications such as the *Cabinet des Nouvellistes*,
fashionable figures were set rigidly against a simple background. Their
formal attitudes mimicked the poses of etiquette guides but were
ideally suited to the stiffly boned and padded fashions of the *Ancien
Régime*. The fine detail of cut, texture, and surface decoration was
indicated by intricately hatched lines, but the overall impression
achieved was of a rather formulaic and genteel rectitude rather than

**70 Nick Knight**

Levi Strauss advertisement, 1996

Fashion imagery of the late twentieth century underlined concepts of individuality. Shoots used ideas of 'lifestyle' to promote items as signifiers of taste and attitude. In this image Levi Strauss questions the association of its jeans with teenagers, broadening their appeal to those who are simply young in outlook. The model is presented not as a professional mannequin but as 'Josephine, 79, teacher, Colorado wears 501 jeans'.

any attempt at either realism or expressive symbolism. By the last quarter of the eighteenth century clothing and graphic styles had changed considerably and the representation of dress took on a fantastical and luxurious air. In the final years of the Bourbon reign, whimsical coiffures and richly furnished accessories, together with a whole repertoire of textiles from silks and cottons to lace and fur, dictated the adoption of a more ebullient graphic style by fashion illustrators. In influential publications of the 1780s like the *Journal des Luxus*, hand-colouring became more prominent, and poses and settings more naturalized (despite the outlandish wardrobes). Following in the painterly tradition of artists like Watteau, Lancrin, and Boucher, it was not uncommon for the producers of plates to set their figures in lush bucolic landscapes, posed in theatrical attitudes that suggested conversation, romance, or even philosophical discourse. Little wonder that fashion prints lifted from magazines and almanacs became the raw material for the scrapbooks and decorative hobbies of respectable young women. They represented both an aspiration to the noble life and the practical medium by which dressmaking and shopping decisions could be arrived at.

The isolation of Paris and its temporary eclipse as a centre for fashionable communications during the years of the Revolution resulted in the geographical reorientation of fashion publishing across Europe. Weimar, Leipzig, and London established themselves as new interconnected centres for the commissioning, production, and circulation of plates in the 1790s and 1810s. In London, continental entrepreneurs

Niklaus von Heideloff and Rudolph Ackermann launched innovative and profitable titles like *The Gallery of Fashion* and *The Repository of Arts, Literature and Commerce* which tapped into Britain's growing sense of economic and industrial confidence. *The Gallery of Fashion* deliberately promoted the fashion choices of the British aristocracy, clothed in the neo-classical drapes which suggested that London was the new Rome. Ackermann's *Repository* included modish furniture and interiors alongside clothing, engraved to a high standard in the elegant, simple lines promoted by artists like Flaxman and Fuseli. However, though cut off from its dictates, Londoners continued to associate France with fashionability, and popular publications like John Bell's *La Belle Assemblée* strove to retain a suggestion of Gallic sophistication, if only in the punning title. In reality Bell's journal relied on English engravers for its illustrative content and was noteworthy for its rational organization and literary flair. In many ways it established a format for the modern magazine in its lively mix of fashion, social reportage, domestic advice, and the advertising of luxuries.

By the mid-nineteenth century the characteristics of fashion plates and the magazines in which they featured reflected the re-emergence of Paris as the capital of the luxury trades, a wider and changed readership, and a broader range of uses to which representations of the latest fashions could be put. The plates of the 1830s distributed through titles such as *The Ladies Cabinet of Fashion, Music and Romance, The Ladies*

**71 Niklaus Von Heideloff**

*Gallery of Fashion*, 1796
In this illustration of English 'evening dresses for opera and concerts', Heideloff poses three aristocratic figures in pseudo-classical drapes against a minimal background. The spare and elegant composition, delicate drawing, and soft hand-colouring of such publications set a stylistic precedent for fashion plates that would endure for a further century.

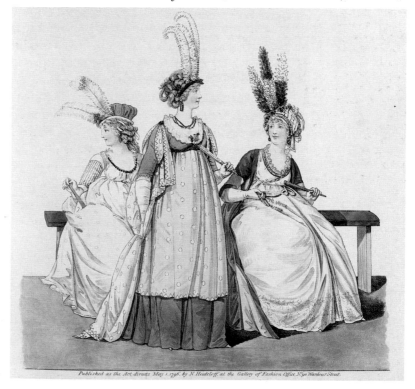

Published as the Act directs May 1 1796 by N. Heideloff at the Gallery of Fashion Office N.90 Wardour Street.

*Magazine of Fashion*, and *The Ladies Museum* promoted a bourgeois ideal of femininity which had become constrained and decorative. The predominant style, with its huge gigot sleeves, layers of laced collars and petticoats, and extravagantly be-ribboned bonnets, allowed for a high level of intricacy in the illustrations themselves but resulted in a mode of representation which turned women into fragile dolls. By the 1840s the endeavours of the fashion trade to reach new markets (in terms of class and age) through the promotion of its products in a range of competing magazines was much more robust. This meant that the illustrations became more literal in their recording of stylistic change and seasonal variation but seemingly less expressive of any social or psychological context. Background and gesture were subservient to the description of colours, textures, and patterns; and exquisite items of millinery or haberdashery were increasingly isolated against an empty page in imitation of the shop window, the exhibition stand or the advertisement. The rising level of abstraction which this implied gave way, in the 1850s and 1860s, to a more sophisticated appeal to the psychological desires of a growing middle-class readership. Publications like *Le Follet* and *The Englishwoman's Domestic Magazine* took advantage of lucrative syndication deals and translation rights to draw on a wider range of illustrative material sourced from Paris-based publishers like Frederick Goubaud. The plates themselves, though often mass-produced to lower standards of finish, evoked the comforts of an idealized but acquisitive lifestyle with crinolined models inhabiting lush gardens and opulent drawing rooms. In the United States the publishers Currier and Ives circulated similarly ambitious panoramas of skating, promenading, dancing, and shopping scenes. Their rich colour, applied by hand to steel-engraved designs by artists such as the prolific Colin-Toudouze family ensured that they stood out from the monochrome embroidery and dress patterns which were interspersed through the magazines; though both functioned together as aids for bringing the escapist fantasies of the emulative middle-class reader to life (with the help of a maid and a sewing machine).[3]

In the final decades of the nineteenth century a further diversification of the market for fashion and for women's magazines is evidenced through their increasingly sophisticated visual content. This is accompanied by a flowering of technical skill in élite publications before the incursions of photography and modernist aesthetics which were to define the nature of fashion illustration in the twentieth century. Mass-market titles for the lower-middle classes, like *Myra's Journal*, offered relatively inexpensive access to representations of fashionable glamour, though perhaps at the expense of artistic standards. At the same time high society publications including *The Queen* or *The Season* looked to illustrators such as Charles Adolphe Sandoz for luxurious images of real couture gowns rendered in the neo-rococo style of

ROBE D'INTERIEUR. (GRANDE DAME.)

PRINCESS GOWN in vieux rose cashmere, set off with shaped bands of cream guipure and Mechlin lace frills. Three tiny tucks head the hem of the peau de soi skirt and encircle the upper part of the sleeve. Yoke, cuffs, and belt in garnet velvet, veiled with cream guipure. Pink ribbon bow, with long streamers, fringed with chenille.

painters like Tissot and Alfred Stevens. Recalling the conversation pieces which influenced the plates of the 1770s and 1780s these *fin de siècle* fantasies showed seductive socialites expensively dressed by couturiers such as Worth and Paquin in elegantly staged settings. As evocations of fashionable desire they are difficult to better. Specialist journals like *Aglaia* offered an alternative perspective to the virulent commercialization represented in mainstream magazines. Through an examination of its Arts and Crafts inspired pictures of rational and aesthetic dress it is possible to chart the emergence of counter-cultural attitudes to bodily adornment which stood in opposition to the Paris styles which dominated the pages of most publications. It was this more revolutionary attitude to identity and appearance that would go on to influence the direction and representation of fashion in succeeding decades when Paris and the fashionable consumer looked to the avant-garde for visual inspiration rather than the refined commercial content of the traditional fashion plate.[4]

### *Vogue* and photography

Though never a straightforward representation of real garments, the published fashion image during the first two hundred years of its evolution was clearly primarily intended to function as a fairly reliable record of the coming mode. This role was subtly redefined in the twentieth century both by the growing importance of photography as the magazine's medium of choice (and a concurrent valorization of the photographer, the art director, and latterly the stylist as influential *auteurs*) and an increasing emphasis in the fashion industry on the imaginative potential of 'lifestyle' and 'art' as promotional tools in which the magazine came to play a central role. The growing autonomy of the fashion press and the dissolution of a singular Parisian fashionable lead gave rise to a modern visual language of fashion that valued symbolism over materiality and surrendered the fashion illustration over to the creative realm of 'the dream'. In this sense mass-reproduced fashion imagery can no longer be read as a direct commentary (if ever it really could) on the political economy of style as it is manufactured and worn.[5]

No other publication has been so closely associated with the visible effects of this shift as *Vogue*. Launched in the United States in 1892 as an élite society journal, it reoriented itself towards the world of high fashion in 1909 under the ownership of Thomas Condé Nast and the editorship of Edna Woolman. British, French, and Italian editions were launched in 1916, 1920, and 1950 respectively. This significantly underpinned the modern idea of fashion as a global phenomenon and pushed the products of its advertisers to a market much broader than those on America's social register who could actually afford the gowns described in its editorial content. More important than its international reach and increasingly formidable sales profile was the

| Significant fashion magazines | | | |
|---|---|---|---|
| launch | title | 1894 | *Woman's Own* |
| | | 1913 | *Vanity Fair* (USA) |
| 1798 | *The Lady's Monthly Museum* | 1931 | *Apparel Arts*—later *GQ* (USA) |
| 1806 | *La Belle Assemblée* | 1931 | *Esquire* (USA) |
| 1830 | *Godey's Lady's Book* (USA) | 1939 | *Glamour* (USA) |
| 1852 | *The Englishwoman's Domestic Magazine* | 1945 | *Elle* (France) |
| | | 1945 | *Ebony* (USA) |
| 1861 | *The Queen* | 1949 | *Modern Bride* (USA) |
| 1867 | *Harper's Bazaar* (USA) | 1953 | *Playboy* (USA) |
| 1873 | *The Delineator* (USA) | 1963 | *Cosmopolitan* |
| 1875 | *Myra's Journal of Dress and Fashion* | 1970 | *Harper's & Queen* |
| | | 1980 | *i-D* |
| 1876 | *McCall's* (USA) | 1981 | *The Face* |
| 1886 | *Woman's World* | 1986 | *Arena* |
| 1890 | *Woman* | 1991 | *Dazed and Confused* |
| 1892 | *Vogue* (USA) | 1991 | *Visionnaire* |

strength of its aesthetic direction. *Vogue* capitalized on design innovations introduced in the production of European art magazines at the turn of the century, repackaging the fashion magazine as a desirable object in its own right, an harmonious and authoritative style guide that functioned as a bible for the fashion-conscious. Setting his horizons beyond the more parochial concerns of the old-style woman's magazine, Condé Nast looked to the philosophical and moral ideals of high modernism as a means of energizing the pages of his journal. During the first thirty years of *Vogue*'s existence photographers including Edward Steichen, George Hoyningen-Huene, Lee Miller, and Horst P. Horst incorporated the techniques of Surrealism in the creation of images which abstracted and fetishized the surfaces of fashionable life. Their work offered a luminous framework through which the reader might negotiate a more complex relationship between clothing, identity, image, and desire than that allowed by the more literal registers of the descriptive fashion plate.

This is not to suggest that the graphic tools of drawing and lithography immediately declined. Following Poiret's encouragement of artists such as Paul Iribe, illustrators such as Erté and Barbier pioneered a luxurious style of fashion illustration in the 1910s and 1920s. This took its references from the theatre and the rarefied world of the decorative arts (drawing imaginative connections between interiors, furniture, costumes, and bodies in an idealized representation of fashionable life as a totalizing art form) and found an apposite home in the pages of *Vogue* and the *Gazette du Bon Ton*. Though the impact of illustration on the magazine lessened from the 1930s to the 1970s, notable painters including Dali, Cocteau, de Chirico, and Bérard, Botero, and Hockney made regular contributions. Indeed the fashion drawing has continued to thrive as a distinctive genre enjoying something of a renaissance in the late 1990s, when ironic homage was paid by a new generation of illustrators working in magazines such as *Wallpaper\** to the imagery and mood of earlier decades.

In the post-war period American *Vogue* flourished under the art direction of Alexander Liberman. Its sparse and clean-cut layouts played host to the cool and attenuated photographic images of Irving Penn, Jerry Schatzberg, and William Klein whose appreciation of the formal qualities of Abstract Expressionist painting and its connections with jazz music and Afro-American culture engendered an electrifying synergy between the formal world of high fashion and the dissonant New York art scene. *Vogue* was not alone in pioneering this new vision. At *Harper's Bazaar* the art director Alexey Brodovitch encouraged an emphasis on documentary techniques and an understanding of the fashion magazine as a kinetic, continuous sequence of textual and pictorial information which complemented photographer Richard Avedon's filmic approach to the recording of style.[6] In Britain during

**73 David Bailey**

*About Town*, November 1961
During the 1960s photographers such as David Bailey rejected the luxurious or surreal settings previously selected for the promotion of stylish clothing in favour of a more gritty realism. Trading on the rising fashionability of London's working-class quarters Bailey here sets a feature on men's overcoats for the bachelor lifestyle magazine *About Town* on the grimy city streets. In this way a mundane garment is imbued with the glamour of the spy film or gangster novel.

**74 Steven Meisel**

Advertisement for Dolce & Gabbana, 1996
Fashion photography in the 1990s engineered a sophisticated visual language replete with references to the history of the genre and to the contemporary obsession with glamour and celebrity. In this image the scene is reminiscent of the glory years of Italian cinema in the 1950s, with pointed reference made to the presence of the paparazzi.

the same period the self-important grandeur of the American publishing house (typified by the figure of famously terrifying editor Diana Vreeland and lampooned in the Hollywood musical *Funny Face*) was challenged by a more radical social and sexual agenda. In *Vogue* of the late 1950s and 1960s (as well as in new titles such as *Queen* and *Nova*, the Sunday colour supplements, and nascent lifestyle journals such as *Man About Town* aimed at young urban men) working-class photographers including Terence Donovan and David Bailey worked alongside bohemian members of the aristocracy such as Anthony Armstrong-Jones and an older generation of urbane dandies like Cecil Beaton and Norman Parkinson in promoting a reconfigured representation of English style. This substituted the Parisian salon and the landscape of uptown Manhattan with a quirky London scene, inflected by ironic class stereotypes, seething with sexual possibilities, and bristling with an irreverent disdain for traditional expectations.

A tendency towards a sexual objectification of the body also surfaced in the output and personal myths of the new generation of photographers and models. Bailey, for example maintained a relationship with the model Jean Shrimpton that clearly endowed his images of her with a palpable sexual frisson. Such permissiveness was at odds with the icy hauteur favoured in the previous decade. The mature (often married) models of the 1950s had been replaced by much younger women whose child-like attractiveness necessarily held a shorter shelf-life than that enjoyed by their forebears. The charged and predatory atmosphere which arose was replicated in the fictional representation of the phallic photographer in the contemporary Antonioni film *Blow Up*. A relaxation of sexual mores was also magnified through the imagery published by *Vogue* and its competitors in the 1970s and 1980s. Its genealogy can be traced through Helmut Newton's darkly provocative scenes of suggested lesbianism and sado-masochism, the homoerotic celebration of the muscular male physique and the camp retro-stylization of the super-model that characterized the glossy work of Herb Ritts, Steven Meisel, and Bruce Weber, and the supposed flirtations with drug culture, anorexia, and paedophilia ascribed by critics to the abject vision of early 1990s' 'new realist' photographers Corinne Day, Wolfgang Tillmans, and Juergen Teller. All signified the ever more complex networks established between the magazine, its (contracted) creative staff, its advertisers, shifting readership demographics, and a broader context in which the creators and audience for such images now engaged with a ubiquitous and indiscriminate popular culture where distinctions between art and pornography, commerce, and fashion were deliberately blurred.[7]

## The style magazine

The increasing engagement of fashion photography with the subcultural interests of the urban young and the gradual exposure of such genres in the pages of established titles like *Vogue* also point to the importance of the independent style magazine as a generator of innovative aesthetic commentaries on fashion culture in the late twentieth century. Beyond the distinctive high cultural rhetoric of *Vogue* and *Harper's Bazaar* journal readers had always had recourse to more popular or niche-marketed titles which appeared to respond directly to their economic and social circumstances and their intimate aspirations. Suburban housewives, unmarried stenographers, shop-workers and adolescent schoolgirls in early twentieth-century Britain and America had access to a wide range of cheap magazines like *Mab's Weekly* and *Woman's Own* which offered dress patterns, beauty tips, film star exposés, and scaled-down interpretations of the latest Paris look alongside the romantic serializations, problem pages, and cake recipes.

*Woman* magazine, August, 1955
Throughout the twentieth century the information needs of most female fashion consumers have been met by a range of middle-brow general interest magazines whose content reflected the day-to-day concerns and aspirations of a predominantly suburban or provincial readership. Such magazines featured articles on domestic management, romantic fiction, dressmaking and knitting patterns, and seasonal photo shoots of mass-produced garments.

However, it was not until the experimental publishing ventures of the 1960s that more discerning British readers were able to locate a challenging visual code that equated with desires not catered for by the conservative presses of Fleet Street. The embracing of consumer culture by a newly enriched teenage constituency, whose immediate concerns oriented around clothing and pop music, provided the context for fan magazines like *Fabulous* and *Rave* through which many trainee fashion photographers passed, honing their distinctive documentary or avant-garde styles. During the later years of the decade, counter-cultural publications such as *Oz* offered a forum for political iconoclasm and graphic experimentation which, whilst not naturally disposed towards the commercial concerns of the fashion business, nevertheless pioneered a space in which the nature and representation of popular culture could be contested and legitimated.[8]

It was from this blurring of mainstream and underground categories

**76 Nick Knight**

Cover image for *The Face*,
February 1986

For the cover of an issue of *The Face* celebrating the tenth anniversary of punk rock, photographer Nick Knight used the latest photographic technology to produce a striking update on punk's confrontational imagery, its fashion content composed by stylist Simon Foxton. Robin Derrick, art director and typographer for the magazine, would then superimpose the famous banner designed by Neville Brody and the slogan 'destroy' over the top of the portrait. This complex layering of meaning and technique was typical of the magazine's influential approach.

that the distinctive style journalism of the 1980s and 1990s emerged, particularly in London and other British cities. The intervening energies of punk fanzines fed into the hybrid concern with music, film, politics, dance, and fashion that characterized influential titles like *The Face*, *Blitz*, and *i-D*, all of which were founded around 1980 (recognizing the high number of male readers amongst the audience for such magazines, these were followed by a rash of men's style titles including *Arena*, *FHM*, *GQ* in the mid-1980s, and latterly the more reactionary *Loaded* and *Maxim*). In their pages the commodification of radical street styles whose genesis can be traced back to the late 1950s found its apotheosis and a kind of dead-end in the concept of 'lifestyle'. Here the minutiae of subcultural dressing were recorded in the blankly anonymous, full-length street and club portraits which have become the trademark of the genre (taken up with gusto in Japanese style publications), or pastiched and bricolaged by photographer/stylists Nick

COMME des GARÇONS

Knight, Ray Petri, and Marc Lebon. Any residue of authentic social allegiances as expressed through clothing was somehow lost in a celebration of the potential fluidity of fashion's surface signifiers. Thus at the height of this post-modernist and very Thatcherite practice during the late 1980s, a single spread in *The Face* might include borrowed references from New York rap culture, the traditional dress of Hasidic Jewish communities and the kitsch extravaganzas of Bollywood, combined with graphic layouts reminiscent of Russian constructivism.[9]

At the time of writing, this play with the autonomous social and aesthetic references of the fashion photograph has found a home inside the covers of independent titles such as *Dazed and Confused*, or the avant-garde show-cases *Purple* and *Visionnaire* (two titles produced for and by fashion industry creatives). Such a development implies an apparent divorce from those traditional assumptions regarding the relationship of style and commerce, dress, and body which governed the production of images in the heyday of post-war *Vogue*. Now the gritty 'hyper-real' contemporary fashion image, as purveyed by Elaine Constantine, Robert Wyatt, or Hannah Starkey is much more likely to critique and question the industry which supports it; to the extent that the pictorial rendering of desire for fashionable clothing takes second place to an exploration of the alienation and neuroses that inevitably attend the purchase and display of dress, but generally remain unspoken.[10] Whilst the fashion image has always operated as a benchmark of standards of taste and beauty, rarely has its message so challenged the very premise upon which fashion culture is built.

# Fashion and Film

6

The moving image has enjoyed an intimate and complex partnership with fashion since its invention in the late nineteenth century. This is a relationship whose contradictions have been even more marked than those associated with the transgressive nature of the static page spread noted in the previous chapter. The fashion photographer has been at relative liberty (within the shifting context of the magazine's structure and organization) to construct an autonomous and often surreal symbolic scenario, in which the representation of clothing acts as a mere prop for broader commentaries on contemporary commerce and culture. However, the film costume designer has constantly found him or herself in service to a variety of often conflicting desiderata which move beyond the purely representational and into the sphere of action. These constraints pivot around the nature of popular cinema as both a realist and an escapist idiom. The moving image must re-create the familiar values and sensations of reality in its bid to suspend belief and sustain that illusion of place and unfolding time suggested by the rapid passing of still transparencies through a projecting lens.

These values echo the material, temporal, and symbolic properties of modern fashion itself, so that the history of film has come to parallel those histories of the practices of dressing and self-presentation which mark a developing understanding of human subjectivity and behaviour in the industrial and post-industrial age. On the screen, as in the real world, dress has been used to communicate character and identity, and to suggest social context. In order to convince, its surfaces have therefore been made to blend in, to appear to be part of a preordained system of appearances. Yet aside from its role in sustaining a coherent semblance of naturalism, screen dressing has also contributed to (and sometimes disrupted) those processes of acting and plot narrative which link cinema back to preceding theatrical and literary genres whose modes of communication have been far from naturalistic. In this latter sense, fashion on the screen has functioned as a performative code, investing heavily in imaginative and spectacular strategies designed to release the audience from its experience of the mundane, whilst shoring up those hierarchies of power associated with class, race, and gender which have ensured the smooth operation of western

131

capitalist economies in the world beyond the auditorium. As many commentators have noted, cinema, especially the Hollywood version of the idiom, has featured as an important adjunct to advertising in promoting a simple and reassuring consumerist version of life. It is in this guise, as well as in its contrary role as a generator of dreams and a focus for the formation of more challenging social identities, that film shares much in common with the slippery practices of fashion. Indeed, in envisaging an overarching conception of what constitutes modern sartorial culture, it is difficult to separate the two. If fashion can be said to be cinematic in its social and visual effects, then cinema is also very clearly a primary product of the aesthetic and technological processes of 'fashioning'.[1]

This was certainly the case in 1910 when the earliest known fashion film was shown in London. *Fifty Years of Paris Fashions* traced the evolution of the couturier's art since 1859 and according to a contemporary trade journal promised the viewer the sensation that 'she is in the showroom of a fashionable modiste with the mannequins walking round for her inspection'. This illusion of privileged access was maintained as a valuable marketing tool by élite department stores and dressmakers whose wares were well beyond the economic and geographical reach of the typical cinema audience. Though the process of filming had a limited impact on direct sales, like the fashion show, it fulfilled an important role in the garnering of publicity and allied the subject to the all-important sense of modernity and spectacle inherent in the medium. Most early publicity films featuring fashion were fairly unadventurous in terms of their structure. They reported straightforwardly on current or forthcoming trends and replicated the established format of the salon fashion show. Often, as in the 1911 *All-British Fashions Exhibition at Kensington Gore* sponsored by Liberty & Co., the broad purpose was clearly promotional and patriotic, 'proving' in the words of the catalogue 'that the skill of British designers is not so far behind that of our French cousins'. However, pioneering film companies such as Pathé and Gaumont used the specific subject matter of fashion as an enticing bait for attracting a large female audience to its programmes. Interspersed between dramatic or romantic features, their fashion shorts utilized the latest in colour technology, atmospheric musical accompaniment, dance, picturesque settings, a personalizing magazine format, and surprise celebrity models. They made a deliberate and sophisticated appeal to the desires of the modern consumer.

During the First World War the fashion short developed sufficiently to incorporate a simple plot, mimicking the melodramatic scenarios of the main features and allowing for a more experimental approach to the selection and designing of costumes. This often involved the collaboration of designers working in the commercial field of fashion, keen to promote their own wares. Poiret had utilized film in

*Maytime in Mayfair*, 1949
Film offered a natural medium for the promotion of fashion and, in the austere context of post-war Britain, the Incorporated Society of London Designers found several opportunities for exposure in those escapist costume and women's pictures popular at the time. Fashion content often took the shape of a fashion show inserted midway through the narrative, as in this film starring Anna Neagle.

his pre-war tour of the United States and American directors swiftly adopted his theatrical approach. Jacob Wilk of World Film Productions recorded a touring show of French fashion organized by Mrs Armstrong Whitney in 1915. In his version, the parading of Worth and Paquin gowns was orchestrated to illustrate a story of romantic competition between rival suitors for marriage in which the bride with the best selection of clothing was seen to win the day. This was taken a stage further in the production of several serials (episodic collections of shorts following a coherent narrative) in the United States and in Europe, where the plot revolved around the display of a collection of specially designed outfits by a single couturier. English couturier Lucile produced thirty-three gowns to be worn by the early film star Edna Mayo in *The Strange Case of Mary Page*, a 'thrilling tale of love and mystery' which ran over fifteen instalments in 1916.[2]

Lucile initiated a tradition by which the couturier was commissioned to provide the wardrobe for a film or the signature look for a studio. By the 1920s and 1930s Schiaparelli had designed for several British films and was assigned to Hollywood actresses Mae West and later Zsa Zsa Gabor. Chanel had a less successful experience under contract to Samuel Goldwyn. The subtlety of her cut and her insistence

*American Gigolo*, 1980
Individual designers have often used film design as a platform for their work. Armani famously designed Richard Gere's wardrobe for the film *American Gigolo* in 1980, its easy sophistication and stress on luxury ushering in a decade of primacy for Italian brands in American and European markets while fulfilling its essential role in the film's screen play as a symbol of decadence and desire.

on artistic autonomy clashed with the bureaucratic structures of the studio system and its prioritization of a spectacular star image, which was not in sympathy with Chanel's particular vision. When the relationship worked, however, a partnership between the fashion and film industries could be economically and aesthetically rewarding, especially during the golden inter-war period of Hollywood. Fashion in its commercial sense presented a potential problem to studio bosses who needed to ensure that their product was endowed with a shimmering modernity. Shifts in taste could spell the ruin of a picture, but the endorsement of Paris acted as an enduring guarantee of fashionability. In Britain during the Second World War, famous designers were used in patriotic propaganda to raise the morale of frustrated consumers and circumvent the restrictions of fabric shortages. Members of the Incorporated Society of London Designers including Molyneux, Hartnell,

Creed, Amies, Mattli, Stiebel, and Morton were variously involved in designing set pieces for women's films such as *Maytime in Mayfair*, *Fashion Fantasy*, and *The Demi-Paradise*. After the war, designers associated with the revived French couture industry like Dior, Balmain, and Givenchy also found Hollywood to be an important source of patronage and a key marketing proposition. And in Italy the political, economic, and social reconstruction process of the 1950s impacted equally on the rapid growth of local film and fashion industries, engineering crucial connections that helped to promote an international appreciation of Italian glamour. This set the context for the later employment of Giorgio Armani as designer for films such as *American Gigolo* (1980).

In *American Gigolo*, as in *The Untouchables* (1987) and *Stealing Beauty* (1999), Armani negotiated a seamless marriage between his own aesthetic vision and business acumen (as a designer devoted to the promotion of an easy, unstructured, but inherently luxurious glamour), and the demands of character and narrative inherent in popular film. This union of costume and fashion is even more unusual in terms of its mobilization around the stage personas of male rather than female actors and the apparent naturalness of its fetishistic visual effects. In the classic scene from *American Gigolo* where the half-naked hero Julian selects items from his wardrobe in preparation for an evening of seduction, Armani's sartorial hallmarks are laid out in order to seduce the cinema audience. In fact, they almost eclipse the erotic potential of Richard Gere's bared and toned torso. 'The gentle folds on the lining, the harmonious juxtaposition of shade and fabric' of the 'light jackets, silk shirts, and knitted ties' in Julian's closet assume the status of the star with seemingly minimal effort. Here the logic and momentum of fashion appear to have swallowed film alive.[3]

Besides the mutually productive relationship between couture houses and film studios which grew in response to cinema's function as the pre-eminent mass-communicator of the twentieth century, Hollywood also pioneered its own sartorial relationship with its audiences through a succession of commercial fashion tie-ins. Under such schemes one-off costumes designed for film stars or their characters could be promoted in fan magazines and women's journals. They were mass manufactured with subtle alterations which rendered the spectacular effects of the silver screen suitable for the sewing machine and for everyday life. The results were marketed as special lines (such as Miss Hollywood Junior whose garments all contained a label decorated with the image of a particular actress) and sold through chains of syndicated shops and concessions in department stores. One notable outlet was Cinema Fashions which, according to its own publicity writer, had 400 outlets in 1937. The economic importance of these developments is illustrated in the fact that before the explosion of

## Influential fashion films

*Letty Lynton* (USA, 1932)—Joan Crawford's Adrian-designed flounced dress was the first iconic Hollywood mode.

*Dinner at Eight* (USA, 1933)—Adrian's bias-cut backless dress and ostrich cape for Jean Harlow introduced Parisian style to an American mass market.

*Gone with the Wind* (USA, 1939)—Walter Plunkett's designs prefigured the New Look and influenced a generation of brides.

*Roman Holiday* (USA, 1953) introduced Audrey Hepburn's distinctive look.

*Rebel without a Cause* (USA, 1955) encapsulated teenage style.

*And God Created Woman* (France, 1957)—Brigitte Bardot's character rejected Hollywood glamour for a sensual simplicity and promoted the bikini.

*A Bout de Souffle* (France, 1960)—Jean Seberg's waif-like haircut became the uniform of bohemianism.

*La Dolce Vita* (Italy/France, 1960) introduced Italian men's style to the world: sharp suits and conspicuous accessories.

*Breakfast at Tiffany's* (USA, 1961)—the last of Audrey Hepburn's screen collaborations with Givenchy.

*Bonnie and Clyde* (USA, 1967)—Faye Dunaway's retro-wardrobe inspired the popularity of soft knitwear and calf-length skirts.

*Annie Hall* (USA, 1977)—Ralph Lauren's designs for Diane Keaton popularized tweed jackets and front-pleated trousers.

*Pulp Fiction* (USA, 1994)—the black suit, white shirt, and Rouge Noir nail polish adopted by Uma Thurman's character immediately crossed over into the mass market.

commercial film production at the turn of the century the district of Hollywood numbered just one shirt manufacturer. By the late 1930s the Associated Apparel Manufacturers of Los Angeles boasted 130 members, and buyers from 250 of America's biggest department stores were permanently based in Southern California.

The need to sell products beyond the film itself also changed the nature of cinematic themes and production values. Early features had favoured romantic historical romances replete with crinolines, or Roman epics with their togas and chariot races. The potential for commercial tie-ins was constrained by this focus on nostalgia and classical mythology and by the mid-1920s directors like Cecil B. de Mille had come under such pressure from the advertising and marketing arm of the film industry in New York that many more movies now looked to contemporary stories for their inspiration. These charted the vagaries of the American dream and were deliberately conceived from a feminine perspective. They show-cased the latest (and more easily reproducible) clothing, hairstyles, and make-up of an aspirational Californian or East Coast lifestyle with modish effect. The woman's film, as it became known, grew to be the dominant genre in this field, though the

*Letty Lynton*, 1932
The white organdie party dress
with over-sized puffed sleeves
designed by film costumier
Adrian for Joan Crawford's title
role in 1932 has taken on an
iconic status in the history of
film fashion. Its widely-copied
and franchized exuberance set
a challenge to the
predominance of Paris as a
generator of trends in America
and established Hollywood as
an important fashion centre.

gangster, cowboy, and detective film offered comparative models for male audiences. It spawned the careers of talented directors like George Cukor, stars of the order of Bette Davis, Joan Crawford, Claudette Colbert, and Norma Shearer, and designers including Adrian and Edith Head whose avant-garde aesthetic began to lead rather than mimic popular trends.

Perhaps the most dramatic and widely cited example of the ascendancy of Hollywood over Paris as a generator of trends in American fashion is the starched white chiffon dress with outlandishly puffed and frilled sleeves worn by Joan Crawford in the 1932 film *Letty Lynton*. That this style was repeatedly reproduced in several variations in films throughout the decade and adopted by both celebrities and ordinary consumers is beyond question. It became almost an icon of its age. But its status as an exemplar of the influence of cinema on fashion is more

complex than the simple question of copying and distribution. The Lynton dress and others like it are implicated in a symbolic network of meanings that connects Joan Crawford's own identity, manipulated for the purposes of the 'star system' but essentially conforming to a myth of the working-class good-time girl made 'lady', to the creed of self-betterment that lay at the heart of the consumerist morality of mid-twentieth-century America. This in turn is related to Holly-wood's own self-image as a generator of productive social values and its rather compromising function as a money-making retailer of dreams. Finally any interpretation of the dress and its popularity should take into account the many competing responses of a contemporary mass-audience stratified by class, ethnic origin, moral outlook, and access to fashion knowledge, retail outlets, or sewing skills. In many ways the symbolic meaning of the Letty Lynton dress paralleled that of the Lucky Strike cigarette packet, whose design was updated by Norman Loewy at about the same time to incorporate the tastes of a divergent mass of consumers from the old world who were beginning to share a sense of American-ness through their consumption habits. It was a blank garment in which all American women could now clothe them-selves (metaphorically and in reality) to signify their modernity and membership of a new society. Like the backless bathing suits and sportswear slacks also promoted by top actresses on screen and at home, or the cosmetic products of Max Factor which re-created the glow of celluloid and the effects of the California sun, the extrava-gances of the studio fashion designer were a supremely confident measure of Hollywood's cultural and industrial clout.[4]

In the immediate post-war period the closely related mediums of fashion and film lost much of their sharp relevance to modern life in the face of an onslaught of vaguely historical and socially conservative set-pieces which revived the glamour and gender-politics of the Second Empire and the *belle époque*. In Britain the contrast between the escapist fantasies of screen costumes designed by Elizabeth Haffenden for the Gainsborough Studios (a tradition of design continued by Cecil Beaton in Hollywood) and the austerity of continued rationing or the homogenizing tendencies of the welfare state, was stark but strangely comforting. In emotional and aesthetic terms the surface richness of such films must have been compensatory for audiences starved of everyday luxuries. There are further links to be made between this cinematic trend and the reactionary yet popular references of the New Look in Europe and the so-called 'sweetheart' line in America. Certainly from the late 1940s onwards the major film studios focused their efforts on expensive and aspirational costume productions whose direct connections with the practical concerns of the fashion industry or the consumer were more tenuous than those which had prevailed in the 1930s. In sugar-coated films like *Gigi* (1958), *My Fair Lady* (1964), or

the modern-set *Funny Face* (1957), which are generally remembered for the fantastical élan of their design, costume came to parody fashion, providing spectacular vehicles for the promotion of a new generation of star-system actresses. It was through the media coverage lavished on the stylish off-screen personalities and tastes of women like Grace Kelly and Audrey Hepburn that the fashion houses ensured publicity, rather than via direct tie-ins with the films themselves.[5]

Later period films, such as the predictable heritage pieces produced in the 1980s by Merchant Ivory, or those more nuanced and imaginative commentaries on history and style like *The Leopard* (1963), *The Piano* (1993), or *The Age of Innocence* (1993), engaged very directly with issues of authenticity and historical reproduction. At first sight this put even more distance between their costumed content and external debates about fashion as a commercial medium, further diminishing the possibility that cinema might maintain a sartorial identification with its contemporary audience. It is perhaps only in the extraordinary flourishes of the wedding dress, which also stands outside the conventions of a mainstream fashion discourse in its momentary attempt to stave off the realities of the world, that any practical synergy between cinema and the design of everyday clothing can now be discerned (though the continuing strategy of product placement, whereby fashionable brands including sunglasses and nail polish have been awarded starring roles in recent Hollywood blockbusters, attests to the enduring faith of advertisers in the commercial clout of film).[6] There is also a clear echo of the anti- or super realist and self-referential rhetoric of film costume in the playfulness and spectacle of the couture runway show. In many ways the catwalk productions of John Galliano and Alexander McQueen sit more comfortably alongside the work of the film costumier than that of the fashion designer, and their filmic impact is in any case pre-empted by Jean Paul Gaultier's striking work for the Spanish director Pédro Almodóvar or the English Peter Greenaway during the 1980s. That is why the contemporary 'fashion film' as a distinctive mode of presentation is in many ways a statement of the obvious, and ultimately self-defeating in its scope and pretensions. Pictures like *Pret à Porter* (1994), which attempted to portray the skewed logic and enclosed culture of the fashion industry, can serve only as distorting mirrors of a parallel universe, whilst critically acclaimed projects such as Wim Wenders's portrait of Yohji Yamamoto, *Notebook on Cities and Clothes*, try to redeem themselves, via the objective medium of the documentary essay or the ascetic registers of art cinema, from the sullying accusation of fashionability. In the current media culture where, for example, the primary focus and symbol of international film award ceremonies are the designer dresses worn by guests and nominees, rather than the content and value of the films in competition, established categories of representation have

Arthouse cinema of the
1980s and 1990s ushered in
a concern with authenticity in
the reproduction of historical
costume and settings. Film
adaptations of literary
classics were scrupulously
researched to achieve a
patina of truthfulness. In his
adaptation of Edith
Wharton's novel, director
Martin Scorsese claimed that
the objects, interiors and
dresses in his film were as
actively involved in
communicating the cultural
and emotional concerns of
late-nineteenth-century New
York society as his actors.

become impossibly incestuous, confused, and contradictory. In both
regimes it seems that surface effect and publicity are the only criteria
worthy of consideration.

# Shopping for Style

7

It is in the spectacular interiors and external displays of the fashion shop that the impact of all those promotional and visual phenomena so far examined pay dividends. Surface effect and publicity are the currency on which the fashion retail sector has thrived since the emergence of the late-modern clothing industry in the nineteenth century. For the efforts of style-leaders, advertisers, editors, and directors over the past 200 years have all in some way been oriented towards an epiphanic moment of engagement between customer and fashionable product which inevitably happens for the first time within the confines of the retail store, or in related scenarios of spending and consuming (such as the second-hand trade, or via the mail-order catalogue). The shop in its broadest definition is the last significant staging post in the trail of the product from design and manufacture to the intimate realm of the wearer, and as such the strategies by which its goods are presented for sale are of prime importance in establishing a sense of what fashion is at any given time or place.

## The department store

The word pictures of novelists such as Emile Zola and the evidence of retail catalogues and advertising ephemera have bequeathed us the idea that shopping for clothing in luxurious surroundings was a particular invention of the Victorians. Yet the spectacular fashion shop was not entirely an invention of mid-nineteenth-century entrepreneurs. Its scope and cultural impact were certainly magnified on a previously unimaginable scale from the 1850s onwards, ensuring a new prominence for that behemoth of the nineteenth-century cityscape, the department store. But many of the characteristics that are recognized as indicators of modern systems of selling were well established by the mid-eighteenth century. These included an emphasis on eye-catching window displays, the atmospheric styling of retail interiors with cascading draperies and exotic props, the construction of impressive temporary vistas, seasonal promotions, the arrangement of goods into discrete departments, an explicit encouragement of browsing, clearly marked prices and the promotion of cash over account sales. All such

Detail of 92

innovations were in evidence in the grand shops and arcades of late eighteenth-century London, Paris, and Berlin.[1]

The economic (as opposed to the cultural or aesthetic) supremacy of the Victorian department store as a symbol of modernity in its own time has probably also been overstated in the literature. In much the same way as its strategies were pre-empted by a previous generation of retailers, so its smaller and longer established high-street competitors accounted for a much higher proportion of custom than is often realized. One estimate of its market share in Britain in 1910 puts the total at only 2 to 3 per cent, though this is in relation to all varieties of consumables including food. In the area of clothing and footwear, department stores probably accounted for about 10 per cent of national sales.[2] Consumers thus directed much of their custom to a wide range of independent dressmakers, drapers, haberdashers, and milliners. For men, whose sartorial needs were not a priority for most department stores, a complex network of tailors, outfitters, and hosiers provided the essential elements of a socially nuanced and rigorously styled wardrobe. Small independent stores like these used display and marketing techniques which were as radical as any proposed by Boucicault (the proprietor of the innovative Parisian department store, Le Bon Marché) or Whiteley (of the eponymous store in Westbourne Grove, London). In London's Savile Row, for example, the nineteenth-century tailor Henry Poole boasted a princely neo-classical façade and a fitting room sumptuously decorated to resemble a rococo palace. Further down the social scale, a frenetic and equally eye-catching culture of open-air markets, 'slop shops' and itinerant peddlers furnished the necessary items for poorer customers, who were barred by price and convention from outlets which promoted themselves as respectable. Hissing gas-

## The rise of the department store

Nineteenth-century Britain witnessed a huge expansion of department stores whose retail and display practices had a profound effect on the selling of fashion. The names of many stores are still familiar brands in the twenty-first century.

Founded

| | | | |
|---|---|---|---|
| 1778 | Flint & Clark (later Clark & Debenham), London | 1849 | Henry Harrod, London |
| 1790 | Dickins and Smith (later Dickins & Jones), London | 1852 | Le Bon Marché, Paris |
| | | 1856 | Lewis's, Liverpool |
| | | 1860 | Jessop & Son, Nottingham |
| 1796 | John Watts (later Kendall Milne), Manchester | 1863 | William Whiteley, London |
| | | 1864 | John Lewis, London |
| 1808 | Hanningtons, Brighton | 1871 | Peter Jones, London |
| 1812 | Swan & Edgar, London | 1875 | Liberty, London |
| 1813 | Benjamin Harvey (later Harvey Nichols), London | 1879 | D. H. Evans, London |
| | | 1882 | Fenwicks, Newcastle |
| 1833 | Peter Robinson, London | 1909 | Selfridges, London |
| 1838 | Bainbridge, Newcastle | | |

**83 Thomas Shotter Boys**

Regent Street looking south from the Hanover Chapel, 1842

In this panoramic scene from the publication *Original Views of London as It Is*, Boys depicts the capital's prime shopping street soon after its completion. The design of Regent Street accentuated the idea of clothes-shopping as a fashionable pursuit, its sweeping curves and well appointed businesses providing an elegant setting for the perambulations of the wealthy and modish.

light and the colourful sales-banter of stall-holders offered an equally theatrical experience for the working-class clothes buyer.[3]

This is not to suggest that the impact of the department store on the sartorial sensibilities of consumers or the nature of fashionable life in the modern period was inconsequential. As concrete edifices dominating the street with their plate-glass and architectural whimsy, and as aspirational spaces informing the psychology and self-construction of shoppers, their effects were considerable. The rebuilding of London's West End retail quarter in the early nineteenth century around the axes of what have now become Piccadilly and Oxford Circuses lent a social prominence to early department stores such as Swan & Edgar, Howell and James, Peter Robinson, and Jay's Mourning House. These lay on, or close to, the fashionable route between Carlton House and the Regent's Park (respectively a royal palace and a garden laid out for the enjoyment of the Prince Regent, later George IV). Resplendent behind neo-classical or renaissance façades, their stucco and colonnading helped present London as a new Rome. By the 1850s and 1860s the act of shopping at such establishments (or at least sending a maid out from the stationary carriage to collect preordered goods whilst the lady presented her well-dressed person to the passing world) had become an established part of the fashionable round of the Season. In Paris a similar theatricalization of fashion merchandizing could be

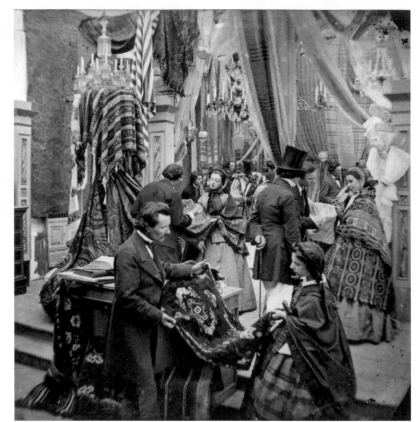

**The interior of a Parisian drapery store, c.1860**

The interiors of nineteenth-century department stores presented the illusion of an exotic souk where draperies were hung in profusion and customers were attended to by charmingly persuasive salesmen. Shopping for clothing and textiles became something of an adventure for the middle-class consumer who found great sensual gratification in these edifices of commerce.

seen in the dramatic glass and steel settings of the early nineteenth-century arcades. It was also an important factor in the later realization of Hausmann's urban plans, which encouraged the erection of department stores on the scale of *Ancien Régime* chateaux along the new boulevards. Such spaces virtually demanded the loitering attention of freshly constituted literary stereotypes and social or artistic characterizations—the *flâneurs*, tailors' mannequins, and kleptomaniacs of shopping legend. In a more mundane sense, their goods and displays also offered the middle-class shopper a guide for living according to materialist bourgeois principles.[4]

At the turn of the twentieth century the heavily policed social connotations of the British department store had softened in the face of a democratizing trend influenced by retailing innovations in Chicago and New York. Building on established practice, pioneers such as Gordon Selfridge continued to develop such consumer-friendly initiatives as restaurants and cafés, musical performances, fashion shows, bargain basements, and even lavatories. These did much to encourage the custom of a new lower middle-class constituency whose journey in from the recently built suburbs was eased by the expansion of public transport networks. The American influence was also felt in Europe after the First World War through the importation of ideas about

Advances in plate-glass and lighting technology allowed for the erection of sophisticated shop-window displays by the beginning of the twentieth century. Training courses in window-dressing equipped shopworkers to produce convincing *tableaux vivants* of society and seasonal events on a par with theatrical scene painting.

standardization, by which the organization of retailing rapidly came to reflect the Taylorist and Fordist principles that dominated on the production line. This was perhaps a natural consequence of a decline in bespoke methods of manufacture in the face of an expansion of the ready-made clothing industry. At the height of its influence, the marketing and display strategies of the department store had striven to suggest the fantastical and protected milieu of élite fashion practices. This was a fantasy made possible by the suggestive quality of the rich textiles which filled its aisles, whose surfaces carried the possibility of future costumes (finished items being made up later in-house or by dressmakers unconnected to the establishment in which the fabrics were acquired). Apart from the ready-made shawls and paletots (coats) which formed the basis of the department store's stock, Victorian and Edwardian customers generally bought a product which was incomplete and thus especially vulnerable to the myth-making of the canny retailer. Such strategic associations lost their relevance in an increasingly democratized marketplace where the finished look could be bought off-the-peg. The arising sense of gratification for the twentieth-century consumer was arguably more immediate and much more accessible. The atmosphere of the generic fashion shop changed accordingly.[5]

By the 1930s national and international chains like Woolworth and C&A were undercutting the traditional department store with a range of standardized but fashionable products at competitive prices. The febrile luxury of the *fin de siècle* had been superseded by a rationalized modernity in which the low-paid shop assistant simply took the

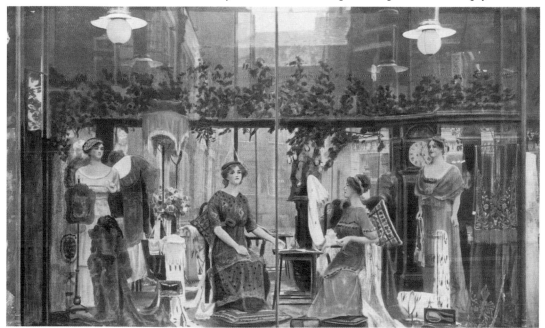

**86**

Design for a C&A store
façade, *c.*1935

By the 1920s and 1930s the
eclectic profusion of
nineteenth-century retail
design had been superseded
by a sleek modernity. Mid-
market outlets such as C&A
adopted the democratic
architectural styles of
American cinemas and
skyscrapers, presenting airy
façades which made much
use of chrome and plate glass.

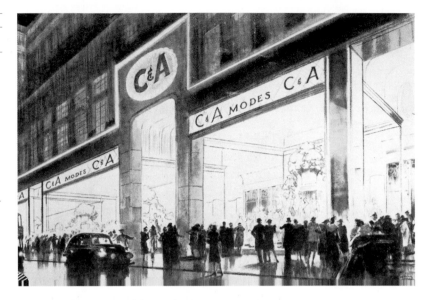

**87**

England's first 'self-service'
clothes shop, 1951

Where traditional department
stores had generally sold only
the textiles for making up into
elaborate gowns, in addition to
a limited number of ready-
made items such as
underwear and shawls, the
expansion of mass-
manufacturing in womenswear
during the mid-twentieth
century gave rise to new style
stores where customers could
try on and take home their
purchases in a single trip.

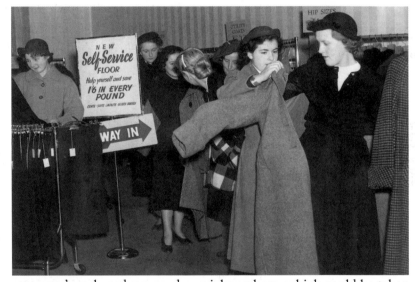

customer's cash and wrapped a serial purchase, which could be taken
home and worn at once (this suggests a rather more realistic paralleling
of high-street fashion with the contemporaneous success of the Model
T Ford motor car than its sensationalist bracketing with Chanel's little
black dress). Yet such speedy and relatively inexpensive transactions
also allowed the recently emancipated shop girl or typist (those sym-
bolic icons of a modern urban femininity) to update her wardrobe at a
frequency which matched the screen transformations of her film-star
heroines. In the small private dress shops and hairdressers which dom-
inated the more refined high streets and parades of the new suburbs an
emphasis on luxurious display and the creation of a feminine atmos-
phere still persisted, informed directly by the bijou styles of the 1925

Exposition des Arts Décoratifs in Paris. Such businesses played an important role, alongside the expansion of women's magazine publishing, in momentarily releasing the wives and daughters of commuters and desk-men from the tedium of a domestic life behind the privet hedge.[6]

## Menswear

As for the clothing needs of the desk-men themselves, the retailing of menswear in Britain and America during the middle years of the twentieth century was a remarkably fecund business. Male consumers in towns and cities across both countries witnessed the effects of seriously considered management, design, and display ideas through the polished, but essentially restrained shop-windows of several national tailoring chains. In the United Kingdom, Montague Burton and J. Hepworth & Son were the giants of this network, and whilst their actual product was not particularly distinguished (they tended to uphold the reticent visual code of the gentleman which disavowed overt displays of individualized taste), their mode of operation rationalized provision at an unprecedented level. Such firms, benefiting from economies of scale, were able to offer made-to-measure suits at competitive prices, with the added benefit of a discreet and attentive service ethic and the atmosphere of a well-appointed club lounge or officers' mess. Working against this more provincial and petit bourgeois trend, metropolitan outlets such as Austin Reed and Simpson of Piccadilly purveyed self-consciously modernist versions of sartorial masculinity that were directly reflected in the avant-garde fittings and merchandizing schemes of their West End headquarters. More attuned to European and American directions in retail architecture

**88 Joseph Emberton and Laszlo Moholy-Nagy**

Simpson Piccadilly, 1936

The élite menswear store Simpson opened in London in 1936 with shopfitting and lighting designed by Emberton and merchandize display by Moholy-Nagy. It introduced the sleek language of continental modernism into the normally conservative world of British menswear retailing with its ingenious display solutions and innovative architectural style.

and garment styling, their public image was associated with the glamour of sea and air travel, or the sophistication of a cosmopolitan 'playboy' lifestyle.[7]

## The boutique

Cosmopolitanism was also a defining element in the organization of the fashion shop in the post-war period, when, from the late 1950s onwards, smaller and more varied outlets were designed to chime with the individuality of new and younger markets, rather than confirming the collective, class-conscious sensibilities that had prevailed during the inter-war years. After the Second World War, and following the Macmillan economic boom, many working- and middle-class British teenagers found they had twice as much disposable income as that enjoyed by their parents when they were young. This newly discovered spending power was channelled into the consumption of leisure, particularly through an intensified engagement with the interconnected realms of popular music and fashion. Radio stations, record companies, dance halls, and clothing manufacturers catered to an increasingly diversified market of youthful consumers who identified their allegiance to style and pleasure through the adoption of a sharply defined look. The ensuing acquisition of the look engendered a whole range of fresh retail strategies and relationships.

Young post-war consumers looked to specialized outlets whose proprietors enjoyed similar tastes and pursuits as their customers and whose sartorial advice could be trusted above that of parents and traditional authority figures. Hairdressers and tailors thus achieved an unprecedented celebrity in the 1960s and 1970s on the basis of their modishness and fashion know-how, and the businesses of such visionaries as Vidal Sassoon, Michael Fish, and Tommy Nutter thrived in tandem with their growing reputations as style-arbiters. Similarly the new breed of entrepreneurial retailer looked to the sartorial expertise of their clients for future directions. The divisive categories of service and deference which had formerly prevailed in the field of fashion shopping had become impossibly blurred as consumers and merchandisers defined new trends together. This relationship was reflected in the apocryphal but telling stories of perceptive boutique-owners who, on witnessing the ways in which their customers pulled at and adjusted garments in their dressing rooms, immediately ordered new lines from the rag-trade which replicated the resulting distorted styles. It also surfaced in a wholesale hyping of London's fashion culture as being especially experimental. In 1955 the womenswear designer Mary Quant opened her first shop, Bazaar, in the King's Road, London. Here she developed a signature style rooted in the bohemian ambience of Chelsea yet receptive to the desires of affluent young women for a look

**89**

Stop the Shop, King's Road, London, c.1969
In an image shot for an Italian magazine feature on the King's Road two models disport in the psychedelic interior of the boutique Stop the Shop, which boasted a revolving turntable for an entrance. Many of these small shops were set up as amateur ventures by fashion enthusiasts and whilst they enjoyed a short trading life their style perfectly captured the ephemerality of life in the swinging city.

that echoed new social and sexual freedoms. By 1963 she was exporting a mass-produced version of her monochromatic, modern English style to New York.

Across town in Soho, the physique photographer Bill Green was also instrumental in engineering the association of a previously run-down inner-city district with a discreet fashion-led revival. In 1954 his new menswear shop Vince catered to a small coterie of gay men whose links to the world of theatre and promotional culture validated an outré taste in clothing that would otherwise have been deemed morally and aesthetically suspect, especially when the practice of homosexuality was still criminalized. His stock of tightly tailored and brightly coloured clothes, together with the relaxed and intimate atmosphere of the shop, set a precedent for John Stephen, a young Glaswegian with

Antonioni's film starring David Hemmings as a rising fashion photographer satirized the superficial concerns of London's style élite during the mid-1960s. However it was this conflation of social change, affluence, pop entrepreneurism, and aesthetic exploration that underpinned the success of the boutique cultures of Carnaby Street and the King's Road.

training in the retail business. Stephen profited from Vince's more 'edgy' reputation by setting up his own stall in premises nearby, just off Carnaby Street. By 1961 he had managed to modify and popularize the Vince look so efficiently that the area was fast attracting international attention as a focus for cutting-edge men's fashion and a stopping-off point on the shopping itinerary of any self-respecting suburban or provincial follower-of-fashion.

The peaking of this process, whereby the new fashion boutique had become a symbol of renewed urban and social vitality, took place in April 1966 when the New York-based *Time* magazine ran a twelve-page cover story under the headline: 'London: The Swinging City'. Naturally the identification of a trend by the popular media seemed to precipitate its decline, and whilst other American magazines such as *Esquire* and *Life* followed *Time*'s lead with further articles on London's position as the new world capital of style, many British designers and entrepreneurs found their profits and sense of optimism shrinking as the decade of 'youth' moved towards middle age. Nevertheless, the label 'Swinging London' proved to be an enduring one and its naming described an extraordinary revolution in attitudes towards the acquisition and use of fashion, both in the British capital and in other major cities across the world. As the traditional and hide-bound clothing manufacturing sector slowly declined, laying waste to working populations, the constantly shifting field of fashion retail and marketing seemed to thrive in the spaces it left behind.

In London's case the consumer-oriented fashion scene expanded,

**91**

Biba, *c.*1967

Barbara Hulaniki pioneered a series of atmospheric shops in London's Kensington in the late 1960s and early 1970s. These specialized in decadent retro gear presented in nostalgic interiors suggestive of a fading Hollywood glamour. Buttressed by a thriving mail-order business, Biba exemplified the new concept of lifestyle retailing, providing, at its prime, distinctively branded food, furniture, and fashion for men, women, and children.

reformed, and continued to attract international attention. By the end of the 1960s, its personalities and styles had been captured on film in Antonioni's *Blow-Up* (1966) and Roeg's *Performance* (1970). Such cinematic narratives fed the aspirational qualities now appended to working-class expressions of defiance and helped to identify London's decaying inner suburbs, with their low property prices and varied communities, as new centres of creative energy and commercial potential. The shopping and lifestyle pages of magazines like British *Vogue*, *Queen*, and *Town* charted an ever-changing succession of notable shops that by 1970 included Barbara Hulanicki's Biba, housed in an old Kensington department store and Tommy Robert's Kleptomania on the King's Road. These epoch-defining stores purveyed a characteristically camp mix of retro-chic, orientalist, and contemporary wares in

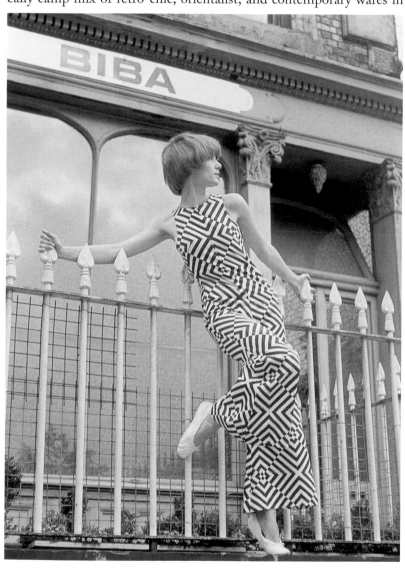

outrageously decorated and sound-tracked interiors, policed by impossibly glamorous staff. Their selling formula has since become the hallmark of the heady early twenty-first-century clothes-shopping experience across the globe.[8]

The life-affirming and profitable rhetoric that buying into youth fashions might help to rejuvenate a jaded sense of identity and place bled outwards during the 1960s and 1970s. It transformed established high-street chains such as Dorothy Perkins into spaces that were closer to day-time discotheques than shops, and encouraged staid mail-order companies like Littlewoods and Grattan to revitalize their catalogues by employing accessible pop stars of the calibre of Lulu to model their ranges. It inspired the launch of breezily hip new outlets such as those opened in Milan, London, and New York by the Italian Elio Fiorucci, with their infamous saloon-door changing-rooms and rhinestone-studded denims, and ensured the success of British firms Chelsea Girl and Top Shop whose cheap but chic goods and rapidly changing stock pioneered the 'just-in-time' principles that now prevail in the manufacture and distribution of mass-market fashion goods.

In a similar vein, counter-cultural entrepreneurs slowly colonized long-established street markets in Islington, Camden, Covent Garden, and Portobello Road with second-hand and vintage clothes stalls, importers of ethnic goods and small craft co-operatives. Such enterprises, though they might have distanced themselves from the purely commercial imperatives of the rag trade, nevertheless owed a debt to those profit-minded pioneers of the late 1950s who had first recognized the benefits to be had from catering to the young in spirit and fostering niche markets. The seeming chaos of the London hippy scene, which generated such popular 'underground' shopping destinations as Antiquarius and Kensington Market also informed the direction of the supposedly iconoclastic Vivienne Westwood and Malcolm McClaren-owned boutiques SEX and Seditionaries. These outlets for new creative talent capitalized on the emergence of Punk by selling fetish-wear and Westwood's early designs to knowing cognoscenti in Chelsea's World's End during the mid- to late 1970s. Carnaby Street itself might well have degenerated into a rather tacky tourist trap by 1975, but its broader legacy clearly had a profound effect on the visual and social character of fashionable clothes retailing in the late twentieth century.[9]

## The designer emporium

However, not all fashion retailers were prepared to continue adopting a 'Carnabyesque' selling style which borrowed its aesthetic referents from the prismatic profusion of the souk, the sensual overload of the brothel, or the influential sci-fi set of the 1967 Roger Vadim film *Barbarella* (which was a combination of both with its psychedelic and

Jigsaw store, New Bond
Street, London, *c*.1995
High-fashion outlets adopted
the 'white cube' aesthetic of
the modern art gallery at the
end of the twentieth century. A
pared-down selection of the
current collection, policed by
formidably groomed shop
assistants, was often displayed
in pristine condition, under
spotlights and against a neutral
background of stone, wood, or
glass. This alienating
atmosphere underlined the
idea that the expensive
clothing on sale held a value
akin to art and was accessible
only to those with the requisite
funds or cultural capital.

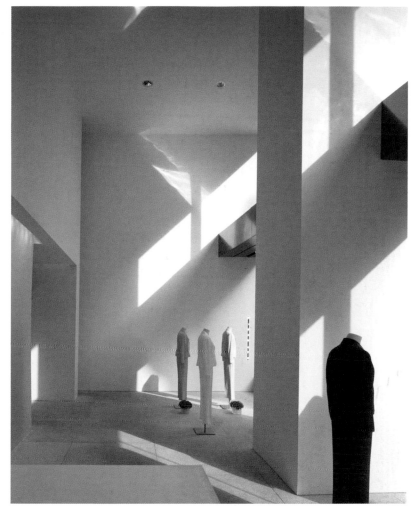

tactile surfaces). During the 1980s and 1990s, many newer businesses
favoured a sleeker or a more confrontational style of interior decoration
and a sales strategy that strove to pare down the *louche* opulence of the
boutique for a form of customer address which betrayed a post-modern
cynicism, stressing a 'cooler' distinction. This is partly to do with a
rapid rise in the importance of the brand in this period, but it can also
be seen as a response to further diversification in the marketplace and
amongst consumers themselves. Global fashion companies from Ben-
etton and Gap to Giorgio Armani and Ralph Lauren strictly control
their brand identity through the careful and homogenizing design of
their shops and an adherence to trademark values. In this scenario, the
rigid ordering of coloured sweaters into abstract patterns on glass and
metal shelves, or the seemingly more subtle introduction of wood
panelling and colonial ephemera, tropical flower arrangements and
leather sofas, remains the same whether the concession is in an airport
lounge, a faceless mid-western shopping mall or amongst the bustle of

Fifth Avenue, New York, the via della Spiga, Milan, or New Bond Street, London. Ironically, the roots of this rather bland shorthand for luxury and dependable quality can be found in the spate of minimalist, brutalist, or heritage interiors crafted for élite labels by architects and designers in the 1980s (Rei Kawakubo's Comme des Garçons shops are a good example of the former trend). Here the intention was more often to protect the prestige and uniqueness of the product through a deliberately alienating referencing of the spatial language of the war zone, the morgue, the museum, the library, or the private house. Inclusiveness and familiarity were alien concepts in such a context, but all of these more recent and apparently contradictory modes of display find further common precedents in the department stores of the 1850s and 1860s with which this chapter began. Now as then the complex mystique and desirability of the fashion commodity depends for its effectiveness on the expensive support of all the smoke and mirrors that the retailers can muster in their bid for a successful sale.[10]

# Part 3
# The Wearing
# of Fashion

# Style and Modernity

8

Several histories of modernity have observed how the industrial structures of modern fashion which were in place by the mid-nineteenth century rigorously reordered the circulation of desirable products and images in the public sphere. Access to fashionable goods was increased both through advances in mass-manufacturing and retailing, and via the promotional media of advertising and, later, film. This process, it is argued, held unprecedented effects for the organization of society and the expression of aesthetic, economic, and moral values. Indeed, it has been claimed that fashion itself now set the agenda for defining the nature of urban life and culture in the west, challenging the older rule of crown, family, and religion.[1] Some media pundits have even made dubious claims for a correspondence between the rising and falling of hemlines and the fiscal health of nations. Yet until fairly recently any serious consideration of the particular contribution made to this new system of governance by consumers themselves has been rare. The reactions of those men and women upon whose bodies designers and stylists have attempted to impose a ceaseless succession of surfaces, engineered to communicate a temporal approximation of trends and tastes, have generally been downplayed.[2]

Even though the modern fashion process is one whereby any autonomy in the creation of meaning has usually been shared between dresser (the fashion industry) and dressed (the consumer), it would also be fair to suggest that standard histories of dress have tended to emphasize the solitary and autocratic role of the designer in 'dictating' trends. Furthermore, studies of the history of manufacturing, advertising, and distribution in fashion have had very little to say at all about the life of sartorial products once they have left the sphere of production and promotion. In these various literatures, if consumers or audiences are acknowledged at all (and this is admittedly a field of research pitted with methodological difficulties), their behaviour has often been classified as simply reactive or passive. Yet fashionable clothing clearly enjoys a communicative role that does not cease once the product is purchased. It is an ongoing indicator of shifting behaviours and preferences that are expressed as powerfully through practices of consumption and use as they are through design or manufacture. In

**93 Napoleon Sarony**
Oscar Wilde, c.1882
The playwright and wit Oscar Wilde developed a series of fashionable stances designed to further his own notoriety, promote high standards of beauty in dress, and critique the pretensions of the establishment. Here the conservative uniform of the gentleman has been subtly subverted so that long hair, luxurious surfaces such as fur and velvet, rich colours, and a theatrical posture carry with them an air of masquerade.

The flapper craze of the 1920s has often been explained as a social and sartorial trend generated by the desires of young women experiencing the empowering effects of emancipation for the first time. Certainly the degree to which it was satirized in popular culture suggests a fear amongst those with vested interests (in politics, religious organisations, education and the media) that such freedoms had gone too far.

FEB 16 1926

Life

FEBRUARY 18, 1926 Teaching old Dogs new tricks PRICE 15 CENTS

many cases these processes work simultaneously, causing a constant blurring of the categories of production and consumption.

Thus beyond the influential work of a number of interested (but often condemnatory) sociologists and semioticians, the interpretation of fashion as a form of creative discourse, where contradictory meanings are constantly made and remade by its consumers, rather than simply displayed 'as intended' by its supposed originators, is relatively rare.[3] Such neglect seems to have occurred in spite of the fact that sartorial practices have taken such a central role in informing a common understanding of the unpredictability of modern existence and its vicissitudes. Furthermore, the deliberate dismissal by some cultural critics of fashion's fluid cultural significance as retrograde, and an attendant rejection of its qualities as too ephemeral and inconsequential to be worthy of study by serious scholars, renders virtually useless

the spectacular potency of trivial matters as fuel for philosophical and aesthetic reflection.

In fact, as more enlightened studies have shown, a careful scrutiny of the ways in which a supposedly inconsequential fashion system functions symbolically amongst its various users, promises rewards as rich as those arising from investigations of the repetitive and singular nature of its economic and material production. In a circular manner this potential has not been lost on a fashion industry which currently seeks to inculcate desire for new products by anticipating and nurturing their emergence at the creative margins of intended markets, rather than by imposing definitions of style from above (witness the manner by which trends in streetwear are now stealthily introduced like a drug, promoted by carefully positioned 'pushers' whose cultural capital amongst 'addicts' exceeds that of the traditional designer or advertiser). It is becoming increasingly difficult to identify exactly where in the chain of supply the alluring, yet fleeting properties which we associate with fashionability are actually created. The final chapters of this book therefore focus their attention beyond the closed worlds of the fashion-related industries, to seek further evidence for the creation of fashionable meaning in the attitudes and wider worlds of both producers and consumers whose reaction to, and interpretation of, clothing has been actively formed by their immediate social, historical, and geographical contexts.

## The dandy

In effect the triumphant development of modern fashion opened up an important new space for the liberating presentation of the private self. The acquisition, wearing, and display of clothing as a means of signifying a unique social identity arguably wielded a more radical cultural influence than the adjacent circumstances of its material and economic production in the industrial or professional context of factory, boardroom, or studio. (It is worth remembering here that fashions succeed or fail at the whim of a fickle market—in this respect the consumer is omnipotent.) At the root of this sartorial presentation sits a performative function that can best be summarized through a description of the evolving character and image of the dandy— an iconic figure whose actions have anticipated and mirrored the re-formation of style as an active component of cultural change since the early nineteenth century. For whilst the historical reality of the dandy might well be confined to the experiences of just a few metropolitan men made famous by their collective tendency to promote their celebrity through the singular arrangement of their costumes and manners, such actions also stand as a universal code of fashionable behaviour. The idea of dandyism reveals the ways in which human bodies are never natural,

**95**

George Bryan Brummell,
*c*.1810

The characteristic elements of dandyism are clearly visible in this engraving of the famous Beau Brummell. The arrogant pose is set off by carefully coiffed hair, an attention to hygiene, an intricately tied cravat, and neat black tailoring. Though the pose is a complex one, the desired effect of the whole ensemble is to suggest a natural simplicity.

but instead constitute a system of meaning through which modern culture, indeed 'fashion', is constructed and widely understood.

The socialite George Bryan 'Beau' Brummell (1778–1840) might reasonably be credited as the originator of the sartorial philosophy of dandyism. Rising from relative obscurity as the son of an equerry to the English court, Brummell, through sheer force of personality, an expertise in matters of etiquette, and a clear mastery of the arts of the dressing room established himself at the centre of London social life. During the 1810s he cultivated a personal aesthetic that drew upon the functional, body-conscious products of Savile Row tailoring. Amongst these West End tradesmen there had evolved over the past half century a sartorial signature style suited to the demands of English aristocrats who required practical items for the equestrian pursuits of the rural landowner alongside a form of dress appropriate for the rounds of court ceremonial, commercial transactions, and leisured display expected of the gentleman in town. Brummell's genius lay in appropriating these items and reconfiguring them as a revolutionary costume which, in its misleading simplicity and openness to misinterpretation, established a hierarchy based on the subjective rule of taste and beauty rather than deference to a status based on such objective criteria as economic power or family lineage.

Brummell's seemingly undemonstrative wardrobe, with spotless linen, expertly tailored blue swallow-tail coat, statuesque buff breeches, and polished riding boots worn during the morning, and a revolutionary monochrome arrangement of black silk and broadcloth adopted for evening wear, placed all responsibility for the construction of a fash-

ionable identity in the hands of the wearer. Similarly the dandy's management of his body also succeeded in stripping away the artifice of tradition in preference for a personal toilette (of artfully windswept locks and a scrupulously shaved and perfumed jawline) that was equally elaborate but which aimed to suggest a hygienic, supposedly natural indifference. This pioneering image gave rise to a paradoxical understanding of dandyism both as the approximation of an unchanging and unassailable classic style which resided beyond the remit of commercial fashions, and the celebration of an oppositional take on the politics of appearance which constituted a form of anti-fashion that nevertheless generated its own band of followers.[4]

The dandy's confrontational stance, which presaged later twentieth-century manifestations of 'cool', found its impact heightened by the challenging context of the city. Brummell's newly fashioned identity drew its meaning from the urbane and multi-layered culture of a rapidly expanding metropolis. It utilized the spaces of private drawing rooms, gentlemen's clubs, operas and theatres, ballrooms, parks, boxing rings, shopping streets, and squares as pedestals for display and relied on the adulation (and rejection) of crowds, audiences, and cliques as a means of lending authority to 'the pose'. Similarly the mechanisms of publicity in the form of the caricature and the newspaper gossip column were called into service to promote new modes of dressing and behaviour to a wider audience. If these scandalous representations appeared to undermine the seriousness of the dandy's business, on balance there is every reason to understand their messages

### The fashioned body

Besides the careful management of his wardrobe, the dandy's preparation of his body also offered a novel perspective on the nature of modern fashion. In the tight cut of his clothing and attention to hygiene the dandy showed how corporeal actions could be as effective in the presentation of the self as sartorial ones. Attitudes towards the body are an integral part of the development of fashionable styles in the nineteenth and twentieth centuries. The dandy's engagement with sports including hunting, fencing, and boxing underscored his physical presence and influenced his appearance. In the broader application of the tenets of dandyism to fashionable life generally, the moulding of the body also drew attention to social status and gender roles. The pale skin and relatively constricting clothes of the mid-nineteenth-century middle-class woman distinguished her from working women and the opposite sex. However, a growing interest in health, exemplified by the activities of the rational dress movement in the 1880s, encouraged the adoption of physiques and garments geared towards such activities as cycling and hiking. The New Woman of the 1890s and the flapper of the 1920s represent the apotheosis of this trend, their lithe bodies fashioned through diet, exercise, and the appropriate costume to symbolize progress. In the later twentieth century the focus on the body has, if anything, intensified, with both men and women encouraged to maintain the appearance of toned vitality promoted through advertising and the design of dress itself.

*Washing Day, c.*1912
In the early twentieth century
membership of an artistic
coterie was signified by the
adoption of radical dress. Here
John's model Dorelia assumes
the identity of a peasant or
gypsy, her bright loose clothing
and assumption of domestic
tasks indicating a rejection of
middle-class strictures
concerning the appropriate
appearance and behaviour of
'respectable' women.

as an ameliorating response to the terrifying power of fashion as a medium for social and cultural change, and a reminder of the ultimate hollowness of life lived as surface signifier.

Following Brummell's fall from grace as an exiled debtor in the 1820s, the tenets of dandyism found new incarnations in the literary reflections of Second-Empire French poets and philosophers. Honoré de Balzac, Jules Amédée Barbey d'Aurevilly, and Charles Baudelaire all realized the polemical potential of the dandy-figure and identified him as a precursor of the bohemian, who in the 1840s and 1850s stood in defiant opposition to materialist bourgeois obsessions and made a novel marriage between artistic creative practice and sartorial experimentation. In the 1880s and 1890s the dandy's concern with self-fashioning was closely allied with the mobilization of personal style by decadents and sexual revolutionaries alongside actors, artists, and writers. Comte Robert de Montesquieu, James McNeill Whistler, and especially Oscar Wilde all appropriated and perfected the surface effects of passing fashionable styles to demonstrate their difference from and disdain for prevalent contemporary moralities. And whilst this supercilious masquerading found later echoes in the nostalgic neo-Edwardianism of the late 1940s, by the dawn of the twentieth century a much evolved dandyism had moved beyond its narrow associations with aristocratic and artistic subcultures to symbolize a more general appropriation of sartorial avant-gardism for subversive or progressive social and aesthetic ends. Indeed some historians have gone so far as to suggest that after 1900 the prerogatives of men such as Brummell and Wilde had been superseded by the self-publicizing vigour of a new generation of theatrical women like Loie Fuller, whose spectacular performances more closely described the obsessions of a modern commodity culture.[5]

Here the practice of dandyism merges with the rise of the celebrity and loses its distinctively élite and masculine connotations. It is not difficult to see how the expertise of a self-promoter like Wilde segued with a concurrent marketing of actresses, professional beauties, and socialites as shining examples of fashionable élan. But the energy of the dandy's stance was not completely drawn back into the commercial and feminized mass culture that it had once aimed to critique. Its influence can be felt across a range of revolutionary sartorial causes célèbres which have punctuated the history of twentieth-century fashion and coincides with the increasing impact of female suffrage and the gradual emancipation of society's outsiders. The homespun eccentricity of artistic dressing associated with the Bloomsbury Group, the utopian fashion designs and radical posturing of the Russian Constructivists and the Italian Futurists, the severe chic of cross-dressing lesbians in the night clubs of the Weimar Republic, the vibrant eroticism and challenge to authority of the flapper girl's raised hemlines and swirling

At the end of the twentieth century the elements of the dandy's philosophy relating to provocation and posturing have been re-incorporated by the mainstream fashion industry in its promotions. Seemingly functional garments such as jeans and underwear are marketed on the flexed bodies of toned models in a deliberate attempt to court outrage.

beads, and the sharp iconoclasm of post-war subcultural dress codes which looked to underground music, sexual libertarianism, and drug culture for their leads, all owed some debt to a brave avant-gardism in matters of self-presentation that can be traced back to Brummell and forward to the contemporary heroic pop star.[6]

There is of course an inevitability about the ability of the fashion trade to reincorporate its critics and market their rebellion as the next commodity. Indeed, through his paradoxical and symbiotic relationship with the industry which he professes to disdain, the dandy has bequeathed some fundamental tropes to the visual armoury of mainstream fashion. The arrogant posturing of power-dressing, the high camp of the couture runway, and the obsession with the perfected body that marked dominant images of fashionability in the late twentieth century, all owe a debt to his blasé style. This is why the dandy provides such a compelling metaphor for the affective qualities of modern

fashion. His attitudes form a useful commentary on the rise of consumer culture and its shifting relationship to the presentation of the self. His body expresses a continuous tension between notions of élite and mass taste, between a controlled exercising of restraint and an abandonment to sensation. His history reveals a constant dialogue between those issues of taste, corporeality, sexual desire, and class or gender identity that saturate fashion with its wider meanings. Most of all, through his masquerading actions we are reminded of what it means to invent, wear, and project fashion's contradictory messages.[7]

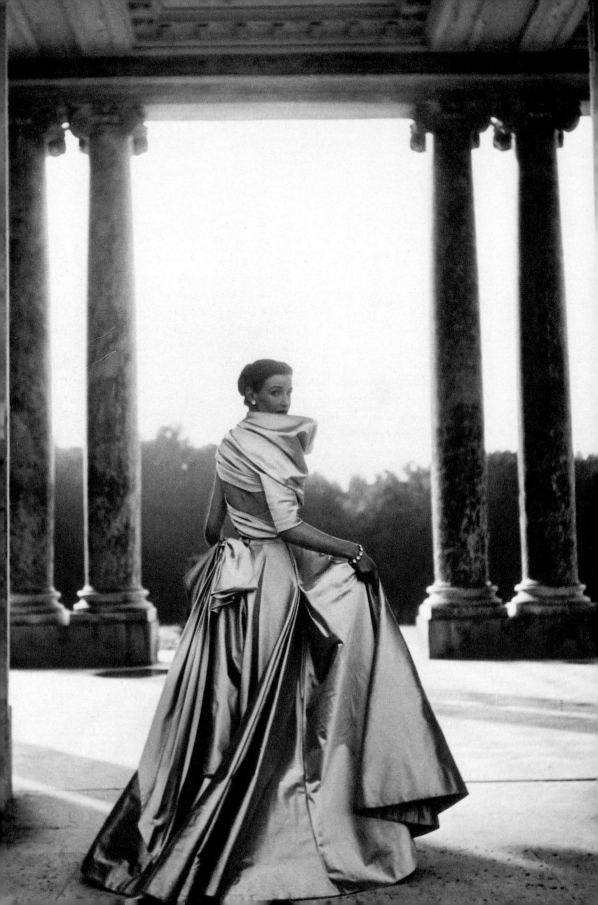

# Fashion Capitals

9

The dandy is a resolutely urban figure. His emergence as a metaphor for modern forms of fashionable consumption is closely bound up with the establishment of particular city sites as a focus for sartorial experimentation and social display. These tended to overlap with those commercial spaces organized by the leisure and fashion industries as points of sale and promotion: the shop, the gallery, or the theatre for example, but they also included those public areas unique to the modern city and central to its role as a generator of new styles. Streets, squares, arcades, and promenades offered places where crowds might congregate, classes intermingle, and individuals compete for attention.[1] Such sites had been developing in the old trading and political centres of the Italian city states, Spain, and the Low Countries since the fourteenth century at least. By the late nineteenth century the most notable modern examples were located in Paris and London, as well as Berlin, Brussels, Vienna, Milan (whose status as a centre for industrial manufacturing and banking funded a civic renaissance that far predated the city's late arrival as the centre of Italian fashion in the 1970s), and New York.

By 1900 these world cities were linked through the economic and symbolic ties of imperialism which ensured that the ordering of the modern fashion industry was shaped around international networks of diplomacy, trade, and labour. This coincided with a circulation of stylistic codes for the 'primitive', the luxurious, and the 'exotic' which placed fashion capitals at the centre of an imaginative geography of consumer desire, where the fashionable goods on show or in use conformed to widely recognized hierarchies of taste. These values can be seen at play in the spectacular uses made of orientalist displays in European and American department stores, or the manner in which the crafted perfection and visual impact of élite metropolitan fashions were accorded a superior status akin to that of art in magazines and exhibitions. Such distinctions were useful for maintaining imperialist ideas of civilization whereby the complex beauty of urban fashion in the developed world was compared with the savage simplicity of clothing in subordinated societies.[2] The immigrant communities whose presence was also an important feature of the modern fashion city, and those

## 98 Christian Dior

Cyclonic line, September 1948

Photographed amongst the atmospheric parks and hotels of Paris, Dior's creations suggested the romance of the eighteenth and nineteenth centuries. Their complex construction, relying on supportive undergarments and dramatic cutting similarly emphasized an idea of femininity that harked back to the decorative roles played by aristocratic women in decades past.

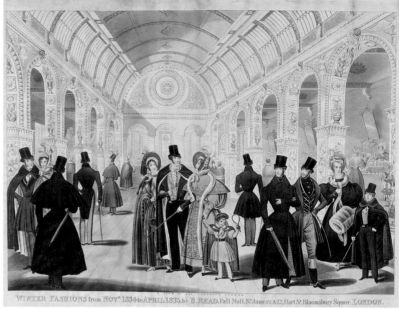

WINTER FASHIONS from NOV.ʳ 1834 to APRIL 1835, by B. READ, Pall Mall, S.ᵗ James's & 12, Hart S.ᵗ Bloomsbury Square, LONDON.

who resided at one remove from the centre in the colonies of European empires, were generally exploited in sweatshops, or co-opted as sources of inspiration for the latest lucrative trends. Similarly, local and seasonal patterns of migration and exchange from surrounding rural areas ensured that cities retained a reputation as magnetic centres, attracting labour, wealth, and creativity, and thus generating fashion.

Deriving from this same mobilization of an imperialist rhetoric, and often (in an evolutionary manner) building on older reputations for particular kinds of sartorial production and display, fashion established itself as a currency by which nineteenth-century cities distinguished themselves and competed against each other. A celebration of luxury goods shared a platform with the promotion of state architecture, exhibition culture, grand street plans, and organized tourism. By the middle years of the twentieth century the influence of an American engagement with European fashion via the instruments of mass culture had also become a defining factor in forging a popular understanding of the generic fashion city. In this conflation of influences, Hollywood film directors and Fifth Avenue editors branded an enduring image of an eternally feminine and elegant Paris as world fashion capital on western consumer consciousness, whilst the idea of a thrusting, dynamic New York developed as a particularly intense example of the promotion of the city as a spectacle of modern commercial culture. In this globalizing vision of fashion's complementary centres, London featured either as a bastion of tradition and conservatism, or as a Gothic formation of fog-shrouded streets and alleyways, the sublime home to high fashion's 'other'.

This development of a symbolic ordering of cities within the fash-

In the late nineteenth century European and American cities promoted themselves as luxury shopping centres. Visits to Paris, in particular, were associated with the acquisition of fashionable goods, the supply of which was advertised internationally through magazines and tourist guides.

ion media has thus had a major impact on the ways in which fashion is currently interpreted in an urban context and vice versa. It has underpinned the growing tendency in fashion photography and journalism to conflate urban culture itself with the consumption and experience of fashion. For Paris, London, New York, or Milan the rhetoric is sometimes one of newness and dynamism, but more often it is of 'an almost organic sense of fashionability growing out of the rich culture of metropolitan life'.[3] This tension between longer histories and future projections, situated in fashion's status as a marker of the present, is what lends clothing and its representation such value as a measure of city cultures that are also assumed to be in constant flux. On a more negative note it also highlights the uneasy manner in which the fashion industry and its consumers have tended to romanticize the decay and danger endemic in city life through a reification of the symbols of urban chic. As recent critics have noted, such representations ignore the very real inequalities which arise from the global management of fashion's material and visual production. The international ubiquity of the branded training shoe, marketed through association with the ghetto glamour of gang culture in New York and Los Angeles, and reliant on the cheap labour of the developing world for its manufacture, is a case in point. The following studies of the work of post-war designers who have become associated with the world's key fashion cities therefore aim to demonstrate how the fabric of urban living has been incorporated into the symbolic cartography of high fashion through the creation and promotion of clothes. They also reveal the deeper and more problematic structures of experience and meaning which underpin such imaginative constructions of place and identity.

## Paris

In February 1947 the evocative imagery of the first couture collection to be presented under the name of the designer Christian Dior imprinted an indelible suggestion of the Parisienne on the consciousness of the fashion world. Dior's iconic framing of the perfectly coiffed woman, scrupulously attired for a leisured existence in the city's most desirable neighbourhoods, seemed entirely natural as a commentary on the cultural heritage of Paris.[4] But its controversial impact raised a series of issues relating to the recent political past of the city and its fashion trades. It drew on a tradition of civic identity which prioritized conservative attitudes towards luxury, taste, and the elegant life that were at odds with a contemporary modernization of gender roles, and it encouraged an unease in the international fashion community at the continued assumption that Paris should lay claim to be the natural home of the élite garment industry. The articulation of these themes through the extraordinary architecture of what would later come to be termed the New Look engineered a beautiful but flawed marriage between ideas of place and body. It resulted in the mass consumption of versions of the style in every city of the developed world—whilst also announcing the decline of the very notion of 'Paris' which had informed its genesis and guaranteed its popularity.[5]

Dior's output over the ten years between the launch of the New Look and his sudden death in 1957 should thus be seen as a refracting mirror of the city which produced it. Dior's signature style can be summarized simply as a commitment to the luxurious use of textiles, both in terms of quality and quantity. It also betrayed an obsession with fairly precise historical stylistic precedents. It showed an impressive understanding of the visual effects to be achieved from the structural composition of garments which emphasized independent sculptural form over the natural line of the wearer's body, and it reflected an adherence to romantic and nostalgic (some would say reactionary) ideals of femininity. All of these facets related to a stereotypical picture of Paris as a repository for luxury goods and craft expertise, and as the natural haunt of the cultured and elegant woman of leisure. The *femme à Paris* had long been a popular subject for painters and writers.[6] In Dior's oeuvre it found a final material resolution, though by the time of his death the practical relevance of such a lifestyle was fading.

Whilst its theatrical debut on the salon runway and subsequent circulation in slick magazine photographs were undoubtedly dramatic, the sensual style of the New Look, with its shoulder-hugging bodice, cinched waist, voluminous ankle-length skirt, and snappy accessorization was not entirely revolutionary. Several Paris collections in the late 1930s had experimented with a reprise of extravagantly crinolined Second-Empire themes, and its reintroduction ten years later could be interpreted as a picking up of loose threads after the intervening

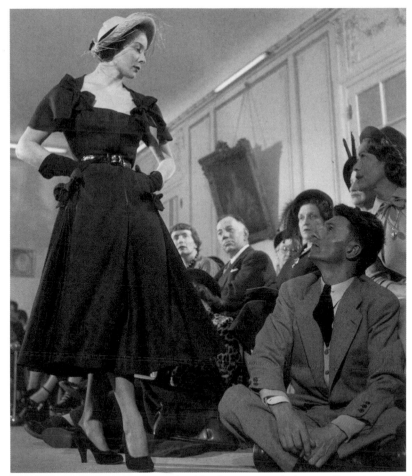

privations (and boxy military look) of war-time fashions. Certainly the
promotional furore surrounding its launch seemed to suggest a sense of
relief, of business returning to usual after a tragic hiatus. However, the
assumption that war and the Occupation had made any significant
impact on the day-to-day running and creative output of the Paris
couture industry is one that requires closer examination.

Dior's career in the intervening years is more strongly suggestive of
continuity than rupture. His comfortable family background in Nor-
mandy as the scion of a line of industrialists provided him with a sense
of security and tradition and influenced his famously taciturn patrician
bearing. Following an early stint as co-owner of a modern art gallery,
the necessity to earn ready cash after its closure in the Depression of the
early 1930s pushed Dior towards utilizing his skill at fashion drawing
and selling his designs to the established couture houses. Having
secured a position at the house of Piguet in 1938, he was engaged to
design the stage costumes for the actress Odette Joyeaux, whom he
dressed in the style of his hero Charles Worth. The outbreak of war saw
Dior enlisted briefly in the French army before his demobilization after

the German invasion. This was followed by temporary employment (through family connections) as a market gardener in Provence. At the end of 1941 when the situation in Paris was a little more stable, Dior returned to couture via a post at the house of Lelong. Lucien Lelong, as President of the Chambre Syndicale de la Haute Couture, and facing a Nazi policy which dictated the dispersal of the industry to Berlin and Vienna, had played a central role in arguing for the retention of the couture trade in occupied Paris where its supply networks, labour, market, and cultural affiliations were embedded and partially protected, if somewhat reduced. Thanks to the success of Lelong's efforts Dior's re-entry into the trade was relatively smooth and he resumed his designs for Odette Joyeaux without noticeable trauma. Her warm recommendation provided further work in the costuming of historical film productions whose uncontroversial period concerns left them free from the interference of the German censors.

The liberation offered even greater opportunities for Dior through his association with the cotton magnate Marcel Boussac. Boussac, who made his fortune through supplying uniforms to the French army during the First World War and trading in military surplus clothing after, had established a cotton manufacturing empire supported through the Depression and a second war by protectionist trade laws and a thriving colonial market. Dior's growing reputation as a designer committed to the survival of an opulent Parisian style of dressing which was essentially nineteenth-century in manner and appearance, offered an attractive prospect to an entrepreneur keen to ensure a continued niche for his traditional French textiles, and in October 1946 Boussac funded the establishment of Dior's own house. The economic and professional contexts which supported Dior through to the launch of his first collection were thus synonymous with the interests that had sustained Paris fashion through its darkest hours. That his product was essentially patriotic is clearly communicated by its design references and the nature of the business which surrounded it. However, this, and the manner in which its imagery was conceived, also had the effect of endowing the New Look with a mood that one fashion historian has described as 'morbid if not fascist'.[7]

The new Dior premises in a small mansion on the avenue Montaigne (a fashionable address, but further west than most established couture businesses) provided an appropriate theatre for the continued performance of a timeless Parisian glamour. Ironically much influenced by the English designers Molyneux and Lucile, its interiors were decorated in discreet shades of grey and white, the better to frame the sensual forms of the New Look lines. The Corolla was the more traditionally feminine of the first two collections to be showcased here, its silhouette accentuating the body's curves and cut as if for the swaying motion of the waltz. Its companion, the Figure of Eight, was more

severely abstracted and suggested architectural rather than botanical influences. Both depended on the underlying structures of cambric, taffeta, wire, and whalebone to mould the wearer into a decorative posture that emphasized bust, waist, and hips. These two themes (of soft romanticism and sharp urban elegance) persisted through Dior's remaining twenty-one collections. Several of them were named after flowers or natural forms, whilst others were given letters or titles reflecting the dynamism of their construction. All shared in an audacious use of rich and colourful fabrics and their allure was heightened through the evocative photography of Louise Dahl Wolfe, Horst P. Horst, and Irving Penn. These images did much to fix the atmosphere of frozen hauteur, fetishistic pleasure, and melancholic longing that many critics have identified in Dior's work. Furthermore they made telling use of location to suggest an intensely Parisian context. Gilded hotel interiors, formal *Ancien Régime* gardens, misty colonnaded vistas, and cobbled sidewalks recalled the old haunts of Atget and Proust rather than the austere circumstances of the post-war city.

Austerity tempered the initial reception of the New Look in the rest of Europe and beyond. Official reaction from the international fashion press and relevant government departments was ambivalent. In the United States, the collections were welcomed as symbolic of the positive power of consumption. The publicity offered through the feisty style reporting of the New York *Herald Tribune* and the hard work of Dior's American-born public relations officer ensured its promotion in department stores across the union. Relatively rich American consumers who had grown used to the democratic informality of sportswear designed in New York or California took a renewed and perhaps sentimental interest in the revival of European design and culture (largely funded by Marshall Aid), and a tour of Italy or the purchase of a Dior gown represented both an act of charity and the acquisition of cultural capital. If voices of dissent were raised, their criticisms targeted the old-fashioned fustiness of corsets and sweeping skirts which threatened to disguise the glowing vitality of American bodies, rather than the sybaritic wastefulness of the New Look's construction.

In Great Britain it was the latter problem which exercised commentators. Marjorie Becket wrote of Dior's new lines in *Picture Post*:

They are launched upon a world which has not the material to copy them, and whose women have neither the money to buy, the leisure to copy, nor in some designs even the strength to support, these masses of elaborate material . . . We are back to the days when fashion was the prerogative of the leisured wealthy woman, and not the everyday concern of typist, saleswoman or housewife. (27 September 1947)

Certainly this was a view shared in part by the Board of Trade which, under the leadership of Sir Stafford Cripps, was concerned to control

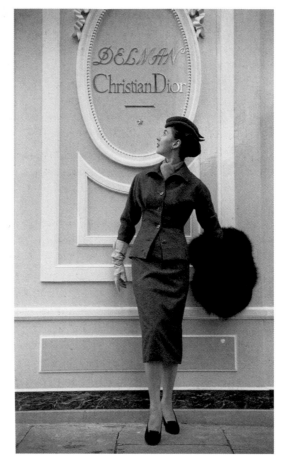

a continuing short supply of fabrics through ongoing rationing. However, though in economic terms the excessive New Look was a temporary affront to the straitened circumstances of British manufacturers and consumers, its psychic connotations chimed with a subtle reorientation in the expectations placed upon middle-class women. The orchidaceous version of femininity which it suggested played well with reactionary drives to recall a female population back to their decorative and maternal duties in the domestic sphere, after a war spent standing in for men in office and factory. The editorials and illustrations of women's magazines, and the melodramatic films of the Gainsborough Studios, alongside Hollywood musicals focusing on an eternal Paris, helped to circulate a corrective model of feminine sartorial behaviour which prioritized the careful toilette and coy seductive charms inherent in Dior's interpretation of fashionability.

Yet the characteristic slipperiness of fashion's meanings also precluded any single reading of the New Look, and women from varying social classes managed to appropriate its forms to their own style of living. Regardless of its supposed wastefulness or backward-looking associations, the New Look's escapist forms provided much pleasure

and not a little confidence for its wearers. Whether the version was the white fairy-tale ball gown of taffeta, nylon, and spangles made by Dior for the twenty-first birthday of Princess Margaret in 1951, or fashioned at home using the fabric from two worn-out dresses (as suggested by a Butterick paper pattern of 1948), or, from 1949, a watered-down off-the-peg copy from a British dress shop, all interpretations retained the capacity to suggest both a cognisance of Parisian modes and a more generalized embracing of glamour for its own sake. As Dior himself stated 'No one person can change fashion—a big fashion change imposes itself. It was because women longed to look like women again that they adopted the New Look.'[8]

It was this suggestive potential that underwrote the undoubted success of the New Look, and with it the partial revival of Paris as the most prestigious fashion city in the world. The creative pre-eminence of the city was however short-lived. A little more than a decade later the combined energy of London and New York pushed Parisian ideals of old-world elegance and compliant femininity from centre stage. The more revolutionary work of Saint Laurent, though still drawing on the traditions of French couture, found its influences in an international rather than a local culture. The allure of the Parisian stereotype (especially of the elegant Parisian woman) nevertheless persisted through the marketing of couture as an élite and luxurious commodity suited to particular lifestyles. Furthermore, in practical terms, the streets of Paris continued to play host to the corporate and retail headquarters of most of the world's major fashion companies even though competition from other cities and a rapid development of global communications made this unnecessary.

By way of a postscript to this picture of the persistence of Parisian themes in the circulation of fashion's urban imagery, it is worth noting how two French-born designers returned to the luxuriant themes of Dior's New Look in the 1980s and 1990s with startling effect, though their work inflected its controlled characteristics with a degree of know-ingness that would have been foreign to its original instigator in the 1940s and 1950s. Following a period in the 1970s when the more relaxed and accessible clothing promoted in Milan offered a sense of modern-ity lacking in the élite Parisian version, this strand of French couture rediscovered its quintessential sensuality and mystique, focused its attention on the crafted perfection for which its product had always won plaudits, and ensured that the material outcomes occupied con-sumer awareness across the globe as irreducible icons of an extravagant but problematic and divergent interpretation of Parisian chic.

At the centre of this revival sits the work of Christian Lacroix. A provincial from Arles, Lacroix's career is nevertheless steeped in the cultural and trade heritage of Paris. Having enrolled during the mid-1970s at the Institut d'Art and the Ecole du Louvre for an MA in

Christian Lacroix, couture,
1998
From the 1980s onwards
Lacroix became well known for
his mixing of eclectic
influences to produce
collections of audacious
contrasts, overpowering in
their sensual appeal. His
attention to detail in terms of
embroidery, exquisite fabric,
and the craft of construction
drew heavily on the traditions
and skills of Parisian couture.

seventeenth-century art history and a qualification in museum cur-
atorship (neither of which was completed), his interest in drawing and
fashion led him, via serendipitous social connections, to jobs at
Hermès and Patou. Eventually, as head of design at Patou, Lacroix
made his mark on the international fashion press in the early 1980s with
his reinterpretation of the late nineteenth-century bustle: the 'pouf'.
His design themes, which borrowed from the sumptuous history of
French fashion, from the theatrical Catholic imagery of southern
Europe, and from the eccentricities of the English aristocracy, were
thus well established by the time Lacroix opened his own house (deco-
rated by the modish post-modern designers Garrouste and Bonetti in a
typically Parisian conflation of restrained Empire classicism and West

African vivacity) on the rue du Faubourg Saint-Honoré in 1987. Holding all of these eclectic influences together in a heady statement of connoisseurship, historicism, and decadence, the work of the house became most closely associated with a celebration of luxury for its own sake, just at the moment when the idea of conspicuous consumption was becoming tarnished as immoral and élitist.

Lacroix's self-invention as the inheritor of Dior's mantle attracted enormous press coverage but also ensured his subsequent vilification as the personification of a brash 1980s hedonism. In retrospect his luscious and unprecedentedly expensive collections, incorporating severe boning, lacing, and padding, shocking juxtapositions of vivid textures, colours, and patterns, complex layers of trimmings, rich Lesage embroideries, glittering costume jewellery, and a battery of cultural references from bull-fights through to flea markets, circuses, and ancient civilizations, seem well deserving of the term kitsch (a phenomenon of taste that Lacroix has explored himself in his several solipsistic collections of memoirs and design commentaries). They certainly magnified Dior's theatrical posturings to operatic proportions. Such excess rapidly attracted the attention of critics as symptomatic of the remarkable unreality of late twentieth-century Paris couture, heightened by the coincidence of Lacroix's first 'Luxe' unveilings falling at the same moment as the crash of global stockmarkets in October 1987. Coming full circle, his work also drew the same charges of misogyny as those levelled at Dior's New Look.[9] Such critiques perhaps underestimated the potency that the 'unreal' practices of a revived couture carried, as evidence not of actual consumer behaviour or attitudes towards gender in Europe and the United States (to which they bear little direct connection—the most significant group of consumers who could afford couture in the late 1980s were super-rich Kuwaiti women), but of the playing out of a more generalized and paradigmatic desire for the transitory fashion moment. In the work of Lacroix this moment was always located in an illusory and beguiling idea of Paris. As he has stated:

For twenty years of my life the fashions of Paris under the Occupation exercised an almost hypnotic power over me: fragile constructions of feathers and draped jersey, mixtures of sulphur yellow and wine red, a clandestine elegance. And the years following the New Look represent for me in every field the apex of a certain 'Parisian civilisation'. You can of course be Parisian without having been born in Paris—sometimes it's even an advantage. Cristóbal Balenciaga is the finest example of Italian sensuality and British chic, combined with the natural grandeur of Spain. This cocktail could perhaps only have been created in Paris, and maybe the recipe is now lost. But I hope not.[10]

The career of Jean Paul Gaultier shares several similarities to that of Lacroix. Born a year after his compatriot, in 1952, Gaultier also credited

his provincial upbringing and inevitable move to Paris as a fundamental influence on his development as a designer. He too spent some time working for Patou, then went to Cardin, immersing himself in the disappearing craft traditions of couture before striking out on his own in the late 1970s. Like Lacroix, his visual references are diverse and his signature themes are characterized by striking juxtapositions. The work of both men is deeply rooted in a celebration of Parisian culture, but here their take on city life differs dramatically. Fashion historian Farid Chenoune has noted that 'wherever his travels in transcouture may take him, Gaultier always returns to Paris. Whether the cosmopolitan streets of Barbes, the Pigalle of the cancan and Toulouse-Lautrec posters, the animated boulevards inhabited by Arletty in *Les Enfants du Paradis* . . . it is Paris that is the capital of his obsessions, the muse of his enduring themes.'[11]

Where Lacroix's concern was with a continuation of the rarefied haut-bourgeois tradition of the Parisian salon (his working practices aiming for the aesthetic incorporation of street-life in the manner of a picturesque scene painter or a leisured collector of curiosities), Gaultier's engagement with the popular culture of the city was invested with a more empathetic understanding of its contradictory contemporary values, bound up as these were with issues of sexual identity, artistic rebellion, and illicit pleasures. This endowed his product with an energy and social relevance that was far more meaningful to a wider constituency of younger consumers, though its forms could be equally luxurious and spectacular. Working under his own name since 1978, Gaultier's collections of the 1980s and early 1990s fused his appreciation of idiosyncratic London street trends with directional, often explicitly erotic explorations of male and female bodies, and a keen understanding of the aesthetic possibilities of new fabrics and technologies. These obsessions worked harmoniously with an astutely

**104**

Jean Paul Gaultier, 1993
Though a skilled technician, Gaultier has largely worked against the restraining traditions of couture, engaging instead with a vaudevillian idea of Paris culture. The consummate showman, he has embraced the popular culture of the street and the club, in his own city and in London, bringing the concept of high fashion as an expressive medium to a contemporary mass audience.

Gaultier has relished
commissions for film and
theatre, designing for directors
Peter Greenaway and Pedro
Almodóvar and, most
famously, dressing the pop star
Madonna for her world tour.
These platforms have allowed
him to indulge a fascination
with sexual identities and
circus-like spectacle which
can be traced back to the
Parisian revues of the 1890s.

populist marketing of Gaultier perfumes, accessories, and ready-to-
wear lines, and a promotion of the breezy personality of the charismatic
designer himself through the newer mediums of pop music and televi-
sion. This marked a significant departure from the traditional idea of
Parisian fashion brands as discreet and rather precious.

From his iconoclastic men in skirts collection 'Et Dieu créa
l'Homme' of 1985, through his interrogation of female underwear as
outerwear which developed from his 'Dadaïsme' collection of 1983, to
his experiments with electronic circuitry and cyber imagery that led
to the futuristic 'Mad Max' collection in 1995, Gaultier's work has
consistently made direct and unapologetic connections to the sensa-
tionalist obsessions of a global popular culture (the dressing of the pop
star Madonna in a golden corset and a phallic suit slit to accommodate
the salmon pink silk of a brassiere for her 'Blond Ambition' tour of 1990
constituted his most impressive coup in this respect). But this has
always been filtered through a mythic idea of Paris as the home of

avant-garde creativity. Gaultier's collaborations with the photographers Jean-Baptiste Mondino and Pierre et Gilles, together with a reliance on his own folk memories, fixed a rather nostalgic, if schizophrenic take on Parisian fashion mores. In Gaultier's vision, striped Breton jerseys and matelot berets sit in jaunty company with a constant returning to the old-world charm of his grandmother's boudoir. These references are powerfully suggestive of his transgressive tendencies and also illuminate the sentimental roots of his broad appeal. As a marketable and newsworthy force, this appeal seriously challenged the prominence of Milan as dominant European fashion city in the mid-1980s (though ironically it was the economic clout and technical mastery of Italian manufacturing groups that often supported the production of French *prêt-à-porter* lines). Gaultier's very visible success aided the retention of a symbolic importance for Paris just as its economic and technical strength were coming under renewed attack from the fashion media and from competing centres of fashion production.[12]

## London

Despite their self-presentation as ardent Parisians, both Lacroix and Gaultier have paid extravagant debt to the distinctive and cosmopolitan fashion culture of London as a formative influence on their own work. Typically Lacroix has singled out for approving comment the traditional idea of life in the British capital as represented through the outdated stereotypes of French schoolbooks: an idealized inter-war homily of respectable afternoon teas and walks in the park in comfortable well-made rainwear. His direct experience of the city is founded on social visits made from the late 1960s onwards. These explorations coincided with the rise of an 'aristocratic' bohemianism that in the intervening years has transformed the environs of Chelsea, Islington, and Notting Hill, turning artists' squats and rented slums into millionaires' residences, and filling the streets with expensive boutiques and fashionable restaurants. Such distinctive glossiness sits well with Lacroix's view of urban living as a cultured and aesthetic experience. Gaultier's indebtedness relies on a very different understanding of period and geography. It draws on the gritty post-punk landscapes of Carnaby Street and Camden Market, thriving underground black and gay club cultures, and the iconoclastic attitudes of London's art and design school students, as displayed through the 1980s and 1990s in the layouts of the *Face* and *i-D* magazines. Both interpretations demonstrate the layered richness of the city's cultural fabric and its dual reputation as the home of traditional and innovative clothing practices. Unlike the regulated fashion culture of Paris, London's sartorial infrastructure represents a collapsing of rules and a tolerance of innovation in the face of surviving traditions. Such productive qualities

Savile Row

From the mid-eighteenth century the district around Savile Row in London has been associated with the provision of bespoke tailoring for aristocratic clients. The Row itself has retained a reputation for patrician conservatism, symbolized by its restrained windows and enduring family firms. Behind the dour façades, however, retailers have shown a willingness to adapt to changes in social mores and tastes under the marketable cover of tradition.

have become a valuable commodity in discussions of the comparative benefits of the world's fashion cities as creative sites, but also reveal London's weaknesses as a serious competitor in sustainable economic terms.[13]

London did not always enjoy an international reputation for the creativity of its clothing designers and consumers, though its size and complexity have long encouraged distinctive but localized interactions with the culture and production of dress amongst its inhabitants. Its position as a global trading centre, and a reputed tolerance for racial difference have also encouraged successive waves of immigrants whose various habits and skills have contributed to its broad social mix and economic adaptability. French Huguenots, Russian and Polish Jews, Turkish and Greek Cypriots, Bangladeshi and latterly Vietnamese immigrants have all at different moments dominated the mass-production of clothing in London, whilst the thriving life of the docks and the arrival in the 1950s of Commonwealth immigrants from the Caribbean have had a major impact on the popular articulation of style in the city.[14]

As far as élite fashion is concerned, from the late eighteenth to the mid-twentieth century the tailored products of Savile Row, cut to service the social and physical demands of the English gentleman and fashioned from British wool, garnered world-wide respect. This idea of London as a repository of traditional craft skills, associated largely with the masculine wardrobe (the perpetually autumnal home of suits,

shoes, hats, and umbrellas), has persisted in touristic imaginings of the city to the present. Close proximity to Paris stunted the growth of a significant upmarket womenswear sector on the same lines, though from the late nineteenth century the tailoring skills for which London artisans were famed were seen as a transferable asset, and the notable quality of sensible women's suits and coats finished in London attracted attention from abroad. From the turn of the century to the start of the Second World War, while West End dressmaking establishments such as Lucile and Redfern provided adapted versions of Parisian couture for English court presentations and the social round of the Season, ladies' tailoring firms were producing neat outfits for the shopping spree or the grouse moor. These endured into the post-war period as a staple item of the fashionable international woman's wardrobe.[15]

The endurance of a smart London style which was essentially genteel in its domestic functionality and undemonstrative visual qualities was partly sustained by the promotion of utility lines during the Second World War. This project (initiated in 1941 by the Board of Trade) sought to present the retailer and middle-class consumer with a range of garments stylish enough to raise morale, yet ingeniously constructed with an eye to the conservation of limited raw materials and labour. Presenting an obvious contrast to the excessive displays of Paris, the scheme was publicized with photographs that made much of its indomitable London milieu, with models posed gamely in squares and public gardens, leaning on their bicycles. The good manners of mid-twentieth-century London dressing were further celebrated through the post-war work of those designers who had been instrumental in defining the utility look. The products of Hardy Amies, Norman Hartnell, Charles Molyneux, Digby Morton, Charles Creed, Victor Steibel, and Mattli defined a rule of taste informed by the polite culture of Mayfair and Belgravia, and reliant on the understated aesthetics of fine tailoring until well into the 1950s. It is against this background, and partly in reaction to it, that the current idea of London fashion has evolved. Aware of the older traditions but receptive to the seismic social, political, and economic changes that reconfigured existing markets and attitudes, younger generations of designers have been defining fresh versions of London fashionability since the early 1960s. It is perhaps no coincidence that the two most important representatives of this creative secession were women. The first, Mary Quant, embraced a lively modernity that would have been quite alien to the patrician circles occupied by men like Amies and Hartnell. Emerging from the informal culture of Chelsea in the mid-1950s, her attitude to life was opposed to all that the salons of Mayfair and St James's stood for. As she recalled:

Nobody has ever been able to make up his mind precisely what the 'Chelsea Set' was but I think it grew out of something in the air which developed into a

serious effort to break away from the Establishment. It was the first real indication of a change of outlook . . . The unwitting originators of this renaissance were the core and inspiration of a revival of the creative arts . . . Ultimately their ideas had enormous influence on people everywhere and on their way of thinking . . . We did not see ourselves as being part of any particular 'set' . . . Our friends and acquaintances were painters, photographers, architects, writers, socialites, actors, con-men, and superior tarts. There were racing drivers, gamblers, TV producers and advertising men. But somehow everyone in Chelsea was that much more positive and go-ahead . . . I became quite caught up in the excitement of the King's Road and I knew it was the only place I really wanted to live . . . if we could find the right premises on the King's Road, we would open a shop. It was to be a bouillabaisse of clothes and accessories . . . sweaters, scarves, shifts, hats, jewellery and peculiar odds and ends. We would call it Bazaar.[16]

Mary Quant's role in the genesis of 'Swinging London' has been well documented and in her autobiographical account of 1966 she offers her own version of the legend. Her characterization of the open social mix of Chelsea and its optimistic entrepreneurial attitude provides much by way of explanation for understanding why this particular corner of London should have played nursemaid to a radical shift in the production of style during the middle of the 1950s, but Quant's own career is equally symptomatic of the tenor of the times. Trained in art and design at Goldsmith's College of Art she was part of the first generation in Britain to experience the expanded opportunities offered by higher education. Though hailing from a comfortable middle-class background herself, the diverse student population associated with the art school supported the forging of anti-establishment sentiments and a hunger for change which her later work bears witness to. This could not have been more different from the hierarchical forms of apprenticeship or training which prevailed in the traditional London fashion sector at the time, though Quant's fine art qualification did mean that she opened her first boutique with virtually no practical knowledge of the manufacturing of clothes (a position of ignorance not uncommon amongst many art school graduates who have gone on to make their mark in the London fashion scene).

When it opened in 1955 Bazaar set a precedent for the rash of innovative but rather amateurish retailing enterprises that were to colonize London's new fashion districts over the course of the following decade. Conceived with Quant's partner Alexander Plunkett-Green, the idea was to provide their peers with the unusual products that marked their new-found distinction in a venture that operated as much on social as commercial lines (it was located over Alexander's restaurant and jazz club and next door to the popular bohemian pub, The Markham Arms). Personal networks within the media and party set, and a knack at quirky visual merchandizing, swelled their client base until it became

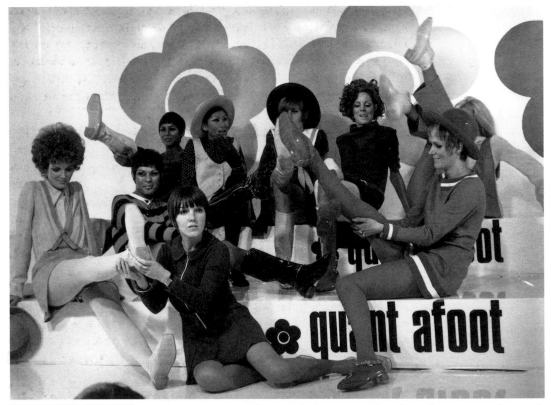

**107**

Mary Quant and models, 1967

Quant, pictured here at the launch of her footwear range Quant Afoot, epitomized the energy of London's young fashion scene from the founding of her boutique in 1957 to the end of the 1960s. Her style was characterized by its simple child-like shapes and bold, flat colours which were complemented by a deliberately naïve but highly successful succession of publicity stunts engineered to promote a thriving international business.

necessary to manufacture their own product in order to meet demand. The charge of amateurism was misconceived, since they disguised, beneath the camaraderie, a thorough knowledge of the desires and aspirations of a new breed of consumers. As Quant herself claimed:

I had always wanted the young to have a fashion of their own . . . absolutely twentieth-century fashion . . . but I knew nothing about the fashion business. I didn't think of myself as a designer. I just knew that I wanted to concentrate on finding the right clothes for the young to wear and the right accessories to go with them.[17]

Quant's first lines were thus a very raw attempt at sating the appetite of those involved in a rejuvenated London social scene for appropriately radical fashions. Butterick paper patterns were chopped about, fabrics sourced at full price from Harrods, and ensembles put together in a crowded bedsit. Original jewellery and accessories were commissioned from art school contacts and with the aid of a few evening classes in cutting, a new sewing machine, and the hourly paid help of a part-time dressmaker, Quant could keep the shop stocked, though profits were initially minimal. Such throw-away crudeness, far from spelling disaster, represented a kind of freedom that was eminently marketable during that period. It was full of the possibilities of self-reinvention in a big city that was also in the process of transforming itself from a

landscape of Victorian shadows and derelict bomb sites to an Americanized utopia (only partially realized) of glass office blocks and concrete motorways. This sense of hope and change was further communicated through the avant-garde literature, theatre, and cinema of the moment, but its most passionate advocates were the real young men and women, like Plunkett-Green and Quant, who were prepared to invest their talents in the potential of the future.

Such was its cachet as a symbol of a so-called British cultural renaissance, and so attractive was the sense of 'London cool' it encapsulated, that the success of Bazaar generated invitations for Quant to design clothes and underwear for J. C. Penney and the American wholesale market in 1962. This was followed in 1963 by the setting up of a London-based design office called Ginger Group which franchised Quant designs for mass manufacture in the UK. Further successes included transatlantic business deals with Puritan Fashions, Butterick Patterns, and the Nylon Hosiery Company in the mid-1960s, and the launch of Mary Quant Cosmetics in 1966. By the close of the decade, having set out as a rebel, Quant had become something of a celebrated national figure. She was awarded several industry and government honours, published her autobiography, and in 1973 received the accolade of a retrospective exhibition 'Mary Quant's London' at the Museum of London.

Such a rapid trajectory was not perhaps unusual, representing instead the tendency of the London establishment to incorporate and commodify the talents of its successful renegades, sometimes with the effect of undermining their original appeal and ongoing relevance. The Beatles and Carnaby Street suffered similarly at the hands of the Wilson government's desperate need to appear to be in league with the forces of cultural modernization. Nevertheless, Quant's story retains an iconic significance as a symbol of London's capacity to generate and inspire revolutionary sartorial change. Credited as the inventor of the mini-skirt and personified as one of the faces of the decade under her characteristic Vidal Sassoon 'five-point' bob, Quant's happy, childlike designs, with their abstract pattern, flat colour, and simple construction, offered many female consumers (and not just the young) genuine relief from the matronly respectability suggested by so much of the London- or Paris-sponsored design that preceded her. Most importantly her example opened up the terrain for a phalanx of art-school-trained and innovative designers such as Thea Porter, Ossie Clarke, Barbara Hulanicki, and Zandra Rhodes, whose work pushed at the boundaries between high and popular culture, art and fashion, craft and commerce, in a distinctively Londonesque manner.[18]

Whilst Quant's work represents an uncompromising modernism, in tune with the democratizing and utopian tenor of the late 1950s and 1960s, the output of Vivienne Westwood has presented a more dystopic

commentary on the collapse of that very world view. Like Quant's though, hers is a creative vision dependent on the broader culture of the city in which she has deliberately chosen to base her business over the past thirty years, and in which she has constructed a remarkable succession of self-reinventions and sartorial challenges to the *status quo*. Born in a small town in Derbyshire in 1941 to a respectable working-class family, Westwood was also a beneficiary of Britain's post-war education and welfare reforms. Educated at Glossop Grammar School, she moved south with her parents during the years when Quant's generation were transforming the social and retail environment of West London. Suburban Harrow in 1957 was, however, worlds away from bohemian Chelsea, and though northern working-class girls making it in the big city were soon to become a staple of popular 1960s novels, Westwood's experience was more circumspect. She endured one alienating term on the jewellery course at Harrow Art School, before embarking on a traditional career path at secretarial college and seeking the security of a respectable marriage. This rose-tinted scenario was short lived, interrupted by a growing acquaintance with the provocative art school student Malcolm McLaren.

Following divorce and enrolment on a teacher-training course, Westwood found many of her frustrated aspirations answered in McLaren's more 'authentic' family background in the rag trade of the Jewish East End and his modish stance as a situationist and latter-day dandy. Their ensuing emotional and creative partnership had a fundamental impact on the development of English fashion over the coming decade. In 1967 Westwood gave birth to their son and the three of them moved to Kennington. Westwood earned an income as a schoolteacher in Brixton whilst McLaren engaged himself in the margins of the student demonstrations that were then rocking educational establishments across the world. Unable to tolerate his lack of commitment to domestic responsibilities, she was forced, temporarily, to leave London to bring up her family in North Wales. She returned in 1970 to take up residence with McLaren in the scruffy council flat in Clapham where she remained for many years. Westwood then submerged herself in an underground fashion scene that could not have been more differentiated from the slick optimism of Quant's milieu. In the intervening years, since the opening of Bazaar, the commercial culture of the capital had adapted to a sense of disillusionment and recessionary realities following the boom time of the mid-1960s. It was this gulf of meaning between an outdated consumerist rhetoric and the new political realities of affluence, added to the bitter memories of her early struggles to assert herself in the context of a supposedly 'swinging' London, that endowed Westwood with a strong individualist streak.

Adopting the confrontational fluorescent wardrobe of the revived teddy boy cult of the early 1970s, which harked back to her teenage love

of rock and roll dancing, Westwood rejected both the mawkish retro-chic romanticism of the vintage emporia that now lined the King's Road, and what she viewed as the naïve sentimentalism of a 1960s' outlook. In the popular traditions of the proletarian British wardrobe, and the seedy debauchery of life in London's art school underbelly revealed to her by McLaren, she discovered the potential for creativity and self-invention that would fire her mature work. The first incarnation of this development was the opening of the shop Let It Rock at the grimy Fulham end of the King's Road in 1971. Here, with McLaren, Westwood sold mid-twentieth-century memorabilia, furniture, bric a brac and authentic 1950s clothing. Having left her teaching post, she gradually fell into renovating and copying drape coats and drainpipe trousers for the shop under the tutelage of East End tailor Sid Green. Following the demise of the teddy boy cult, the duo reopened the business as Too Fast To Live Too Young To Die in 1973. The vaudeville theatricality of ted gear gave way to the denim and leather masochism of James Dean, and jeans and biker jackets were augmented with T-shirts printed up with McLaren's propagandist slogans. These were then customized by Westwood with overtly sexual and violent motifs including nipple-revealing zips and chicken bones shaped to spell profanities.

A year later, its sexual themes developed into a brazen celebration of the sadistic imagery of pornography, the shop changed its name to SEX and stocked a selection of rubber fetish items, customized lingerie, and ever-more explicit T-shirts. Besides the expected patronage of exhibitionists and voyeurs and the more edgy members of the

**108**

SEX boutique, 1975

Vivienne Westwood and colleagues assume pseudo-pornographic poses to promote the King's Road boutique SEX. The bondage and fetish gear on display would go on to form a staple item in the armoury of punk.

pop and fashion worlds, SEX also attracted a following of suburban and provincial outsiders whose anti-establishment energies positioned them simultaneously against the reactionary attitudes of middle England and the complacency of the metropolitan style élite. It was precisely this grouping of followers who would form the core membership of what would become known after 1976 as the Punk revolution. Alongside McLaren's Svengali-like orchestration of Punk's assault on a moribund London music scene through his promotion of the Sex Pistols, Westwood and her assistants at SEX contributed towards the sartorial styling of the nihilism that fixed the emergence of the Punk phenomenon in the popular consciousness. Their pulling together of sado-masochistic bondage paraphernalia, Nazi military decorations, and clothing associated with the nursery or the asylum, produced a surreal commentary on the anarchic tendencies of sartorial display. In imbuing these combinations with a fierce talismanic power, Westwood paid subconscious homage to the process of bricolage described by the anthropologist Lévi-Strauss in his examinations of the fetishistic uses made of artefacts by primitive societies. Such practices would come to form a central tenet of her mature design philosophy.[19]

Ironically the commercial success of Punk underwrote Westwood's emergence as a bona fide fashion designer, whilst the predictable spiral into self-destruction of its original protagonists did little to dent her growing professional confidence. Indeed, towards the end of the 1970s she purposefully distanced herself from what she saw as Punk's decline into decadence. SEX evolved into Seditionaries in 1976 and its profitable promotion of mass-produced T-shirts, accessories, and fanzines gradually distilled the independent and home-made Punk ethic into a sound business proposition. By 1979 many of its core customers had themselves realized the marketing potential inherent in Punk's philosophies and were restyling themselves at the centre of a glossy night-club revival of 'glamour', popularly labelled New Romanticism.

Westwood mirrored the aesthetic and political ramifications of these developments in her epochal 'Pirate' collection of 1981. This was the first time she had enjoyed the opportunity of presenting a coherent design statement under her own name. In its amalgamation of vivid African colours, seventeenth-century sartorial references, Hollywood high-seas bravura, and innovative use of serpentine prints and ostentatious draping (at a time when mainstream designers favoured a tight angular cut) the collection certainly suggested those daring elements of visual and intellectual piracy that McLaren was exploring in his own music-oriented pursuits, but in practice their partnership was winding down. For Westwood the debut marked her entry into the fashion establishment and a new confidence. The clothes, whose covert romanticism and underground edginess shadowed and critiqued the ostentatious ceremonial of the 1981 royal wedding, explored elements

of masquerade that struck a chord amongst style editors, international buyers, and even museum curators (the Victoria and Albert Museum requested an example for their permanent collection). They also laid a precedent for the development of signature Westwood themes over the remainder of the century, though the context of her work increasingly looked to the model of the traditional couture collection rather than the theatre of the street.

An ambivalent and teasing, but essentially respectful relationship with the dress codes of the British establishment, together with the careful research and reinterpretation of historical costume and a commitment to craft techniques, have proved to be constant elements in Westwood's design practice since 1981. To this can be added a tendency to incorporate seemingly indiscriminate references to world cultures

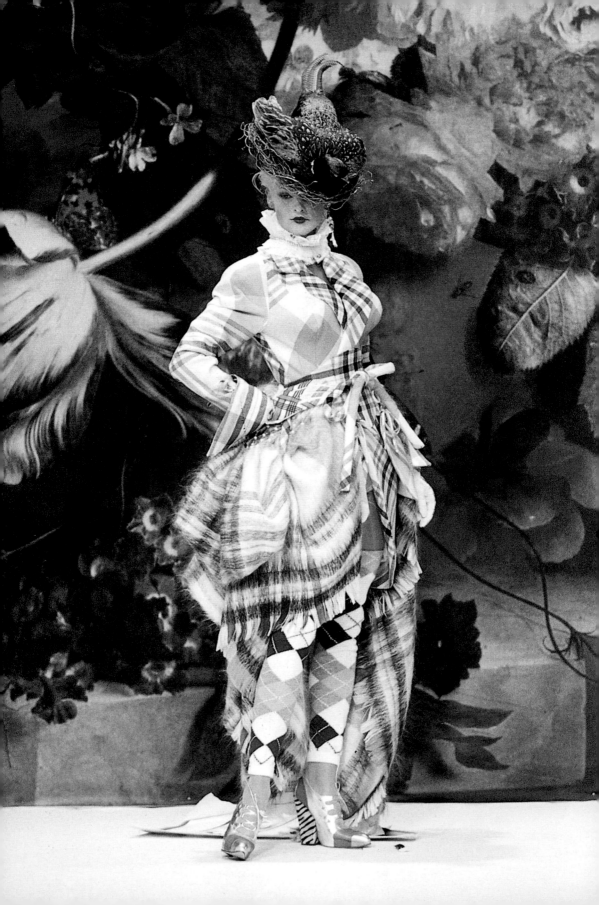

**110 Vivienne Westwood**

Autumn/winter 1995

By the 1990s Westwood had developed her eclectic style on a more dramatic scale. Citing as her central inspiration the sensuality of French high culture during the era of the rococo on display at London's Wallace Collection, she produced a series of swaggering collections which were often accompanied by a manifesto on philosophy, aesthetics, culture, and sexual politics. They also made ingenious use of traditional British textiles including Harris tweed, tartans and Argyle knits.

and a habit of overlaying the whole with sometimes tendentious but often provoking intellectual justifications. From the primitivist and Rastafarian quotations of the 'Buffalo' look of 1982, through the controversial blending of Victorian crinoline and 1960s mini-skirt in the eponymous 'Mini-Crini' collection of 1985, to the playing with Yorkshire tweeds, Derbyshire knits, Scottish plaids, and crown jewels that marked 'Harris Tweed' of 1987, Westwood demonstrated her skill at imaginative composition and at anticipating forthcoming trends. By the early 1990s her style had become ever more grandiose and historicist in orientation. 'Voyage to Cythera' (1989), 'Portrait' (1990), 'Dressing Up' (1991) and 'Cut, Slash & Pull' (1991) made painterly references to the works of Watteau and Boucher, engaging in a nostalgic Francophilia that was echoed in Westwood's attempt to revive the idea of the early nineteenth-century literary salon. Later collections such as 'Anglomania' (1993) and 'On Liberty' (1994), whilst presenting interesting perspectives on the framing of the ideal female body and the nature of modern eroticism, with their notorious platform shoes, bustiers, and bustles, seemed to some critics to recycle earlier ideas with diminishing returns.

Following the closure of Seditionaries in 1979 Westwood traded intermittently from the same site under the sign World's End. Her clothes were also sold in the early 1980s from the West End shop Nostalgia of Mud, and during the 1990s from outlets in Davies and Conduit Streets in the heart of Mayfair. In some respects Westwood had, by the late 1990s, evolved into a parody of herself. Yet despite the ridicule that her work and persona have often attracted, she emerges as perhaps one of the most significant fashion figures of the late twentieth century. Interestingly, her London outlets have continued to rely for their custom on a small hard core of loyal followers drawn from a largely London-based media, club, and fashion scene. Unsurprisingly, such a passive policy, which refuses to predict particular markets for each collection but is deeply rooted in a particular cultural milieu, has garnered a barely respectable volume of sales. It is in Japan that Westwood has encountered the most significant commercial success, her eccentric and markedly English work signifying an energy and anti-corporate ideal attractive to a generation of consumers frustrated by the conformity expected by the Japanese system. In other respects hers is a story that perfectly reflects the dichotomous nature of London fashion. Having wielded a huge creative influence, the Westwood business has not been able to sustain itself as a powerful global brand in financial terms. Periods of bankruptcy have alternated with rescue packages from Italy and ill-judged high-street collaborations. In essence the precarious set-up of Westwood's studio has not progressed so far from the kitchen-table approach she had adopted in the early 1970s, whilst vintage Westwood items surviving from that era fetch

record amounts at auction. This is a telling incoherence that sits quite comfortably amidst the productive chaos of London itself.[20]

## New York

Everybody wants a piece of New York. New York is the hub. New York is international. New York is the bridge. New York means being international.[21]

In describing the motivation for linking her ready-to-wear clothing brand to the identity of her native city through the merging of their initials into the trademark DKNY, the contemporary designer Donna Karan goes to the heart of the fashion stereotype that is New York. In popular myth it is a town full of the potential for success. Though it shares in the chaotic creativity of London, it retains less of a sense of the labyrinthine mystery and densely layered histories that render the older city puzzlingly impenetrable to the newcomer. Descriptions of New York's intensely modern characteristics tend to emphasize the fiercely non-discriminatory efficiency by which its fluid energies are channelled and comment on its democratically open boundaries. As hub and bridge, this accessible New York has operated on two fronts through the past two centuries, during which time its importance as a fashion centre has grown. Like Paris, London, and Milan, it sits as a hub in a network of global fashion connections, but more famously it has long acted as a bridge into America for waves of immigrants and products from the rest of the world and, looking the other way, for the transmission of new American things and ideas out towards an ageing Europe. New York's reputation as a shimmering point of transit and exchange has contributed to the popular understanding that it is not quite 'of' the country to which it is geographically attached, and its independent values have often been seen as being incompatible with those shared on the rest of the continent. Indeed, as Karan suggests, far from representing 'Americanness' New York is a state of mind that is 'being international'.

In some ways this transitional quality has informed the clean lines, simple construction, and disarming functionality of the clothing styles that are often associated with New York-based designers. It has endowed them with a strange blankness, a characterless transparency of meaning akin to the rational layout of the city's grid-like plan. Clearly this is not entirely reflective of the vibrant street life and aggressively differentiated cultures that the visitor to the city experiences on the ground. Design historian Adrian Forty has argued for an understanding of twentieth-century American design as a homogenizing socio-political force, engineered to smooth over the ethnic differences which have driven deep fault lines across its diverse population. Under the guise of mass consumption, all new Americans were invited to

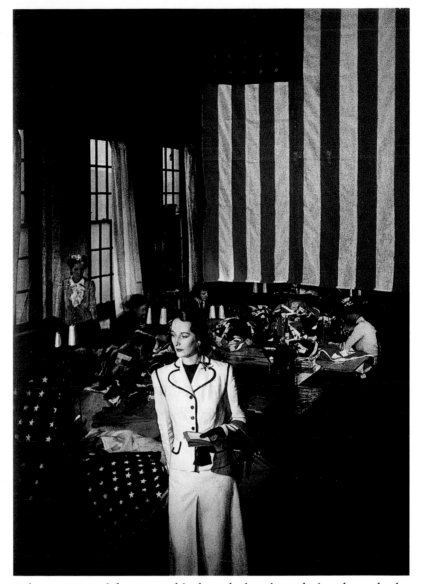

unite across racial, geographical, and class boundaries through the
ownership of standardized products which were bereft of distinctive
historical, cultural, or aesthetic markers.[22] The seeming blandness of
American fashion would appear to uphold such a reading, and in an era
of increasing globalization this has offered unlimited opportunities for
market domination beyond American shores. However, a study of the
micro-history of New York's garment trades and a closer reading of its
output and reception lends a greater complexity to the seemingly inex-
orable rise of what might be termed the Gap phenomenon.[23]

Again, like London and to an extent Paris, where the same process
had taken place a century earlier, a fashion industry was able to grow up
in New York during the late nineteenth century because of pre-existing

commercial and manufacturing communities. New York already boasted a thriving financial market in Wall Street which drew a wealthy and fashionable élite whose consumerist aspirations were well served on Broadway and Fifth Avenue, lending the city its veneer of rampant fashionability and positioning it above the more conservative cities of Boston and Philadelphia as the taste capital of the United States. Its cosmopolitan harbour also welcomed the immigrant labour force necessary to sustain the continued expansion of the ready-to-wear manufacturing sector which, by 1900, was concentrated in Manhattan. Between then and 1925 the total product value of American womens-wear produced in New York rose from 65 to 78 per cent.[24] The rise of standardization and the serial manufacturing of cheap clothing during the 1920s meant that the production of workwear, menswear, and hosiery moved out of the centre to larger factories in the suburbs and adjoining states; and in the 1940s and 1950s the sweatshops and design agencies which had been growing up around Hollywood in California posed serious competition in the manufacture of fashionable womens-wear. In the more recent past this trend has continued with the hiving-off of manufacturing to Taiwan and the Pacific Rim. But through all this change and gradual movement towards dispersal, the reputation and atmosphere of the garment industry in midtown New York have retained their formidable symbolic integrity.

Located around Seventh Avenue since the 1920s, when the largely Jewish and Italian labour force moved from the tenement sweatshops of the Lower East Side to work in the new steel-framed lofts above Fourteenth Street, the archetypal and highly visible rag trade of New York has been able to reap great advantages from its central location in the geography and psyche of the city. In practical terms, the opening of Penn Station on Seventh Avenue in 1910 and the simultaneous growth of a shopping district around Madison Avenue, formed natural in-centives for the expansion of garment-making there. Manufacturers and wholesalers now had closer access to national communication net-works and the comings and goings of out-of-town buyers, and were well-positioned to pick up on consumer trends. They also sat con-veniently between a burgeoning downtown art scene, which provided the necessary vision of designers and illustrators, and the polished glamour of uptown fashion magazine publishers, who offered pub-licity. Alongside the hum of sewing machines, the increasingly congested district echoed with the related activities of showrooms, design offices, accessories-makers, and modelling agencies. The streets themselves became cluttered with off-cuts, entrepreneurs, customers, and personnel, and the never-ceasing transport of dress rails and samples. All of this intense proximity encouraged the production of garments which required short manufacturing runs, a rapid turnover of styles, and quick delivery, feeding the frenetic pace, snappy image, and

results-orientated design language for which the New York fashion business has become famous.

Beyond the circumstances of its production, New York fashion can also be seen as a response to the social and cultural demands made of clothing by American consumers. A constantly evolving rhetoric of American dressing first emerged during the years of the Revolution as a patriotic challenge to the dominance of English taste. The fiercely Protestant domestic philosophy current amongst élite colonial women favoured the simplicity of homespun goods, viewed the thrifty use of materials as a necessary condition for self-sufficiency, and cast any ostentation in dress as morally suspicious. During the late nineteenth century, in a period of prosperity following the Civil War, the East Coast descendants of these colonial pioneers restyled themselves as New Women and 'dollar princesses'. Their fictional counterparts are well described in the novels of Henry James and Edith Wharton. Turning away from the self-denying strategies of their grandmothers, they embraced the opulence of Parisian couture and furnished their elegant houses with imported *Ancien Régime* furniture. This conspicuous display of French luxury was partly the result of a sense that equivalent American goods were unsophisticated, and partly a continued reaction against English style, which was still associated with political subjugation and was in any case too redolent of an old-world class system insufficiently flexible to accommodate updated American attitudes towards the accumulation of wealth.[25]

Though many of the extravagant dresses flaunted by society women of the Golden Age were copied, or more usually adapted, from French models, they always carried false Paris labels to assuage the anxieties of the American customer that she was wearing the correct thing. This shadowing of Parisian style continued until well into the 1920s. But by the inter-war years, the increasing trade in ready-to-wear clothes, which were unmistakably American rather than French in origin and association, and a growing consumer confidence in the rightness of an American way of life, helped to achieve a much stronger identity for New York fashion. The rational and democratic practicality of the blouse, the skirt, and the shirt-waist dress, which had emerged at the turn of the century as the uniform of the ubiquitous Gibson Girl, suited both the informal and active nature of modern life and the organization of production in New York. The partial eclipse of Paris during the Second World War accelerated the promotion of what was now known as American sportswear and encouraged further the isolationist attitude of the fashionable American woman, who increasingly viewed European design with vague suspicion rather than envy. By 1950 New York had become the prime focus of her sartorial aspirations and its starkly functional, self-consciously smart product carried the traces of two hundred years of evolution.[26]

Cotton twill sheath dress with slash pockets by Clare McCardell, 1953

In this picture for *Harper's Bazaar* photographed in the Alhambra by Dahl-Wolfe, the simple lines and functional priorities of McCardell are foregrounded with a striking economy against the more decorative background of Moorish tiles.

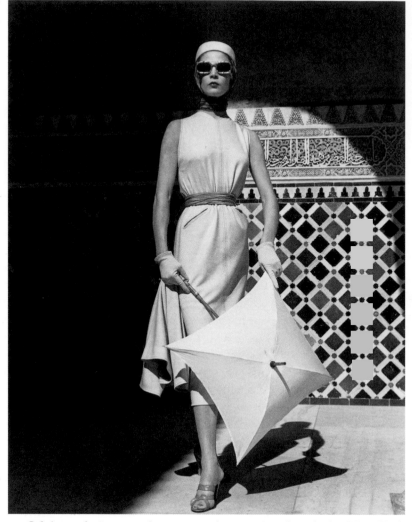

Of those designers who came to be associated with the New York design style in subsequent years, Claire McCardell was probably the most influential, her simple collections encapsulating the essence of American sportswear. Much of her work adhered to a basic and unchanging set of stylistic and practical criteria. From 1940 to her death in 1958, soft and serviceable wools and cottons in strong colours were cut loosely to relax around the form of the individual body. Items were constructed with the minimum of seams and those that were visible were often top-stitched in a contrasting thread so that their lines contributed honestly to the effects of pattern and proportion on a particular look. Interchangeable components offered the wearer the freedom to customize her wardrobe to suit various functions and occasions, from the beach party to golfing and home entertaining. Ingenious wraps, hoods, fasteners, and belts were introduced for their visual interest and their ease of use, concurring with one of the key tenets of

architectural modernism—that form should follow function. In their unpretentious and wearable manner McCardell's designs stood as the antithesis to the Parisian New Look, though her dirndl skirts and natural shoulder-lines pre-empted its silhouette, just as her shorts and thigh-length skirts pre-dated the fashionable Paris line of the 1960s. Most often photographed in outdoor locations on active models, her accessible clothing perfectly fitted the dominant stereotype of 1950s American femininity, with its youthful, outgoing wonder in the great potential of contemporary life.

Other designers of McCardell's generation worked more closely within a traditional Parisian idiom, adapting the distanced *froideur* of the Dior template to the more sociable expectations of the New York cocktail crowd. Charles James opened a couture house on East Fifty-Seventh Street in 1940, moving, after a tempestuous and short-lived business relationship with cosmetics giant Elizabeth Arden, to Madison Avenue in 1945. By reputation James epitomized the neurotic and highly sensitive stereotype of the waspish Manhattan designer promoted in film and popular fiction. His work was similarly theatrical in effect, making use of luxurious fabrics in exotic combinations of colour and inventive sculptural forms. Most at home with the production of spectacular evening gowns and ball dresses, James's approach to the aesthetics of fashion paralleled the strategies of styling adopted by American automobile and product designers in the middle years of the twentieth century. In his fetishizing of lustrous textures, and naked appeal to the status-conscious consumer, his fashions mirrored the gleaming curves and sparkling surfaces of what has been termed the 'populuxe' material environment of affluent post-war American society, and as such they were especially well adapted to the polished and acquisitive context of the New York social scene. Attempts to branch out into ready-to-wear lines in the 1950s, though an obvious professional development given the democratizing trends of the time, ended (largely because of James's difficult temperament) in a succession of commercial failures, and James returned to the production of spectacular bespoke pieces more suited to the rarefied lifestyles of those eccentric New York dowagers who had always supported his work.

Mainbocher also opened an East Fifty-Seventh Street couture house in the city in 1940, following two decades working in Paris as editor of French *Vogue* and as director of his own salon. Whilst looking to the same gorgeous textiles as James, his austerely draped designs adhered more closely to the practical precepts of an American style of dressing that seemed more typical of its time. Utilizing a similar modular philosophy to that promoted by McCardell, Mainbocher became famous for simple sheath evening dresses which could be dressed up with aprons, shawls, and sashes ('glamour belts') of tulle, fur, and brocade, or twinned with embroidered and silk-lined cashmere

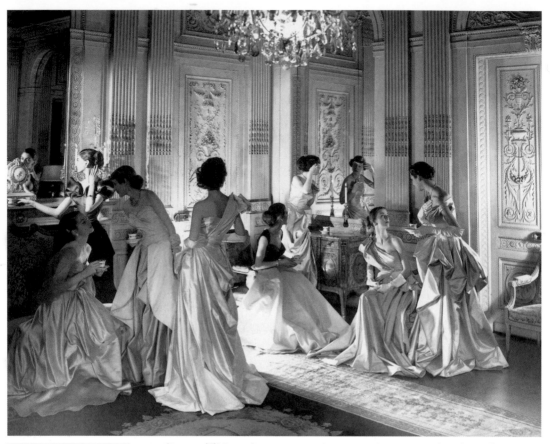

cardigans. This rather provocative commitment to the idea of glamour was also evident in his wasp-waisted corset, produced in 1940 a good six years before Dior's return to nineteenth-century inspired lines. A certain playful staginess in his approach to design (reflected in many commissions for Broadway plays and musicals) further informed Mainbocher's penchant both for paring down the complex construction of the couture gown whilst retaining its expensive materials, and, in a reversal of this effect, for introducing demotic, all-American fabrics such as mattress ticking and gingham into lavish evening ensembles. Whilst the revival of Parisian couture under Dior had aimed to elevate fashion to the status of an élite art form, New York couturiers of the 1950s and 1960s seemed much more open to those influences of commerce and popular culture that were themselves reconfiguring the fields of painting, printmaking, and sculpture through the work of Pollock, Rothko, Warhol, Oldenburg, and others. This willingness to acknowledge (if not directly subscribe to) changing values certainly sustained Mainbocher's relevance up to the point of his retirement in 1971. It encouraged him to adapt his sinuous line and glitzy embellishments to the expectations of a younger generation of consumers, who were enjoying New York's revived international repu-

tation (bolstered by the relocation of the modern art scene from Paris to Manhattan) as a sophisticated centre of 'cool', whilst simultaneously maintaining his distance as the surviving representative of an older tradition honed in Paris.

During the 1960s a generation of New York-based designers, including Bill Blass, Betsey Johnson, and Scaasi took the vibrant, sometimes challenging street culture of New York as a more direct inspiration, and as such their work came to represent its distinctive 'kookiness' to the rest of the world (Rudi Gernreich performed a similar function for sexually liberated California with his topless bathing suit and see-through blouses). Blass's chic mid-price suits and dress ensembles, with their deliberate mixing of casual and formal elements, and playful nods to unisex styling, clearly captured something of the youthful élan which was informing the atmosphere of professional uptown Manhattan. Johnson, like Quant in London before her, contributed directly to the usurping of the salon as the natural home of new trends by the downtown boutique. In the outlet Paraphernalia, for whom she designed quirky mini-dresses using synthetics and industrial elements such as shower rings, and kit form do-it-yourself garments, Johnson pioneered the 'happening' retail space. Alongside competing shops which boasted such evocative titles as Splendiforous and Abracadabra, and Johnson's later venture Betsey, Bunky and Nini, Paraphernalia provided lifestyle accoutrements with which consumers could construct ever-shifting identities, fitted to the throw-away, self-consciously faddish tenor of modern city living. It was in the psychedelic environment of such quintessentially New York institutions that the outlandishly decadent, one-off garments of Scaasi, finished in aluminium, cellophane, huge sequins, and clashing op-art stripes, made the most perfect sense. They offered a more expensive version of the grittier drag associated with followers of Andy Warhol's contemporaneous Factory, and were entirely appropriate as costume for 'all tomorrow's parties'.

In some ways the Sixties counter-culture in New York was an alienating phenomenon that spoke largely to itself. It attracted dedicated tourists of sleaze and a rich mythology of dangerous edginess, but offered little of lasting value to the broader development of New York fashion in a global context. London had already claimed that territory, and 'kookiness' did not play so well to the innately conservative consumers of middle America who still constituted the core market for New York-produced fashions. Significantly Halston, the most influential of the Sixties generation, was the first to see beyond the exotica of Greenwich Village. Having established his reputation as a designer of surreal head jewellery for the department store Bergdorf Goodman (producing the mirrored helmets, flowered hoods, and fringed lampshades that were *de rigeur* as costume for the nightclub and loft party

Ultrasuede suit and coat,
1972

Halston emerged from the
New York counter-culture to
design sinuous, pared-down
garments for the 1970s jetset.
These were notable for their
flattering lines and use of softly
draping textiles such as
ultrasuede. They perfectly
captured the ethos of
American sportswear inherited
from McCardell whilst retaining
the soigné glamour associated
with Manhattan living.

scene that sustained New York's reputation for pleasurable excess), Halston moved into the more staid environment of couture and ready-to-wear towards the end of the decade. He championed a fluid, uncluttered, and well-crafted look using pliable jersey fabrics, soft tie-dyed patterns and subtle pale colours. This supplanted the child-like lines that had recently been so popular with a mature elegance (informed by an orientalizing hippy culture) that was more appropriate for the *soigné* sophistication of a new international celebrity culture. By the late 1970s Halston was dressing the illustrious clientele of the famous Studio 54 club in floating kaftans, halter-necked bias-cut evening dresses, and slinky suede shirt-dresses. His casual, easy-to-wear and eminently reproducible signature items not only looked back to the practical dicta of McCardell, but also laid the foundation (alongside other champions of informal ready-to-wear such as Geoffrey

Beene and Perry Ellis) for the global dominance of the New York brand label at the end of the twentieth century.

Calvin Klein and Donna Karan, who best epitomize the expansive confidence associated with the most recent incarnation of the New York fashion scene, were both born and trained in the environs of the city. Klein studied at the Fashion Institute of Technology in the early 1960s and Karan at Parsons School of Design a few years later. They garnered their experience of the trade in the tough environment of

Seventh Avenue and rose to international prominence on the back of the recasting of New York in the popular imagination as a thrusting powerhouse of corporate triumphalism and free-trade machismo in the early 1980s. Their brand of body-conscious, sartorial fitness, which offered the promise of luxury in an accessible form, provided the ideal wardrobe for the confident, classless, and authoritative yuppie stereotypes who signified material and emotional success in countless aspirational advertising campaigns, television soap operas, and Hollywood blockbusters to the end of the century.

Benefiting from the emerging consumerist concept of the lifestyle choice, Klein had, by the mid-1970s, successfully developed an interchangeable wardrobe of softly tailored separates designed for the needs of the generic (and increasingly prominent) professional urban woman. Presented in classic tones of grey, beige, navy, and black, the range could be worn for all eventualities at home, at work, and on the town. This sense of adaptability to context was extended through the 1980s and 1990s by the promotion of his label as a guarantee both of quality and of an evasive sense of insouciance that characterized the Klein look. Directed towards men, teenagers, and children, as well as women, 'CK' monogrammed blue jeans, crisp shirts, ergonomic underwear, and fresh unisex scents littered a soft monochrome advertising landscape (created by photographers Deborah Turbeville and Guy Bourdin) that hymned the praises of a spiritual family unity and the quest for personal expression. The compelling Klein imagery traded on a strangely diffuse and non-specific desire for an impossible perfection, rather than the overt thrill of sexual gratification that had become the favoured tool of fashion promoters. Significantly, shoots tended to take place in the relaxed but neutral environment of the beach and the summer house, or against hygienically blank backdrops. The sublime maelstrom of Manhattan life was rarely represented directly, though its values were subtly referenced. In its blandly seductive generalizations, Klein's design language was thus well suited to the challenges set up by the diversity of the global marketplace.

Donna Karan's work, which caught the public eye after the showing of her first independent collection in 1985, was perhaps more assertive in its promotion of a clearly identifiable consumer position and context. Karan has often argued that she designs for women like herself and her supple black and tan basics were clearly intended to support the exertions of the ambitious New Yorker (though careerism is a motivation with global possibilities, as Karan's commercial success has since proved). Smoothly contoured and eminently comfortable body-suits, tubular dresses, and wraps in a combination of stretch fabrics and luxurious cashmere were suggestive of the multiple roles supposedly taken on by late twentieth-century urbanites, and the self-help rhetoric of Donna Karan implied that fashion (and its corollary

Modern Souls campaign,
1995

In support of the idea that
Donna Karan designs for the
contemporary independent
and urbane woman, Italian
model and fashion academic
Benedetta Barzini features in a
promotion for the New York
designer in the
characteristically pared-down,
comfortable and sleekly
monochrome wardrobe
associated with the DK brand.

DONNA KARAN
NEW YORK
19 NEW BOND STREET LONDON

shopping) might perform the same organizing and supportive func-
tion in life as that offered by the au pair, the gym instructor, and
the psychoanalyst. The attractiveness of this premise supported the
opening of large branches of DKNY in cities across the world during
the 1990s, selling, like Calvin Klein, an attitude and experience rather
than a distinctively individualized material product.

Karan was not alone in hanging her disarmingly simple garments
on the marketing hook of aspirational identities. Such a strategy has
been central to much New York fashion over the course of its history,
binding the confusion of a fractured New World outlook into the
comforting but conservative inclusiveness of recognizable dreams and
stereotypes. Differing from Klein and Karan only in his nostalgic
championing of the iconography of the Ivy League college and the
Western ranch as inspiration for his designs, fellow New Yorker and

near contemporary Ralph Lauren also shared in their skill at maintaining the appeal of a consistently attractive but conceptually unchallenging brand to a huge national and international market. Some might argue that this approach (honed, in Lauren's case, in the retail rather than manufacturing sphere) undermines the very essence of creativity upon which fashion is generally understood to thrive, though like his peers Lauren has striven to deny that there is any contradiction between his very American celebration of individual freedom and the constraints imposed upon choice by the commercial imperatives of his industry. This conflict, it might be argued, sits at the heart of the problematic sartorial legacy of New York. As Lauren suggests, its design and marketing culture, manufacturing infrastructure, and social

attitudes have very efficiently produced a universalizing style of clothing that effectively precludes any consideration of fashion at all:

> I believe that fashion is a function of lifestyle. I believe in clothes that are natural to the way people live today . . . I want my clothes to become more personal and special as they are worn. I use only natural fabrics, avoid gimmicks, and concentrate on evolving and perfecting the classics. I strive for three things in the clothes I design: quality, simplicity, and longevity. The look I strive to achieve is anti-style—an untrendy, unpackaged individual look.[27]

## Milan

If New York fashion is representative of an anti-style stance, then in the popular mapping of fashion's geographies Milan stands as one of the most self-consciously stylish of world fashion cities. It is also the youngest, though this is not to suggest that Italy was without an influential fashion culture before Milan's late re-emergence on the international fashion scene in the mid-1970s (an earlier moment of global fame is revealed in the fact that the English term 'millinery' has its sixteenth-century roots in the name of a city that was even then closely associated with fine fabrics and accessories). The cultivation of an elegant personal appearance had formed a central tenet of aristocratic life in the Italian city states since before the publication of Baldassare Castiglione's well-known *Book of the Courtier* in the early sixteenth century. Furthermore, the industrial production of rich cloth to service such a market, together with the existence of a highly skilled craft community of tailors, seamstresses, leather-workers and accessories-makers in commercial centres like Genoa, Turin, Naples, Venice, Florence, and Rome, supported the enduring international reputation of the Italians as purveyors of particularly exquisite fashion goods. In more recent decades the well-publicized work of charismatic bohemian designers such as the Venetian couturier Fortuny, or those sartorial innovators connected to the Futurist movement, similarly ensured that the relationship between art and fashion was a prominent factor in debates about the characteristics of Italian clothing culture that have been in circulation since the early twentieth century.

It was, however, only after the calamity of the Second World War that Italian fashion began to attract serious attention as an industrial and cultural force equal to the power of Paris and New York. American financial support administered through the Marshall Plan of the late 1940s guaranteed that the beleaguered textile factories of the north had access to adequate capital and raw materials. As this process of political and economic reconstruction continued through the 1950s and 1960s, Italian manufacturers and consumers also embraced an American idea of modernity, filtered through Hollywood film and the newer medium

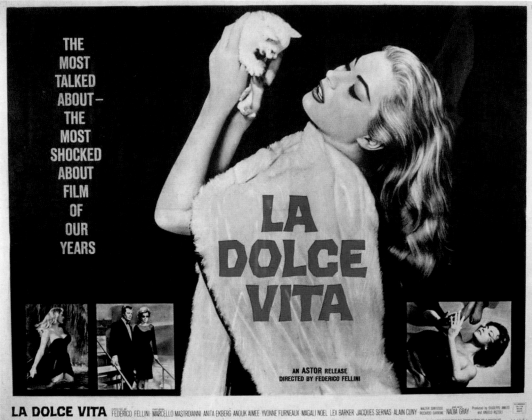

THE
MOST
TALKED
ABOUT –
THE
MOST
SHOCKED
ABOUT
FILM
OF
OUR
YEARS

LA DOLCE VITA

AN ASTOR RELEASE
DIRECTED BY FEDERICO FELLINI

LA DOLCE VITA   FEDERICO FELLINI MARCELLO MASTROIANNI ANITA EKBERG ANOUK AIMEE YVONNE FURNEAUX MAGALI NOEL LEX BARKER JACQUES SERNAS ALAIN CUNY NADIA GRAY   Produced by GIUSEPPE AMATO and ANGELO RIZZOLI

**118 Federico Fellini**

Poster for *La Dolce Vita*, 1959
If Milan played host to the
development of the modern
Italian fashion industry in the
post-war period, Rome
represented the more
established centre of
traditional couture and a
general culture of hedonism
and conspicuous
consumption. A focus for
playboys, models, film
magnates, actors and
actresses, the eternal city
functioned as the soul of Italian
economic and social
reconstruction in the 1950s.
The moral ambiguity of this
fashionable milieu was
effectively captured in Fellini's
film of 1959.

of television, which promoted the positive aspects of a consumer
society. A populist appetite for accessible luxury and new employment
opportunities in the vicinity of Milan drew peasant workers from the
south, and this movement of labour, aspirations, and taste combined
with the distinctively glamorous nature of established élite Italian
lifestyles (famously satirized as *La Dolce Vita* by the film-maker Fellini)
to transform the cultural landscape of the country. Those small family
firms of the Veneto and Emilia-Romagna, who made up a significant
element of the Italian manufacturing sector (known as the Third
Italy), traditionally aimed for excellence in the design and finish of
their goods whilst maintaining an adaptable and innovative approach
to the needs of the mass market, and therefore rose easily to the chal-
lenge of these new consumer-driven demands. An ensuing domestic
boom coincided with (indeed was partly supported by) a very favour-
able reception for new mass-produced Italian goods in the rest of
Europe and in the United States. Alongside clothing and textiles,
Italian-made domestic utensils, food and drink, office equipment, fur-
niture, and automobiles were universally celebrated for their sharp
modern styling, high quality of manufacture, beautiful materials, and
urbane social characteristics.[28]

Working within such a context, dress designers including the Fontana sisters at couture level, Emilio Pucci at made-to-measure and the company Max Mara at the less evolved ready-to-wear end of the industry, thus pioneered a distinctive mode of modern fashion during this period. They took some notice of the lead of Dior in Paris, and rather more of the lighter elegance of American sportswear. But the unique contribution made by Italian stylists and manufacturers lay both in the attention they paid to the detailed intricacies of construction and decoration at all levels, and in their freshening focus on the expressive use of colour, print, and fabric texture. The enthusiastic patronage of American film actors and celebrities including Ava Gardner and Jackie Kennedy, together with the hyping of local Cinecittà stars such as Gina Lollobrigida and Sophia Loren as national beauties, also did much to raise the profile of a recognizable Italian look. The origins of this concerted effort to publicize home-grown fashion talent stretch back to Fascist attempts to co-opt beauty and the garment trades for patriotic purposes in the 1930s. Mussolini's regime isolated Turin as the city of Italian fashion and through the efforts of the National Fashion Office aimed to impose Italian materials and pseudo-folk styles on the industry and the indigenous consumer. But from the 1950s onwards the export market took priority. After the war sporadic fashion shows were held in Zurich and Milan by individual companies. More ambitious group shows were held in Venice at the International Film Festival of 1949, and most famously in the Villa Torregiani in Florence in 1951, where all significant collections by Italian designers were unveiled for the first time to the international fashion press and the all-important American department store buyers.

By the early 1970s Milan had supplanted Rome and Florence as the new capital of the Italian fashion business, echoing a shift in emphasis from the promotion of couture and made-to-measure clothing to an unprecedented acceptance of ready-to-wear as the saving grace of a traditional industry in renewed crisis. A younger generation of designers including Krizia, Missoni, Versace, and Armani, who had enjoyed a wider-ranging experience of the design, manufacturing, marketing, and retailing of clothing than their forebears in the rapidly shrinking bespoke sector, found the industrial and commercial infrastructure of Milan to be a more congenial base than the stuffier inward-looking salons of the older centres. Many of these new names benefited from the financial backing of corporate sponsors such as the GFT (Gruppo Finanziario Tessile) whose interest lay in understanding and anticipating the desires of a mass market. Under the auspices of such institutions enlightened creative practices borrowed from the disciplines of architecture and product design, which unashamedly enlisted modish philosophical and semiotic strategies to further solutions to functional questions, were seen as entirely appropriate methods

for increasing public awareness and market share. This conceptual radicalism went hand-in-hand with an entirely practical commercial approach, based on the precedent provided by long-established merchant trading houses such as Fendi and Gucci. Selling branded products (usually luggage and accessories) whose value lay in the excellence of their crafting, these family-based outfits well understood the importance of high standards of manufacture, and had pioneered the discreet promotion and retailing of accessible luxuries since the late nineteenth century.

Although the dual appeal of intellectual seriousness and material refinement attracted unprecedented international attention, the success of this 'second economic miracle' also owed much to the acquisitive attitudes of the Italian consumer and the materialist culture of Milan itself. The extravagantly dressed boutiques of the via della Spiga valorized the slick and expensive tastes necessary to furnish what Castiglione had referred to in the sixteenth century as the elusive quality of *sprezzatura*, a disdainful bearing of relaxed self-confidence still prized by the fashionable Italian of the twenty-first century. But this localized abundance of glittering commodities also represented the freedom to be found in expressing identity through an engagement with conspicuous consumption that was synonymous with the restructuring of Italian society in the last quarter of the twentieth century. The fruits of political activism in the late 1960s, a loosening of the tight hold on social mores traditionally enjoyed by the Catholic Church, widening access to education and employment, and rising standards of living had pushed Italy beyond its agrarian, feudal past, to a present that found its meaning in a collective lifestyle dream. Nowhere were the effects of this new modernity more evident than in the cosmopolitan shopping streets, exhibition halls, and design studios of Milan, or the iconic products of the designers Gianni Versace and Giorgio Armani.

Versace's unique skill lay in his ability to translate the material outcomes of this very specific cultural and economic transformation so that they met the more diffuse desires of an international market. Trained as an architect in his native southern Italy, but raised as a tailor in the professional context of his mother's dressmaking business, Versace developed an early and useful knowledge of fashion outside Italy through his role as a buyer for the family firm in Paris and London during the late 1960s. Between then and 1978, when he established his own eponymous business, Versace worked as a designer for several of the small Milanese fashion companies whose rising fortunes were also changing the profile of the city. His own journey from an artisanal background in the south to the relatively sophisticated ambience of the north was one that had been shared by many of his compatriots, and there is something in his mature work that pays naked homage both to the idea of traditional roots in the sensual primitivism of an older way

of life and the promise of worldly success inherent in the capitalist systems of the modern world.[29]

Throughout the 1980s and 1990s Versace pioneered a distinctively voluptuous signature style which utilized extraordinarily rich fabrics and always emphasized the sexuality of the wearer. Running alongside commissions for opera and ballet costumes from La Scala and Maurice Béjart, his designs embraced a vivid theatricality and were rapidly adopted by those in the film, leisure, and media industries whose professional responsibilities or psychological profile dictated prominent public exposure. From the clinging sinuosity of the metallic fabrics and

sculpted leather employed in his collections in the early 1980s, through the fluid veiling and exposing of skin which marked most of his evening wear later in the same decade, to the opulent Mannerist prints and glittering accessories that signalled glamour and expense in the 1990s, Versace's output made conscious play with the overlapping categories of beauty and vulgarity. Under the aggressive business control of his brother Santo, the brand also functioned on two complementary levels. It came to be regarded as the chosen uniform of the super-rich, retailed at prohibitive prices in spectacular boutiques at the world's most exclusive locations, whilst through the wider marketing of fragrances, diffusion lines, and from 1993, home furnishings, it formed the paradoxical symbol of a more popular celebration of excess.

In the trademark of the Medusa's head, which Versace adopted as his crest, the designer astutely signalled his understanding of the sublime propensity of fashion to shock and horrify, but most importantly to control. The careful orchestration of his own life and product offered a decadent template of uncontested distinction. Versace's personal tastes and desires were photographed for a succession of promotional books and advertising campaigns which hymned the glossy perfection of his several palaces, and lovingly detailed the bronzed bodies of his coterie. The imagery was deliberately intoxicating in its totalizing, sensual appeal, and left little room for subversion or alternative choices on the part of his intended audience. The commercial clout of an organization that was enjoying a turnover of £600 million and profits of £60 million in 1996 also tended to stifle dissent in the industry, ensuring maximum press coverage and adulation. But Versace's vision was, according to some critics, ultimately empty of any profounder meaning and quite terrifying in its aesthetic predictability—a veritable pornography of fashion. The mythic status of the brand was only strengthened in 1997 when the designer was murdered on the steps of his Miami mansion by a celebrity-obsessed psychopath. True to the Italian stereotype, his legacy and label were then taken up by his sister and muse Donatella, who continues to purvey the compelling Versace version of Milanese glamour with typical verve.

Fashion historian Valerie Steele characterizes the Italian 'look' which has so influenced global trends at the end of the twentieth century, as an ongoing competition between two contrasting paradigms. The first, personified by Gianni Versace, favours an overblown, operatic celebration of life's pleasures and tragedies. It is a fiery tradition, infused with a kitsch nostalgia, rooted in the emotional psyche of the south, and currently upheld in the work of the design team Domenico Dolce and Stefano Gabbana. The second, which is well-represented in the recent output of Miuccia Prada, takes refuge in the cooler refinement of an almost monastic simplicity. It favours the more abstract, anti-historicist pursuit of luxury for its own sake, restricts its

influences to a function-led, minimalist aesthetic, and draws its antecedents from the craft traditions of the northern tailor. This latter paradigm has generally enjoyed the upper hand in critical evaluations of Italian design, and finds its most influential practitioner in the figure of Giorgio Armani.[30]

Armani's background is more firmly wedded to the reforming ethic of the Milanese design philosophy than Versace's. Crossing disciplines from an education in medicine, he first worked in the fashion industry as a menswear buyer for the department store La Rinascente, whose landmark shop dominates the piazza del Duomo in the centre of Milan. Housed in an austerely authoritarian Novecento-style building of the late 1920s, its enlightened retailing policy embraced the new spirit of Italian design, reflecting increasing affluence and discerning attitudes amongst its middle-class consumers. In 1953, the year before Armani's appointment, La Rinascente had hosted the exhibition 'The Aesthetic of the Product' to showcase innovation, and this was followed by the sponsoring of an annual prize (the Compasso d'Oro) for the best design of the year. Progressing from buying to designing himself, Armani worked for the Cerruti group through the 1960s, before establishing his own label in 1974. Highly conscious of the commercial need to accommodate as broad a segment of the consuming public as possible, he developed a quietly unobtrusive sartorial register, marketing his brand in the United States from 1980, and to a younger international clientele via the jeans and sportswear-based Emporio Armani line from 1989. As Armani himself has stated, with typical reticence: ' I design clothes that can be produced at a certain cost, that can be sold and worn.'[31]

This disarming practicality belies an attention to form and finish that revolutionized the direction of fashion in the mid- to late 1980s, particularly in terms of the design of formal menswear. Armani famously eviscerated the structured business suit, sloping the shoulders, freeing the stiffened lining in the jacket's interior, lowering the buttons and lapels and adopting fabrics which were lighter in weight, colour, and texture. Even though, as Richard Martin has demonstrated, this seemingly radical departure from tailoring tradition owed much to the design of the American Ivy League sack-suit of the late 1950s, its cultural connotations were profound. The Armani male look signalled the rise of a feminine attention to the feel of clothing and an abandonment to its tactile qualities, whilst retaining a puritanical and very modernist hold on a subtly differentiated framework of restrained colours and limited shapes. It revealed a contemplative attitude that had been explored in Armani's earlier designs for the film *American Gigolo*, whose images had helped to carve out a new space for masculine narcissism and uncomplicated consumption, and was followed through in lucid designs for opera. In Armani's own flagship department store,

opened in Milan in 2000, the mood was also reflected in the transformation of a shop into a calm and airy temple for the honouring of perfected commodities.[32]

It found its more complex and unsettling resolution in the staging of a retrospective Armani exhibition at the Guggenheim Museum in New York during the same year. Exquisitely displayed pieces were grouped according to type in a gallery whose celebrated interior spiral had been gently subverted to resemble both the structure of an oversized garment and the halls of a well-appointed shopping mall. The heated controversy which met the opening of a show which was in most respects non-confrontational and conservative in its rendering of clothing as spectacle, revealed the continuing potential within Milanese

design for politely questioning the categorization of fashion as either art or commerce, and quietly challenging the assumptions it raises amongst its audiences. Moreover it offered proof that contemporary sartorial goods operate in 'the realm of values'. This may be especially true of those designed in Milan, a city whose designers have always sought to project a particular sense of life and culture onto the rest of the world. But it also holds for the differentiated fashion imagery of post-war Paris, London, and New York. Such stereotypical images are clearly not entirely fixed in their geographical associations, even though their validity partly lies in a concrete industrial history and aesthetic heritage. As we have seen, their coherence is constantly challenged by the global nature of their production and reception, and the subjective order of their content. Indeed it is precisely the fluid and flexible nature of such values that endows the modern fashion system with the extraordinary capacity to both create and challenge social realities and identities. This a truth well-known to the urban dandy and constantly reiterated on the runways of the world's fashion capitals as they promote their seasonal collections. It also reverberates beyond the citadels of the garment industry, affecting the strategies of all who engage in the process of fashionable dressing.

# Fashion and Identity

10

The idea of the smoothly organized fashion city, with its dandyish connotations and its relentless promotion of the fashioned product, forms just one of the versions of modernity which have had a dominant influence on the ways in which the development of fashionable dress has been understood and progressed over the past two centuries. Connected to this formation in terms of its urban location, but constituting a rather different understanding of clothing behaviour, is the more chaotic figure of the Romantic bohemian. Standing in opposition to the controlled and artificial posturing of the aristocratic dandy, the shambolic but fiercely honest gestures of the bohemian have revealed the manner in which fashion can communicate individual passions and authentic cultural meanings as effectively as it contrives to disguise or mould them. Like the dandy, the symbolic figure of the bohemian has provided a code for interpreting modern rituals of dressing.

These two strategies of selfhood are rooted in their metropolitan contexts. Both evolved in the early nineteenth century as a means of negotiating the bewildering nature of city life with its undifferentiated crowds of strangers and unsettling capacity for reversing traditional social hierarchies. In the drift towards anonymity and alienation that followed the rise of industrial capitalism and urbanization, the communicative power of clothing emerged as an important tool, both for guaranteeing a sense of belonging and as an aid to identification. Whilst the industrial infrastructure of fashion design, production, and marketing tended to adopt the aspirational techniques of the dandy in its relentless promotion of sartorial wares (as demonstrated in chapter eight), many less privileged consumers discovered that the progressive politics of bohemianism offered a more sympathetic framework for dressing the self. In the twentieth century especially, the countercultural stance of the bohemian outsider has proved to be a very effective technique for ensuring that not all innovative developments in fashion have originated amongst the economic and cultural élites described in the preceding studies of the world's fashion cities. It has also offered a useful position from which to orchestrate a trenchant critique of fashion practices in general.[1]

Historically, the bohemian's rise mirrors that of the dandy and

**121 Horace Vernet**

Fashionable gentleman,
Paris, 1810

During the first decade of the
nineteenth century,
subcultural groups such as the
Incroyables chose to mark
their radical political and social
views through extreme dress.
This is reflected here in the
high collars, louche
unbuttoning of coat and
waistcoat, and eclectic props
derived from riding dress and
English fashions which are in
direct opposition to the
antiseptic control of the dandy
style.

*Culotte & Guêtns de Peau couleur de Cuir Canne à Pamphlue*

sometimes overlaps with it. As a familiar social type he first appeared in
the late eighteenth century, though his milieu was located in Paris
rather than London and his cult was not so exclusively homosocial as
his rival's. And where the dandy had taken care to associate his superior
self with the élite spaces of Society, the bohemian's forerunners
favoured the anti-social squalor and poverty of the *demi-monde*, or the
dangerous fringes of political, artistic, and literary life. Indeed the
bohemian's unusual dress was often as much a consequence of necessity
as it was a predetermined ensemble. Recognizable through the im-
modest disorder or oppositional theatricality of their clothing, groups
such as the monarchist Incroyables and Merveilleuses, or the republi-
can Barbus presented a deliberate affront to the expectations of
fashionable decorum. They found early kinship in the studios of
radical painters such as David and Girodet, and, following the turbu-
lence of the Revolution and the years of the Directory, swiftly threw
their energies into the broader cultural project of Romanticism. The
Romantic spirit set itself against the rationalism of Enlightenment
philosophies and celebrated the darker sentiments of the unpredictable
imagination. Embracing creativity, spontaneity, and novelty, its creed
was essentially hedonistic, though the bohemian's relentless pursuit of
pleasure and experience was engineered to reveal the inner psyche and
did not serve simply as a sybaritic end in itself.

**Ascot Races, 1934**
In the nineteenth and early twentieth centuries, fashion both confirmed existing social structures and occasionally undermined them. Here there is a striking contrast between the pale elegance of the race-goer with the parasol and both her male companion in his morning suit and top hat and the two older women in overcoats. Any contemporary observer would have been encouraged to draw several conclusions regarding class and gender hierarchies from such a scene.

Some historians and social theorists interested in the relationship between identity and the material world have argued that the Romantic bohemian's concern with displaying authentic emotions and desires set an important precedent for modern assumptions that the intimate concerns of selfhood can be read directly from the surface of the body, and deciphered through an examination of the manner in which sartorial commodities are fashioned around it by the subject.[2] Supported, paradoxically, by the illusory and manipulative strategies of those designers, retailers, and advertisers whose businesses expanded through the nineteenth century to serve a growing middle-class market, and given further credence by the emerging disciplines of psychology and

sociology, the expressive ideals of the Romantic thus rendered mean-
ingless the older aristocratic division between the orchestrated and
hierarchical performance of public and private personalities which the
dandy had himself opted to sabotage. Following this trend, the liber-
ated modern fashion consumer moved away from a concern with
elaborate artifice towards a more natural communication of status and
individual preference which might confirm or challenge the *status quo*.
In the twentieth century these more generalized interventions revolved
largely around the issues of gender, sexuality, class, race, and age, and
had a radical effect on the evolution of popular and more experimental
fashions into the early years of the twenty-first.[3]

During the first quarter of the twentieth century, bohemianism was
still associated with the extreme behaviour of a largely metropolitan
avant-garde whose experimentation with artistic and sexual freedoms
dictated a distinctive style of costume. Much of this owed its origins to
practices pioneered in the nineteenth century, including the ethical
and moral crusading of rational and aesthetic dressers and the mas-
querading theatricality of an amateur and commercialized fancy-dress
craze. But men and women attached to later bohemian communities
such as the Bloomsbury Group, or associating themselves with the cre-
ative quarters of Montparnasse in Paris, Greenwich Village in New
York, or the night-club scene in Berlin, were far more assertive in pro-
claiming their eccentricities and subversive intent through fashion
than their Victorian forebears. In their shocking adoption of styles
more generally associated with the opposite gender, and fearless cham-
pioning of garish colours, nakedness, and second-hand opulence, these
sartorial revolutionaries pre-empted the standard uniform of the sensi-
tive, alienated post-war teenager by several decades.

Elizabeth Wilson traces the early evolution of this art-school style
of countercultural dressing in London and Paris during the 1910s and
1920s, focusing on the figure of Nina Hamnett as an archetypal
example. In 1912 Hamnett bobbed her hair in the crophead style that
was *de rigeur* amongst radical female students of the Slade School of
Art, and braved the uncomprehending stares of passers-by in the
Tottenham Court Road in her clergyman's hat, checked coat, red skirt,
white stockings, and men's dancing pumps. She later adopted the
working-man's costume of corduroy trousers and blue shirt for paint-
ing in her studio, owned a vibrant example of Cubist-inspired knitwear
acquired from the Omega Workshop, and borrowed extravagant haute
couture for frequenting modish night spots. As Hamnett herself
stated: 'One had to do something to celebrate one's freedom and escape
from home.'[4]

That this sense of release from the constraints of dominant societal
expectations afforded by the adoption of particular kinds of clothing
was not confined to the experiences of a fairly privileged metropolitan

A flapper, 1925
Everything about the appearance of this flapper challenges earlier assumptions about the proper behaviour and appearance of the respectable woman. Her provocative pose, exposed stockinged legs, cigarette, striking make-up, and bobbed hair depart from the modesty expected of women in the previous decade. Yet such an image gained enormous popularity through its circulation in print and film.

clique is demonstrated by the controversy surrounding the image of the flapper, the young woman of emancipated tastes in dress, which dominated various aspects of popular culture in Britain and America during the same period. In several ways her democratic figure, with its cropped and shingled hair, boyish lack of curves, and ebullient dance-influenced costume closely paralleled Hamnett's transgressive stance. It was, however, a more universal trend whose impact spread far beyond the garrets and bars of the avant-garde. Celebrated in Holly-wood films, criticized in newspaper editorials, co-opted for countless women's magazine illustrations and advertisements, and approximated in the rather self-conscious photographs of millions of suburban and provincial family albums, the accessible style of the flapper certainly seems to have offered a lively commentary on the tricky relationship between fashion, gender identity, class, and modernity during the mid-1920s. Taken up with vigour by shop-girls and stenographers, the influence of the look can also be detected in the designs of Chanel, Vionnet, and Paquin, who were surely susceptible to its far-reaching implications for the future of couture and went to some effort to annexe its formidable power for their own work.[5]

Whilst acknowledging her importance, contemporary historians of fashion and gender have found it difficult to agree on what the precise significance of the flapper was. A simple reading might suggest that her seemingly unconstrictive wardrobe and simplified toilette symbol-ized a growing equality of opportunity in biological, professional, and political terms. This was, after all, a period when more women were working in occupations previously associated solely with men, when the right to vote was extended for the first time to a proportion of the

female population, and when social mores offered greater freedoms for women to behave independently without fear of censure. On closer examination however, all of these concessions were only partial, and any link with the reform and modernization of the feminine wardrobe needs to be placed in the context of wider economic, technological, and aesthetic cycles which had been set in motion years or decades earlier. These operated in spheres that lay beyond the effects of short-term social gains, and in any case impacted equally on the dress and demeanour of working- and middle-class men. What does seem to be clear is the fact that the new fashions offered enormous psychic and morale-boosting compensations to many of the women who wore them. The appearance of freedom may have been won in spite of the uncomfortable pressure of breast-flattening rubber corsets and the potentially dangerous electrical heat of hair-waving machines, but its vivid and energizing impact was such that conservative commentators were entirely convinced of its close association with all manner of supposed depravities and the collapse of a whole way of life—engendering a frisson amongst consumers that afforded some recompense for the hollowness of its promise.[6]

## Subcultural dress and the teenage consumer

A similar rhetoric of moral panic was in operation in the post-war years in Britain and America, but attention was then more firmly focused on the sartorial habits of young working-class men. Subsequent analysis of the so-called 'teenage phenomenon' of the 1950s and 1960s has chosen to seek meaning for this further paradigm shift in the fashioning of identities through recourse to subcultural theory. Subcultural readings aim to explain the clothing and leisure choices of the young through noting the deliberate ways in which like-minded groups mark their difference from the dominant culture and their peers by utilizing the props of material and commercial culture. Such differences might pivot around questions of age, class, gender, and race, but in essence the 'uniforms', music, language, and styles of behaviour adopted as badges of belonging have generally been characterized by their tendency to shock, disrupt, and finally change the values of a stifling *status quo*. Inevitably, 'straight' society has usually redirected the original subcultural challenge back into the cycle of trends associated with western consumer capitalism. This has led to a succession of street-based styles whose uneasy dialogue with the profit-based concerns of the organized fashion business has arguably had more effect on the general direction of fashionable taste over the past four decades than the individual vision of any particular famous designer.[7]

Ironically it was the very affluence of mainstream post-war society which encouraged the emergence of its first notable subcultural

'demons' in the early 1950s. In London especially, the spectacular
excesses of American popular culture already held a strong appeal for
working-class male youths whose daily reality had been constrained by
austerity. The draped suits offered to such a market by canny neigh-
bourhood tailors in the late 1940s boasted a capacious cut which stood
in vivid contrast to the grey monotony of 'demob' clothing. Like the
continental New Look, and the Western accents of slicked hair, denim,
and bootlace ties adopted by rock and roll singers, such transatlantic
'spiviness' seemed to set a deliberate challenge to the puritanical tenor
of contemporary English attitudes. Closer to home, a revival of interest
in the sharper tailoring and arrogant posture of the Edwardian gent
amongst the metropolitan élite, the electrifying impact of West Indian
styles of dressing following the first wave of post-colonial immigration,
and a longer tradition of working-class dandyism which had its roots
in the music-hall culture and gang-based hooliganism of the mid-
nineteenth century, all combined to heighten a sensitivity towards
oppositional dress amongst proletarian teenagers of the 1950s. But
most importantly it was the extra cash made available through near
full-employment and a burgeoning network of sympathetic retail
outlets with products geared towards such consumers that heralded the
emergence of the ubiquitous teddy boy.

With his opulent demeanour and apparently *louche* attitude, the teddy boy conformed to some aspects of romantic bohemianism—especially in terms of dress. However, his associations with violent crime and racial tensions, strengthened through sensationalist press coverage, meant that he fell some way short of the ideal, and ensured his eclipse by less parochial youth styles as the decade waned. By the early 1960s the cosmopolitan figure of the mod (represented in France by his equivalent the *minet*) had usurped the ted as the focus of a new wave of moral panic and commercial manipulation. Far from betraying any bohemian sympathies, the obsessively neat mod conformed more closely to the authoritarian rules of a latter-day dandyism. His sharp Italianate mohair suits, stiffly lacquered short hair, and unapologetic consumerism (of clothes, scooters, pills, and dance music) afforded a superior social weaponry that was far more subtle in its assault on mainstream complacency than the flick-knives, brothel creepers, and bike chains of the reactionary ted. The challenge presented by the mod was not embodied in physical violence or the status of an outsider, but in his subversive potential as a threat to the older assurances of class- and gender-based hierarchies and traditions.

It was the figure of the mod who formed the focus for the expanding boutique culture of Carnaby Street in the late 1960s. He set a precedent for the tide of countercultural retail outlets which engulfed first the King's Road and later Covent Garden and Camden Town in the 1970s and 1980s; he lent his distinctive look to a spate of successful pop groups; and he put London on the map as an acknowledged global centre for subversive street-level creativity. The rather naïve optimism which had accompanied this assault on conservative mores fuelled a complex global genealogy of interconnected musical tastes, visual imagery, revolutionary political movements, and challenging clothing styles. These ran from the hippy craze of the late 1960s (which drew its intellectual fervour from earlier 'beat' experimentation and its style from San Francisco, Morocco, and India), through such localized phenomena as an interest in northern soul in Manchester and Leeds or the combination of Jamaican music and football fanaticism associated with the skinhead culture of England's declining industrial cities, to a more universal celebration of glam rock in the mid-1970s (a rare example, like Beatlemania before it, of a subcultural trend linked almost exclusively to young girls). But the momentum was dissipated by a growing realization that all such sartorial agitation was prey to rampant and cynical commercialization. By 1977 any residual optimism was extinguished, or at least subjected to an intense critique, by the nihilism of Punk.[8]

Setting itself against the by now slick operations of an established music industry and disdaining the seasonal fickleness of youth-oriented fashion entrepreneurs for whom subcultural style was an

**125**

Punks at a pop festival, England, *c*.1983

Seven years on from its emergence in 1976 the punk style had become a stylized version of outrage by the early 1980s—the subject of tourist postcards. The spiked Mohican hair and artfully shredded jerkin in this image look towards this more pantomimic trend, whilst the tartan, Doctor Marten boots, and second-hand jacket hark back to the origins of the cult.

opportunity for capitalization rather than a mode of authentic expression, the philosophy of Punk embraced a spirit of independent and anarchic creativity. This resulted in a stance that at first was resolutely anti-fashion, drawing adherents from across gendered and social divides. Though Punk defied attempts at sartorial categorization, its outrageous wardrobe suggested a clear agenda for disruption and conflict. Disparate items in fetishized materials were provocatively sourced in the rag market, the army surplus store, the sex shop, and the ironmongers. Ripped apart and accessorized with pins and razor-blades, the style consciously evaded rational meaning, arousing fury at its 'dumb' incorporation of fascist insignia and pornographic imagery. As it developed, Punk moved inexorably into the cycle of commodification which it had set out to subvert. However it is fair to claim that the bondage trousers, lapel badges, and screen-printed T-shirts associated with its popularization were largely produced in small runs by informal companies set up by those at the margins who were sympathetic to the cause. Distributed through underground networks, advertised in the backs of fanzines, and sold in dank backstreet outlets, the uniform of Punk largely evaded the worst excesses of mass-marketing.

Like those other subcultural styles which preceded it, Punk may well eventually have become just another momentary fad, parodied by

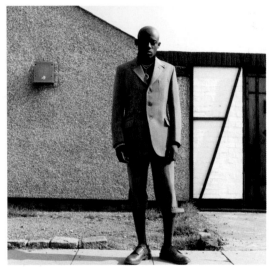

**126 Jason Evans (Travis)**

'Strictly', 1991

In this collection of images published in the London style magazine *i-D*, a series of black models are posed in a variety of garments ranging from Savile Row tailoring to streetstyle and traditional dress, against a backdrop of the English suburbs. The shoot underlines the impossibility of a coherent sartorial or social identity and offers up the notion of 'difference' as a positive engine for cultural expression.

the high street and photographed by tourists, but its egalitarian influence was somehow more significant, infiltrating the ways in which the business of fashion itself is now created and understood. Many of its protagonists had themselves first experienced the empowering effects of subcultural dressing as young suburban teenagers hanging on the coat-tails of the mod phenomenon. They brought this knowledge with them to Punk and carried it forward into the fragmented post-modern leisure culture that grew out of the amateurish and anti-establishment activities of pioneers such as Westwood and McLaren in the late 1970s, and which they themselves now directed. The editors of the lifestyle magazines, the account managers of the PR and advertising agencies, the entrepreneurs associated with the new street-wise retail chains, and the tutors on the fashion and cultural studies courses which defined or described the character of urban living in London and other cities

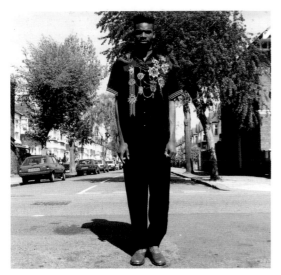
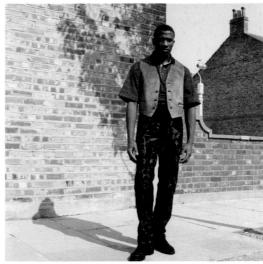
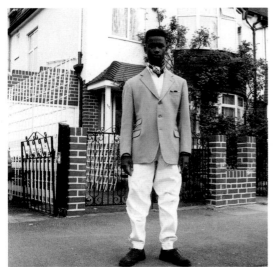

during the 1980s and 1990s had either once identified themselves as mods or punks, or at least owed some debt to the pervasive social and aesthetic influence of these ground-breaking style movements.[9]

In a more general consumerist sense, the democratic, unmediated ethic of Punk opened up a scenario at once utopian and troubling, in which an explicit self-expression through dress and music has become the unquestioned norm, almost a civil rights issue amongst the young, whilst those universal injustices relating to gender, race, or sexuality which Punk had promised to undermine continue to thrive unchecked in the very music and fashion-based industries which have grown up in Punk's wake. This has led both to the strange blandness and commercial opportunism of a global club culture where all sartorial communication is premised on momentary pleasure rather than on challenging the causes of the alienation which underpins the scene, and to the

quasi-tribal proliferation of countless subcultural identities that are ever more ephemeral and ambivalent in their meanings.[10]

In the British dance music revolution of the early 1990s, for example, followers of the rave scene celebrated the right to party en masse in a uniform of T-shirts, track-suits, and trainers of a formless bagginess and fluorescent spectrum that suggested either an infantile regression into Ecstasy-fuelled escapism, or a subversive evasion of 'straight' responsibilities. Their revels were acted out in derelict warehouses or in rural locations, against a background of inner-city decay, rising unemployment, and increasingly authoritarian government legislation. The enduring symbol of the movement was appropriated from the care-free lapel badges of the early 1970s, later utilized by European anti-nuclear activists: a yellow 'smiley' face. This generic, but still rather provoking image of politicized hedonism, which infuriated a reactionary tabloid press, fractured as the decade progressed into a series of neutered and apolitical fancy-dress ensembles. These later versions were costumes to be worn in the context of a now industrialized club scene which famously extended to the Spanish holiday island of Ibiza and beyond. Their eroticized forms (sometimes constructed at home in the spirit of DIY) were derived from disparate sources including beachwear, ghetto-glamour, sado-masochistic role-play, and science fiction or cyber fantasies, the most spectacular outfits carefully referenced and recorded in the pages of highly commercialized dance magazines. Rather than connote a specific allegiance to the sexual or political persuasions suggested by the symbolism of their parts, such costumes (often including body-modifications such as piercings and tattoos) were deliberately tailored by manufacturers and consumers to fit with the clientele and musical repertoire of particular club nights and venues, and were generally discarded or disguised for the purposes of everyday life. Their variety has been likened to a supermarket of styles—the epitome of a consumerist lifestyle attitude that seeks no sense of allegiance, no explanation or justification, and by extension carries no profound implications. As Punk's most influential interpreter Dick Hebdige so prophetically stated at the moment when Punk itself began to implode: 'The key to punk style remains elusive. Instead of arriving at the point where we can begin to make sense of the style, we have reached the very place where meaning itself evaporates.'[11]

## Radical design

The paradoxical position of the subcultural revolutionary is one shared by a new design avant-garde, whose work in the field of high fashion during the 1980s and 1990s has reinterpreted the energetic street idiom and challenging creative questions of Punk for a contemporary commercial scenario. In this fascinating development the unpredictable

political and social messages that were central to the ethos of the original subculture have arguably been undermined by the antithetical concerns of a global luxury fashion industry, whose sights are set primarily on the profits to be garnered from manufacturing outrage. From the perspective of a younger generation of designers, for whom economic entrepreneurism goes hand-in-hand with creative resistance and provocation, there is perhaps no contradiction. But it is clear that where once the cultural function of high fashion was either to foment social and aesthetic change from a position of influence, or, in the case of the middle market, to respond to its effects in the context of a broader production–consumption binary, in the early twenty-first century the self-constructed role of radical fashion design seems to be to present a very specialized commentary on the vicissitudes of contemporary taste and aesthetics. This is often an insular critique that bears little relationship to the immediate concerns of mainstream clothing manufacturers and consumers, but has everything to do with internal fashion culture debates about genre, hierarchy, presentation, and style, and more pragmatically (from the viewpoint of luxury industry conglomerates) with capturing maximum media attention. In this sense the natural home of the élite and directional fashion statement (the product) now resides in the fashion museum, the scholarly journal, the colour supplement, and the glossy monograph rather than in the wardrobe, on the street, or in the shop. Such products often seem destined to be showcased rather than sold, and their strikingly remote but often painfully beautiful manifestations are artefactual in the purest sense, embodying a level of craft and a discursive power that lie beyond the standard rag-trade understanding of commodification. Indeed, the protagonists in the field regularly stress their affinity to the working practices of architects, artists, and philosophers, deliberately eschewing any reference to commerce in discussions of their work. Unsurprisingly, for some critics radical fashion is an effete nonsense, a symptom of crippling intellectual and moral decadence. Yet its haunting imagery provides a fitting conclusion to a book whose central aim has been to chart and explain modern fashion's unique potency as a focus for debate, dissent, and degeneration, and the gradual atrophying of its former power as a medium of social change and control.[12]

Rei Kawakubo of Comme des Garçons can in many respects be cited as the progenitor of a radical fashion movement. Though belonging broadly to the same generation as Yves Saint Laurent, Issey Miyake, and Jean Paul Gaultier—designers whose work has been equally rigorous in its challenge to the *status quo*—her interventions are characterized by an almost monastic solipsism that has generated a parallel fashion discourse of unique intensity. Born in 1942, Kawakubo trained in fine art at Keio University, Tokyo. She worked in the advertising department of acrylic fibre manufacturer Asahi Kasei, and as an

Comme des Garçons, 1999
Rei Kawakubo and more recently Junya Watanabe's work for Comme des Garçons has consistently challenged those ideas of comfort, proportion, and taste associated with high fashion. Here an imbalance in sleeve lengths and the relationship of top to bottom are rectified through the careful manipulation of angles, colour, and texture in an ensemble of simple beauty.

independent stylist of fashion shoots before formally establishing her own clothing label in 1973. Comme des Garçons enjoyed significant success in Japan, where Kawakubo pioneered an austere and carefully controlled brand image. Her output was marketed through Tokyo department stores Seibu and Isetan, displayed in the clinical interior of her own shop (designed by Takao Kawasaki) which opened in 1976, and promoted in the progressive Japanese women's magazine *An-An*. The goods with which Comme des Garçons was associated were notable for their stark simplicity, derived from traditional workwear but cognisant (often critical) of contemporary attitudes towards the presentation of the body. This inherent reticence, or avoidance of overt sexual display, achieved through a relaxed cut and techniques of wrapping, together with an almost myopic attention to detail in the subtle manipulation of fibres, were distinctive characteristics which Kawakubo carried into the European and American markets in the early 1980s.

Comme des Garçons' arrival in Paris in 1982 coincided with a general renaissance in the fields of retail architecture, graphic design, and advertising, and Kawakubo's minimalist philosophy was rapidly adopted as a kind of uniform, denoting the prevalent sensibility for those working in the creative professions. To wear Comme des Garçons was to proclaim membership of a sect, and certainly some of the more uncompromising features of Kawakubo's sartorial vision

demanded the kind of informed understanding that could only belong to an initiate. Her collections constantly interrogated those assumptions of taste and tradition that have bedevilled attitudes towards appropriate dressing in the west. Thus the form of the suit has been reversed and deconstructed, its fastenings misaligned, its seams and panels unpicked and extended, or ruthlessly terminated. Kawakubo has also made great play with texture and pattern, allowing fabric to billow where the wearer might expect tautness, celebrating the harsh crinkliness or slippery polish of synthetics, knotting cotton, and pulling holes in knits, half dyeing completed garments, and causing stripes and checks to follow unexpected routes across bodies which have sometimes been padded or cut out of all proportion.

All of this dissonance is held carefully in check by a masterly control of context. The austere Comme des Garçons logo promises a consistent package and a stamp of authentication which places the product beyond temporal trends. Kawakubo has thus succeeded in making alliances that challenge the constraints of the traditional fashion system. As early as 1983 Comme des Garçons diversified into furniture production. Its clothing lines have repeatedly been presented as abstracted representations of mood or creative happenstance rather than carefully pitched fashionable commodities, forming the focus of exhibitions at the Pompidou Centre, Paris ('Mode et Photo: Comme des Garçons') in 1986 and the Kyoto Costume Institute, Tokyo ('Essence of Quality') in 1993, as the content of a bi-annual cultural magazine *Six* launched in 1988, and as pivotal exhibits in a spate of major gallery shows examining the relationship between art, fashion, and modernity that took place in Brussels, Florence, and London during the late 1990s. In the midst of all this activity the introverted Kawakubo has maintained a distinctive reticence. Eschewing the celebrity culture associated with the theatre of fashion promotion, she has notably employed models more famous for their achievements or attitude than their physical beauty. She has also supported an ideal of creativity that is collaborative rather than egoistic, nurturing the talents of younger designers such as Junya Wattanabe whose work segues into the familial identity of the brand. Through her adoption of such strategies Kawakubo is seemingly content to allow the rather organic oeuvre of Comme des Garçons to speak for itself. Indeed, her gnomic comment in 1997 that 'creation is not something that can be calculated' can be taken as a maxim for much of the work that has followed her lead, setting a precedent for the informal and egalitarian approaches to work now common in most avant-garde design agencies in the west.[13]

In London during the same period a rather different conception of the radical designer surfaced, in which the couture genius was aggrandized over ideals of collaboration and an effacement of the self—even

though much of the work produced in this context still relied for its impact on a complex network of professional support and the innovative blending of skills and ideas from adjacent creative disciplines. From the mid-1980s onwards, a succession of young designers, many of whom shared a common educational experience at Central Saint Martin's College of Art and Design, won the rapid acknowledgement of the international fashion press. Their vivid personal visions informed a series of highly theatrical collections, the content of which nudged the spectacular imagery of high fashion into the heart of contemporary cultural discourse. The first star of this generation was John Galliano whose 1984 St Martin's graduation show took as its inspiration the extreme attenuation and seductive physicality of dress at the time of the French Revolution. Galliano maintained an interest in the creative possibilities of historical costume which would go on to underpin his success as a mature designer. This partly reflected the context of London's avant-garde club scene at that time, which was dominated by St Martin's and Middlesex Polytechnic fashion students who, following the example of Westwood, placed a premium on the glamour of dressing up. But it was also supported by the training in directed research in museum collections and galleries which Galliano had received at college and in his part-time job as a dresser at the National Theatre.

Having been lauded as an *enfant terrible* by the British fashion press, Galliano moved to Paris and eked out a living as an independent designer, producing small collections and commissions until his appointment as principal designer at Givenchy in 1995. Two years later Galliano transferred to Dior, where he continued to thrive. In many ways the skills attributed to the British interloper fitted easily within a traditional concept of couture and were thus far from being radical in their effects. Indeed his mastery of bias cutting and exquisite beading and decorative techniques were almost reactionary in their suggestion of a forgotten golden age of bespoke dress construction. Such effects tended to support the creation of final collections whose sinuously moulded and heavily accessorized pieces proffered a boudoir version of femininity that was hazy and old-fashioned, imbued with the sentimental aura of sepia photographs.

Galliano's understanding of spectacle and presentation was, however, far more innovative and influential. In collaboration with his stylist Amanda Harlech, he orchestrated a series of atmospheric and eclectic *mis-en-scènes* which set his extravagant collections in evocative Parisian sites ranging from the Grand Hotel to the Gare d'Austerlitz. These dream-like scenarios radically shifted standard conceptions of the collection and the fashion show, though they found a clear precedent in Poiret's scandalous parties. With the aid of new lighting and special effects technologies Galliano choreographed a phantasmagoric

**128**

John Galliano, spring 1994
Photographer David Seidner
poses a model in the manner
of an Ingres portrait, drawing
attention to Galliano's concern
to reinterpret the romantic
styles of the past in a
contemporary idiom. The
fusion of saturated colours and
historical motifs, and the
ethereal manner of
presentation have become
Galliano hallmarks.

theatre of fashion variously suggestive of the fairy-tale chateau, the silver screen, ancient civilizations, and the nineteenth-century circus. In these exotic locations he positioned models whose imperious garb recalled Edwardian courtesans, mythological *femmes fatales* and icons of early twentieth-century popular culture. The luxuriousness of this imagery was perhaps not so unusual in the context of the promotional culture of late twentieth-century Parisian couture. After all, Lacroix and Gaultier were also experimenting with similar idioms at the same time. But Galliano's nostalgic reveries were somehow imbued with an understanding of their wider cultural relevance, their potency as signifiers of the sublime excessiveness of the fashioned image.[14]

Alexander McQueen has followed in Galliano's wake, extending the potential of the fashion show as a medium for spectacle and utilizing the design of clothing as a tool for making provocative interventions in debates about the body and identity. Though often proclaiming his marginality and finding significant creative succour in his

**129**

Alexander McQueen for Givenchy, 1998

This image underscores McQueen's dual reputation as a highly skilled cutter, trained in Savile Row, and a consummate showman whose catwalk shows constantly make reference to the spectacle, ephemerality, and morbidity of fashion culture.

East End and Celtic roots, McQueen benefited from a professional background that was in many ways entirely conducive to a career in the rarefied world of couture. Apprenticed at sixteen to the tailors Anderson & Sheppard in Savile Row where, according to his own cannily crafted mythology, he honed his radical credentials by defacing the linings of important clients' jackets with profanities, he secured a valuable knowledge of arcane cutting techniques that have since informed his sharply constructed mature pieces. Having extended his experience of more directional contemporary fashion design through work at Koji Tatsuno in London and Romeo Gigli in Milan, McQueen

then registered for a master's degree at Central Saint Martin's. On graduation in 1992, his work attracted the attention of idiosyncratic *Vogue* (later *Sunday Times*) stylist Isabella Blow, who saw in his Jack the Ripper inspired student collection a violent energy, hard eroticism, and historical sensitivity that seemed entirely unique and not a little contentious.

McQueen's courting of controversy has been a constant feature of his career. In 1996, having established his reputation as an iconoclast in a series of provocative London shows, he took over from Galliano as principal designer at Givenchy. However where Galliano's work there had generally been seductively romantic, McQueen favoured a more nightmarish version of sensory intoxication. In collaboration with stylists Katie Grand and Simon Costin (respectively a future pioneer of the radical British fashion magazine *Dazed and Confused* and a jeweller whose incorporation of human tissue into his work had caused a tabloid panic in the late 1980s) he engineered fashion presentations that were shockingly audacious. In his pre-Givenchy London shows McQueen had drawn adverse press criticism for the implied misogyny (vigorously denied by the designer) that was detected in collections such as 'The Birds' (1994) where models were trussed in sellotape and imprinted with tyre marks in a suggestion of road-kill, or 'Highland Rape' (1995) in which tailored jackets and lace dresses were ripped apart and stained with blood. But regardless of the outlandish styling, many commentators acknowledged the swaggering confidence of his designs which either accentuated the sexuality of the wearer, as in his infamous bumster trousers, or displayed a dazzling virtuosity in their quasi-surgical manipulation of form and line.

Themes of horror and cruelty continued to dominate McQueen's presentations both for Givenchy and for his own label during the late 1990s. 'It's a Jungle Out There' of 1997 took the metaphor of the food chain in the natural world and extended its meaning to incorporate references to sadism and torture in urban life. Utilizing pony skin and leather, the show focused on the Thompson's gazelle of the African savannah, a creature whose vulnerable beauty and inevitable fate as prey inspired feelings of great empathy in a designer whose view of the fashion world was anything but rose-tinted. The tendency towards narrative and fable was strengthened in McQueen's Givenchy show of the same year. 'Elect Dissect' was held in the interior of a medical school and followed the chilling story of a psychopathic surgeon-cum-connoisseur. Styled by Costin, the surgeon's victims returned as avenging ghosts dressed in the imperial exotica of Spain, Burma, Japan, and Russia. Their fetishized costumes made striking reference to McQueen's interest in late Victorian dress, the anatomical plates of Andreas Vesalius, and the potential of taxidermy as a designing tool. He made his end of show bow with a falcon on his wrist.

**130 Hussein Chalayan**

Aeroplane dress, 1999

Chalayan's work has often blurred the boundaries between fashion, engineering, architecture, sculpture and product. In this piece a dress is moulded and secured like the components of an aircraft. In a further development of this theme, one piece in the collection responded to remote control, raising and lowering its panels like the elements of a wing. Such spectacular one-offs are used to complement and offset the more commercial garments which constitute the bulk of Chalayan's output, garnering valuable press coverage and critical commentary.

The Gothic obsessions continued in subsequent shows, several of which borrowed the idea of the giant tanks that artist Damien Hirst had used for similar philosophical ends in his own reflections on mortality and decay. In 'Untitled' of autumn 1997, models negotiated a glass runway that gradually filled with black ink as rain poured from the rafters and thunder rumbled in the background, and in spring 1999 the action took place within a huge translucent cube which held snow drifts, blasted trees, and ice in homage to the cult horror film *The Shining*, whilst ice-skaters in frozen layers of lace, felt, and metal circled to the musical accompaniment of howling wolves. McQueen's work thus functions on one level as a contemporary memento mori, entirely cognisant of fashion's internal dynamic as a marker of impending death. But it also, as cultural theorist Caroline Evans has pointed out, focuses popular attention on the rising relevance of an erotic nihilism which has been evident in cultural discourse for a long time, surfacing periodically in the works of de Sade, Huysmans, Bataille, and Genet, and (perhaps most radically of all) brought to prominence in the 1990s by a couturier.[15]

If McQueen's imagination was fired by dread and irrationality, the work of Turkish-born London resident Hussein Chalayan occupied a psychic terrain that offered a sense of cool, logical respite, in which the medium of fashion was reclaimed as a part of that platonic ordering of human activity which saw the clothed body take its place alongside architecture, engineering, mathematics, and philosophy as a fitting focus for creative and intellectual endeavour. Another alumnus of Central Saint Martin's, Chalayan, in his early work, shared some aspects of McQueen's obsession with mortality and decay. For his graduation show in 1993 Chalayan buried a series of dresses with piles of iron filings in his garden then dug them up to discover the effects of decomposition on their appearance and texture. On the runway, the iron residue was manipulated over the surfaces of the textile with magnets. However, far from suggesting the action of grave robbing which might have inspired McQueen to Gothic excess, Chalayan's experiment remained very much within a scientific idiom, interested in the abstract relationship between cause and effect.

Chalayan's conceptual approach to fashion design, arguably drew his practice much closer to the work of European designers such as the Belgian Martin Margiela. Like Margiela he has pioneered a presentation of fashion which seems to find its references beyond the clothing industry in the critical debates of cultural theory. Margiela's work has frequently been interpreted as a physical parallel of Jacques Derrida's theories of deconstruction. His most notable pieces appear to challenge traditional means of constructing and contextualizing clothing, subjecting the structure and life of a garment to an intense scrutiny that is more usually found in academic rather than commercial fora. In this

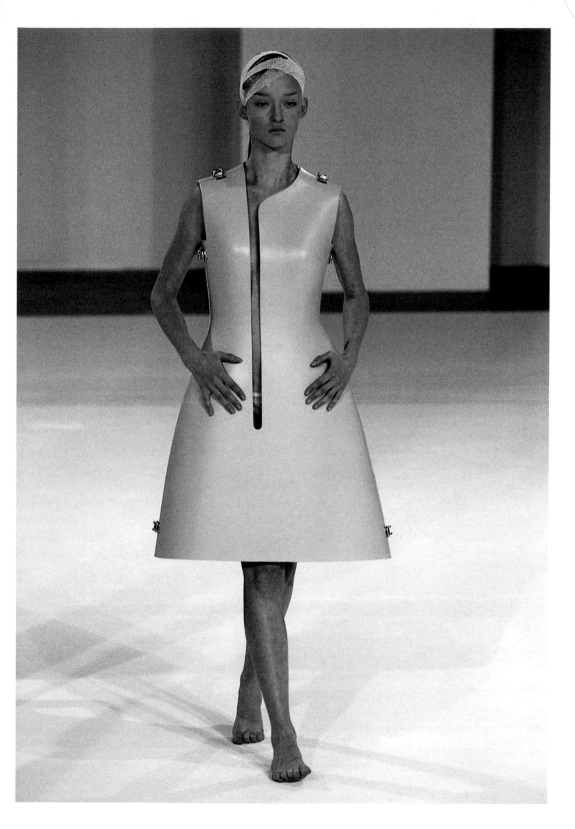

Margiela's cerebral output and its promotion as a collective statement rather than the individualized product of a single author, has much in common with Chalayan's hesitant and introspective attitude to fashion as a laboratory for furthering ideas rather than desirable commodities. However, such comparisons tend to overlook the economic imperatives bearing down on both designers. Whilst their more challenging pieces tend to receive critical acclaim in the academy, fashion journalists and curators neglect to consider the broader appeal of their less dramatic pieces in the wider marketplace. Though Chalayan's own label 'Cartesia' has enjoyed mixed financial fortunes, his idiosyncratic personal vision has translated well into the pared-down knitwear and minimalist separates which he has designed for high-street retail chains including Marks & Spencer, Top Shop, and Tse. He has also been hired to transform the identity of traditional British jewellery firm Asprey.

Chalayan's vision, though occasionally constrained by its perceived non-commercial bias, thus claims a clarity of purpose and sense of impact that have nevertheless succeeded (along with artists like Lucy Orta and labels like Samsonite, Prada, CP Company and Vexed Generation) in shifting the paradigm of directional fashion as an expressive medium. Its concern with issues of technical precision and high-performance capabilities looks back towards the functional precepts of high modernism, which formerly tended to reject any treatment of fashion as a frippery, and resonates with a contemporary interest in the ambivalent potential of cybernetics, surveillance, virtuality, and new concepts of mobility for transforming the landscape of twenty-first-century life. In the grammar of creativity pioneered by Chalayan and his generation, fashion thus finds a renewed and respectable relevance. The resolution of the clothing collection is placed on a par with the design of transport systems, urban planning, and communication networks as an active medium of critique and change. His various millennial collections, presented between 1999 and 2001 have all engaged with futuristic concepts and disciplinary cross-fertilization: the furniture suite that transforms into a set of clothes, the paper dress that opens out into a giant airmail envelope, and the fuselage-like carapace of cantilevered panels that automatically rise and fall to reveal the goffered tulle of a ballerina's skirt.[16]

These are the powerful images produced by fashion culture at the start of a new century. Unsettling and novel though their implications may seem, they do not arise out of, nor exist within a vacuum. They profit from a genealogy and infrastructure established at least two centuries earlier and they respond to the needs and obsessions of a social and cultural world that has entirely changed over the duration of the same period. The moral and economic challenges of the early 2000s threaten to reorder the existing scheme of life in unimaginable

ways and it may well be that the reign of modern fashion as a paradigm for the aspirations and limits of western consumer culture is approaching an end. But in Chalayan's combination of high-tech sophistry and voluptuous materiality we are able to salvage some sense of its current prescience.

# Notes

## Introduction

1. *Fashion Theory: The Journal of Dress, Body and Culture* (Oxford, 1998– ) is dedicated to the study of fashion from multi-disciplinary positions and joins periodicals like *Costume* and *Dress* which have served the needs of museum curators for over thirty years. The expanding provision for the academic study of fashion is also represented by increasing opportunities for research in the field at post-graduate level in British and American universities.

2. See Elizabeth Wilson, *Adorned in Dreams: Fashion and Modernity* (London, 1985), Fred Davis, *Fashion Culture and Identity* (Chicago, 1992), Jennifer Craik, *The Face of Fashion: Cultural Studies in Fashion* (London, 1994), Gilles Lipovetsky, *The Empire of Fashion* (Princeton, 1994),Christopher Breward, *The Culture of Fashion* (Manchester, 1995), and Diana Crane, *Fashion and Its Social Agendas* (Chicago, 2000).

3. See Thorstein Veblen, *The Theory of the Leisure Class* (New York, 1899), John C. Flugel, *The Psychology of Clothes* (London, 1930), Roland Barthes, *The Fashion System* (London, 1985), and Mike Featherstone and David Frisby (eds), *Simmel on Culture* (London, 1997).

4. See Beverly Lemire, *Fashion's Favourite: The Cotton Trade and the Consumer in Britain 1660–1800* (Oxford, 1991) and *Dress, Culture and Commerce: The English Clothing Trade before the Factory 1660–1800* (Basingstoke, 1997), Phillipe Perrot, *Fashioning the Bourgeoisie: A History of Clothing in the Nineteenth Century* (Princeton, 1994), and Daniel Roche, *The Culture of Clothing: Dress and Fashion in the Ancien Régime* (Cambridge, 1994).

5. See Janet Arnold, *A Handbook of Costume* (London, 1973), Cecil Willet and Phyllis Cunnington, *A Dictionary of English Costume* (London, 1976), Anne Buck, *Dress in Eighteenth Century England* (London, 1979), James Laver and Amy de la Haye, *Costume and Fashion: A Concise History* (London, 1995), and François Boucher, *A History of Costume in the West* (London, 1996).

6. Richard Martin's 'Fashion and Surrealism' held at the Costume Institute of the Metropolitan Museum of Art, New York in 1987 and Peter Wollen's 'Addressing the Century' held at the Hayward Gallery, London in 1999 are key examples of this tendency.

7. See Elizabeth Rouse, *Understanding Fashion* (London, 1989), Naomi Tarrant, *The Development of Costume* (London, 1994), Malcolm Barnard, *Fashion as Communication* (London, 1996), Joanne Entwistle, *The Fashioned Body* (Cambridge, 2000), and Lou Taylor, *The Study of Dress History* (Manchester, 2002).

## Chapter 1. The Rise of the Designer

1. See Aileen Ribeiro, *The Art of Dress: Fashion in England and France 1750–1820* (New Haven, 1995) and *Ingres in Fashion: Representations of Dress and Appearance in Ingres' Images of Women* (New Haven, 1999) for a detailed account of these formative years in the history of Parisian fashion. Phillipe Perrot in *Fashioning the Bourgeoisie: A History of Clothing in the Nineteenth Century* (Princeton, 1994) offers a useful reconstruction of the organization of the clothing trades in the city at the time of Worth, whilst Valerie Steele's *Paris Fashion* (Oxford, 1998) provides the most comprehensive overview of the rise of Paris as a fashion centre.

2. For an indication of London's thriving commercial culture in the early nineteenth century see Celina Fox, *London: World City 1800–1840* (New Haven, 1992).

3. Alison Gernsheim's classic *Fashion and Reality 1840–1914* (New York, 1981) offers useful descriptions of the many competing styles which constituted the fashionable wardrobe by the late nineteenth century, against which Worth's claims as an innovator can be set.

4. Paul Poiret's autobiography *My First Fifty Years* (London, 1931) is full of such colourful anecdotes. Whilst not wholly reliable as an objective account of events, his memoir provides an entertaining insight into the psyche of a designer.

5. See Charles Rearick, *Pleasures of the Belle Epoque* (New Haven, 1985) for an account of the *louche* culture of Paris at this time.

6. Poiret's ability to imbue dress with contemporary cultural concerns through an engagement with the avant-garde is analysed in Peter Wollen's *Raiding the Icebox: Reflections on Twentieth-Century Culture* (London, 1993).

7. Such concerns were also associated with the figure of the New Woman whose impact is assessed by Elaine Showalter in *Sexual Anarchy: Gender and Culture at the Fin de Siècle* (London, 1991).

8. More work needs to be done on the role of Vienna as a fashion capital during this period, but Carl E. Schorske's magisterial *Fin de Siècle Vienna: Politics and Culture* (London, 1980) provides a useful introduction to the broader context.

9. Nancy Troy offers an analysis of the promotional strategies used by Parisian designers in the period in *Modernism and the Decorative Arts in France* (New Haven, 1991).

10. For an inspiring deconstruction of the imagery of Chanel see Caroline Evans and Minna Thornton, *Women and Fashion: A New Look* (London, 1989).

11. Notable biographical accounts of Chanel's life include Marcel Haedric, *Coco Chanel: Her Life, Her Secrets* (London,

1972), C. Baillen, *Chanel Solitaire* (London, 1973), Edmonde Charles-Roux, *Chanel* (London, 1976), and *Chanel and Her World* (London, 1981), Paul Morand, *L'Allure de Chanel* (Paris, 1976), Jean Leymarie, *Chanel* (New York, 1987), and Axel Madsen, *Coco Chanel: A Biography* (London, 1990).

12. See P. Arizzoli-Clemental et al., *Paquin: une retrospective de 60 ans de haute couture* (Lyons, 1989).

13. The male designer Jean Patou headed one of the most prolific of the Parisian fashion houses in the 1920s and his sports-influenced lines also offered fierce competition to Chanel. See Meredith Etherington-Smith, *Patou* (London, 1983).

## Chapter 2. Making Clothes

1. This is a definition often taken by those involved in the display of historical dress within the context of the art museum. Richard Martin and Howard Koda's work at the Costume Institute of the Metropolitan Museum of Art in New York presents the most explicit acknowledgement of this paradigm. See Richard Martin and Howard Koda, *Orientalism: Visions of the East in Western Dress* (New York, 1994), Richard Martin, *Fashion and Surrealism* (London, 1997), and Howard Koda, *Extreme Beauty* (New York, 2001).

2. See Ruth Barnes and Joanne Eicher (eds), *Dress and Gender: Making and Meaning* (Oxford, 1992) and Susan Kaiser, *The Social Psychology of Clothing* (New York, 1998), for examples of this more anthropological perspective.

3. Recent work in the field of cultural studies has begun to focus on fashion as an exemplar of the relationship between practices of production and consumption in contemporary society. See the essay 'Fashion: Unpacking a Cultural Production' by Peter Braham in Paul du Gay's edited collection *Production of Culture: Cultures of Production* (London, 1997), pp. 121–69.

4. Following the influential publication of Roland Barthes's *The Fashion System* (London, 1985) several authors have attempted to pinpoint the elusive nature of fashionability. The collections *Chic Thrills* edited by Juliet Ash and Elizabeth Wilson (London, 1991) and *Defining Dress* edited by Amy de la Haye and Elizabeth Wilson (Manchester, 1999) present a selection of essays whose findings offer various interpretations. See also Anne Hollander's *Seeing Through Clothes* (Berkeley, 1978), Gilles Lipovetsky's *The Empire of Fashion* (Princeton, 1994), and A. Warwick and D. Cavallaro's *Fashioning the Frame* (Oxford, 1998).

5. There are several studies of the history and workings of the couture house, though many of them tend to replicate the mythology of the sector rather than subject it to close analysis. Among the most useful are Diana De Marly's *The History of Couture 1850–1950* (London, 1980), Caroline Rennolds Milbank's *Couture* (New York, 1985), and Beverly Birks's *Haute Couture 1870–1970* (Tokyo, 1993).

6. Indeed it was not uncommon for middle-class women in Britain and America to make use of a professional dressmaker for special items as late as the 1960s and 1970s.

7. See James Schmiechen's *Sweated Industries and Sweated Labour: The London Clothing Trades, 1860–1914* (London, 1984).

8. David Hounshell's *From the American System to Mass Production, 1800–1932* (Baltimore, 1984) and Barbara Burman's *The Culture of Sewing* (Oxford, 1999) offer interesting accounts of the impact of the sewing machine.

9. See Andrew Godley, *Jewish Immigrant Entrepreneurship in New York and London, 1880–1914* (Basingstoke, 2001).

10. A great deal of fashion literature, some of it autobiographical, reflects the energy of the ready-to-wear business. Notable examples include Eric Newby's *Something Wholesale* (London, 1962), Bernard Roshco's *The Rag Race* (New York, 1963), Leonard Halliday's *The Fashion Makers* (London, 1966), W. Vecchio and R. Riley's publication of the same name (New York, 1968), and Roma Fairley's *A Bomb in the Collection: Fashion with the Lid Off* (Brighton, 1969).

11. See Eric Sigsworth's *Montague Burton, the Tailor of Taste* (Manchester, 1990) and Frank Mort's essay 'Montague Burton, the Tailor of Taste' in his own *Cultures of Consumption: Masculinities and Social Space in Late Twentieth-Century Britain* (London, 1996), pp. 134–43. Other enlightening studies of the organization of the menswear industry, several written as company histories, include John Taylor's *It's a Small, Medium, Outsize World* (London, 1966), Richard Walker's *The Savile Row Story* (London, 1988), Berry Ritchie's *A Touch of Class: The Story of Austin Reed* (London, 1990), David Wainwright's *The British Tradition: Simpson* (London, 1996), and Katrina Honeyman's *Well Suited: A History of the Leeds Clothing Industry, 1850–1990* (Oxford, 2000).

12. M. L. Disher's *American Factory Production of Women's Clothing* (London, 1947) and Margaret Wray's *The Women's Outerwear Industry* (London, 1957) provide a comprehensive overview of the sector as it existed on both sides of the Atlantic at mid-century.

13. See Christopher Sladen's *The Conscription of Fashion* (Aldershot, 1995).

14. Contrary to the expectations raised by its title, Ben Fine and Ellen Leopold's *The World of Consumption* (London, 1993) includes a useful examination of the mass-production of fashion in the late twentieth century.

15. See Annie Phizacklea's *Unpacking the Fashion Industry* (London, 1990) and Andrew Ross's *No Sweat* (London, 1997) for polemical accounts of human rights abuses within the fashion industry.

16. Charles F. Sabel and Jonathan Zeitlin address the issue of flexible specialization in their *World of Possibilities: Flexibility and Mass Production in Western Industrialisation* (Cambridge, 1997).

17. Angela McRobbie offers the most comprehensive history of fashion education in Britain in her *British Fashion Design: Rag Trade or Image Industry* (London, 1998). Individual colleges have also published accounts of their own histories, for example Helen Reynolds on the London College of Fashion in *Couture or Trade* (Chichester, 1997) and Christopher Frayling and Clare Catterall on the Royal College of Art in *Design of the Times* (London, 1996).

## Chapter 3. Innovating Change

1. Examples of an anthropological approach to dress include T. Polhemus and L. Proctor, *Fashion and Anti-Fashion* (London, 1978), J. Cordwell and R. Schwartz, *The Fabrics of Culture: An Anthropology of Clothing and Adornment* (The Hague, 1979), and Ruth Barnes and Joanne Eicher, *Dress and Gender: Making and Meaning* (Oxford, 1992).

2. Though Joanne Entwhistle in *The Fashioned Body*

(Cambridge, 2000) makes a convincing argument for the closer consideration of embodiment as a vital component of the fashion experience.

3. See Naomi Tarrant, *The Development of Costume* (London, 1994) for an account of the status of surviving clothing written from the perspective of a museum curator.

4. In his *Theory of the Leisure Class* (New York, 1899), the economist Thorstein Veblen provided the most influential account of the social impulse to display that lay behind late nineteenth-century high fashion.

5. Stella Mary Newton's *Health, Art and Reason: Dress Reformers of the Nineteenth Century* (London, 1974) is still unsurpassed as an account of the influence of the Arts and Crafts movement on fashion.

6. See David Kunzle, *Fashion and Fetishism* (Ottawa, 1982), Valerie Steele, *Fashion and Eroticism* (Oxford, 1985) and *The Corset: A Cultural History* (New Haven, 2001), and Leigh Summers, *Bound to Please* (Oxford, 2001) for a comprehensive rehearsal of nineteenth-century debates on the moulding of the body.

7. Other than Newton's *Health, Art and Reason*, there is little published in English on Jaeger's career and philosophies. Elisabeth Kaufmann's *Gustave Jaeger 1832–1917* (Zurich, 1984) offers a detailed study in German.

8. G. K. Chesterton, *George Bernard Shaw* (London, 1910), p. 95, cited in Newton, *Health, Art and Reason*, p. 139.

9. Elsa Schiaparelli, *Shocking Life* (London, 1954), p. 46.

10. Amelia Jones, 'The Ambivalence of Male Masquerade: Duchamp as Rrose Sélavy' (pp. 21–31)and Briony Fer, 'The Hat, the Hoax, the Body' (pp. 161–73) on aspects of the Surrealist body and its relationship to dress in the collection edited by Kathleen Adler and Marcia Pointon, *The Body Imaged* (Cambridge, 1993) provide a useful background against which Schiaparelli's work can be read.

11. See Marius Kwint, Christopher Breward, and Jeremy Aynsley (eds) *Material Memories: Design and Evocation* (Oxford, 1999).

12. Schiaparelli, *Shocking Life*, p. 229.

13. See Mark Wigley, *White Walls: Designer Dresses* (Boston, 1995), Christopher Reed, *Not at Home* (London, 1996), Richard Martin, *Cubism and Fashion* (New York, 1998), and Ulrich Lehmann, *Tigersprung: Fashion and Modernity* (Boston, 2000) for interesting discussions of the relationship between modernism and fashion.

14. Cited in Lesley Miller's exemplary *Cristóbal Balenciaga* (London, 1993).

15. See Margherita Guerritore's *Ungaro* (Milan, 1992) and Valerie Guillaume's *Courrèges* (London, 1998) for accounts of these designers' work. Joel Lobenthal's *Radical Rags: Fashion of the Sixties* (New York, 1990) offers a useful overview of the sea-change in attitudes towards design which encouraged Balenciaga's retirement.

16. Yves Saint Laurent and Diana Vreeland, *Yves Saint Laurent* (New York, 1983), pp. 23–4.

17. See Valerie Mendes, *Pierre Cardin: Past, Present, Future* (London, 1990).

18. There are underlying plays with the construction of gender identity and notions of creativity at work here. Whereas Saint Laurent's image conforms to a feminized notion of the passive romantic, Miyake utilizes the robust persona of the male artist/maker.

19. See Leonard Koren, *New Fashion Japan* (Tokyo, 1984) and Richard Martin and Howard Koda, *Orientalism: Visions of the East in Western Dress* (New York, 1994).

20. Issey Miyake, *Making Things* (Paris, New York, 1998), p. 150.

21. See Donna Haraway, *Simians, Cyborgs and Women* (London, 1991) for a discussion of the cultural and political context of human/machine debates in the 1980s.

22. It should also be noted that 'Pleats Please' was a relatively cheap diffusion range which in some ways replicated the easy-care, anti-glamour rhetoric of post-war mass fashion marketing. Herein lies the biggest gap in meaning between the artistic promotion of Miyake's work and its functional reality.

## Chapter 4. Disseminating Desire

1. Fred Davis, *Fashion, Culture and Identity* (Chicago, 1992), p. 151.

2. See Marshall Berman, *All that is Solid Melts into Air* (London, 1983) for the classic account of this process and its cultural effects. This text follows in a tradition best exemplified by the work of Walter Benjamin, whose unfinished *Arcades Project* (Cambridge, MA, 1999) is prototypical of a Marxist approach which aims to critique the workings of consumer culture whilst remaining enthralled by the spectacle of its products.

3. See Joanne Finkelstein, *The Fashioned Self* (Cambridge, 1991).

4. Ellen Moer's *The Dandy: Brummell to Beerbohm* (London, 1960) still provides the clearest guide to the history of dandyism in literature.

5. See Clare Hughes's *Henry James and the Art of Dress* (Basingstoke, 2001).

6. See the catalogue of the Hayward Gallery exhibition *Addressing the Century: 100 Years of Art and Fashion* (London, 1998).

7. For trenchant examinations of the rise of celebrity culture see Rhonda Garelick, *Rising Star: Dandyism, Gender and Performance* (Princeton, 1998), and Chris Rojek, *Celebrity* (London, 2001).

8. Joel Kaplan and Sheila Stowell, *Theatre and Fashion: Oscar Wilde to the Suffragettes* (Cambridge, 1994).

9. See Peter Bailey's *Popular Culture and Performance in the Victorian City* (Cambridge, 1998) and Erika Rappaport's *Shopping for Pleasure: Women in the Making of London's West End* (Princeton, 2000) for detailed studies of fashion tie-ins in theatres and department stores at the turn of the century. Andreas Huyssen offers a more theorized account of the feminization of popular culture in the early twentieth century in his *After the Great Divide: Modernism, Mass Culture, Postmodernism* (Basingstoke, 1988).

10. Edmonde Charles-Roux, *Théâtre de la Mode* (New York, 1991).

11. There are many celebratory publications focusing on the supposedly glamorous world of modelling, the most interesting are autobiographical. Notable examples include Jean Shrimpton's *The Truth About Modelling* (London, 1964) and *An Autobiography* (London, 1990), Lucie Clayton's *The World of Modelling* (London, 1968), and Twiggy's *Twiggy: An*

*Autobiography* (London, 1975). Michael Gross's *Model: The Ugly Business of Beautiful Women* (New York, 1995) offers a more objective analysis.

12. Rebecca Arnold's *Fashion Desire and Anxiety: Image and Morality in the Twentieth Century* (London, 2001) provides an enlightening slant on this phenomenon.

13. The jean enjoys a literature all of its own. Lee Hall's *Common Threads: A Parade of American Clothing* (Boston, 1992) sets it in the material context of the history of American dress while Stuart and Elizabeth Ewen's *Channels of Desire: Mass Images and the Shaping of America* (Minneapolis, 1992) see it as a repository of shifting cultural values.

14. See the essays in Jane Pavitt's edited collection *Brand.new* (London, 2000) for a description of the shift in branding practices from attempts to guarantee consistency and quality by manufacturers of medicines and foodstuffs in the early nineteenth century to the emphasis on fashionable associative qualities which defines product branding today.

## Chapter 5. Fashion on the Page

1. See Thomas Richards, *The Commodity Culture of Victorian Britain* (London, 1991) for an exposition on the cultural impact of the mass-reproduced image in the nineteenth century.

2. In their *Social Communication as Advertising* (New York, 1986), W. Leiss, S. Kline and S. Jhally provide a useful account of this shift towards the concept of lifestyle. Celia Lury's *Consumer Culture* (Cambridge, 1996) offers a more recent summary of the relevant literature in this field.

3. See Margaret Beetham, *A Magazine of Her Own? Domesticity and Desire in the Woman's Magazine 1800–1914* (London, 1996) for an interpretation of the uses made of fashion magazines by nineteenth-century consumers. *Victorian Women's Magazines: An Anthology* (Manchester, 2001) edited by Beetham and Kay Boardman presents a good selection of original material.

4. Madeleine Ginsburg's *An Introduction to Fashion Illustration* (London, 1980) still provides the most comprehensive summary of the stylistic history of pictorial fashion journals.

5. See David Crowley and Paul Jobling's *Graphic Design: Reproduction and Representation since 1800* (Manchester, 1996) for a critical history of the fashion press and its developing product in the modern period.

6. Teal Triggs's *Communicating Design: Essays in Visual Communication* (London, 1995) offers a rewarding analysis of the formal design of magazines.

7. There is an extensive literature devoted to the history of fashion photography, much of it produced in lavish style for a popular audience. Brett Rogers and Val Williams (eds) *Look at Me: Fashion and Photography in Britain 1960–1999* (London, 1999) includes an exceptionally trenchant essay on the history of the genre in the UK (Val Williams, 'Fashion was the Least Important Thing', pp. 99–117), whilst Martin Harrison's *Appearances: Fashion Photography Since 1945* (London, 1991) is an informed survey of international developments.

8. See Roger Sabin, *Comics, Comix and Graphic Novels* (London, 1996).

9. See Dick Hebdige, *Hiding in the Light: On Images and Things* (London, 1988) and Paul Jobling, *Fashion Spreads: Word and Image in Fashion Photography since 1980* (Oxford, 1999).

10. This questioning of the boundaries of the fashion photograph has also been a driving force in the recent production of digitally manipulated images by photographers including Nick Knight and the reframing of the fashion image as fine art in the work of Jeurgen Teller, Wolfgang Tilmans, and Rankin.

## Chapter 6. Fashion and Film

1. Aside from the many celebratory accounts of fashion in the movies or the dress of the stars, the collections *Fabrications: Costume and the Female Body* (London, 1990), edited by Jane Gaines and Charlotte Herzog, and *Stardom: Industry of Desire* (London, 1991), edited by Christine Gledhill offer critical accounts of the role played by clothing in film. Stella Bruzzi's *Undressing Cinema* (London, 1997) is the most recent example of the fashion/film studies cross-over publication.

2. See Elizabeth Leese, *Costume Design in the Movies* (New York, 1976) for a comprehensive history of fashion/film tie-ins during the early years of cinema.

3. See Bruzzi, *Undressing Cinema*, p. 26.

4. See Richard Dyer, *Heavenly Bodies: Film Stars and Society* (Basingstoke, 1986) and *Stars* (London, 1997), also Sarah Berry, *Screen Style: Fashion and Femininity in 1930s Hollywood* (Minneapolis, MN, 2000).

5. The re-creation of historical dress in film has attracted several scholars including Ed Maeder whose *Hollywood and History: Costume Design in Film* (London, 1987) provides an authoritative overview. See Susan Harper, *Picturing the Past: The Rise and Fall of the British Costume Film* (London, 1994) and Pam Cook, *Fashioning the Nation: Costume and Identity in British Cinema* (London, 1996) for a British perspective.

6. See David Desser and Garth S. Jowett (eds), *Hollywood Goes Shopping* (Minneapolis, MN, 2000).

## Chapter 7. Shopping for Style

1. See Neil McKendrick, John Brewer, and J. H. Plumb, *The Birth of a Consumer Society* (London, 1982) and John Brewer and Roy Porter (eds), *Consumption and the World of Goods* (London, 1993) for accounts of fashionable shopping practices in the early modern period.

2. See Geoffrey Crossick and Serge Jaumain (eds), *Cathedrals of Consumption: The European Department Store 1850–1939* (Aldershot, 1999), p. 6.

3. See Christopher Breward, *The Hidden Consumer: Masculinities, Fashion and City Life* (Manchester, 1999).

4. There is a large and evolving literature on the culture of the Victorian department store. Important texts in this genre include Alison Adburgham's *Shops and Shopping* (London, 1981), Michael Miller's *The Bon Marché: Bourgeois Culture and the Department Store* (London, 1981), Rosalind Williams's *Dream Worlds: Mass Consumption in Late Nineteenth-Century France* (Berkeley, 1982), Rachel Bowlby's *Just Looking* (London, 1985), Elaine Abelson's *When Ladies Go a-Thieving: Middle-Class Shoplifters in the Victorian Department Store* (Oxford, 1989), and Erika Rappaport's *Shopping for Pleasure: Women in the Making of London's West End* (Princeton, 2000).

5. See John Benson, *The Rise of Consumer Society in Britain 1880–1980* (London, 1994) and Rachel Bowlby, *Carried Away: The Invention of Modern Shopping* (London, 2000).

6. Sally Alexander's essay on the 1920s shop-girl ('Becoming a Woman in London in the 1920s and '30s' in S. Alexander (ed.), *Becoming a Woman and Other Essays in 19th and 20th Century Feminist History* (London, 1994), pp. 203–24) offers a perspective on working-class aspirations whilst Alison Light's *Forever England: Femininity, Literature and Conservatism Between the Wars* (London, 1991) provides an engaging analysis of middle-class consumerist concerns.

7. Frank Mort provides a useful account of Montague Burton's retail strategies in *Cultures of Consumption: Masculinities and Social Space in Late Twentieth-Century Britain* (London, 1996).

8. See Greville Havenhand's *Nation of Shopkeepers* (London, 1970) and Nik Cohn's *Today There are No Gentlemen* (London, 1971) for contemporary accounts of the 1960s retail revolution. J. S. Hyde Harris and G. Smith's *1966 and All That* (London, 1986) and Joel Lobenthal's *Radical Rags: Fashions of the Sixties* (New York, 1990) provide useful retrospective analyses.

9. See Raphael Samuel's essay on retro-chic in *Theatres of Memory*, Volume I (London, 1994), pp. 83–118.

10. See Rob Shields (ed.), *Lifestyle Shopping: The Subject of Consumption* (London, 1992). The psychological and sociological aspects of contemporary shopping have generated several important studies including Rachel Bowlby's *Shopping with Freud* (London, 1993), Sean Nixon's *Hard Looks: Masculinities, Spectatorship and Contemporary Consumption* (London, 1996), and Daniel Miller's *Shopping, Place and Identity* (London, 1998).

## Chapter 8. Style and Modernity

1. See Elizabeth Wilson, *Adorned in Dreams: Fashion and Modernity* (London, 1985) and Gilles Lipovetsky, *The Empire of Fashion* (Princeton, 1994) for useful accounts of the relationship between fashion and modernity.

2. Some anthropologists have focused their attention on the uses made of fashion by contemporary consumers. Ann Brydon and Sandra Niessen's *Consuming Fashion* (Oxford, 1998) is a typical example.

3. Joanne Finkelstein's *The Fashioned Self* (Cambridge, 1991) and Malcolm Barnard's *Fashion as Communication* (London, 1996) offer highly critical interpretations of the workings of the fashion system.

4. See Ellen Moers, *The Dandy: Brummell to Beerbohm* (London, 1960) and James Laver, *Dandies* (London, 1968) for classic essays on dandyism in the context of literature and dress.

5. Keith Tester (ed.), *The Flaneur* (London, 1994), Rita Felski's *The Gender of Modernity* (Cambridge, 1995), Rhonda Garelick's *Rising Star: Dandyism, Gender and Performance in the Fin de Siècle* (Princeton, 1998), Perry Meisel's *The Cowboy and the Dandy* (Oxford, 1999), and Susan Fillin-Yeh's edited collection *Dandies: Fashion and Finesse in Art and Culture* (New York, 2001) all extend the study of dandyism to a consideration of contemporary celebrity and popular culture.

6. A significant example of this trajectory would be the career of the American pop star Madonna, whose shifting image has formed the focus for several cultural studies texts including Fran Lloyd's *Deconstructing Madonna* (London, 1993) and Pamela Robertson's *Guilty Pleasures: Feminist Camp from Mae West to Madonna* (London, 1996).

7. See Efrat Tseelon's *The Masque of Femininity: Presentation of Women in Everyday Life* (London, 1995) and *Masquerade and Identities: Essays on Gender, Sexuality and Marginality* (London, 2001).

## Chapter 9. Fashion Capitals

1. It is worth noting that the relationship between fashion and rural life has received less attention than the study of the city as a centre for fashionable activities. Notable exceptions to this rule include ethnographical works on peasant dress, though much work remains to be done on themes of pastoralism in mainstream fashion.

2. The essays and reviews of architect Adolf Loos provide vivid examples of this genre of criticism. See A. Loos, *Spoken Into the Void: Collected Essays 1897–1900* (Cambridge, MA, 1982).

3. David Gilbert, 'Urban Outfitting' in Stella Bruzzi and Pamela Church Gibson (eds), *Fashion Cultures: Theories, Explorations and Analysis* (London, 2000), pp. 7–24 at p. 20.

4. See Walter Benjamin's essay 'Paris, Capital of the Nineteenth Century' reprinted in Peter Demetz (ed.), *Reflections* (New York, 1978) and Adrian Rifkind's *Street Noises: Parisian Pleasure 1900–1940* (Manchester, 1993) for a discussion of the cultural status of Paris. Valerie Steele's *Paris Fashion: A Cultural History* (Oxford, 1988) and Stephen de Pietri and Melissa Leventon's *New Look to Now: French Haute Couture 1947–1987* (New York, 1989) provide key perspectives on Paris as a fashion capital.

5. Essays by Lou Taylor ('Paris Couture, 1940–1944', pp. 127–44) and Angela Partington ('Popular Fashion and Working-class Affluence', pp. 145–61) in the collection *Chic Thrills* edited by Juliet Ash and Elizabeth Wilson (London, 1992) offer complementary studies of the context and impact of French fashion in the 1940s and early 1950s.

6. See Tamar Garb, *Bodies of Modernity* (London, 1998).

7. Elizabeth Wilson, *Adorned in Dreams: Fashion and Modernity* (London, 1985), pp. 44–6.

8. Steele, *Paris Fashion*, p. 270.

9. See Nicholas Coleridge, *The Fashion Conspiracy* (London, 1989), pp. 185–6 and Susan Faludi, *Backlash: The Undeclared War Against Women* (London, 1992), pp. 203–4, 213–17.

10. Christian Lacroix, *Pieces of a Pattern: Lacroix by Christian Lacroix* (London, 1992), p. 147.

11. Farid Chenoune, *Jean Paul Gaultier* (London, 1996), p. 15.

12. See Coleridge, *The Fashion Conspiracy*, p. 226.

13. See Andrew Tucker's *The London Fashion Book* (London, 1998) for a celebratory survey of London's contemporary fashion districts.

14. Christopher Breward, Becky Conekin, and Caroline Cox (eds), *The Englishness of English Dress* (Oxford, 2002). See also Roy Porter, *London: A Social History* (London, 1994) for a comprehensive account of the social and economic characteristics of the city which inform its industry and the appearance of its inhabitants.

15. See Amy de la Haye (ed.), *The Cutting Edge: 50 Years of British Fashion* (London, 1997), Colin McDowell, *Forties Fashion and the New Look* (London, 1997), and Christopher Sladen, *The Conscription of Fashion* (Aldershot, 1995) for useful interpretations of English style in this important period.

16. Mary Quant, *Quant by Quant* (London, 1966), pp. 34–5.

17. *Quant by Quant*, p. 43.

18. Arthur Marwick is one of several historians who have

attached great importance to Quant's career. See his *The Sixties: Cultural Revolutions in Britain, France and the US 1958–1974* (Oxford, 1998), p. 466.

19. For commentaries on the significance of Punk in late twentieth-century British culture see Jon Savage, *England's Dreaming: The Sex Pistols and Punk Rock* (London, 1991), Greil Marcus, *Lipstick Traces* (London, 1989) and *In the Fascist Bathroom: Writings on Punk, 1977–1992* (London, 1993), Michael Bracewell, *England is Mine: Pop Life in Albion from Wilde to Goldie* (London, 1997), and Roger Sabin (ed.), *Punk Rock, So What?* (London, 1999).

20. The personality and output of Vivienne Westwood have inspired several publications, among the most rewarding are Fred Vermorel's bizarre *Fashion and Perversity: A Life of Vivienne Westwood and the Sixties Laid Bare* (London, 1996), Jane Mulvagh's lively biography *Vivienne Westwood: An Unfashionable Life* (London, 1998), and Kevin Davey's *English Imaginaries* (London, 1999).

21. Ingrid Sischy, *Donna Karan New York* (London, 1998), p. 14.

22. Adrian Forty, *Objects of Desire* (London, 1986). See also Andrew Heinz, *Adapting to Abundance: Jewish Immigrants, Mass Consumption and the Search for American Identity* (New York, 1990).

23. The American clothing company Gap has become a target, alongside fast-food retailers McDonald's and Starbucks, for criticism by anti-globalization activists who see in its striving for market domination a damaging irreverence for local cultures, economies, and traditions. See Naomi Klein, *No Logo* (London, 2000).

24. Nancy Green, 'Sweatshop Migrations' in David Ward and Oliver Zunz (eds), *The Landscape of Modernity: New York City 1900–1940* (Baltimore, 1992), pp. 213–32 at p. 214. For further relevant accounts of the history of New York see Frederick Binder and David Reimers, *All the Nations under Heaven: An Ethnic and Racial History of New York City* (New York, 1995), George Lankevich, *American Metropolis* (New York, 1998), and Christopher Mulvey and John Simons (eds), *New York: City as Text* (London, 1990).

25. See Maureen Montgomery, *Displaying Women: Spectacles of Leisure in Edith Wharton's New York* (New York, 1998) and Clair Hughes, *Henry James and the Art of Dress* (Basingstoke, 2001).

26. Of the several texts focusing on New York fashion, two offer useful introductory perspectives. The first, which takes an economic bias is Nancy Green's *Ready to Wear, Ready to Work* (Durham, NC, 1997). The second, concerned largely with style and consumption, is Caroline Rennolds Milbank's *New York Fashion: The Evolution of American Style* (New York, 1989). See also Sarah Tomerlin Lee's *American Fashion* (London, 1975) and Lee Hall's *Common Threads: A Parade of American Clothing* (Boston, 1992).

27. Ralph Lauren entry in Sara Prendergast (ed.), *Contemporary Designers* (Detroit, 1997), p. 476.

28. Penny Sparke's *Italian Design 1870 to the Present* (London, 1988) is a useful introduction to the broader design context of modern Italy. There is little published in English specifically on Italian fashion but Nichola White's *Reconstructing Italian Fashion* (Oxford, 2000) offers a detailed account of the formation of the industry in the post-war period.

29. See Reka Buckley and Stephen Gundle's essay 'Flash Trash: Gianni Versace and the Theory and Practice of Glamour' in Bruzzi and Church Gibson, *Fashion Cultures*, pp. 331–48.

30. See Valerie Steele's essay 'The Italian Look' in Giannino Malossi (ed.), *Volare: The Icon of Italy in Global Pop Culture* (New York, 1999), pp. 88–93 at p. 91.

31. Giorgio Armani entry in Prendergast, *Contemporary Designers*, p. 25.

32. Richard Martin, 'Milano 02138' in Malossi, *Volare*, pp. 76–80. Further consideration of the impact of the Armani suit can be found in Anne Hollander, *Sex and Suits* (New York, 1994).

## Chapter 10. Fashion and Identity

1. See Colin Campbell, *The Romantic Ethic and the Spirit of Modern Consumerism* (Oxford, 1987) and Elizabeth Wilson, *Bohemians: The Glamorous Outcasts* (London, 2000).

2. See Georg Simmel, *Fashion, Individuality and Social Forms* (Chicago, 1971), Richard Sennett, *The Fall of Public Man* (London, 1986), Alexandra Warwick and Dani Cavallaro, *Fashioning the Frame* (Oxford, 1998), and Joanne Entwistle, *The Fashioned Body* (Cambridge, 2000).

3. Recent critical writings on fashion have tended to focus on these more polemical and discursive issues in their examination of dress. Prime examples of the genre would include Caroline Evans and Minna Thornton, *Women and Fashion: A New Look* (London, 1989), Angela McRobbie (ed.), *Zoot Suits and Second Hand Dresses* (Basingstoke, 1989), and Shari Benstock and Suzanne Ferriss (eds), *On Fashion* (New Brunswick, 1994). Such texts are primarily interested in the ways in which gendered identities are performed through sartorial means, sharing common ground with the influential ideas of Judith Butler as expressed in *Gender Trouble: Feminism and the Subversion of Identity* (New York, 1990).

4. Wilson, *Bohemians*, p. 169.

5. See Birgitte Soland, *Becoming Modern: Young Women and the Reconstruction of Womanhood in the 1920s* (Princeton, 2000).

6. See Entwistle, *The Fashioned Body*, pp. 169–72, for a summary of academic debates regarding the significance of the flapper's dress.

7. The two most influential texts on subcultural practices have been Stuart Hall and Tony Jefferson (eds), *Resistance through Rituals* (London, 1977) and Dick Hebdige, *Subculture: The Meaning of Style* (London, 1979). The bias of these interpretations towards the experience of young men has been challenged by Angela McRobbie in *Feminism and Youth Culture* (London, 1991). For a more explicit discussion of the relationship between clothing styles and subcultural affiliations see Ted Polhemus, *Streetstyle* (London, 1994) and Cathie Dingwall and Amy de la Haye, *Surfers, Soulies, Skinheads and Skaters* (London, 1996). David Muggleton's *Inside Subculture: The Postmodern Meaning of Style* (Oxford, 2000) addresses the theme using the opinions of the young themselves.

8. See Nik Cohn, *Today There Are No Gentlemen* (London, 1971), Stanley Cohen, *Folk Devils and Moral Panics* (London, 1972), and Bill Osgerby, *Youth in Britain since 1945* (Oxford, 1998) for a history of British street styles since the Second World War. Farid Chenoune's *A History of Men's Fashion* (Paris, 1996) is excellent in its coverage of American and European equivalents.

9. Jon Savage presents the most perceptive account of Punk in *England's Dreaming: The Sex Pistols and Punk Rock* (London, 1991). See also Alan Tomlinson (ed.), *Consumption, Identity and Style* (London, 1990) and Roger Sabin (ed.), *Punk Rock, So What?* (London, 1999) for an analysis of its cultural legacy.

10. See Sara Thornton, *Club Cultures: Music, Media and Subcultural Capital* (Cambridge, 1995).

11. Hebdige, *Subculture*, p. 117.

12. Ian Griffiths's essay 'The Invisible Man' in Ian Griffiths and Nichola White (eds), *The Fashion Business: Theory, Practice, Image* (Oxford, 1999), pp. 69–90, is critical of the turn towards representation and spectacle in contemporary fashion practice. See Susannah Frankel's interviews with contemporary designers in *Visionaries* (London, 2001), alongside Colin McDowell, *Fashion Today* (London, 2000), Claire Wilcox (ed.), *Radical Fashion* (London, 2001), and Rebecca Arnold, *Fashion, Desire and Anxiety* (London, 2001), for further discussion of this fraught moral and creative terrain.

13. France Grand, *Comme des Garçons* (London, 1998) and Deyan Sudjic, *Rei Kawakubo and Comme des Garçons* (London, 1990).

14. Colin McDowell, *Galliano* (London, 1997).

15. Caroline Evans, 'Desire and Dread: Alexander McQueen and the Contemporary Femme Fatale' in Joanne Entwistle and Elizabeth Wilson (eds), *Body Dressing* (Oxford, 2001), pp. 211–12.

16. See Andrew Bolton, *The Supermodern Wardrobe* (London, 2002).

# Further Reading

## Introduction

Arnold, Janet, *A Handbook of Costume*, London, 1973.

Barnard, Malcolm, *Fashion as Communication*, London, 1996.

Barthes, Roland, *The Fashion System*, London, 1985.

Boucher, François, *A History of Costume in the West*, London, 1996.

Breward, Christopher, *The Culture of Fashion*, Manchester, 1995.

Buck, Anne, *Dress in Eighteenth Century England*, London, 1979.

Craik, Jennifer, *The Face of Fashion: Cultural Studies in Fashion*, London, 1994.

Crane, Diana, *Fashion and Its Social Agendas*, Chicago, 2000.

Davis, Fred, *Fashion, Culture and Identity*, Chicago, 1992.

Entwistle, Joanne, *The Fashioned Body*, Cambridge, 2000.

Featherstone, Mike and David Frisby (eds), *Simmel on Culture*, London, 1997.

Flugel, John C., *The Psychology of Clothes*, London, 1930.

Laver, James and Amy de la Haye, *Costume and Fashion: A Concise History*, London, 1995.

Lemire, Beverly, *Fashion's Favourite: The Cotton Trade and the Consumer in Britain 1660–1800*, Oxford, 1991.

Lemire, Beverly, *Dress, Culture and Commerce: The English Clothing Trade before the Factory*, Basingstoke, 1997.

Lipovetsky, Gilles, *The Empire of Fashion*, Princeton, 1994.

Mendes, Valerie and Amy de la Haye, *20th Century Fashion*, London, 1999.

Perrot, Phillipe, *Fashioning the Bourgeoisie: A History of Clothing in the Nineteenth Century*, Princeton, 1994.

Roche, Daniel, *The Culture of Clothing: Dress and Fashion in the Ancien Régime*, Cambridge, 1994.

Rouse, Elizabeth, *Understanding Fashion*, London, 1989.

Tarrant, Naomi, *The Development of Costume*, London, 1994.

Taylor, Lou, *The Study of Dress History*, Manchester, 2002.

Veblen, Thorstein, *The Theory of the Leisure Class*, New York, 1899.

Willet, Cecil and Phyllis Cunnington, *A Dictionary of English Costume*, London, 1976.

Wilson, Elizabeth, *Adorned in Dreams: Fashion and Modernity*, London, 1985.

## Chapter 1. The Rise of the Designer

Arizzoli-Clemental, P. et al., *Paquin: une retrospective de 60 ans de haute couture*, Lyons, 1989.

Baillen, C., *Chanel Solitaire*, London, 1973.

Charles-Roux, Edmonde, *Chanel*, London, 1976.

Charles-Roux, Edmonde, *Chanel and Her World*, London, 1981.

Coleman, Elizabeth Ann, *The Opulent Era: Fashions of Worth, Doucet and Pingat*, London, 1989.

De la Haye, Amy and Shelley Tobin, *Chanel: The Couturiere at Work*, London, 1994.

De Marly, Diana, *Worth: Father of Haute Couture*, London, 1980.

Deslandres, Yvonne and Dorothy Lalanne, *Paul Poiret 1879–1944*, London, 1987.

Etherington-Smith, Meredith, *Patou*, London, 1983.

Evans, Caroline and Minna Thornton, *Women and Fashion: A New Look*, London, 1989.

Fox, Celina, *London: World City 1800–1840*, New Haven, 1992.

Gernsheim, Alison, *Fashion and Reality 1840–1914*, New York, 1981.

Haedric, Marcel, *Coco Chanel: Her Life, Her Secrets*, London, 1972.

Leymarie, Jean, *Chanel*, New York, 1987.

Madsen, Axel, *Coco Chanel: A Biography*, London, 1990.

Morand, Paul, *L'Allure de Chanel*, Paris, 1976.

Poiret, Paul, *My First Fifty Years*, London, 1931.

Rearick, Charles, *Pleasures of the Belle Epoque*, New Haven, 1985.

Ribeiro, Aileen, *The Art of Dress: Fashion in England and France 1750–1820*, New Haven, 1995.

Ribeiro, Aileen, *Ingres in Fashion: Representations of Dress and Appearance in Ingres' Images of Women*, New Haven, 1999.

Schorske, Carl, *Fin de Siècle: Vienna Politics and Culture*, London, 1980.

Showalter, Elaine, *Sexual Anarchy*, London, 1991.

Steele, Valerie, *Paris Fashion*, Oxford, 1998.

Troy, Nancy, *Modernism and the Decorative Arts in France*, New Haven, 1991.

Wollen, Peter, *Raiding the Icebox: Reflections on Twentieth-Century Culture*, London, 1993.

## Chapter 2. Making Clothes

Ash, Juliet and Elizabeth Wilson (eds), *Chic Thrills*, London, 1992.

Barnes, Ruth and Joanne Eicher (eds), *Dress and Gender: Making and Meaning*, Oxford, 1992.

Birks, Beverly, *Haute Couture 1870–1970*, Tokyo, 1993.

Braham, Peter, 'Fashion: Unpacking a Cultural Production' in Paul du Gay (ed.), *Production of Culture: Cultures of Production*, London, 1997, pp. 121–69.

Burman, Barbara, *The Culture of Sewing*, Oxford, 1999.

De la Haye, Amy and Elizabeth Wilson (eds), *Defining Dress*, Manchester, 1999.

De Marly, Diana, *The History of Couture 1850–1950*, London, 1980.

Disher, M. L., *American Factory Production of Women's Clothing*, London, 1947.

Fairley, Roma, *A Bomb in the Collection: Fashion with the Lid Off*, Brighton, 1969.

Fine, Ben and Ellen Leopold, *The World of Consumption*, London, 1993.

Frayling, Christopher and Clare Catterall, *Design of the Times*, London, 1996.

Godley, Andrew, *Jewish Immigrant Entrepreneurship in New York and London, 1880–1914*, Basingstoke, 2001.

Halliday, Leonard, *The Fashion Makers*, London, 1966.

Hollander, Anne, *Seeing Through Clothes*, Berkeley, 1978.

Honeyman, Katrina, *Well Suited: A History of the Leeds Clothing Industry, 1850–1990*, Oxford, 2000.

Hounshell, David, *From the American System to Mass Production, 1800–1932*, Baltimore, 1984.

Jarnow, Jeanette and Beatrice Judelle, *Inside the Fashion Business*, New York, 1965.

Kaiser, Susan, *The Social Psychology of Clothing*, New York, 1998.

Koda, Howard, *Extreme Beauty*, New York, 2001.

McRobbie, Angela, *British Fashion Design: Rag Trade or Image Industry*, London, 1998.

Martin, Richard, *Fashion and Surrealism*, London, 1997.

Martin, Richard and Howard Koda, *Orientalism: Visions of the East in Western Dress*, New York, 1994.

Milbank, Caroline Rennolds, *Couture*, New York, 1985.

Mort, Frank, *Cultures of Consumption: Masculinities and Social Space in late Twentieth-Century Britain*, London, 1996.

Newby, Eric, *Something Wholesale*, London, 1962.

Phizacklea, Annie, *Unpacking the Fashion Industry*, London, 1990.

Reynolds, Helen, *Couture or Trade*, Chichester, 1997.

Ritchie, Berry, *A Touch of Class: The Story of Austin Reed*, London, 1990.

Roshco, Bernard, *The Rag Race*, New York, 1963.

Ross, Andrew, *No Sweat*, London, 1997.

Sabel, Charles F. and Jonathan Zeitlin, *World of Possibilities: Flexibility and Mass Production in Western Industrialisation*, Cambridge, 1997.

Schmiechen, James, *Sweated Industries and Sweated Labour: The London Clothing Trades, 1860–1914*, London, 1984.

Sigsworth, Eric, *Montague Burton, the Tailor of Taste*, Manchester, 1990.

Sladen, Christopher, *The Conscription of Fashion*, Aldershot, 1995.

Taylor, John, *It's A Small, Medium, Outsize World*, London, 1966.

Vecchio, W. and R. Riley, *The Fashion Makers*, New York, 1968.

Wainwright, David, *The British Tradition: Simpson*, London, 1996.

Walker, Richard, *The Savile Row Story*, London, 1988.

Warwick, Alexandra and Dani Cavallaro, *Fashioning the Frame*, Oxford, 1998.

Wray, Margaret, *The Women's Outerwear Industry*, London, 1957.

## Chapter 3. Innovating Change

Adler, Kathleen and Marcia Pointon (eds), *The Body Imaged*, Cambridge, 1993.

Benaim, Laurence, *Issey Miyake*, London, 1997.

Berge, Pierre, *Yves Saint Laurent*, London, 1997.

Colchester, Chloë, *The New Textiles*, London, 1993.

Cordwell, J. and R. Schwartz, *The Fabrics of Culture: An Anthropology of Clothing and Adornment*, The Hague, 1979.

Demornex, Jacqueline, *Madeleine Vionnet*, London, 1991.

Fer, Briony, 'The Hat, the Hoax, the Body' in Kathleen Adler and Marcia Pointon, (eds), *The Body Imaged*, Cambridge, 1993, pp. 161–73.

Guerritore, Margherita, *Ungaro*, Milan, 1992.

Guillaume, Valerie, *Courrèges*, London, 1998.

Handley, Susannah, *Nylon*, Baltimore, 1999.

Haraway, Donna, *Simians, Cyborgs and Women*, London, 1991.

Healy, Robin (ed.), *Balenciaga: Masterpieces of Fashion Design*, Melbourne, 1992.

Holborn, Mark, *Issey Miyake*, Cologne, 1995.

Jones, Amelia, 'The Ambivalence of Male Masquerade: Duchamp as Rrose Sélavy' in Kathleen Adler and Marcia Pointon (eds), *The Body Imaged*, Cambridge, 1993, pp. 21–31.

Jouve, Marie Andrée and Jacqueline Demornex, *Balenciaga*, London, 1989.

Kaufmann, Elisabeth, *Gustave Jaeger 1832–1917*, Zurich, 1984.

Kirke, Betty, *Madeleine Vionnet*, New York, 1998.

Koike, Kazuko (ed.), *Issey Miyake: East Meets West*, Tokyo, 1978.

Koren, Leonard, *New Fashion Japan*, Tokyo, 1984.

Kunzle, David, *Fashion and Fetishism*, Ottowa, 1982.

Kwint, Marius, Christopher Breward, and Jeremy Aynsley (eds), *Material Memories: Design and Evocation*, Oxford, 1999.

Lehmann, Ulrich, *Tigersprung: Fashion and Modernity*, Boston, 2000.

Lobenthal, Joel, *Radical Rags: Fashions of the Sixties*, New York, 1990.

Martin, Richard, *Cubism and Fashion*, New York, 1998.

Mendes, Valerie, *Pierre Cardin: Past, Present, Future*, London, 1990.

Miller, Lesley, *Cristóbal Balenciaga*, London, 1993.

Newton, Stella Mary, *Health, Art and Reason: Dress Reformers of the Nineteenth Century*, London, 1974.

Palmer White, Jack, *Elsa Schiaparelli*, London, 1986.

Penn, Irving, *Issey Miyake*, New York, 1988.

Polhemus, T. and L. Proctor, *Fashion and Anti-Fashion*, London, 1978.

Rawsthorne, Alice, *Yves Saint Laurent*, London, 1996.

Reed, Christopher, *Not at Home*, London, 1996.

Saint Laurent, Yves and Diana Vreeland, *Yves Saint Laurent*, New York, 1983.

Schiaparelli, Elsa, *Shocking Life*, London, 1954.

Steele, Valerie, *Fashion and Eroticism*, Oxford, 1985.

Steele, Valerie, *The Corset: A Cultural History*, New Haven, 2001.

Summers, Leigh, *Bound to Please*, Oxford, 2001.

Wigley, Mark, *White Walls: Designer Dresses*, Boston, 1995.

## Chapter 4. Disseminating Desire

Arnold, Rebecca, *Fashion, Desire and Anxiety: Image and Morality in the Twentieth Century*, London, 2001.

Bailey, Peter, *Popular Culture and Performance in the Victorian City*, Cambridge, 1998.

Benjamin, Walter, *The Arcades Project*, Cambridge, MA, 1999.

Berman, Marshall, *All that is Solid Melts into Air*, London, 1983.

Charles-Roux, Edmonde, *Théâtre de la Mode*, New York, 1991.

Clayton, Lucie, *The World of Modelling*, London, 1968.

Ewen, Stuart and Elizabeth, *Channels of Desire: Mass Images and the Shaping of America*, Minneapolis, 1992.

Finkelstein, Joanne, *The Fashioned Self*, Cambridge, 1991.

Gross, Michael, *Model: The Ugly Business of Beautiful Women*, New York, 1995.

Hall, Lee, *Common Threads: A Parade of American Clothing*, Boston, 1992.

Hayward Gallery, *Addressing the Century: 100 Years of Art and Fashion*, London, 1998.

Hughes, Clair, *Henry James and the Art of Dress*, Basingstoke, 2001.

Huyssen, Andreas, *After the Great Divide: Modernism, Mass Culture, Postmodernism*, Basingstoke, 1988.

Kaplan, Joel and Sheila Stowell, *Theatre and Fashion: Oscar Wilde to the Suffragettes*, Cambridge, 1994.

Pavitt, Jane (ed.), *Brand.new*, London, 2000.

Rojek, Chris, *Celebrity*, London, 2001.

Shrimpton, Jean, *The Truth About Modelling*, London, 1964.

Shrimpton, Jean, *An Autobiography*, London, 1990.

Slater, Don, *Consumer Culture and Modernity*, Cambridge, 1997.

Twiggy, *Twiggy: An Autobiography*, London, 1975.

## Chapter 5. Fashion on the Page

Beetham, Margaret, *A Magazine of Her Own? Domesticity and Desire in the Woman's Magazine 1800 1914*, London, 1996.

Beetham, Margaret and Kay Boardman (eds), *Victorian Women's Magazines: An Anthology*, Manchester, 2001.

Cotton, Charlotte, *Imperfect Beauty*, London, 2000.

Crowley, David and Paul Jobling, *Graphic Design: Reproduction and Representation since 1800*, Manchester, 1996.

Farrelly, Liz, *Wear Me: Fashion and Graphics Interaction*, London, 1995.

Ginsburg, Madeleine, *An Introduction to Fashion Illustration*, London, 1980.

Harrison, Martin, *Appearances: Fashion Photography since 1945*, London, 1991.

Hebdige, Dick, *Hiding in the Light: On Images and Things*, London, 1988.

Jobling, Paul, *Fashion Spreads: Word and Image in Fashion Photography since 1980*, Oxford, 1999.

Leiss, W., S. Kline, and S. Jhally, *Social Communication as Advertising*, New York, 1986.

Lury, Celia, *Consumer Culture*, Cambridge, 1996.

Richards, Thomas, *The Commodity Culture of Victorian Britain*, London, 1991.

Rogers, Brett and Val Williams (eds), *Look at Me: Fashion and Photography in Britain 1960–1999*, London, 1999.

Sabin, Roger, *Comics, Comix and Graphic Novels*, London, 1996.

Triggs, Teal, *Communicating Design: Essays in Visual Communication*, London, 1995.

## Chapter 6. Fashion and Film

Berry, Sarah, *Screen Style: Fashion and Femininity in 1930s Hollywood*, Minneapolis, MN, 2000.

Bruzzi, Stella, *Undressing Cinema*, London, 1997.

Church Gibson, Pamela, *BFI Art and Design Catalogue: Fashion*, London, 2002.

Cook, Pam, *Fashioning the Nation: Costume and Identity in British Cinema*, London, 1996.

Cook, Pam and Philip Dodd (eds), *Women and Film: A Sight and Sound Reader*, Philadelphia, 1993.

Desser, David and Garth S. Jowett (eds), *Hollywood Goes Shopping*, Minneapolis, MN, 2000.

Dyer, Richard, *Heavenly Bodies: Film Stars and Society*, Basingstoke, 1986.

Dyer, Richard, *Stars*, London, 1997.

Engelmeier, Regine and Peter, *Fashion in Film*, Munich, 1990.

Gaines, Jane and Charlotte Herzog (eds), *Fabrications: Costume and the Female Body*, London, 1990.

Gledhill, Christine (ed.), *Stardom: Industry of Desire*, London, 1991.

Harper, Sue, *Picturing the Past: The Rise and Fall of the British Costume Film*, London, 1994.

Leese, Elizabeth, *Costume Design in the Movies*, New York, 1976.

Maeder, Ed, *Hollywood and History: Costume Design in Film*, London, 1987.

Massey, Anne, *Hollywood Beyond the Screen*, Oxford, 2000.

## Chapter 7. Shopping for Style

Abelson, Elaine, *When Ladies Go a-Thieving: Middle-class Shoplifters in the Victorian Department Store*, Oxford, 1989.

Adburgham, Alison, *Shops and Shopping*, London, 1981.

Alexander, Sally, 'Becoming a Woman in London in the 1920s and '30s' in S. Alexander (ed.), *Becoming a Woman and Other Essays in 19th and 20th Century Feminist History*, London, 1994, pp. 203–24.

Benson, John, *The Rise of Consumer Society in Britain 1880–1980*, London, 1994.

Bowlby, Rachel, *Just Looking*, London, 1985.

Bowlby, Rachel, *Shopping with Freud*, London, 1993.

Bowlby, Rachel, *Carried Away: The Invention of Modern Shopping*, London, 2000.

Breward, Christopher, *The Hidden Consumer: Masculinities, Fashion and City Life*, Manchester, 1999.

Brewer, John and Roy Porter (eds), *Consumption and the World of Goods*, London, 1993.

Cohn, Nik, *Today There Are No Gentlemen*, London, 1971.

Crossick, Geoffrey and Serge Jaumain (eds), *Cathedrals of Consumption: The European Department Store 1850–1939*, Aldershot, 1999.

Havenhand, Greville, *A Nation of Shopkeepers*, London, 1970.

Hyde Harris, J. S. and G. Smith, *1966 And All That*, London, 1986.

Jackson, Peter, Michelle Lowe, Daniel Miller, and Frank Mort (eds), *Commercial Cultures: Economies, Practices, Spaces*, Oxford, 2000.

Light, Alison, *Forever England: Femininity, Literature and Conservatism Between the Wars*, London, 1991.

McKendrick, Neil, John Brewer, and J. H. Plumb, *The Birth of a Consumer Society*, London, 1982.

Miller, Daniel, *Shopping, Place and Identity*, London, 1998.

Miller, Michael, *The Bon Marché: Bourgeois Culture and the Department Store*, London, 1981.

Nixon, Sean, *Hard Looks: Masculinities, Spectatorship and Contemporary Consumption*, London, 1996.

Rappaport, Erika, *Shopping for Pleasure: Women in the Making of London's West End*, Princeton, 2000.

Samuel, Raphael, *Theatres of Memory*, Volume I, London, 1994.

Shields, Rob (ed.), *Lifestyle Shopping: The Subject of Consumption*, London, 1992.

Williams, Rosalind, *Dream Worlds: Mass Consumption in Late Nineteenth-Century France*, Berkeley, 1982.

## Chapter 8. Style and Modernity

Blau, Réné, *Nothing In Itself: Complexions of Fashion*, Bloomington, 1999.

Bordo, Susan, *Unbearable Weight: Feminism, Western Culture and the Body*, Berkeley, 1993.

Brydon, Ann and Sandra Niessen (eds), *Consuming Fashion*, Oxford, 1998.

De Grazia, Victoria and Ellen Furlough (eds), *The Sex of Things*, Berkeley, 1996.

Etcoff, Nancy, *Survival of the Prettiest: The Science of Beauty*, London, 1996.

Felski, Rita, *The Gender of Modernity*, Cambridge, 1995.

Fillin-Yeh, Susan, *Dandies, Fashion and Finesse in Art and Culture*, New York, 2001.

Garelick, Rhonda, *Rising Star: Dandyism, Gender and Performance in the Fin de Siècle*, Princeton, 1998.

Laver, James, *Dandies*, London, 1968.

Lloyd, Fran, *Deconstructing Madonna*, London, 1993.

Meisel, Perry, *The Cowboy and the Dandy*, Oxford, 1999.

Moers, Ellen, *The Dandy: Brummell to Beerbohm*, London, 1960.

Pountain, Dick and David Robins, *Cool Rules: Anatomy of an Attitude*, London, 2000.

Robertson, Pamela, *Guilty Pleasures: Feminist Camp from Mae West to Madonna*, London, 1996.

Tester, Keith (ed.), *The Flaneur*, London, 1994.

Tseelon, Efrat, *The Masque of Femininity: Presentation of Women in Everyday Life*, London, 1995.

Tseelon, Efrat (ed.), *Masquerade and Identities: Essays on Gender, Sexuality and Marginality*, London, 2001.

Winkler, Mary and Letha Cole (eds) *The Good Body*, New Haven, 1994.

## Chapter 9. Fashion Capitals

Binder, Frederick and David Reimers, *All the Nations under Heaven: An Ethnic and Racial History of New York City*, New York, 1995.

Bracewell, Michael, *England is Mine: Pop Life in Albion from Wilde to Goldie*, London, 1997.

Breward, Christopher, Becky Conekin, and Caroline Cox (eds), *The Englishness of English Dress*, Oxford, 2002.

Buckley, Reka and Stephen Gundle, 'Flash Trash: Gianni Versace and the Theory and Practice of Glamour' in Stella Bruzzi and Pamela Church Gibson (eds), *Fashion Cultures: Theories, Explorations and Analysis*, London 2000, pp. 331–48.

Canadeo, Anne and Richard Young (eds), *Ralph Lauren: Master of Fashion*, Oklahoma, 1992.

Celant, Germano and Harold Koda, *Giorgio Armani*, New York, 2000.

Chenoune, Farid, *Jean Paul Gaultier*, London, 1996.

Coleman, Elizabeth Ann, *The Genius of Charles James*, New York, 1982.

Coleridge, Nicholas, *The Fashion Conspiracy*, London, 1989.

Davey, Kevin, *English Imaginaries*, London, 1999.

De la Haye, Amy (ed.), *The Cutting Edge: 50 Years of British Fashion*, London, 1997.

De Marly, Diana, *Christian Dior*, London, 1990.

De Pietri, Stephen and Melissa Leventon, *New Look to Now: French Haute Couture 1947–1987*, New York, 1989.

Demetz, Peter (ed.), *Reflections*, New York, 1978.

Dior, Christian, *Dior by Dior*, London, 1957.

Ehrman, Edwina and Catherine McDermott, *Vivienne Westwood: A London Vision*, London, 2000.

Faludi, Susan, *Backlash: The Undeclared War Against Women*, London, 1992.

Forty, Adrian, *Objects of Desire*, London, 1986.

Gaines, Steven and Sharon Churcher, *Obsession: The Lives and Time of Calvin Klein*, New York, 1992.

Garb, Tamar, *Bodies of Modernity*, London, 1998.

Gilbert, David, 'Urban Outfitting' in Stella Bruzzi and Pamela Church Gibson (eds), *Fashion Cultures: Theories, Explorations and Analysis* (London, 2000), pp. 7–24.

Giroud, François, *Dior*, London, 1987.

Goss, Elaine and Fred Rottman, *Halston: An American Original*, London, 1999.

Green, Nancy, 'Sweatshop Migrations' in David Ward and Oliver Zunz (eds), *The Landscape of Modernity: New York City 1900–1940*, Baltimore, 1992, pp. 213–32.

Green, Nancy, *Ready to Wear, Ready to Work*, Durham, NC, 1997.

Heinz, Andrew, *Adapting to Abundance: Jewish Immigrants, Mass Consumption and the Search for American Identity*, New York, 1990.

Hollander, Anne, *Sex and Suits*, New York, 1994.

Klein, Naomi, *No Logo*, London, 2000.

Kohle, Yohannan, *Claire McCardell: Redefining Modernism*, New York, 1998.

Lacroix, Christian, *Pieces of a Pattern: Lacroix by Christian Lacroix*, London, 1992.

Lankevich, George, *American Metropolis*, New York, 1998.

Loos, Adolf, *Spoken into the Void: Collected Essays 1897–1900*, Cambridge, MA, 1982.

McDowell, Colin, *Forties Fashion and the New Look*, London, 1997.

Marcus, Greil, *In the Fascist Bathroom: Writings on Punk, 1977–1992*, London, 1993.

Martin, Richard, *Versace*, London, 1997.

Martin, Richard, 'Milano 02138' in Giannino Malossi (ed.), *Volare: The Icon of Italy in Global Pop Culture*, New York, 1999, pp. 76–80.

Martin, Richard and Harold Koda, *Christian Dior*, New York, 1996.

Marwick, Arthur, *The Sixties: Cultural Revolutions in Britain, France and the US 1958–1974*, Oxford, 1998.

Mauries, Patrick, *Christian Lacroix: The Diary of a Collection*, London, 1996.

Milbank, Caroline Rennolds, *New York Fashion: The Evolution of American Style*, New York, 1989.

Miles, Malcolm, Tim Hall, and Iain Borden (eds), *The City Cultures Reader*, London, 2000.

Moffit, Peggy and William Claxton, *The Rudi Gernreich Book*, New York, 1991.

Montgomery, Maureen, *Displaying Women: Spectacles of Leisure in Edith Wharton's New York*, New York, 1998.

Mulvagh, Jane, *Vivienne Westwood: An Unfashionable Life*, London, 1998.

Mulvey, Christopher and John Simons (eds), *New York: City as Text*, London, 1990.

Musée de la Mode et du Costume, Paris, *France, le monde selon ses créateurs*, Paris, 1991.

Partington, Angela, 'Popular Fashion and Working-class Affluence', in Juliet Ash and Elizabeth Wilson (eds), *Chic Thrills*, London, 1992, pp. 145–61.

Porter, Roy, *London: A Social History*, London, 1994.

Prendergast, Sara (ed.), *Contemporary Designers*, Detroit, 1997.

Quant, Mary, *Quant by Quant*, London, 1966.

Rifkind, Adrian, *Street Noises: Parisian Pleasure 1900–1940*, Manchester, 1993.

Segre, Simona, *Mode in Italy*, Milan, 1999.

Sischy, Ingrid, *Donna Karan New York*, London, 1998.

Sparke, Penny, *Italian Design 1870 to the Present*, London, 1988.

Steele, Valerie, *Paris Fashion: A Cultural History*, Oxford, 1988.

Steele, Valerie, 'The Italian Look' in Giannino Malossi (ed.), *Volare: The Icon of Italy in Global Pop Culture*, New York, 1999, pp. 88–93.

Taylor, Lou, 'Paris Couture, 1940–1944', in Juliet Ash and Elizabeth Wilson (eds), *Chic Thrills*, London, 1992, pp. 127–44.

Tomerlin Lee, Sarah, *American Fashion*, London, 1975.

Tucker, Andrew, *The London Fashion Book*, London, 1998.

Vermorel, Fred, *Fashion and Perversity. A Life of Vivienne Westwood and the Sixties Laid Bare*, London, 1996.

Votalato, Greg, *American Design in the Twentieth Century*, Manchester, 1998.

White, Nichola, *Reconstructing Italian Fashion*, Oxford, 2000.

## Chapter 10. Fashion and Identity

Benstock, Shari and Suzanne Ferriss (eds), *On Fashion*, New Brunswick, 1994.

Bolton, Andrew, *The Supermodern Wardrobe*, London, 2002.

Butler, Judith, *Gender Trouble: Feminism and the Subversion of Identity*, New York, 1990.

Campbell, Colin, *The Romantic Ethic and the Spirit of Modern Consumerism*, Oxford, 1987.

Chenoune, Farid, *A History of Men's Fashion*, Paris, 1996.

Cohen, Stanley, *Folk Devils and Moral Panics*, London, 1972.

Cole, Shaun, *Don We Now Our Gay Apparel*, Oxford, 2000.

Dingwall, Cathie and Amy de la Haye, *Surfers, Soulies, Skinheads and Skaters*, London, 1996.

Entwistle, Joanne and Elizabeth Wilson (eds), *Body Dressing*, Oxford, 2001.

Evans, Caroline, 'Desire and Dread: Alexander McQueen and the Contemporary Femme Fatale' in Joanne Entwistle and Elizabeth Wilson (eds), *Body Dressing*, Oxford, 2001, pp. 211–12.

Fausch, Deborah (ed.), *Architecture in Fashion*, New York, 1994.

Frankel, Susannah, *Visionaries*, London, 2001.

Grand, France, *Comme des Garçons*, London, 1998.

Griffiths, Ian and Nichola White (eds), *The Fashion Business: Theory, Practice, Image*, Oxford, 1999.

Guy, Ali, Eileen Green, and Maura Banim (eds), *Through the Wardrobe: Women's Relationships with Their Clothes*, Oxford, 2001.

Hall, Stuart and Tony Jefferson (eds), *Resistance through Rituals*, London, 1977.

Hebdige, Dick, *Subculture: The Meaning of Style*, London, 1979.

Keenan, William (ed.), *Dressed to Impress*, Oxford, 2001.

McDowell, Colin, *Galliano*, London, 1997.

McDowell, Colin, *Fashion Today*, London, 2000.

McRobbie, Angela, *Feminism and Youth Culture*, London, 1991.

McRobbie, Angela (ed.), *Zoot Suits and Second Hand Dresses*, Basingstoke, 1989.

Marcus, Greil, *Lipstick Traces*, London, 1989.

Muggleton, David, *Inside Subculture: The Postmodern Meaning of Style*, Oxford, 2000.

Osgerby, Bill, *Youth in Britain since 1945*, Oxford, 1998.

Polhemus, Ted, *Streetstyle*, London, 1994.

Sabin, Roger (ed.), *Punk Rock, So What?* London, 1999.

Savage, Jon, *England's Dreaming: The Sex Pistols and Punk Rock*, London, 1991.

Sennett, Richard, *The Fall of Public Man*, London, 1986.

Simmel, Georg, *Fashion, Individuality and Social Forms*, Chicago, 1971.

Soland, Birgitte, *Becoming Modern: Young Women and the Reconstruction of Womanhood in the 1920s*, Princeton, 2000.

Sudjic, Deyan, *Rei Kawakubo and Comme des Garçons*, London, 1990.

Thornton, Sara, *Club Cultures: Music, Media and Subcultural Capital*, Cambridge, 1995.

Tomlinson, Alan (ed.), *Consumption, Identity and Style*, London, 1990.

Wilcox, Claire (ed.), *Radical Fashion*, London, 2001.

Wilson, Elizabeth, *Bohemians: The Glamorous Outcasts*, London, 2000.

Timeline
Museums and
Websites
List of Illustrations
Index

| Fashion | | Events | |
|---|---|---|---|
| 1730 | Industrialization of British textile industry increases with invention of John Kay's Flying Shuttle | | |
| 1770 | Rose Bertin emerges as premier *marchande de modes* in Paris | | |
| 1778 | George 'Beau' Brummell born | | |
| 1780 | Development of early fashion magazines in Paris, London and Berlin | 1783 | American War of Independence ends |
| | | 1789 | French Revolution |
| | | 1792 | French Revolutionary and Napoleonic Wars |
| 1804 | Louis Hyppolite Leroy provides costumes for Napoleon's court | | |
| 1804 | Jacquard loom patented | | |
| | | 1811 | John Nash's Regent Street, London, built |
| | | 1815 | Napoleonic Wars end |
| 1822 | Charles Macintosh invents waterproof garment | | |
| 1825 | Birth of Charles Frederick Worth | | |
| | | 1830 | Charles Darwin embarks on *The Beagle* |
| | | 1832 | Great Reform Act, UK |
| | | 1833 | Abolition of slavery in British territories |
| | | 1835 | Henry Fox Talbot takes first negative photograph |
| | | 1837 | Ascension of Queen Victoria |
| 1838 | Worth apprenticed to Swan & Edgar | | |
| 1845 | Worth moves to Paris | | |
| 1846 | Sewing machine patented by Elias Howe | | |
| | | 1848 | Karl Marx and Friedrich Engels publish *The Communist Manifesto* |
| 1850 | Manufacturers including Levi Strauss start to make and promote denim work trousers for American cattle-drivers and gold prospectors | 1851 | The Great Exhibition in Hyde Park, London |
| 1852 | *The Englishwoman's Domestic Magazine* launched with instructions and patterns for home dressmaking | 1852 | Coronation of Napoleon III, rebuilding of Paris |
| | Le Bon Marché department store opens in Paris | | |
| 1856 | William Perkin discovers aniline dye | 1856 | Celluloid first synthesized by Alexander Parkes |
| | | | Publication of Owen Jones's *Grammar of Ornament* |
| | | | Publication of Flaubert's *Madame Bovary* |
| 1858 | Worth establishes a business with Otto Bobergh | 1858 | Japan opened to foreign trade |
| | | 1859 | Isabella Beeton's *Book of Household Management* published |
| | | 1861 | Start of American Civil War |
| | | 1862 | International Exhibition, South Kensington, London |
| | | 1863 | Baudelaire publishes *Peintre de la vie moderne* |
| 1864 | Worth and Bobergh supply Empress Eugénie's wardrobe | 1865 | Abolition of slavery in USA |
| | | 1866 | Atlantic telegraph cable laid |
| | | 1867 | Universal Exposition, Paris |
| 1868 | Precursor of the Chambre Syndicale de la Couture Parisienne founded | 1868 | Typewriter patented in USA |
| | | 1869 | Opening of Suez Canal |
| | | 1870 | Franco-Prussian War |
| 1871 | Worth reopens after temporary closure during Franco-Prussian War | 1873 | World Exposition, Vienna |
| 1875 | Liberty store opens in London | | |
| | | 1877 | Phonograph invented by Thomas Edison |
| | | 1878 | Introduction of electric light |
| 1883 | Coco Chanel born | | |
| | | 1884 | Art Workers Guild founded, UK |
| 1885 | Marshall Field's department store built in Chicago | 1885 | Safety bicycle and internal combustion engine developed |
| | | 1886 | Erection of Statue of Liberty, New York |

Timeline markers: 1800, 1850, 1875

| Fashion | | Events | |
|---|---|---|---|
| 1887 | Gustave Jaeger's *Essays on Health Culture* published in English | | |
| 1892 | *Vogue* USA launched | 1889 | World Exposition, Paris |
| | | 1893 | Chicago World Fair |
| | | 1894 | *The Yellow Book* founded |
| | | | Lumière brothers make first moving pictures in France |
| 1895 | Worth dies | 1895 | Trial of Oscar Wilde |
| | Cristóbal Balenciaga born | | |
| 1896 | Paul Poiret works for Jacques Doucet | | |
| | | 1897 | Foundation of the Sezession group in Vienna |
| | | 1898 | Opening of Paris Métro |
| | | 1900 | World Exposition, Paris |
| | | | Sigmund Freud publishes *The Interpretation of Dreams* |
| 1901 | Poiret employed by Gaston Worth | 1901 | Death of Queen Victoria |
| 1903 | Poiret establishes his own couture house | 1903 | First flight by the Wright brothers |
| 1907 | Poiret's tubular 'Josephine' model introduced | | Wiener Werkstätte founded |
| 1908 | Paul Iribe illustrates *Les Robes de Paul Poiret* | 1908 | Henry Ford launches 'Model T' |
| | | | Adolf Loos's *Ornament and Crime* published |
| 1909 | Selfridges store opens in London | 1909 | Cubism coined as an art term |
| 1910 | Chanel opens her first shop in Paris | 1910 | Futurist manifesto published |
| | Earliest fashion film *Fifty Years of Paris Fashions* shown in London | | Diaghilev premieres *Scheherazade* and *The Firebird* |
| | New York garment district establishes itself around Penn Station | | |
| 1911 | George Lepape illustrates *Les Choses de Paul Poiret*. Poiret hosts his 'Thousand and Second Night' party, establishes the Atelier Martine, House of Rosine, Colin Workshop, and the Petite Usine. | | |
| 1912 | Poiret tours Europe and the United States | 1912 | *Titanic* sinks |
| | Madeleine Vionnet opens a fashion house in Paris | 1913 | Marcel Proust publishes *A la recherche du temps perdu* |
| | | | The Armory Show of Modern Art held in New York |
| 1914 | Poiret founds Le Syndicat de Défense de la Grande Couture Française | 1914 | Start of the First World War |
| 1915 | Barrett Street Trade School (later London College of Fashion) founded | | |
| 1916 | British *Vogue* launched | 1916 | Foundation of Dada movement |
| | | 1917 | Russian Revolution |
| | | 1918 | End of the First World War |
| 1919 | Balenciaga opens first couture house in San Sebastian | 1919 | Foundation of Bauhaus |
| 1920 | French *Vogue* launched | 1920 | Women's suffrage approved in USA |
| 1922 | Elsa Schiaparelli starts a career in knitwear design | 1922 | Fascists take over Italian government |
| 1924 | Rayon selected as generic term for artificial silk (in development since 1880s) | 1924 | André Breton publishes *Manifesto of Surrealism* |
| | | 1925 | Exposition des Arts Décoratifs et Industriels, Paris |
| 1926 | Chanel launches her little black dress | | |
| 1928 | Chanel opens her house on the rue Cambon | | |
| | Muriel Pemberton establishes a diploma in fashion at the Royal College of Art, London | | |
| 1929 | Schiaparelli opens a Paris boutique and shows first collection | 1929 | Great Depression |
| | School of the Chambre Syndicale de la Couture founded in Paris | | |
| 1931 | *Apparel Arts* (precursor of *GQ* magazine) launched (UK) | | |
| | Chanel employed by Samuel Goldwyn in Hollywood | | |

1900

1925

## Fashion

| | |
|---|---|
| 1932 | *Letty Lynton* (film) released |
| 1936 | Yves Saint Laurent born in Algiers |
| | Chambre Syndicale de la Couture reorganized into its modern form in response to industrial unrest |
| 1937 | Balenciaga moves his business to Paris |
| 1938 | DuPont launch nylon |
| | Launch of Schiaparelli's 'Shocking' perfume |
| | Christian Dior secures a position at Piguet |
| 1939 | Schiaparelli moves to New York |
| | Vionnet retires |
| 1940 | Chanel closes her house following the occupation of Paris |
| | Charles James and Mainbocher open their first New York couture houses |
| 1941 | Utility scheme launched in Britain by the Board of Trade; Incorporated Society of London Fashion Designers founded |
| | Dior moves to Lelong |
| | Vivienne Westwood born |
| 1944 | Poiret dies |
| 1945 | The Chambre Syndicale de la Couture organizes the touring Théâtre de la Mode |
| 1946 | Louis Reard introduces the bikini |
| | Dior sets up his own house with the backing of Marcel Boussac |
| 1947 | Dior's New Look launched |

| | |
|---|---|
| 1950 | Italian *Vogue* launched |
| 1951 | Villa Torregiani fashion show in Florence promotes Italian design to the world |
| | Christian Lacroix born |
| 1952 | Jean Paul Gaultier born |
| 1954 | Schiaparelli closes her business |
| | Chanel reopens on the rue Cambon |
| | Vince menswear shop opens near Carnaby Street, London |
| | Giorgio Armani employed as buyer at La Rinascente, Milan |
| 1955 | Mary Quant opens Bazaar, King's Road, London |
| | Invention of Velcro |
| 1957 | Dior dies |
| | Saint Laurent takes over as chief designer at Dior and launches his first collection under Dior the following year |
| | Department of Dress established at St Martin's School of Art, London, by Muriel Pemberton |
| 1958 | Claire McCardell dies |
| 1959 | Lycra introduced by DuPont |
| | Pierre Cardin expelled from the Chambre Syndicale de la Couture for launching a ready-to-wear collection |
| 1960 | Saint Laurent sues Dior for replacing him with Marc Bohan |
| 1962 | First Yves Saint Laurent collection |
| | Foundation of the Council of Fashion Designers of America |
| | Quant designs for the American market |

## Events

| | |
|---|---|
| 1933 | Hitler becomes Chancellor in Germany |
| 1936 | First regular television broadcasts by BBC |
| 1939 | Outbreak of the Second World War |
| | New York World's Fair |
| 1945 | End of the Second World War |
| 1948 | Marshall Plan for European recovery |
| 1950 | McCarthyism in US |
| 1951 | Festival of Britain |
| 1952 | Independent Group formed in London |
| 1955 | Opening of Disneyland and first McDonald's Restaurant in USA |
| | First nude centrefold in *Playboy* |
| | Elvis Presley contracted to RCA |
| | James Dean stars in *Rebel without a Cause* |
| 1957 | Launch of Sputnik |
| | Race riots in USA |
| | Treaty of Rome—launch of Common Market |
| 1958 | First commercial transatlantic flights |
| | Simone de Beauvoir publishes *The Second Sex* |
| 1959 | Launch of the Barbie doll |
| 1960 | Introduction of the contraceptive pill |
| 1961 | 'Young Contemporaries' exhibition, London |
| | Construction of Berlin Wall |

Timeline markers: **1950**, **1960**

## Fashion

| | |
|---|---|
| 1963 | Issey Miyake graduates from Tama Art University, Tokyo |
| | *Cosmopolitan* magazine launched (UK) |
| | Diana Vreeland appointed editor-in-chief at US *Vogue* |
| 1964 | Menswear course introduced at the Royal College of Art, London |
| 1965 | *Nova* magazine launched (UK) |
| | Costume Society formed in UK |
| | Saint Laurent's 'Mondrian' collection |
| 1966 | Twiggy wins her first modelling contract |
| | *Time* Magazine publishes 'Swinging London' article |
| | Saint Laurent introduces 'Le Smoking' and launches Rive Gauche |
| 1968 | Balenciaga retires |
| | Ralph Lauren launches Polo |
| | Fashion course receives degree status at Royal College of Art under Janey Ironside |
| | Saint Laurent pioneers his 'Safari' look |
| 1969 | Biba store opens in London |
| 1970 | Issey Miyake designs uniforms for Osaka International Exposition and opens Tokyo design studio with Makiko Minagawa and Tadanori Yokoo |
| 1971 | Saint Laurent poses naked for the launch of his men's fragrance |
| | Chanel dies |
| | Malcolm McClaren and Vivienne Westwood open the first incarnation of their shop Let It Rock, Chelsea, London |
| | Mainbocher retires |
| 1972 | Balenciaga dies |
| 1973 | Rei Kawakubo establishes Comme des Garçons |
| | Costume Society of America founded |
| 1974 | Armani establishes his own label |
| | McClaren and Westwood relaunch their shop as SEX |
| 1975 | Saint Laurent's tailored trouser suit for women photographed by Helmut Newton |
| 1976 | Miyake's 'Piece of Cloth' |
| | Calvin Klein establishes his jeans label |
| | McClaren and Westwood rename SEX as Seditionaries in tandem with the rise of Punk |
| 1978 | Gaultier launches his first line |
| | Gianni Versace founds his own business |
| 1980 | *i-D* magazine launched (UK) |
| | *American Gigolo* (film) released with costume designs by Armani |
| 1981 | *The Face* magazine launched (UK) |
| | Westwood's first collection 'Pirate' launched |
| 1982 | Kawakubo establishes herself in Paris |
| 1983 | Gaultier introduces underwear as outerwear |
| | Diana Vreeland's Saint Laurent show at the Metropolitan Museum of Art, New York |

## Events

| | |
|---|---|
| 1963 | Betty Friedan publishes *The Feminine Mystique* |
| | Assassination of John F. Kennedy |
| | The Beatles World Tour |
| 1966 | The Cultural Revolution, China |
| 1967 | Summer of Love, San Francisco |
| 1968 | Student demonstrations |
| 1969 | First supersonic flight |
| | First man on moon |
| | Stonewall gay riot, New York |
| | Woodstock festival, USA |
| 1970 | Germaine Greer publishes *The Female Eunuch* |
| 1972 | Alternative Miss World competition founded by Andrew Logan |
| 1973 | US withdrawal from Vietnam |
| | International oil crisis |
| 1977 | Opening of Studio 54 club, New York |
| | Release of *Never Mind the Bollocks* by The Sex Pistols |
| 1979 | Margaret Thatcher elected British Prime Minister |
| 1980 | Ronald Reagan elected President of the USA |
| | Memphis design group formed, Milan |
| 1981 | First newspaper reports of AIDS |
| | Launch of MTV |
| 1983 | Apple Macintosh computer introduced |

**1970**

**1980**

## Fashion

| | |
|---|---|
| 1984 | John Galliano graduates from St Martin's School of Art, London |
| 1985 | Gaultier experiments with skirts for men<br>Westwood introduces the 'mini-crini'<br>Donna Karan launches her first collection |
| 1987 | Lacroix opens his own couture house<br>Westwood's 'Harris Tweed' collection launched |
| 1988 | Miyake launches 'Pleats Please' |
| 1989 | Armani launches his Emporio Armani line |
| 1991 | *Dazed and Confused* magazine founded (UK) |
| 1992 | Alexander McQueen graduates from Central St Martin's College of Art and Design, London |
| 1993 | Hussein Chalayan graduates from Central St Martin's College of Art and Design, London |
| 1995 | Galliano appointed principal designer at Givenchy |
| 1996 | Galliano moves to Dior<br>McQueen announced as Galliano's replacement at Givenchy |
| 1997 | Martin Margiela hired by Hermès<br>Versace murdered<br>*Fashion Theory* (academic journal) first published, UK |
| 2000 | McQueen moves to Gucci<br>Armani exhibited at the Guggenheim Museum, New York |
| 2002 | Saint Laurent retires |

**1990**

**2000**

## Events

| | |
|---|---|
| 1984 | Los Angeles Olympics<br>Inauguration of the Turner Prize for innovative British art, Tate Gallery, London |
| 1985 | Taboo Club, London |
| 1987 | 'Black Monday' economic crash |
| 1989 | Demolition of Berlin Wall |
| 1990 | Introduction of the Internet |
| 1991 | Gulf War |
| 1992 | EuroDisney opens near Paris |
| 1997 | Death of Princess Diana<br>Sensation exhibition, Royal Academy of Arts, London<br>Cloning of Dolly the Sheep |
| 2001 | Terrorist attack on World Trade Center, New York |
| 2002 | Introduction of common European currency |

**Gallery/Museum**

**Australia**

Museum of Victoria
PO Box 666E
Melbourne VIC 3001

National Gallery of Victoria
180 St Kilda Road
Melbourne VIC 3004

Museum of Applied Arts and Sciences
500 Harris Street
Ultimo
Sydney NSW 2007

**Austria**

Modesammlungen des Historischen Museum
Hetzendorf Strasse 79
1120 Vienna

Österreichisches Museum für Angewandte
Kunst
Stubenring 5
A-1010 Vienna

**Belgium**

Flanders Fashion Institute
Nationale Straat
2000 Antwerp

Musée du Costume et de la Dentelle
6 rue de la Violette
1000 Brussels

The Vrieselhof Textile and Costume Museum
Schildesteenweg 79
2520 Oelegem

**Canada**

McCord Museum
690 Sherbrooke Street West
Montreal
Quebec H3A 1E9

Bata Shoe Museum
327 Bloor Street West
Toronto
Ontario M5S 1W7

Royal Ontario Museum
100 Queen's Park
Toronto
Ontario M5S 2C6

**France**

Musée de la Chemiserie et de l'Elégance
Masculine
rue Charles Brillaud
36200 Argenton-sur-Creuse

Musée du Chapeau
16 route de Saint-Galmier
42140 Chazelles-sur-Lyon

Musée des Tissus
30–34 rue de la Charité
69002 Lyon

Musée de la Mode
11 rue de la Canabière
13001 Marseille

Musée Galliera, Musée de la Mode de la Ville de
Paris
10 avenue Pierre Premier de Serbie
75116 Paris

Musée de la Mode et du Textile
Palais du Louvre
107 rue de Rivoli
75001 Paris

Musée Internationale de la Chaussure
2 rue Sainte-Marie
26100 Romans

**Germany**

Museum fur Kunst und Gewerbe
Steinorplatz 1
20099 Hamburg

Deutsches Textilmuseum
Andreasmarkt 8
4150 Krefeld

Bayerisches Nationalmuseum
Prinzregenten Strasse 3
80538 Munich

Münchner Stadtmuseum
Jacobsplatz 1
80331 Munich

**Gallery/Museum**

Germanisches Nationalmuseum
Kornmarkt 1
90402 Nuremberg

Württembergisches Landesmuseum
Schillerplatz 6
70173 Stuttgart

Deutsches Ledermuseum
Frankfurter Strasse 86
63067 Offenbach/Main

**Ireland**

National Museum of Ireland
Kildare Street
Dublin 2

**Italy**

Galleria del Costume
Palazzo Pitti
50125 Florence

Museo Palazzo Fortuny
Camp San Beneto
3780 San Marco
Venice

Accademia di Costume e di Moda
via della Rondinella 2
00186 Rome

**Japan**

Kobe Fashion Museum
2–9 Koyocho-naka
Higashinda-ku
Kobe 658

Nishijin Textile Museum
Imadegawa, Kamigyoku
Kyoto

Kyoto Costume Institute
Wacoal Corporation
29 Nakajimacho Kisshoin, Minami-ku
Kyoto 601

**The Netherlands**

Rijksmuseum
Stadhouderskade 42
1071 ZD Amsterdam

Centraal Museum
Agnietstraat 1
3512XA Utrecht

Haags Gemeentmuseum
Stadhouderslaan 41
2517 HV The Hague

**New Zealand**

Canterbury Museum
Roleston Avenue
Christchurch 1

**Norway**

Kunstindustrimuseet in Oslo
St Olavsgate 1
0165 Oslo

**South Africa**

Bernberg Fashion Museum
1 Duncombe Road
Forest Town 2193
Johannesburg

**Spain**

Museo Textil de la Diputácion de Barcelona
Parc de Vallparadis-Carrer Salmeron 25
08222 Barcelona

Museo Textil y de Indumentaria
Calle de Montcada 12
08003 Barcelona

**Gallery/Museum**

**Sweden**

Nordiska Museet
Djurgardsvagen 6–16
S-115 93 Stockholm

**Switzerland**

Textilmuseum
Vadianstrasse 2
9000 St Gallen

Bally Shoe Museum
Parkstrasse 1
5012 Schonenwerd
Zurich

**United Kingdom**

Museum of Costume
The Assembly Rooms
Bennett Street
Bath
Avon BA1 2QH

Ulster Museum
Botanic Gardens
Stranmillis Road
Belfast BT9 5AB

Brighton Art Gallery and Museum
Church Street
Brighton
East Sussex BN1 1UE

National Museums of Scotland
Chambers Street
Edinburgh EH1 1JF

Judith Clark Costume
112 Talbot Road
London W11 1JR

State Apartments and Royal Ceremonial Dress
Collection
Kensington Palace
London W8 4PX

Museum of London
London Wall
London EC2Y 5HN

Victoria and Albert Museum
Cromwell Road
London SW7 2RL

Gallery of English Costume
Platt Hall
Rusholme
Manchester M14 5LL

Museum of Costume and Textiles
51 Castle Gate
Nottingham NG1 6AF

**United States of America**

The Museum of Fine Arts
465 Huntington Avenue
Boston
MA 02115

Chicago Historical Society
1601 Clark Street at North Avenue
Chicago
IL 60614

Wadsworth Atheneum
Hartford
CT 06103

Indianapolis Museum of Art
1200 West 38th Street
Indianapolis
IN 46208-4196

Kent State University Museum
Rockwell Hall
Kent
OH 44242

Los Angeles County Museum of Art
5905 Wilshire Boulevard
Los Angeles
CA 90036
The Brooklyn Museum of Art
Eastern Parkway
Brooklyn
New York
NY 11238

The Costume Institute
Metropolitan Museum of Art
1000 Fifth Avenue
New York
NY 10028-0198

The Museum at The Fashion Institute of
Technology
West 27th Street at Seventh Avenue
New York
NY 10001-5992

Museum of the City of New York
1220 Fifth Avenue
New York
NY 10029

## Gallery/Museum

Philadelphia Museum of Art
26th Street and Benjamin Franklin Parkway
Philadelphia
PA 19130

The Arizona Costume Institute
The Phoenix Art Museum
1625 North Central Avenue
Phoenix
AZ 85004

The RISD Museum
224 Benefit Street
Providence
Rhode Island
02903-2723

## Websites

### General

Fashion Angel
www.fashionangel.com

Fashion Directory
www.fashion.tripnet.se

Fashion Net
www.fashion.net

Fashion Serve
www.fashionserve.com

Fashionweb
www2.fashionweb.co.uk/fashionweb

Worth Global Style Network
www.wgsn-edu.com

### Museums and Galleries

Museum of Costume, Bath
www.museumofcostume.co.uk

Costume Gallery
www.costumegallery.com

Judith Clark Costume
www.judithclarkcostume.org

Victoria and Albert Museum
www.vam.ac.uk

### Magazines

*International Herald Tribune*
www.iht.com/IHT/FASH/index.html

*Lumiere*
www.lumiere.com

*SoWear*
www.sowear.com

*Style.com*
www.style.com

*Vogue*
www.vogue.co.uk

*Women's Wear Daily*
www.wwd.com

### Societies

Costume Society
www.costumesociety.org.uk

Costume Society of America
www.costumesocietyamerica.com

Design History Society
www.brighton.ac.uk/dhs/

# List of Illustrations

The publisher and author would like to thank the following individuals and institutions who have kindly given permission to reproduce the illustrations listed below.

1. Dressmaker's dummy, 1955. Hulton Archive/Getty Images, London.
2. Pierre Cardin, day coat in plum wool, autumn 1966. Metropolitan Museum of Art, New York, Gift of Mrs Charles Wrightsman, 1961 (CI.68.785). Photograph © 1995 The Metropolitan Museum of Art.
3. A clothing store interior, London c.1990. Elizabeth Whiting & Associates, London/photo Paul Smith.
4. Gustav Klimt, *Portrait of Johanna Staude*, 1918. Oil on canvas (unfinished), 70 × 55 cm. Osterreichische Galerie Belvedere, Vienna/AKG London/photo Erich Lessing.
5. Lun*na Menoh, 'Spring and Summer Collection 1770–1998', 1998. Photo Relah Eckstein, courtesy Lun*na Menoh.
6. Emily Jo Gibbs, dandelion bag, 1997. Satellites of Fashion/Emily Jo Gibbs/Gry Garness/Crafts Council, London.
7. Maison Martin Margiela, stockman-shaped jacket and a study of drapery, c.2000. Museum Boijmans van Beuningen, Rotterdam.
8. Jean Baptiste Martin, *A Promenade in the Gardens at Versailles*, c.1690 (detail). Oil on canvas. Château de Versailles et de Trianon/Réunion des Musées Nationaux/photo Arnaudet.
9. Elisabeth Vigée-Le Brun, *Queen Marie Antoinette and Her Children*, 1786. Oil on canvas. Château de Versailles et de Trianon/Réunion des Musées Nationaux/photo Gérard Blot.
10. Louis Le Coeur, *The Palais Royal Garden Walk*, 1787. Engraving. Bibliothèque Nationale de France, Paris.
11. Charles Frederick Worth. Photograph. Musée de la Mode et du Textile, Paris/Collection UCAD.
12. Franz Xavier Winterhalter, *The Empress Eugénie Surrounded by Her Ladies-in-Waiting*, 1855. Oil on canvas. Musée National du Château, Compiègne/AKG London/photo Erich Lessing.
13. Franz Xavier Winterhalter, *Empress Elizabeth of Austria*, 1865. Oil on canvas. Bundesmobiliensammlung, Vienna/photo Bridgeman Art Library, London.
14. Adolphe Charles Sandoz, stylish outdoor costumes, designed at the Maison Worth, Paris, 1895. Plate designed and engraved by Sandoz and Derbier for *The Queen* (17 August 1895). Board of Trustees of the Victoria and Albert Museum, London.
15. Worth display at the Exposition Universelle, Paris, 1900.

'Going to the Drawing Room'. Photograph. Brooklyn Museum of Art, Brooklyn, NY.
16. Man Ray, Jacques Doucet, c.1925. Photograph. © Man Ray Trust/ADAGP, Paris and DACS, London 2003/Telimage.
17. Paul Poiret, lampshade dress, c.1912. Hulton Archive/Getty Images, London.
18. Georges Lepape, *Les Choses de Paul Poiret*, 1911. Board of Trustees of the Victoria and Albert Museum, London.
19. Paul Poiret and his models, c.1920. Photograph. Musée de la Mode et du Textile, Paris. Archive Paul Poiret/Collection UFAC/photo Delphi.
20. Paul Poiret, folk-inspired dress, 1922. Musée de la Mode et du Textile, Paris. Archive Paul Poiret/Collection UCAD/photo Laurent Sully Jaulmes.
21. Robert Doisneau, Coco Chanel, 1954. Network Photographers/Rapho/Robert Doisneau.
22. Coco Chanel, costumes for Diaghilev's *Le Train bleu*, 1924. Board of Trustees of the Victoria and Albert Museum, London.
23. Magazine illustration of Chanel daywear, 1928.
24. Coco Chanel, bouclé wool suit, early 1960s. Network Photographers/Rapho/Eugene Kammerman.
25. 'Not what but how next?', c.1985. Courtesy Chanel.
26. Lipnitzki-Viollet, the Worth salon, rue de la Paix, Paris, 1907. © Boyer-Viollet, Paris.
27. The Grover and Baker sewing machine, c.1870. Cooper-Hewitt, National Design Museum, Smithsonian Institution, Washington.
28. A garment factory in the East End of London, 1957. Hulton Archive/Getty Images, London.
29. The London College of Fashion, 1915. Photo courtesy the London College of Fashion.
30. Fashion teaching at the Royal College of Art, 1949. Hulton Archive/Getty Images, London/photo Kurt Hutton.
31. Issey Miyake, Dunes, spring 1998. Judith Clark/R. Tecchio, Paris.
32. The Artificial Silk Exhibition, London, 1926. Hulton Archive/Getty Images, London.
33. William Powell Frith, *The Private View at the Royal Academy*, 1881. Oil on canvas. The Pope Family Trust/photo Bridgeman Art Library, London.
34. Jaeger catalogue, 1885. Jaeger Archive, London.
35. Dr Gustave Jaeger, c.1880. Jaeger Archive, London.
36. A party in rational dress, c.1895. Hulton Archive/Getty Images, London.

92. John Pawson, Jigsaw store, New Bond Street, London, *c.*1995. Arcaid, London/photo Richard Glover.

93. Napoleon Sarony, Oscar Wilde, *c.*1882. Photograph. Library of Congress, Washington, DC.

94. *Life* magazine, 1926. Collection MPI, Hulton Archive/Getty Images, London.

95. George Bryan Brummell, *c.*1810. Engraving. AKG London.

96. Augustus John, *Washing Day*, *c.*1912. Tate Britain, London/photo © Tate, London 2002/courtesy of the artist's estate/Bridgeman Art Library.

97. Calvin Klein Jeans campaign poster, 1995. Photo Rex Features, London.

98. Christian Dior, cyclonic line, September 1948. © *Vogue* (October 1948)/The Condé Nast Publications Ltd/photo Clifford Coffin.

99. Benjamin Read, A view of the Pantheon, London, 1834. Aquatint on paper. Guildhall, Corporation of London/Bridgeman Art Library.

100. Advertisement for Les Grands Magasins du Louvre, Paris, 1884. Kubler Collection (3341), Cooper-Hewitt, National Design Museum, Smithsonian Institution, Washington, DC/Art Resource, New York.

101. Robert Capa, The New Look, Paris 1947. © Robert Capa R/Magnum.

102. The Dior boutique, Paris, 1953. Hulton Archives/Getty Images, London/photo Kurt Hutton.

103. Christian Lacroix, couture, 1998. Judith Clark, London/C. Lacroix.

104. Jean Paul Gaultier, 1993. © Corbis.

105. Jean Paul Gaultier, bustier for Madonna's Blond Ambition tour, 1990. Associated Press/photo Sean Kardon.

106. Savile Row. Rex Features, London/photo Nils Jorgensen.

107. Mary Quant and models, 1967. Hulton Archive/Getty Images, London.

108. SEX boutique, 1975. Rex Features, London.

109. Vivienne Westwood, Pirate collection, 1981. Courtesy Vivienne Westwood/photo Robyn Beech.

110. Vivienne Westwood, autumn/winter 1995. Judith Clark, London.

111. In a Seventh Avenue flag factory. Horst/© *Vogue* (July 1943), The Condé Nast Publications Inc.

112. Louise Dahl-Wolfe, cotton twill sheath dress with slash pockets by Clare McCardell, 1953. Center for Creative Photography, University of Arizona.

113. Cecil Beaton, dresses by Charles James, 1948. Cecil Beaton Archive, courtesy Sotheby's Picture Library, London.

114. Halston, ultrasuede suit and coat, 1972. Costume Collection, Museum at the Fashion Institute of Technology, New York/photo Irving Solero.

115. Calvin Klein, checked suit, 1994. Rex Features, London/photo Today.

116. Donna Karan, Modern Souls campaign, 1995. Picture-Desk, London/photo Peter Lindbergh/Lighthouse Artists Management.

117. Ralph Lauren, advertisement for Polo. Picture-Desk, London.

118. Federico Fellini, poster for *La Dolce Vita*, 1959. Riama-Pathé/courtesy the Kobal Collection/PictureDesk, London.

119. Donatella Versace, ready-to-wear, 1998. Judith Clarke, London/R. Tecchio.

120. Giorgio Armani, suit and blouse, 1992. Rex Features, London.

121. Horace Vernet, fashionable gentleman, Paris, 1810, *Almanach des Modes* (1810–18). Musée de la Mode et du Textile, Paris/Collection UCAD/photo Laurent Sully Jaulmes.

122. Ascot Races, 1934. Hulton Archives/Getty Images, London.

123. A flapper, 1925. Hulton Archive/Getty Images, London.

124. Henry Grant, window-shopping youths, London, *c.*1951. © Museum of London.

125. Punks at a pop festival, England, *c.*1983. © Museum of London.

126. Jason Evans (Travis), 'Strictly', 1991. Courtesy Jason Evans, Hove.

127. Comme des Garçons, 1999. Judith Clark, London/R. Tecchio.

128. John Galliano, spring 1994. Photo Andrew Macpherson, Los Angeles, CA.

129. Alexander McQueen for Givenchy, 1998. Judith Clark, London/R. Tecchio.

130. Hussein Chalayan, aeroplane dress, 1999. Judith Clark, London/R. Tecchio.

131. Martin Margiela, 1998. Ronald Stoops.

The publisher and author apologize for any errors or omissions in the above list. If contacted they will be pleased to rectify these at the earliest opportunity.

# Index